# Masterworks of Ming and Qing Painting from the Forbidden City

Honolulu Academy of Arts
Honolulu, Hawaii
January 7 - February 12, 1989

High Museum of Art
Atlanta, Georgia
February 28 - April 2, 1989

The Cleveland Museum of Art
Cleveland, Ohio
April 15 - May 21, 1989

The Minneapolis Institute of Arts
Minneapolis, Minnesota
June 3 - July 9, 1989

The Metropolitan Museum of Art
New York, New York
September 16 - October 29, 1989

# *Masterworks of Ming and Qing Painting from the Forbidden City*

by

Howard Rogers
and
Sherman E. Lee

Published by

**International Arts Council**

Published in the United States of America by
International Arts Council
Publications Division
Box 1266
Lansdale, PA 19446

Printed in Japan

Publisher: Charles H. Moyer
Editor: John Stevenson
Photography: The Palace Museum

Front Cover: *Tranquil Spring* (detail) by Lang Shining (Giuseppe Castiglione),
circa 1735, with colophon added by the Qianlong emperor in 1782,
ink and color on silk, Catalogue No. 55.

Endpaper: The view looking north from the Meridian Gate, main entrance to
the Forbidden City, across a large courtyard to the Gate of Supreme Harmony,
entrance to the main ceremonial halls of the Imperial Palace. In the foreground is
the Stream of Golden Water, spanned by five bridges of white marble.

Back cover: *Thatched House in the Peach-blossom Village* (detail) by Qiu Ying,
circa 1545, ink and color on silk, Catalogue No. 17.

*Slide sets, posters, note cards and postcards of the
paintings reproduced in this book are available from the
International Arts Council at the above address.
Send a self-addressed, stamped envelope for ordering information.*

LIBRARY OF CONGRESS CATALOGING-IN-PUBLICATION DATA:

Rogers, Howard, 1940-
    Masterworks of Ming and Qing Painting from the
Forbidden City.

    Catalog of an American museum tour of paintings from
the Palace Museum in Beijing.
    Bibliography: p. 205
    Includes index.
    1. Painting, Chinese—Ming-Ch'ing dynasties,
1368-1912—Exhibitions.   2. Kuo li Pei-p'ing ku kong po
wu yüan—Exhibitions.   I. Lee, Sherman E.   II. Kuo li
Pei-P'ing ku kung po wu yüan.   III. Title.
ND1043.5.R64  1988       759.951       88-32805
ISBN 0-9621061-2-7
ISBN 0-9621061-1-9  (pbk.)

# Contents

# Foreword

The Palace Museum, in Beijing's Forbidden City, houses the largest, finest, and most important collection of Ming and Qing dynasty painting in the world. No painter of the Ming or Qing eras can be fully understood without knowledge of the Palace Museum collection, and the greatest achievements of Chinese artists are more often seen there than anywhere else.

Never before has any part of that great painting collection been exhibited in this country. Perhaps only once or twice in our lifetimes will we have the opportunity to glimpse in a single exhibition the full sweep and flow of the dynamic Chinese artistic tradition in its historical and artistic entirety. This is such an occasion, and it is one to celebrate. What prevails throughout this exhibition is a concern for high artistic quality and distinction. No historical biases intervene, no critical theories are interjected. The academician artist sits beside the retired scholar, the prince beside the priest. Their art is allowed to speak for itself, to tell its own story. An unusually high percentage of the paintings are true masterpieces, while all of them are rewarding; and, like a human epic, they reveal the enduring beauty and outstanding achievement of China's painters.

During the 500 and more years of the Ming (1368-1644) and Qing (1644-1911) dynasties, most of the artistic characteristics and ideals that we today regard as essentially Chinese (as opposed to French, Italian or Japanese) were defined, explored, and realized in their art by a succession of hundreds of Chinese painters. Ming and Qing painting represents the essence of Chinese artistic culture, and if we are to understand and appreciate that culture, we might most usefully begin here.

This long epoch chronologically corresponds to Western art history from the beginning of the Italian Renaissance to the flourishing of

Impressionism in France. While few other comparisons can be made between the two traditions, it is interesting that in both China and Europe around 1400 there occurred powerfully influential revivals of interest in ancient, classical ideals – in Europe those of Greece and Rome, in China those of the Song Dynasty. In both civilizations, moreover, by around 1900, as the old order was crumbling, profound challenges to the very bases of tradition began to transform the nature of both art and civilization.

Most of what we know and think about the Chinese artist is based upon our study of Ming and Qing painters. Our knowledge of Chinese art theory is fundamentally formed from the writings of Ming and Qing painters and critics. The Chinese tradition of art itself, in both China and the West, is substantially the Ming-Qing tradition. That tradition, while subordinate to Chinese institutions and policies during the same period, is also a separate system in many ways, and study of it will offer insights into the history of China that differ from those formed from the examination of other systems.

To observe the great pageant of Ming and Qing painting is to view a colorful, dynamic, profound, restless, and ever-changing – yet ever Chinese – drama of artistic creation evolving over 500 years. Whatever we may choose to ask about art and artists, about creativity and tradition, about artist and patron, about the academies and schools of painting, about representation, narrative, signs, symbols, and stylistic meanings, about intentions and their ambiguity, we can and do ask of Ming and Qing painting. And, to understand the art of painting as a human endeavor, we must look at the painting of the Ming and Qing dynasties because it embodies and defines the art of painting in China.

Richard M. Barnhart
Professor and Chairman
Department of the History of Art
Yale University

# Preface

*Masterworks of Ming and Qing Painting from the Forbidden City* is the first exhibition of extremely fine, ancient Chinese paintings to come to the United States from the People's Republic of China, and it does so on the tenth anniversary of the establishment of full diplomatic relations between the two countries. It is a very appropriate way to celebrate that important event.

The exhibition consists of seventy-six paintings of which fifty-five are hanging scrolls, sixteen are handscrolls, and five are albums. Fifty-three of the paintings were done on paper and twenty-three on silk. The first thirty-three paintings are of the Ming dynasty (1368-1644) while the remaining forty-three are of the Qing dynasty (1644-1911 and pronounced "Ching"). To give some Western historical perspective to their age, several of the scrolls were painted before Christopher Columbus was born while the most recent painting is one hundred years old. All are from the permanent collection of the Palace Museum in Beijing, popularly known as the Forbidden City. One of the criteria used to select the paintings was that they be among the very finest works of the most important artists of this golden, five hundred and forty-three year period of Chinese history.

The idea for the exhibition originated during a banquet I gave for Chinese artists in Beijing in September of 1985. I mentioned to some of the guests that although Chinese painting is one of the great art forms of the world, it is little known to the average American. They pointed out that the People's Republic of China had never sent a show of important, ancient Chinese paintings to America and suggested that we organize one. I agreed, and I am very proud of the International Arts Council's role as organizer of this exhibition which has been described by His Excellency Han Xu, China's Ambassador to the United States, as a milestone in the cultural relations between our two countries.

Many people contributed to the success of this project, some of whom are listed on the next page. I want to particularly thank Professor Manchiang Niu and his wife Lillian whose tireless efforts made the entire exhibition possible, and Professors Zhang Zhongpei and Yang Xin, Director and Deputy Director of the Palace Museum, along with the Palace Museum staff for their enthusiasm and cooperation. Special appreciation goes to the Cultural Relics Bureau of China and to the Ministry of Culture for their assistance and support and to the authors of this catalogue, Professor Howard Rogers and Dr. Sherman Lee, and to Dr. James Cahill for their valuable advice and counsel in selecting the paintings. I want to extend further thanks to the directors, curators, and staffs of the five American museums that are exhibiting the show and to Northwest Airlines which provided transportation to the United States for the exhibition and its personnel.

Charles H. Moyer
Chairman
International Arts Council

# Acknowledgments

The International Arts Council gratefully acknowledges the contributions of many people around the world who helped make the exhibition and this book possible. Among others, we wish to thank:

Richard M. Barnhart
Jack R Bershad
Maureen Blomgren
Bertram S. Brown
James Cahill
Arnold Chang
George Chaplin
Wei-Wei Chiu
Michael R. Cunningham
Hon. Curtis Cutter
Beth A. Desnick
Keith Doms
George R. Ellis
Reenie Feingold
Stanley Z. Feingold
Felice Fischer
Timothy Fiske
Wen Fong
Oliver Franklin
Diane W. Frederick
David L. Glaesser
Harold Gray
H. E. Han Xu
Paula M. Hancock

David Hardwicke
Anne d'Harnoncourt
Maxwell K. Hearn
John F. Horn
Huang Zhou
Robert D. Jacobsen
Jin Feng
M. J. Lapensky
Sherman E. Lee
Howard A. Link
Stephen Little
Hon. Winston Lord
Ian Lowe
Thomas Malim
Evan M. Maurer
Philippe de Montebello
Esther H. Moyer
Alfreda Murck
Lillian Paoying Niu
Manchiang Niu
Paul Perrot
Edmund P. Pillsbury, Jr.
John S. Pillsbury, Jr.
Katharine C. Pillsbury

B. C. B. Portman
Howard Rogers
Mary Ann Rogers
Edwin P. Rome
Hon. Edward L. Rowny
Arthur M. Sackler
Michael Sullivan
Nancy Swanson
William S. Talbot
Brian P. Tierney
Mary Tregear
Evan H. Turner
Thurston Twigg-Smith
Willibald Veit
Gudmund Vigtel
Storry Walton
H. E. Wang Meng
Selden Washington
William C. Wren
Yang Xin
Robert S. Young
Henry Zhang
Zhang Zhongpei
Zhao Hongyue

# Eastern China

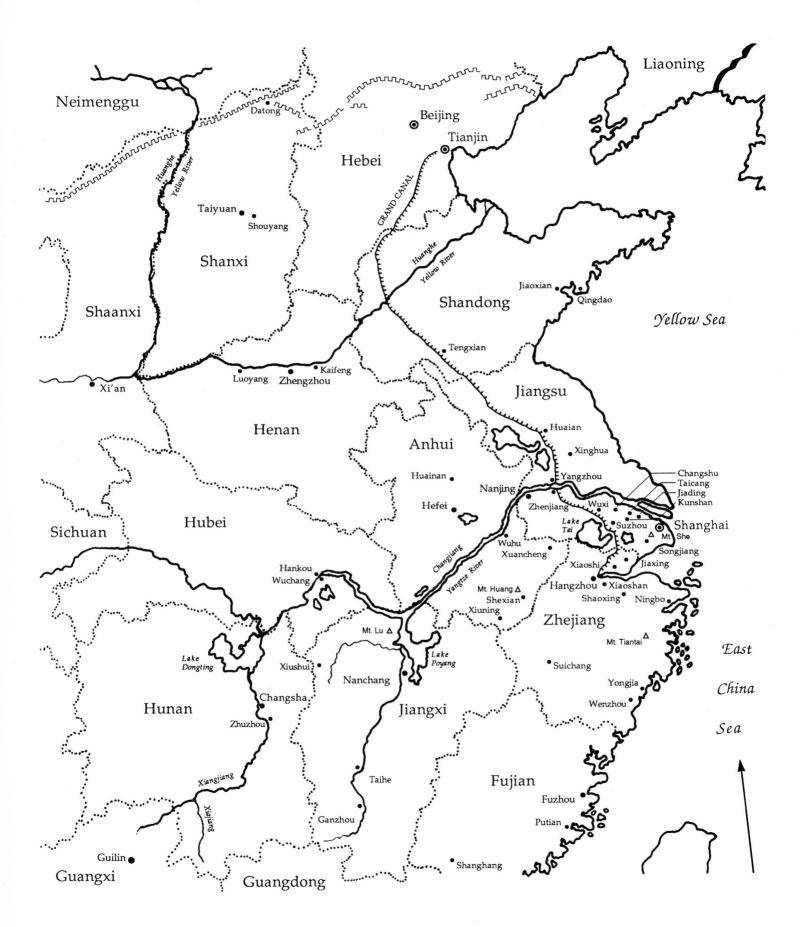

Neimenggu

Datong

Beijing ⊙
Tianjin ⊙

Liaoning

Hebei

Huanghe
Yellow River

GRAND CANAL

Taiyuan
Shouyang

Shanxi

Huanghe
Yellow River

Shandong

Jiaoxian
Qingdao

Yellow Sea

Shaanxi

Tengxian

Kaifeng
Luoyang  Zhengzhou

Jiangsu

Xi'an

Henan

Anhui

Huaian

Xinghua

Huainan

Yangzhou

Changshu
Taicang
Jiading
Kunshan

Nanjing

Zhenjiang  Wuxi

Hefei

Lake
Tai

Suzhou

Shanghai ⊙

Mt.
She

Sichuan

Hubei

Wuhu
Xuancheng

Xiaoshi

Songjiang
Jiaxing

Changjiang

Yangtze River

Mt. Huang △
Shexian
Xiuning

Hangzhou  Xiaoshan
Shaoxing  Ningbo

Hankou
Wuchang

Zhejiang

Mt. Tiantai △

Mt. Lu △

Lake
Poyang

East

Lake
Dongting

Xiushui

Nanchang

Suichang

China

Hunan

Changsha

Zhuzhou

Jiangxi

Yongjia
Wenzhou

Sea

Xiangjiang

Taihe

Fujian

Xiangjiang

Ganzhou

Fuzhou
Putian

Guilin

Guangxi

Shanghang

Guangdong

# Jiangsu-Anhui-Zhejiang region

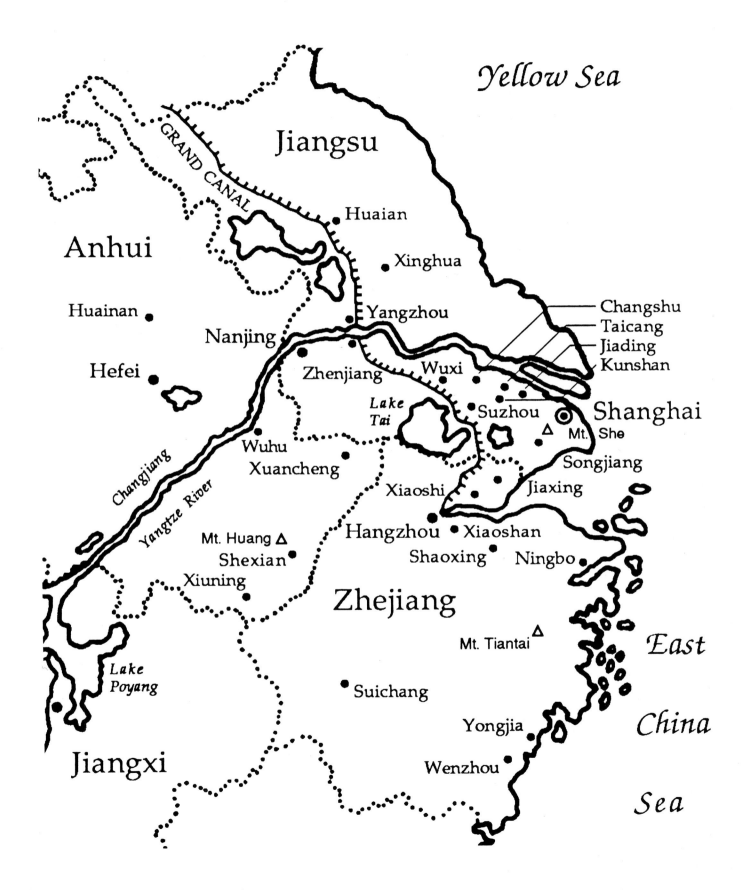

# Chronology

| | | | | |
|---|---|---|---|---|
| **SHANG** | ca. 1600-ca.1100 B.C. | | **YUAN** | 1279-1368 |
| **ZHOU** | ca. 1100-256 B.C. | | **MING** | 1368-1644 |
| Western Zhou | ca. 1100-771 B.C. | | | |
| Eastern Zhou | 770-256 B.C. | | Hongwu | 1368-1398 |
| Spring and Autumn period | 770-476 B.C. | | Jianwen | 1399-1402 |
| Warring States period | 475-221 B.C. | | Yongle | 1403-1424 |
| | | | Hongxi | 1425 |
| **QIN** | 221-207 B.C. | | Xuande | 1426-1435 |
| | | | Zhengtong | 1436-1449 |
| **HAN** | 206 B.C.-A.D. 220 | | Jingtai | 1450-1456 |
| Western Han | 206 B.C.-A.D. 9 | | Tianshun | 1457-1464 |
| Eastern Han | 25-220 | | Chenghua | 1465-1487 |
| | | | Hongzhi | 1488-1505 |
| **SIX DYNASTIES** | 220-589 | | Zhengde | 1506-1521 |
| Three Kingdoms | 220-265 | | Jiajing | 1522-1566 |
| | | | Longqing | 1567-1572 |
| Jin | 265-420 | | Wanli | 1573-1620 |
| Western Jin | 265-316 | | Taichang | 1620 |
| Eastern Jin | 317-420 | | Tianqi | 1621-1627 |
| | | | Chongzhen | 1628-1644 |
| Northern and Southern Dynasties | 420-589 | | **QING** | 1644-1911 |
| **SUI** | 581-618 | | Shunzhi | 1644-1661 |
| | | | Kangxi | 1662-1722 |
| **TANG** | 618-907 | | Yongzheng | 1723-1735 |
| | | | Qianlong | 1736-1795 |
| **FIVE DYNASTIES** | 907-960 | | Jiaqing | 1796-1820 |
| | | | Daoguang | 1821-1850 |
| **SONG** | 960-1279 | | Xianfeng | 1851-1861 |
| Northern Song | 960-1127 | | Tongzhi | 1862-1874 |
| Southern Song | 1127-1279 | | Guangxu | 1875-1908 |
| | | | Xuantong | 1909-1911 |
| **LIAO** | 916-1125 | | | |
| **JIN** | 1115-1234 | | | |

# The Palace Museum

by

Yang Xin

The Palace Museum is a national museum established on the site of the Imperial Palace of the Ming and Qing dynasties. The Imperial Palace, also known as the Forbidden City, was completed in 1420, in the eighteenth year of the reign of the Yongle emperor. Twenty-four emperors of the Ming and Qing dynasties lived here during a span of almost five hundred years. After the fall of the Qing dynasty, the Museum was officially established in 1925 and was opened to both Chinese and foreign visitors.

The Forbidden City is located in the center of the city of Beijing. It is nine hundred and sixty meters (3,150 feet) long and seven hundred and fifty meters (2,460 feet) wide, and occupies an area of over seven hundred and twenty thousand square meters (178 acres). Surrounded by high walls, the buildings inside are designed and constructed according to traditional Chinese theories of "yin-yang" and the "five elements" of metal, wood, water, fire and earth.

The large and small palaces, halls, and pavilions spread throughout the area are set off by dark red walls and roofed with yellow tiles. With painted rafters and carved beams, the buildings are imposing and majestic. The Forbidden City is actually a crystallization of traditional Chinese architectural achievement, and comprises the most complete and magnificent group of ancient Chinese buildings in existence. It is the supreme masterpiece of traditional Chinese architecture.

There is a wealth of artistic and cultural artifacts stored within the Forbidden City, including many items which were used and collected by the imperial courts of the Ming and Qing dynasties. The establishment of the Palace Museum marked the beginning of the protection of cultural relics by the government. Since 1949, the collection has been enriched through government-sponsored purchase and the acceptance of individuals' contributions. The Palace Museum now has a total collection of nearly one million artifacts, making it the largest museum in China.

Ancient Chinese paintings comprise a major part of the vast Palace Museum collection. Both in terms of quantity and of quality, the painting collection can be ranked first among collections in Chinese and foreign museums. For this reason the collection has always been a great attraction to Chinese and foreign scholars and the public. If we could ever display all of the more than 9,000 paintings in the Palace Museum collection, I believe that scholars of Chinese painting from all over the world would flock to Beijing. Such an exhibition would be a wonderful opportunity for them to see a complete picture of the historical development of Chinese painting. It is unfortunate that at the present time we are not able to hold such an extensive exhibition here because of the lack of proper exhibition space, so this event must be left to later generations to accomplish.

Chinese painting has a very ancient history, going back more than two thousand years even if we count only from the time of paintings on silk excavated from the tombs of the Warring States Period in Changsha, Hunan province, and do not take into account the beautiful patterns on clay pots or the mysterious sketches on habitations of primitive times. In the long course of history, generations of Chinese painters have developed a unique aesthetic sense and national style, using their own special materials and implements. On the other hand, Chinese painters never refused to learn from the art of other nations, assimilating it into their own. Consequently, Chinese painting has remained unique in both form and style and is regarded as a model example of the arts in Asia.

To enjoy Chinese painting one should have some knowledge of Chinese history, geography, customs and traditions, religious and political beliefs, aesthetic conceptions and interests. Only then can one have a proper understanding of the paintings, and an appreciation of features that other nations do not share.

The art of any nation has its own uniqueness and history. In recent years, American scholars have done research into many aspects of Chinese painting. Through their abundant literature they have introduced this ancient form of art and its achievements to the American people and to the whole Western world. The American people's interest in Chinese painting is steadily increasing. Chinese painting is at the same time enjoying a greater and greater world reputation. We think it is an encouragement and a support to a country if its art is understood and enjoyed by more and more nations. Scholars have set up a bridge of friendship in creating this understanding.

After two years of preparatory work, the exhibition *Masterworks of Ming and Qing Painting from the Forbidden City* will be shown in five large American cities. This exhibition is a new bridge of friendship which will further enhance understanding between the Chinese and American peoples and promote academic exchange between the two countries. Hence, I would like to give my deep thanks to Mr. Charles H. Moyer and Professor Manchiang Niu who have contributed their hard work to set up this bridge. I would also like to thank Dr. Sherman Lee and Professor Howard Rogers; they gave very precious suggestions to the exhibition and have written this excellent catalogue.

I wish every success to the exhibition and I believe that it will be warmly welcomed and highly valued by the American public and American Overseas Chinese. From this, the Palace Museum will take great glory and pride.

Yang Xin
Deputy Director
The Palace Museum

# Ming and Qing Painting

by

Sherman E. Lee

The painters' inheritance in the Ming (1368-1644) and Qing (1644-1911) dynasties was both ancient and extensive. Painted images and calligraphic writing in ink on silk were already more than 1700 years old, and the materials, formats, and techniques of painting had developed in flexibility and complexity to a point where further subtlety was both unimaginable and superfluous. Painting with ink and/or color on tomb and temple walls was practiced by application to dry plaster surfaces, but by Ming times this discipline was declining and practiced only by lowly regarded professional masters. Screen paintings, usually single rather than multi-panelled, continued to be made, but usually by artisans for purely decorative purposes. The dominant formats were the hanging scroll, the handscroll, and the album. The former corresponded to the Western easel painting; it had brocaded textile border-frames and was capable of being rolled up for easy and safe storage. The handscroll, almost uniquely Far Eastern, was a long horizontal length of papers or silks from a few to dozens of feet in length, which could be unrolled an easy viewing length at a time and then rolled up again for storage in a protective box. This particular format was extremely flexible and could be orchestrated, whether for landscapes, figures or other subjects, in space and time simultaneously, thus approximating the temporal art of music – sound instead of images in suggested space through real time.

The album was a more recent invention only a few centuries earlier. It became a popular format for Ming and Qing artists, at least in part because of its literary derivations (both calligraphy albums and printed accordion-fold books predate pictorial images in album form). Like the handscroll, though less flexibly and continuously, the album was sequential in time, framed pictures in succession. They could be related images – seasonal, topographic, flora or fauna – or they could be anthologies of friendly artists' homages to the styles of earlier masters.

The folding fan was especially popular with the literary-official-gentry classes, certainly not because of its origins in Japan, but because of its combination of utility in the hot weather of south China, symbolism because of its scepter or tablet-like shape when folded, and personal pictorial expression on its small and specialized shape. Fans were

omnipresent as exchange gifts among the scholar-gentry-painters and their numbers increased greatly as the two dynasties ran their courses.

The tools and media of painting had been perfected over five hundred years before the founding of the Ming dynasty. Brushes with various tips, from badger to mouse hair, from soft and spreading to stiff and scrubby, from tiny ones for fine line-work to massive accumulations of hair and bristle designed to make expansive calligraphic strokes, were a common heritage. Inks were made principally from soot and charcoal derived from various woods, bonded by a variety of animal hide and vegetable adhesives. Pressed into elaborate and decorated forms, ink could be sooty and lacquer-like or soft and smooth, thin or thick depending in part upon the amount of water mixed with the cake on the grinding surface of the inkstone. Ink was so varied in its appearances that it was commonplace to write of the "colors of ink." True colors were derived from natural materials, blue from lapis lazuli, green from malachite, red from cinnabar or from red ochre earth, yellow from mercuric sulfide originating in coxcomb.

Silk, from fine to coarse, from single and double weave to satin, had been the ground for the earliest of all portable Chinese paintings in the fourth century B.C. Paper was developed some four centuries later and rapidly became popular for calligraphy, later rivalling silk for paintings. By the beginning of the Ming dynasty, paper was the dominant ground, again, like albums, in considerable part because of its associations with calligraphy and literacy. Rag paper was one of the earliest types, but variety was rapidly developed and mulberry, ramie, bamboo fiber, grain husks, hemp and other fibrous materials became standard and much varied paper types. It should be noted that "rice paper" was a late and poor material, a dried paste, easily damaged and fobbed off on traders, missionaries, and seamen in the south after the opening of the Canton port.

The keys to the use of these inherited formats and materials were the techniques and disciplines transmitted from the glorious past. Chief among these was calligraphy. While the Chinese language developed out of pictographs, usually shorthand images, it rapidly left the representational to arrive at thousands of complex and subtle characters combining organized brush strokes. The difficulty of the resulting combinations, often formed with as many as twenty or more carefully organized brush strokes, meant that full literacy was usually restricted to a relatively small class of scholars and officials, by Ming and Qing times called *wenren* in Chinese, meaning "literary men" or "literati." The organization of individual characters and of sets required careful planning, control and aesthetic understanding of composition and relationships of brush strokes. Since representational painting developed after calligraphy (the art of writing), brush and ink as used in calligraphy dominated pictorial art: brush strokes are for the Chinese the most important element in painting. As a corollary, any literatus, because of his training and experience, could be an artist.

This is not to say that other requirements for good painting did not exist: such Western standards as composition, adequacy of representation, harmony of color, the suggestion of space, and expression, were carefully considered and codified by the Chinese. From the fourth century B.C. when "painting is drawing boundaries," to the end of the Southern Song period in 1279, Chinese painters developed successive miracles of representation, first in animals, then in painting the human figure, and finally in the depiction of nature through landscape. The last was certainly their most remarkable achievement, antedating any such Western accomplishment by at least six hundred years.

The great age of figure painting was that of the Tang dynasty (618-907), and its standards dominated later works in the same genre. For landscape, now and forever the dominant subject, the Five Dynasties period (907-960) and the Northern (960-1127) and Southern (1127-1279) Song dynasties were the standard bearers. Landscape developed from rational and monumental reality to visual and intuitive appearances, establishing norms and conventions with overwhelming influence on the artists who followed.

The Ming and Qing masters also had a large inheritance of artistic theory establishing the boundaries of their own assumptions about art. The preceding theory and aesthetics of calligraphy naturally shaped thinking about painting, which was made by the same writing brushes with ink on the same grounds. But music also assumed a major role in establishing theories of visual art. The moral and social role of music was well placed within Confucian thought by the fifth century B.C. and its tones and reverberations set off vibrations in the aesthetics of pictorial art.

The classic expression of such theories of art, providing the base for almost all subsequent formulations in a very traditional Chinese society, were the Six Canons of Xie He (ca.500-535?). The last four are similar to traditional Western ideas of pictorial truth:

3. Fidelity to object in form;
4. Correspondence to type (in color);
5. Division and planning;
6. Transmission of the past by copying.

The first two are crucial to the appearance and appreciation of Chinese painting and the second presents a quite different attitude from the common understanding of the brush in the West:

1. Spirit-resonance (or animation by spirit-consonance);
2. Bone method (of brush).

The first term originates in musical theory. "Spirit-resonance," *qiyun*, implies a sympathetic vibration from artist through picture to observer, as a vibrating tone moves from one bell through air to another. Other analo-

gies were developed. The *qiyun* was a part of nature's rhythm, a vital force, not unlike Bergson's *élan vital*, at one with both a Confucian view of nature as a rational model for humanity, and a Daoist intuition of nature as permeated by rhythms shared by humanity. In the Chinese view of anatomy, *qiyun* was the blood and arteries of humanity, and the artist transmitted this quality through his arm to the brush onto the painting and further by empathetic and "sympathetic responsiveness of the vital spirit" (Sakanishi, S.) to the observer.

Mystical, or at least intuitive, spirit-resonance carries with it concepts of greatness of character (related to Western "genius") revealed in brushed characters or images. The man is his writing. In this it makes the transition from canon one to two, *gu fa*, "bone method," derived wholly from the practice and theory of calligraphy. The evaluation of the writing must keep in mind standards of stroke production; the individual brush strokes must have "bones" or structure, whether strongly, elegantly or wildly made. This is different from Western pictorial practice where the overall, or part by part, effect of the image dominates and the emotional or rational impact of the great work is determined by "expression." The Chinese, except perhaps for a short time in the late Southern Song dynasty, *read* their paintings primarily in terms of brushwork and with the first two and least objective of the Six Canons in mind. However charming a pictorial effect may be, it can be fatally flawed by inadequate brush control, rhythm, and structure.

The position in society of the painter of pictures evolved in two major and extended stages. Until the end of the Song dynasty one can speak of art as a profession, within the already existing limitations of literacy. Painters were patronized by the court, nobility, the wealthy, and religious institutions, whether Confucian, Daoist or Buddhist. Some had specialties: figures, "fur and feathers," architectural painting, landscape. They came from different segments of the literate, though some examples are known of artists coming from humble origins. They were trained in the study of calligraphy, then by apprenticeship to established artists and, in some periods, by imperial academies. High officials, princes, even emperors could become famous painters; famous painters could become high officials, even to such exalted rank as prime minister. But in this earlier phase, most painting was done to order; more rarely as part of the numerous gift obligations. Occasionally one reads of professional painters resenting the obligations resulting from patronage.

By the Northern Song dynasty more is heard of gentlemen painters, scholars and kindred spirits executing works as "play," as gifts without the stain of compensation. Such masters were also concerned with their assumed moral superiority to professional "artisans" and that their works revealed their high moral and aesthetic character, which calligraphy always revealed. These ripples became a flood in the succeeding dynasty, the Yuan (1279-1368), which was a foreign rule by Mongol invaders from the north and west.

This brings us to what was for the Ming artists the immediate past, the end of Southern Song and the foreign Yuan dynasty, the thirteenth and fourteenth centuries. The late Southern Song painters were handicapped for the future on two counts: their dynasty had "ignominiously" acquiesced in the loss of the north to the Tartars and then had been conquered by the new Mongol rulers; and they had developed a style of painting that relied, not on brush strokes and reverence for the past, but on ink washes and a new realism of atmosphere and silhouette akin to the later Western approach of the seventeenth century. The latter "fault" was in fact a progressive accomplishment, but one with little future support, in part because of its negation of traditional brush strokes and because of its production in a period of political and social surrender to foreign, barbarian conquerors.

With the overwhelming triumph of the Mongols, the moral, political and aesthetic foundations for future development were in place. Traditional professional and/or academic masters still worked for religious institutions, the merchants, and, to a limited extent, the court. But the scholar-officials were now confronted with a critical moral-political choice: whether to serve or boycott a foreign (barbarian) dynasty. Responses were mixed, but a sufficient number refused service to form a critical mass in the mid-fourteenth century. Among them were influential scholar-painters who rejected the preceding Southern Song academy and its pictorial style as "products of ignoble refugees," and who initiated a new style based consciously on the earlier Northern Song style of monumental landscape painting with its social and political associations with rectitude and dynastic legitimacy. This new and revolutionary style was called *wenren hua*, "literary men's painting."

The artistic reaction was against wash and realism. It emphasized brush strokes and what have properly been called "written pictures." There were strong overtones of art-historical attitudes, of resurrecting "true" traditions of the past, of painting themes and variations on those traditions. From a material point of view the change was epitomized by the overwhelming choice of paper over silk as a ground. Paper was more receptive to all movements and pressures of the brush, and was the favorite material of the *writer*. Silk became the characteristic ground of the professional *painter*.

The *wenren* revolution had an apparently short life. The founder of the Ming dynasty, Zhu Yuanzhang (1328-1398), who became the Hongwu emperor, was a peasant-soldier-general. While he initially used the *wenren* as luminaries and officials, their independence and perhaps their instability gradually led to their demise. Four of the leading *wenren* painters who took service under the founder of the native Ming dynasty died at his orders, two were executed and two died in prison, one a suicide. This unkindly reception certainly dampened *wenren* spirits, while the desire of the emperor and his immediate successors in the fifteenth century to revive the traditional art academy of the Song dynasty with its concomitant patronage was enough to ensure new life for the traditions of

Southern Song and a delay to the further development of *wenren* painting.

But it is equally important to know what the early Ming painters did *not* know, particularly the writing on art criticism and the painting developments of the late Ming dynasty some one hundred and fifty years later. While it may seem quixotic to write of what had not yet happened in the period from 1370 to 1520, the reality is that most Chinese and some Western art historians analyze and criticize the early Ming painters by the extreme *wenren* standards established around the turn of the seventeenth century by Dong Qichang (cat. 28). He and his friends developed the Northern (bad) and Southern (good) schools classification, and included the academic and Zhe school painters of early Ming, as well as their Southern Song predecessors, among the damned. The *wenren* philosophy became the cult of an in-group making and consuming its art. The painters of the first twenty-seven paintings in the exhibition, dating from about 1412 to about 1600, knew nothing of Dong's theories and little of such prejudice in their own time. Such was the world of the early Ming painters. What was possible for them and what did they create within these inherited possibilities and within a revived native and still traditional society? The results can be seen to be varied, creative, and a major contribution to the history of world art in general and to Chinese painting in particular.

## Ming Painting

The reigns of the Hongwu, Yongle and Xuande emperors were relatively strong and well-organized, supported by a strong agricultural base in the south below the Yangtze river, and by a particularly large and efficient merchant fleet. The desire for a revived imperial cultural patronage could be supported, and great advances in the arts of porcelain, lacquer, and enamel were made. After an interregnum of twenty years, successive rulers managed, with growing ineptitude, to maintain their own courtly production in the useful arts; but in painting imperial patronage quickly declined and this field was left to the private world of the *wenren*.

The direct result of early Ming power and prosperity was a flourishing imperial and merchant patronage reflected in the variety and creativity shown by nine major works in the exhibition. While landscape is the dominant theme, dramatic and decorative bird-and-flower paintings were produced by specialists such as Lin Liang (cat.4) and Lü Ji (cat.5), and large-scale figure paintings of exemplary history (cat.8 and 11) played a

major role in official production. The starting point for the styles of all these works is that of later Southern Song painting, principally the works of the imperial academy of the late-twelfth and thirteenth centuries. The Ming transformation of these usually intimate and tranquil images was in the direction of increased scale (larger pictures for large official rooms), greater contrasts of ink tone (greater visibility), more dramatic action in both figures and landscape, and more expressionist tensions in the asymmetric compositions inherited from the Ma-Xia school of Southern Song. Most of these early Ming artists are described as belonging to the Zhe school, after the first character in Zhejiang, the home province of the school's acknowledged master, Dai Jin (cat. 6), and the region best preserving the late Song traditions. There, in many cases, the monasteries, temples and shrines (usually those of Buddhist or Daoist allegiance) were the principal patrons of the "old" style painters through the fourteenth century. The new power and scale of the Zhe school were unsympathetic to later *wenren* critics and most often drew the epithet "vulgar." Further, the figure painters often took their models from farm and village types, and this too proved uncongenial to later writers on art.

The Zhe style continued to attract some masters of the sixteenth century, notably the "crazy" Xu Wei (cat.24) and the decorative specialist in "fur and feathers," Zhou Zhimian (cat.26), who was certainly influenced by the large pictures of Lü Ji. By the mid-sixteenth century, with effective patronage impossible in the troubled and declining countryside, let alone within the growing corruption and chaos at the imperial court, the academic-professional painters declined catastrophically in talent, production and reputation. Only the Japanese collected their works and only now is renewed recognition being given to their very real and creative accomplishment.

Many painters bridged the slowly growing gap between the professionals and the *wenren*. Some, such as Du Jin and Shi Zhong, were scholar-officials who worked in a free Zhe manner. Others, adapting traditional modes, not exclusively those of Southern Song, were members of or at least involved with the in-group around the leading *wenren* artist of the early Ming period, Shen Zhou (cat.12). Shen was the founder of the "Wu school," centered in the garden city of Suzhou, but named after the region surrounding it, Wu. The traditional artists associated with Shen were Zhou Chen (cat.14), Tang Yin (cat.16), and Qiu Ying (cat.17), great masters all. Zhou Chen was a consummate landscape painter, much occupied in transforming the styles of the late Northern Song academician, Li Dang, and the later Southern Song artist, Ma Yuan, the Ma of the Ma-Xia school. He was also a superb figure painter and, most remarkably, a social critic, at least in one handscroll, half of which is in the Honolulu Academy of Arts, the other half in the Cleveland Museum of Art. His immediate follower, Tang Yin, owed much to Zhou Chen. Tang, a failed scholar, hit a strain between Zhe and *wenren* in landscapes that, like his teacher's, mined the landscape masters of Northern and early Southern Song. His

figure painting is more elegant than Zhou's, perhaps reflecting his intimate familiarity with the ambience associated with pleasure-houses. Qiu Ying was the most skilled professional of his day and was particularly interested in pre-Song painting with its copious use of color in figure painting and the so-called blue-green-gold method of landscape. This archaism, combined with the decorative appeal of his carefully applied color, proved most popular. All three of these artists usually worked in a detailed and careful technique unlike the freer and more abstract brush-play of the *wenren*, and it may well have been their close association with the early Wu school painters that influenced these *wenren* to work on a smaller scale and in a detailed manner, to the ultimate detriment of this first major *wenren* group.

Considering the ferocity of the first Ming emperor's treatment of some of the leading *wenren* masters of the late Yuan dynasty, there was good reason for the group's decline in the fifteenth century. Only three works in the exhibition represent the period. Wang Fu's scroll of ca.1412 (cat.1) is a completion of a lesser artist's beginning, but the last part of the scroll is a marvel of spaciousness and brush control, changing the earlier artist's atmospheric approach into a fitting *wenren* accomplishment in a pure fourteenth century way. The bamboo landscape handscroll by his follower, Xia Chang (cat.2), builds on Wang Fu's most splendid invention, a close-up, segmented view of nature where the part reveals the whole. The brilliant brushwork is associated with the subject, dear to the scholar due to bamboo's resilience under pressure and because of its silhouette, so amenable to skillful brush practice.

But these works, and a pitifully few others surviving from the century, only partially account for the appearance and achievement of Shen Zhou, the first and greatest master of the Wu school. The handscroll *The Flavor of Seclusion*, ca.1490, is a masterful epitome of Shen's most mature and accomplished manner. Compared to Wang Fu's gracious lyricism, Shen's landscape seems boldly direct in brushwork, producing a kind of Olympian coldness that defies comparison with any other works of his time. His fame and the force of his accomplishment carried the Wu school to pre-eminence, an accomplishment made easier by the decline of imperial patronage at the beginning of the sixteenth century and the consequent decline of the Zhe school.

Shen was fortunate in his friend and pupil, Wen Zhengming (cat.15). *Tasting Tea*, a hanging scroll of 1534, is characteristic of the work of Wen's middle years – elegant, refined, complex and somehow miniature in scale. His family and followers, who make up the major part of the Wu school, took these works as their model rather than the moving, difficult, and austere works of his old age. The results are almost always quiet and beautiful in tone with elegant and careful brushwork. Each artist has his own flavor within the common style: Lu Zhi, with his angular, crystalline but fanciful construction of the most famous site of Suzhou, *Mount Huqiu* (Tiger Hill, cat.18); Wen Jia's variation of 1563 on the famous poem by Bo

Juyi, *The Song of the Lute* (cat.19), with its nostalgic subject and its equally strong nostalgia for the ways of Yuan painting, especially the two-part landscape compositions first made popular by Ni Zan, one of the four great masters of Yuan; Wen Boren's 1560 effort (cat.20) to match the monumental landscapes of the tenth century with the incongruously refined brushwork of the later Wu school; and the others, always with quality, but always with a caution that remains well within the boundaries of what had become "scholar's taste": pure, clean, elegant, learned, refined, but inbred and unadventurous. If one compares the later Wu school output to the unbridled energy of the mad Xu Wei, in his *Flowers of the Four Seasons* (cat.24), harking back to the bolder paintings of the Zhe school, one can grasp the relative accomplishments of both schools. One senses, however, the dead-end of both directions and an evident need for change.

This was provided by the paintings and theories of Dong Qichang (cat.28), who, with Shen Zhou, was the most important and creative *wenren* artist of the Ming dynasty, as well as the outstanding theorist of the period. His maturity in painting and the publication of his *Huashuo* (1627) coincided with the rapid decline of Ming fortunes and of his own. A wealthy and arrogant landowner, he suffered heavy losses in the peasant uprisings of 1616, but his high official positions continued to indicate his importance as an outstanding scholar-official.

The heartland of Chinese painting since at least as early as the Southern Song dynasty, with its capital at Hangzhou, had become the south, especially what was called the "eye area," including Lake Tai and the great garden cities of Yangzhou and Suzhou. Painters unfortunate enough to come from the north usually migrated to the south. Scholars charged with duties at the capital, Beijing, found numerous excuses for long stays in the more pleasant southland. With the capital power-center in serious decline and with much internecine trouble, the more prosperous and temperate south provided a location allowing relative independence for the *wenren* and even for numerous professional masters – usually *wenren* without means except that provided by selling their art to an audience of "upscale" merchants and landowners. With both the Zhe and Wu schools more or less moribund, the resulting vacuum was filled by numbers of painters we now call "Individualists" (cat.27-33). These painters were as bound by their artistic inheritance as anyone, but they ransacked all aspects of the past and present. Fortified by the old *wenren* idea of "the brush is the man," they used their individual preferences and prejudices to produce idiosyncratic art. Like the quirky and strange art of our own time, theirs was marked by difficulty, enormous variety, and cloaked references to a large and great past. Some of them grouped themselves by geography, though that, and acquaintance, was often the only thing they had in common – thus the "schools" of Suzhou, Songjiang, and Jiading.

Dong Qichang attempted a traditional Confucian "Great Synthesis." We have already mentioned his unfortunate division of the history of

painting into the approved Southern and condemned Northern schools. The other theoretical lynchpin of his system was a qualification of the sixth principle of Xie He, transmission by copying. Dong considered that this should be a creative act, transforming the original through a thinking individual who had deep and broad knowledge of the past. Perhaps the closest things to this approach in the West are Brahms' variations on earlier themes from composers such as Haydn; or, in painting, Picasso's extraordinary variations on Delacroix, Velasquez or Ingres. In stressing this practice, Dong was trying to bring a structure derived from tradition to the increasing social and artistic fragmentation of his time. It was part Renaissance, part eclectic, but especially it was Chinese and Confucian, traditional and rational.

Of course images based on such theory can look radically different, depending on the artist's individuality. The quirky Wu Bin (cat.27) and suave Lan Ying (cat.30) can each be said to have followed Dong's theories, but how different the concrete results. What practical and concrete images did Dong Qichang himself provide? In these he reacted against other images of the immediate past, especially those of Wen Zhengming's followers in the Wu school. The small handscroll by Dong in the exhibition reveals intellectual strength wedded to direct, simplified, large-scale structures that exist in struggle and tension. Dong learned from the great monumental masters of the tenth and eleventh centuries how to produce such monumentality, and he transformed this knowledge into *his* time through the overweening ambition and stubbornness of *his* character. The results, especially in his large hanging scrolls, are remarkably analogous, but not similar, to the achievements of a Masaccio or a Cezanne, in reconstructing art from a past, whether early Chinese landscapes, classical or Poussinesque. If Dong's results are sometimes strident and awkward, one should remember the elegant miniaturization he vigorously fought and replaced.

Dong's friends and direct followers, save for Xiang Shengmo (cat.31), were not major figures; but Dong's influence in terms of enlarged scale, forceful and unusual composition transmitted from Northern Song prototypes, permeates the numerous individualists active at the end of the Ming dynasty and the even more famous four individualists of the transition to early Qing (cat.41, 44-46). Many of the former, such as Wu Bin, made their living by painting; Chen Hongshou (cat.33) designed book illustrations for ancient classics as well as for Yuan and Ming novels, a literary genre at its apogee during Ming times. Both Chen and his Northern counterpart, Cui Zizhong (cat.32), were masters of fine-line figure painting in an archaistic mode reminiscent of the distant Six Dynasties period (220-589). They were equally accomplished in colored landscapes with veiled and quirky hints of the great blue and green methods of the late Tang masters, the "big and little" Generals Li. Wu Bin, too, was a figure painter of distinction, and these three masters are now much appreciated, perhaps in part because their creative distortions recall the ways of mod-

ern Western Expressionists.

A handscroll, *Various Entertainments*, by Zhang Hong (cat.29), presents this artist's direct and observant style in a most unusual subject for a *wen-ren*. There should be more examples of such scenes from everyday life since the Ming *wenren* were enthusiastic consumers of the popular novels of the day. We have seen that Chen Hongshou drew for book illustrations, and indeed Zhang's scroll is organized into units that would be appropriate for such illustration. What is important, and is related to the artist's most original and innovative landscapes, is the directness of observation, a far cry from the often stereotyped "mountain-water" pictures of the Wu school.

It now seems most likely, according to James Cahill and Michael Sullivan, that these last decades of the Ming dynasty witnessed a second episode of Western influence on Chinese painting. Late classical shading methods had been transmitted through India and central Asia as early as the fifth and sixth centuries. Now Catholic missionaries appear in China, notably Matteo Ricci, and book illustrations, engravings, and a few icons provided stimulating visual material for the Chinese to ponder. Most official reactions to Western pictures were derogatory, stressing that mere realism was not enough, and that the Westerners were ignorant of "spirit and brush," the beginning two of Xie He's Six Canons. Still, the pictorial evidence in the art of Zhang Hong and Gong Xian (cat.46), for example, strongly supports the assumption of Western influence. Gong's unusual use of light and shade in more evanescent and fleeting, less ideal and timeless, ways is a particular case in point.

# Qing Painting

The Qing dynasty officially dates from 1644, but pacification of the south and southwest delayed effective control and the benefits of Manchu rule until the early 1680s. A foreign dynasty, the Manchus descended from the Jurchen Tartars. The early emperors, Kangxi, Yongzheng, Qianlong, Jiaqing and Daoguang, provided a stable and effective rule with prosperous development in a country whose population increased enormously. Exclusionary in terms of open trade and emigration, the first three emperors were deeply interested in Western ideas and technology, and especially in the art presented them as gifts or actual production by the Jesuits at the court in Beijing, particularly the gifted Giuseppe Castiglione (Lang Shining, cat.55). The wise decisions by these rulers to

adopt as many of the Chinese laws and mores as possible led to a degree of toleration for the Manchus unheard of for the Mongols in the fourteenth century.

The court patronized at least two of the *wenren* painters, particularly the now orthodox school begun by Dong Qichang and carried on most conspicuously by two generations of *wenren*, the Four Wangs: Wang Shimin and Wang Jian (cat.34 and 35); Wang Hui and Wang Yuanqi (cat.49 and 50). Two other artists are usually added to the Wangs: Yun Shouping (cat.52) and Wu Li (cat.51). Both Wang Hui and Wang Yuanqi were patronized by the Kangxi emperor, but the others chose to withhold their service and nurse the traditional *wenren* grievance regarding foreign rule. Wu Li became a Catholic and took the vows of priesthood. The works of all six men are academic in the best sense: skillful, decorous, and knowledgeable about both the subject and the complex art history of the *wenren* tradition. Yun, though best known as a painter of flowers in both traditional and *wenren* manners, also produced equally soft and pleasing landscapes. Wang Yuanqi was probably the most original of the group and boldly practiced some of the tensions and disjunctions developed by the master of them all, Dong Qichang.

We have seen the proliferation of "individualism" in late Ming as the dynasty collapsed. The time of troubles in early Qing provided a continuum for these loosely associated individuals and the time for the appearance of the four most famous and creative of the individualists active just before and after 1700. These are: Kuncan (cat.41), a Chan priest and Ming loyalist; Zhu Da (cat. 44), an eccentric Buddhist monk, also known as Bada Shanren, who was descended from a Ming imperial line; Yuanji (cat.45), twelfth generation descendant of the first Ming emperor, who was also a monk and is often called Shitao; and Gong Xian (cat.46), a Nanjing Ming loyalist, famous also for his poetry. The marked differences in their individual painting methods well justify their claims to individuality, while their unified loyalty to the native Ming dynasty bestows a favorite *wenren* mantle upon them – though Yuanji did visit the Kangxi court. These, and other lesser artists of their political and social persuasion, followed the well-travelled path of "eremitism," a retreat into the cleanliness and spirituality of nature as a welcome alternative to the immorality of the world, particularly exemplified by the decline of the Ming court and the triumph of the foreign Manchus. The eremitic tradition was an old one, sometimes Daoist, Buddhist, or Confucian, but more often a combination of "the three religions." In any case, foreign rule or not, retreat was a welcome respite from official appointment at an imperial court usually riddled with intrigue.

Kuncan's hairy and tangled landscapes; Zhu Da's abbreviated but firm brushwork recalling that of another, earlier eccentric, Xu Wei; Yuanji's brilliant usage of wash, unusual compositions, and directly observed images, recalling the approach of Zhang Hong; and Gong Xian's deep and somber ink-play of light and shade; all justify their unusually high place

in Chinese art history. The most various of the four was certainly Yuanji and that variety endears him particularly to modern critics and collectors. His *Plucking Chrysanthemums* of 1671 (cat.45) is an especially rewarding early work. The direct reaction to the unusual appearance of the pruned tree is characteristic of his keen-eyed and sympathetic approach to nature.

Another group of individualists is associated with Anhui province: Xiao Yuncong (cat.36), Cheng Zhengkui (cat.37), Cheng Sui (cat.38), Hongren (cat.40), and Zha Shibiao (cat.42), all five landscapists. Xiao is the most complex master and is represented here by a particularly unexpected version of his complicated and rhythmical compositions. It appears almost as if carved in low relief, like a rubbing, and distinctly monochromatic. The more than one hundred serial compositions of Cheng Zhengkui, all titled *Dream Journey Among Rivers and Mountains*, are represented here by No. 25, an early and less abbreviated handscroll than the surviving later scrolls. Cheng Sui and Hongren display their characteristic austere use of ink in compositions owing much to Ni Zan, the most refined and austere model among the Four Great Masters of Yuan.

There are paintings by and records of numerous other painters in increasing numbers as the Qing dynasty continued. Some make moderate or slight contributions to the history of painting; many produced merely comfortable exchanges from one scholar to another. Their imagery was based on the increasing number of painting manuals available to all who could read and, especially, write. The most famous of these woodblock-printed manuals was the *Mustard Seed Garden Manual of Painting* (1679, 1701) with its beautifully registered color and monochrome prints of a myriad of motifs for the aspiring scholar-painter. Instruction included specialized subjects such as bamboo, orchids and rocks, as well as the various elements of landscape, and in all manner of historic styles. Proliferation of the results of this instruction, whether in theory or practice, did not necessarily raise levels of accomplishment throughout China.

However, technical competence was essential for the court painters, particularly those specializing in decorative pictures. Some, such as Leng Mei (cat.57), were accomplished in "fur and feathers"; portraitists were attached to the court, such as Yu Zhiding (cat.53), whose Chinese counterparts to "conversation pieces" place the accepted *wenren* in a "retreat" setting, comfortably in the midst of tranquil and accomodating nature; still others, such as Yuan Jiang (cat.58), were quite marvelous landscape artists, painting large subjects in ink and color with quotations from early Song masters transformed by an appealing, jazz-like rhythm in the contours of rocks, islands, and mountains. Elements of modelling in light and shade betray the influence of the court's most unique master, Giuseppe Castiglione, the Jesuit who adopted the Chinese name Lang Shining.

*Tranquil Spring* (cat.55), both typical and unusual for Castiglione, is a perhaps unfinished double portrait of the future Qianlong emperor with an older, moustachioed mentor. It is typical in the loving and subtle attention to the modelling in light and shade of the details of the *wenren* subject

matter – the jade vessel and book on the table, the stalks of bamboo, and especially the beautifully conceived flowing and rounded drapery of the robes on the figures. Two of the traditional "three friends" of the scholar – bamboo, pine and prunus – are present. The relationship between the prince and the other figure, perhaps a tutor, seems sympathetic and friendly, even on terms of equality. The faces are delicately, almost imperceptibly, modelled in light and shade. The setting, however, is handled in a Chinese manner with the folds of ground punctuated by "dots" and, most unusual, a flat lapis-blue sky that performs a similar function to that found in the gold backgrounds of Western medieval art – a near and palpable color but with the suggestion of infinity beyond. Halfway between the Western and Eastern worlds is the rock at the left foreground. This is an early example of the artistic union achieved by Castiglione and hinted at by Yuan Jiang in 1708 (cat.58).

Among the eighteenth-century regional groupings of artists, such as Nanjing, Anhui, Yangzhou, the latter is currently much in favor, and this exhibition displays eight works of the school. The names included in the Eight Eccentric Masters of Yangzhou varied from critic to critic, and the artists here (cat.60, 61 and 63-68) are taken from at least thirteen candidates included in different lists of the eight. Most of these artists are quite specialized in both style and subject matter. Zheng Xie (cat.66) painted bamboo and orchids, but not according to the manuals. His rapidly brushed and unkempt scrolls vary greatly in size and quality. Some of the larger works are amazingly successful considering the artist's deliberate "throw-away" of the usually graceful subjects. Li Shan (cat.63) is equally bold and rapid in his brushwork but achieves rather striking decorative effects that were emulated by like-minded masters of the nineteenth century such as Ren Xun (cat.74) and Zhao Zhiqian (cat.75).

Other Yangzhou artists, including the professional master Hua Yan (cat.60), used the full range of subjects but with flexible, gracious brushwork and an imaginative use of compositional possibilities. Hua's reputation is clearly on the rise despite the large number of works by or attributed to him. The playful complexity of *Squirrels Pecking at Chestnuts* shows him at his best.

Jin Nong (cat.64), a true self-instructed amateur, and his Chan Buddhist pupil, Luo Ping (cat.68), are usually paired and their productions do seem closely related, even contiguous. One of the most unusual of all Yangzhou paintings is Jin's *The Radiant Moon*, while Luo Ping's *Blossoming Plums* is closer to his teacher's manner than to Luo's often inventive and playful figure paintings. Jin Nong's distinctive, and easily forged, "square" calligraphy enhanced his reputation in *wenren* circles.

The late Qing painters of the nineteenth century are still insufficiently studied and appreciated. They are gradually emerging as the study of the eighteenth-century individualists begins to meet the current interest in modern Chinese painting produced after the fall of the Empire in 1911.

Some of these late Qing artists have been collected in the West for

some time, notably Qian Du (cat.70) and Dai Xi (cat.72), with their obsessive but beautifully detailed brushwork and marvelously constricted compositions. They are clearly traditional and owe much to the work of the Wen family in the sixteenth-century Wu school. Gai Qi's *Plucking Lotus Blossoms* (cat.71) would be a star in any grouping, its limpid color and inventive all-over composition perfectly expressing the actuality of a lotus pond. The broad and rapidly brushed manner of Ren Xun and Zhao Zhiqian has already been mentioned in connection with Li Shan, but the effectiveness of this manner in their sets of four decorative hanging scrolls is difficult to achieve and their success is notable.

Perhaps Ren Xiong's *Self-Portrait* (cat.73) is the most remarkable and meaningful of all the nineteenth-century paintings here. It is not gracious, nor does it emphasize virtuosity of brushwork. It is not even traditionally "Chinese," partly in its modelling of the head and exposed bust, but particularly in the aggressive attitude and disturbing expression of the face. The "time of troubles" then rapidly developing in the Central Kingdom is strikingly reflected in this image. Clearly, there are discoveries to be made in the nineteenth-century mixture of old artistic traditions, new attitudes, bitter frustrations, and rapidly increasing discontent.

## Postscript

While it should now be clear that preparation and study will increase one's understanding of the great tradition of Chinese painting, including the works of the Ming and Qing dynasties, it should be equally clear and encouraging that these paintings are delightful in their own right as pictorial images in an international context. Such appreciation is not merely superficial just because it is incomplete. The creative and accomplished masters of Chinese painting are separated from their less excellent compatriots precisely because as artists they thought and felt in visual images. Protagonists from a different culture, they can approach us and begin to exercise their powers in images different from, but as convincing as, the various images produced in the West, past and present. The further steps of study leading to increasing contextual understanding depend upon the measure of our delight in the paintings before us. They are not just specimens or artifacts from an unknown culture but marvelously visible works of art embedded in one of the world's oldest and greatest cultures.

Sherman E. Lee

# Color Plates

Photography by

The Palace Museum

# Wang Fu and Chen Shuqi

*Autumn Thoughts on the Xiao and Xiang*

王　绂
陈叔起
潇湘秋意图卷

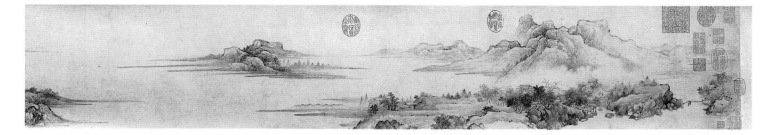

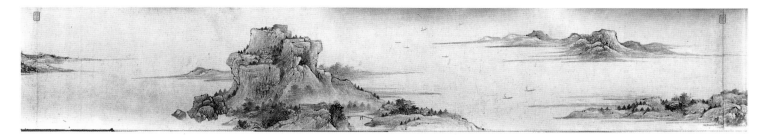

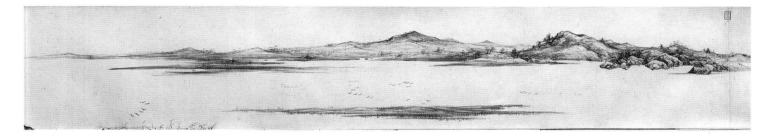

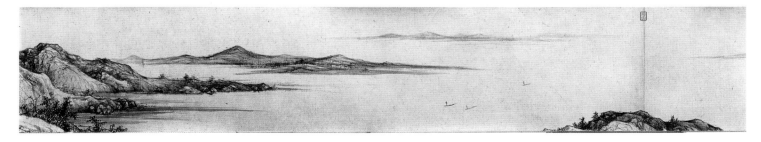

Catalogue No. 2
**Xia Chang**

*Spring Rain on the Xiang River*

夏　昶

湘江春雨图卷

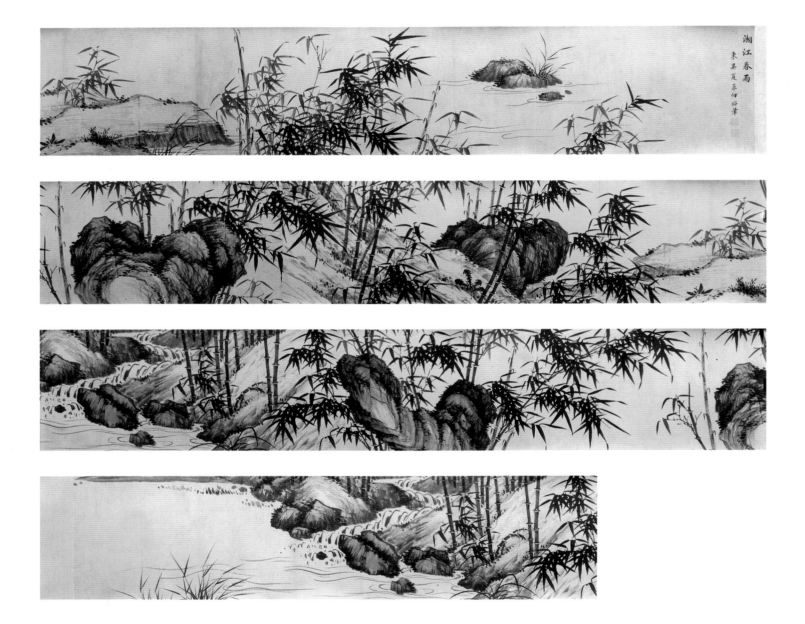

Catalogue No. 3
**Li Zai**

*Clear Peaks
Over Distant Banks*

李 在
阔渚遥峰图轴

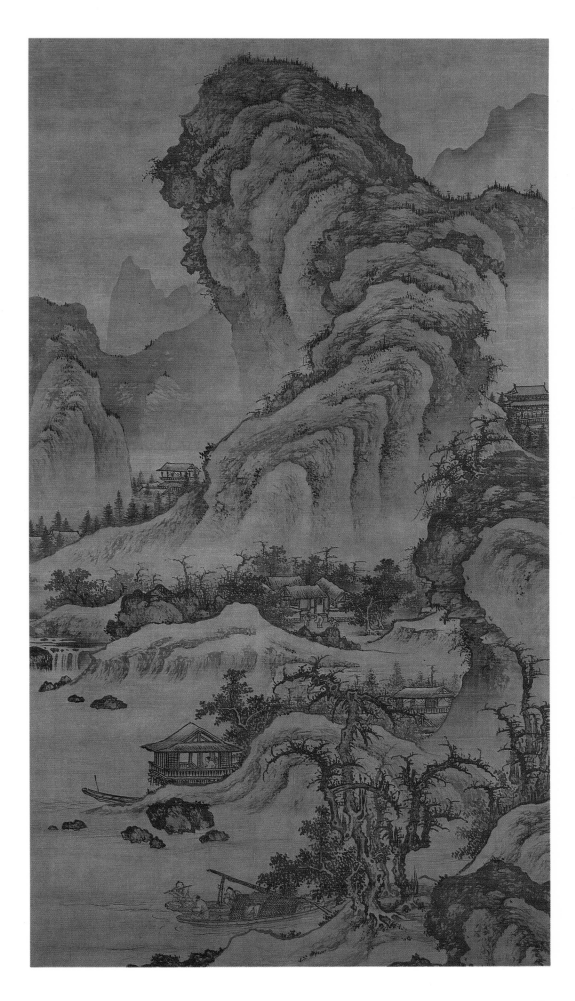

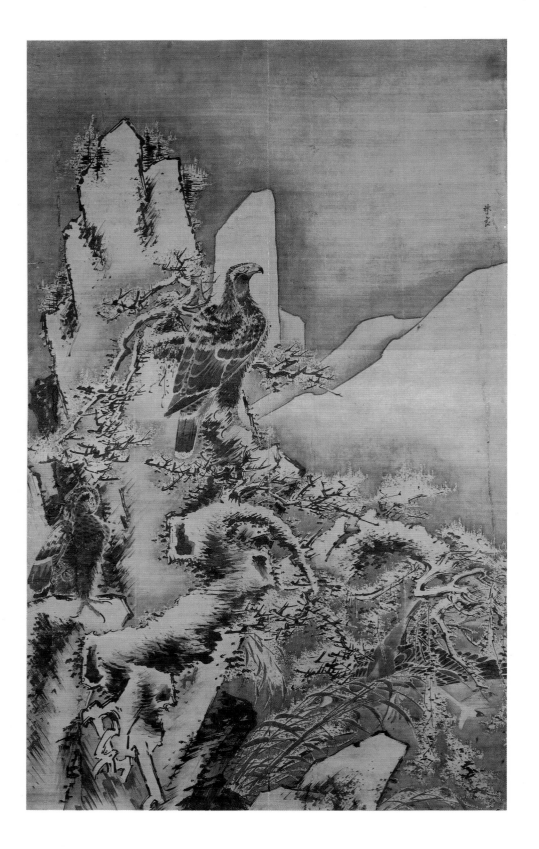

Catalogue No. 4
**Lin Liang**

*Eagles and Goose in
a Snowy Landscape*

林 良
雪景鷹雁圖軸

Catalogue No. 5 ➡
**Lü Ji**

*Pomegranate, Hollyhocks,
and Rooster*

呂 紀
榴葵綬雞圖軸

36

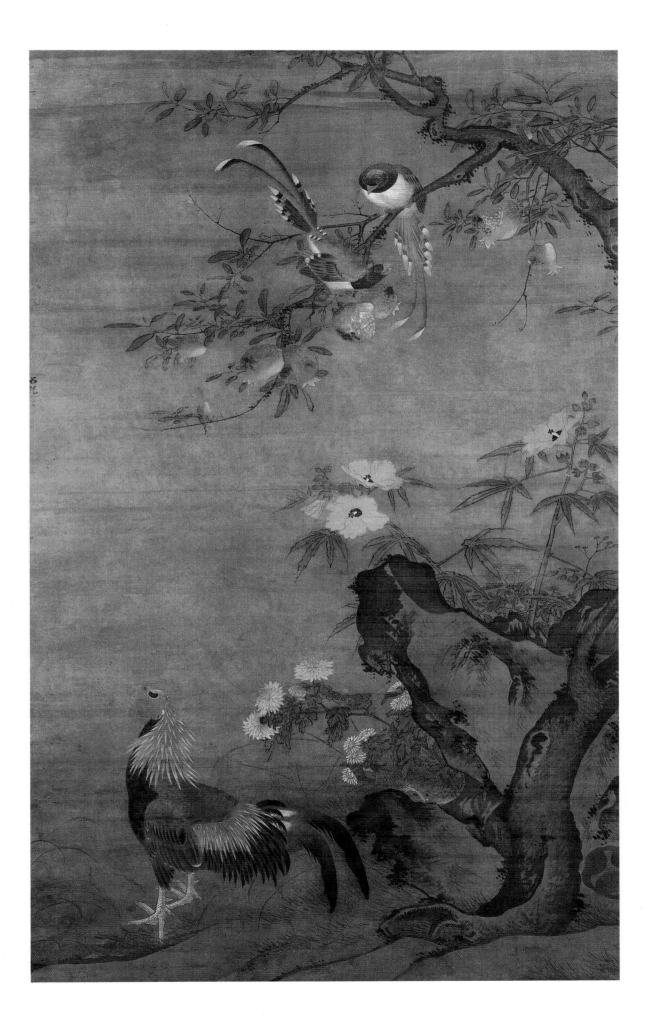

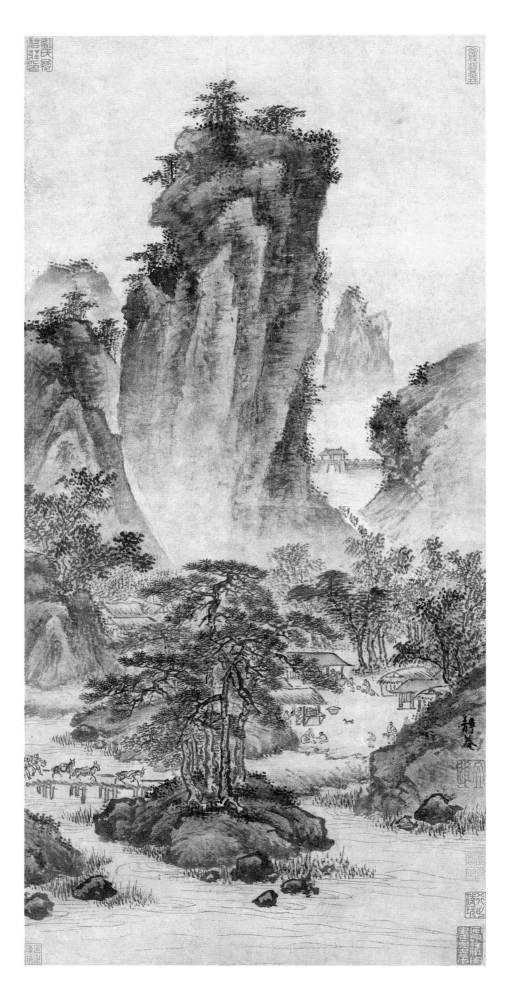

Catalogue No. 6
**Dai Jin**

*Travellers Through
Mountain Passes*

戴 进
关山行旅图轴

Catalogue No. 7 ➡
**Wu Wei**

*The Pleasures of Fishing*

吴 伟
渔乐图轴

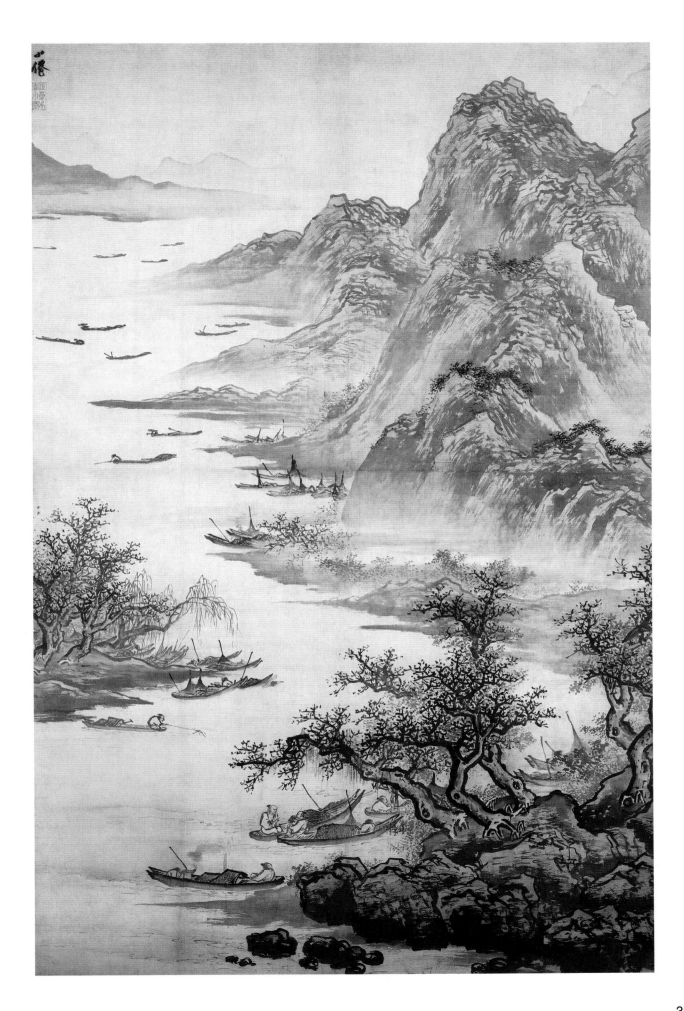

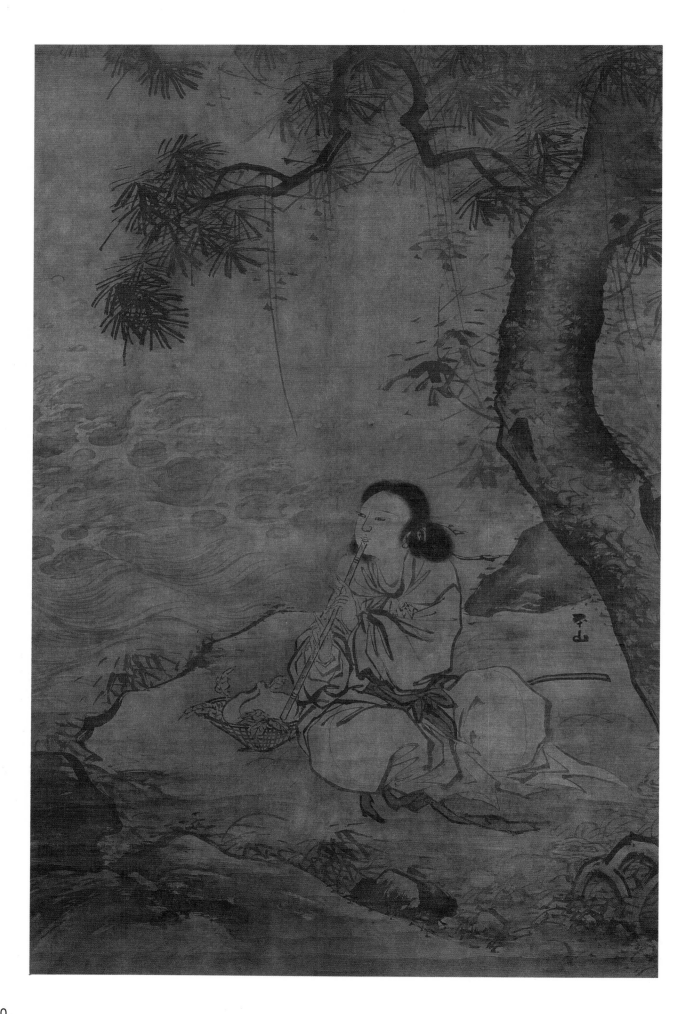

Catalogue No. 9
**Jiang Song**

*Reading in a*
*Fishing Skiff*

蒋　嵩
渔舟读书图轴

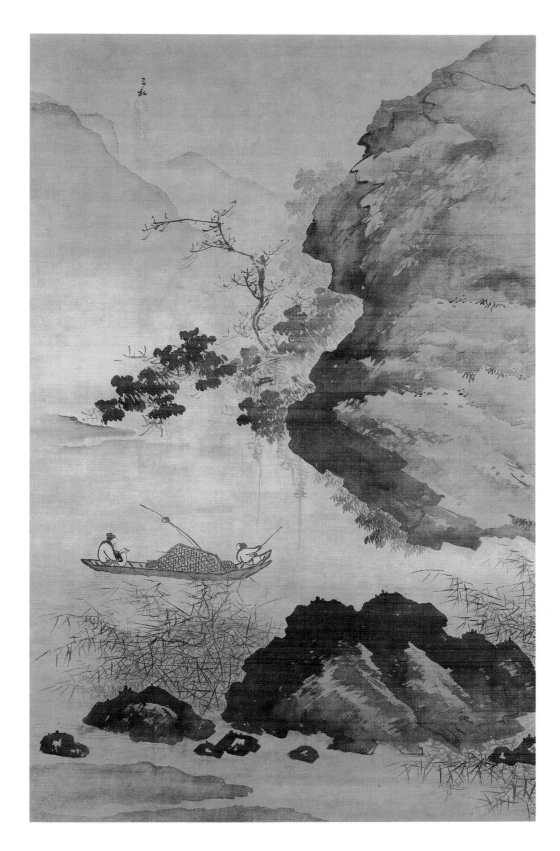

◄ Catalogue No. 8
**Zhang Lu**

*Female Immortal*
*Playing the Flute*

张　路
吹箫女仙图轴

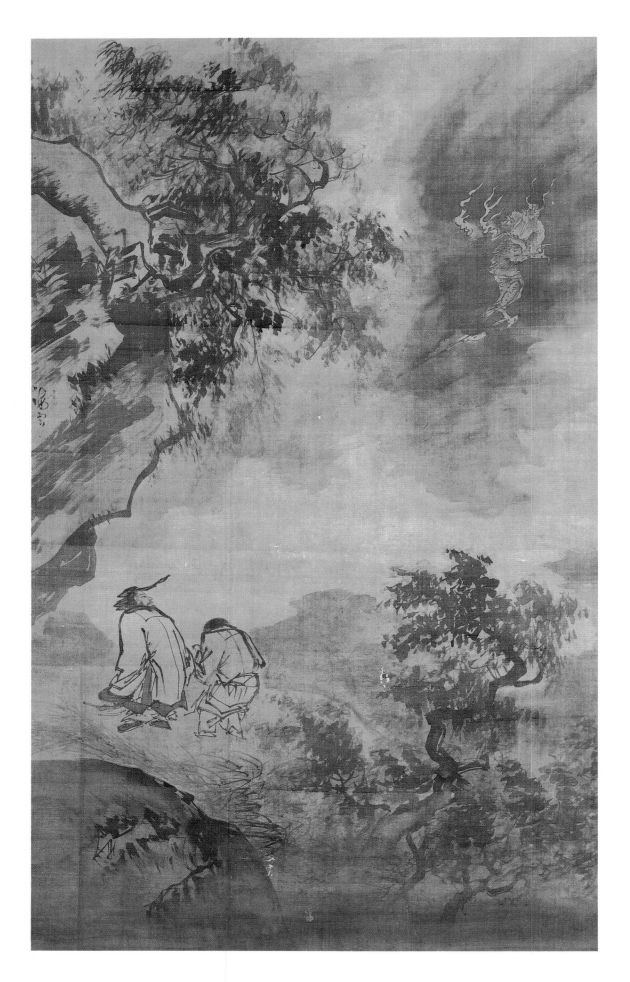

Catalogue No. 11
**Zheng Wenlin**

*Playing Chess Beneath
Spring Willows*

郑文林
春柳奕棋图轴

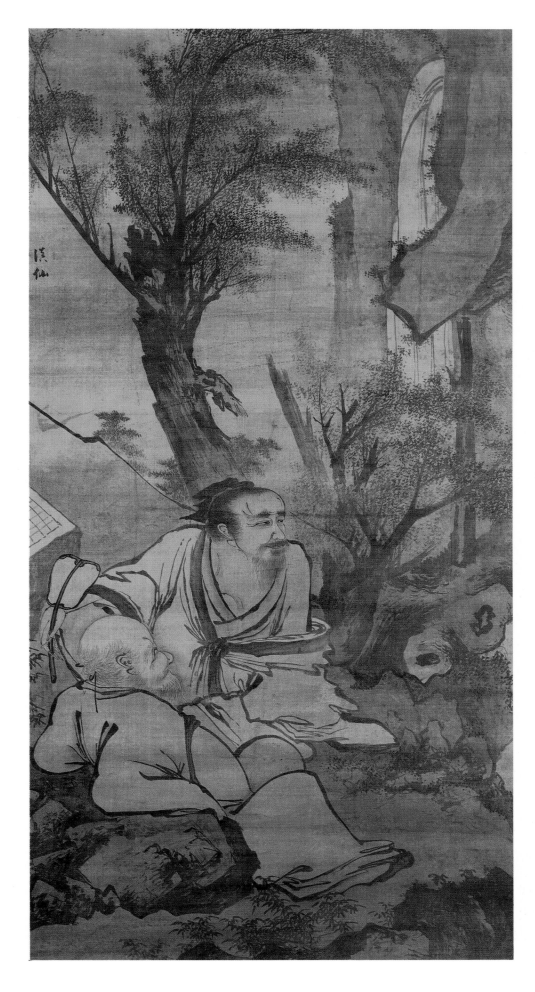

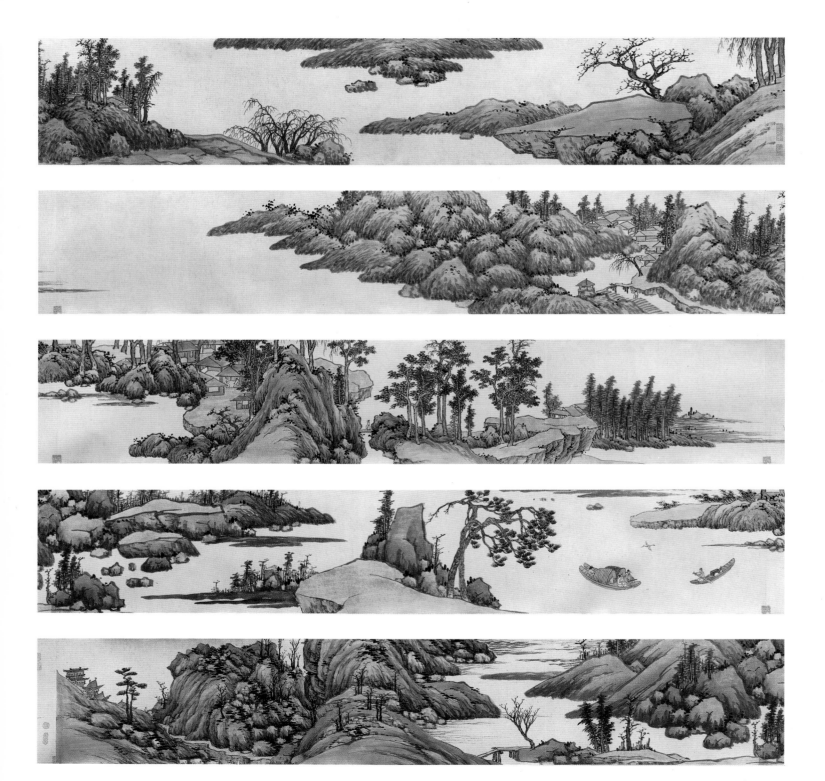

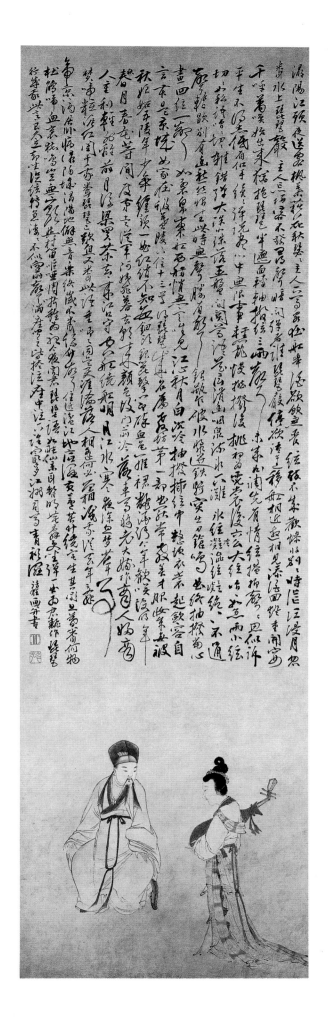

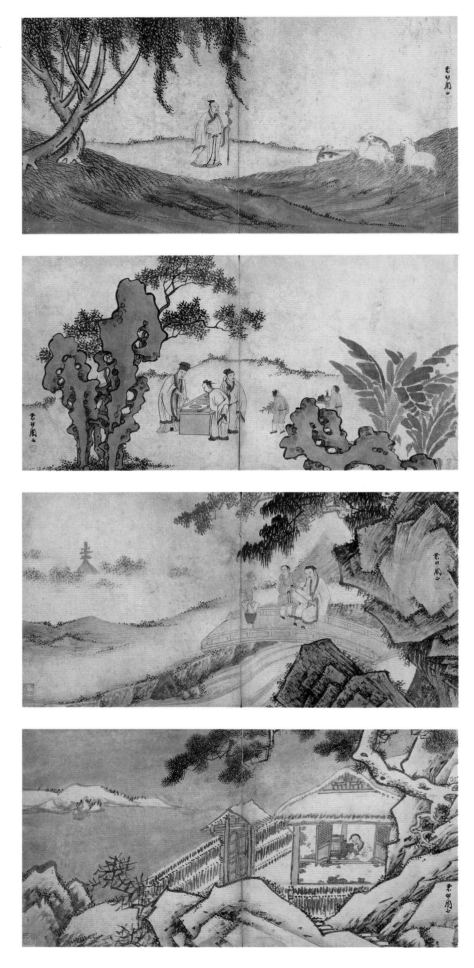

Catalogue No. 14
**Zhou Chen**

*Illustrations to Historical Tales*

周　臣
人物故事册

Leaf 1

Leaf 2

Leaf 3

Leaf 4

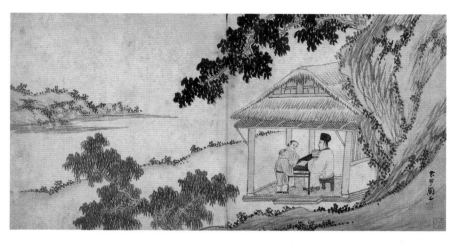

Leaf 5

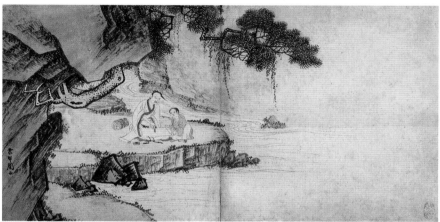

Leaf 6

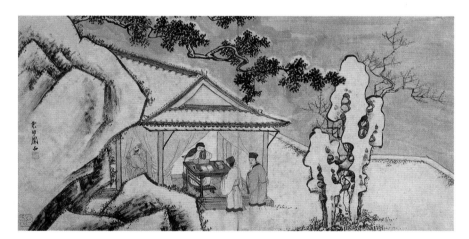

Leaf 7

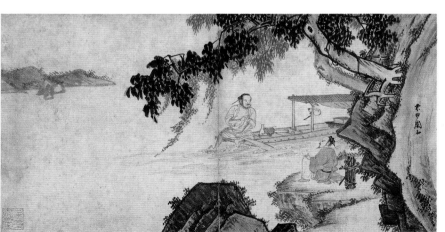

Leaf 8

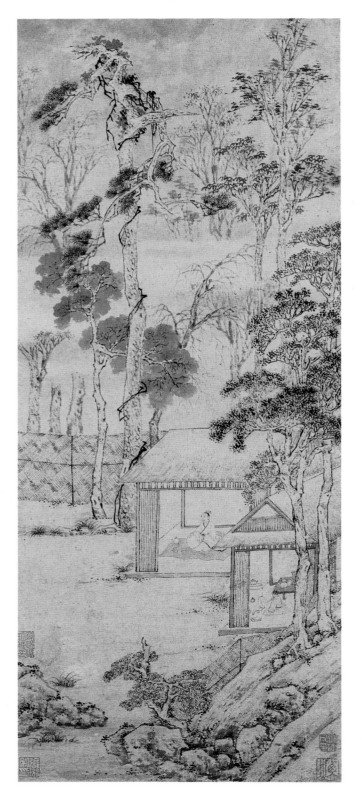

detail

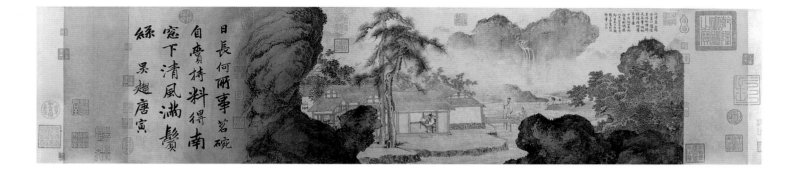

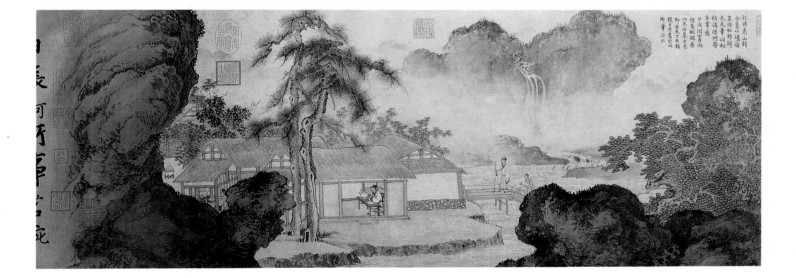

detail

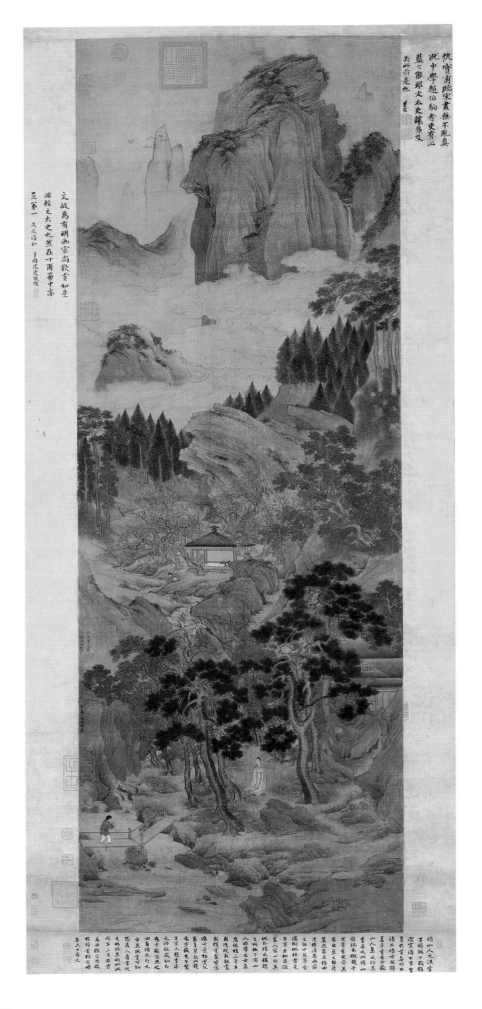

Catalogue No. 17
**Qiu Ying**

*Thatched House in the Peach-blossom Village*

仇 英
桃村草堂图轴

Catalogue No. 18
**Lu Zhi**
*Mount Huqiu (Tiger Hill)*

陆 冶
虎丘山图轴

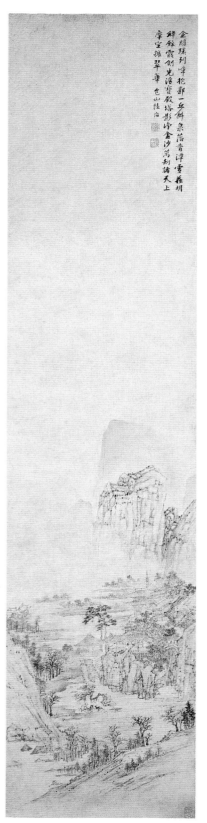

Catalogue No. 19
**Wen Jia**
*Illustration to the Song of the Lute, 1563*

文 嘉
琵琶行图轴

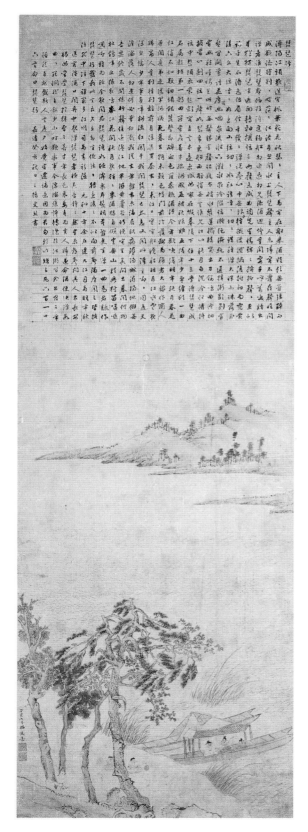

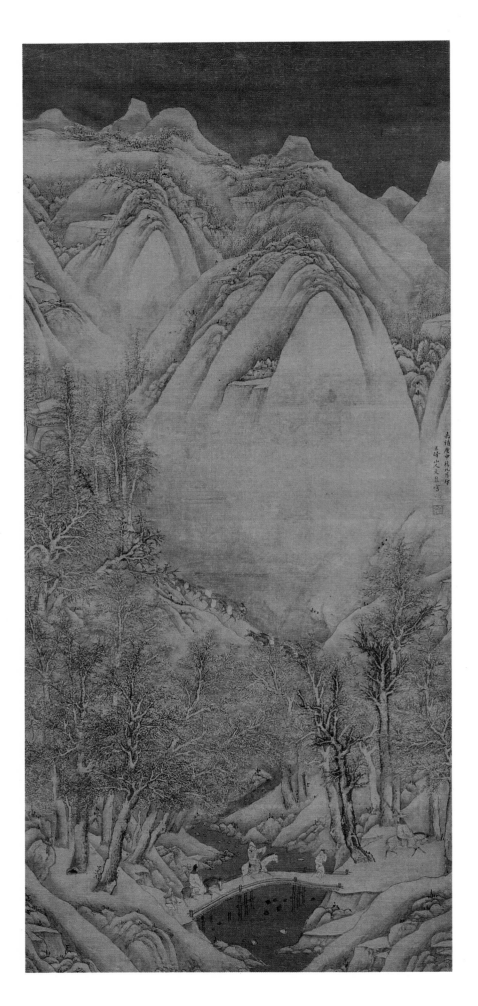

Catalogue No. 20
**Wen Boren**

*Travellers Amidst
Snowy Mountains, 1560*

文伯仁
雪山行旅图轴

Catalogue No. 21
**Qian Gu**

*Garden Grove After
a Snowfall, 1541*

钱　谷
雪后园林图轴

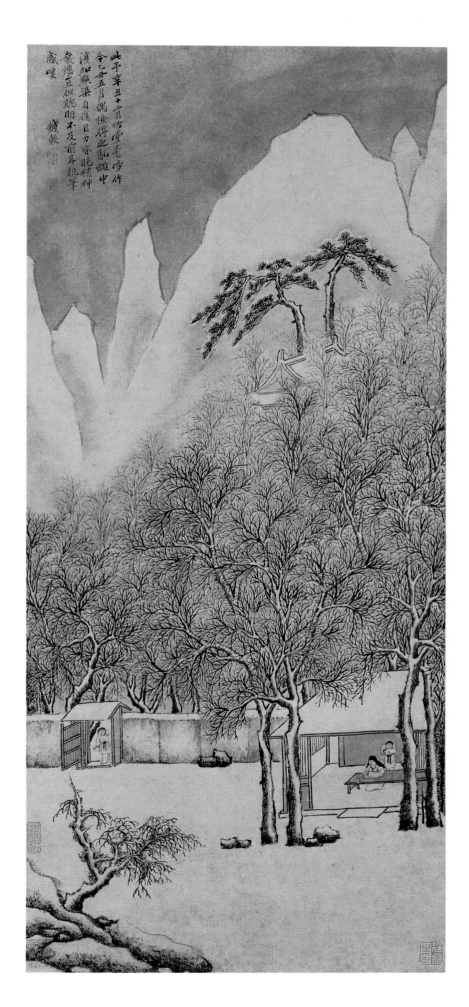

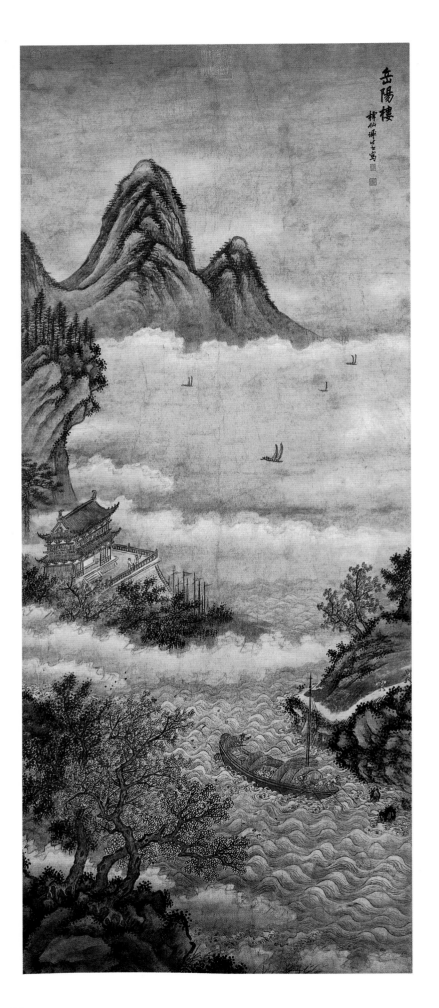

Catalogue No. 22
**Xie Shichen**
*The Yueyang Tower*

谢时臣
岳阳楼图轴

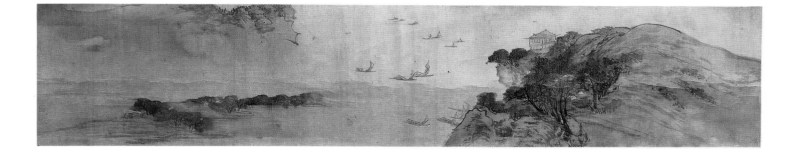

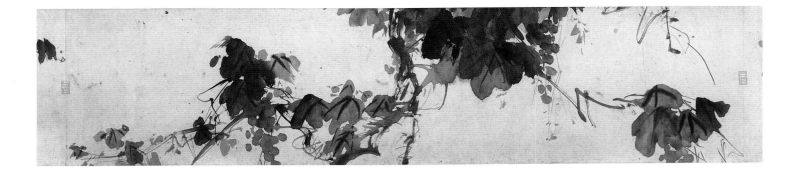

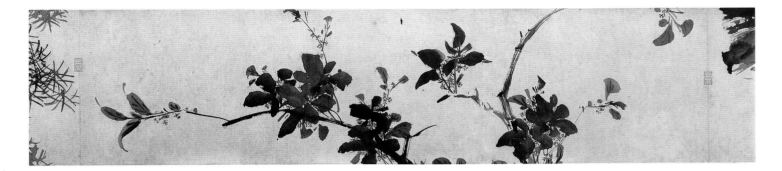

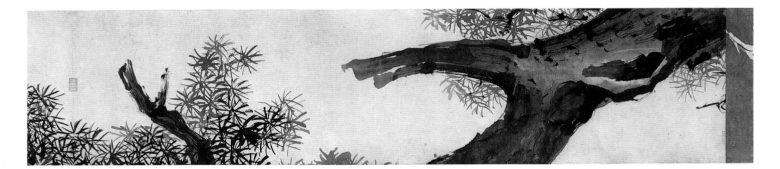

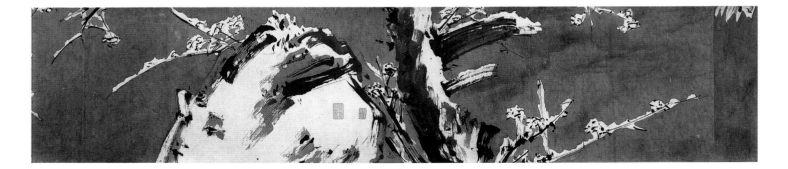

Catalogue No. 24
**Xu Wei**

*Flowers of the Four Seasons*

徐　渭
四时花卉卷

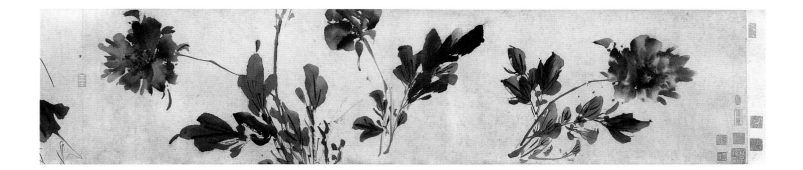

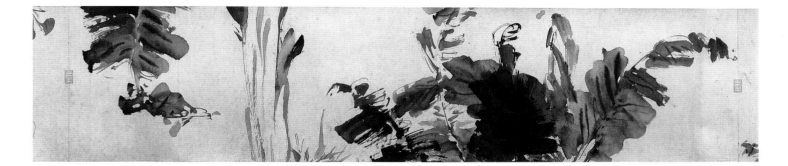

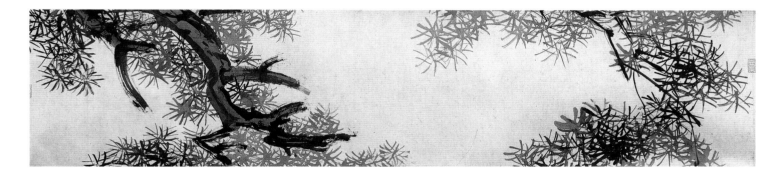

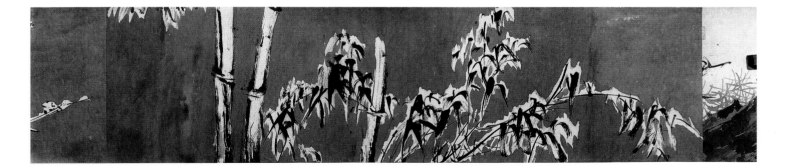

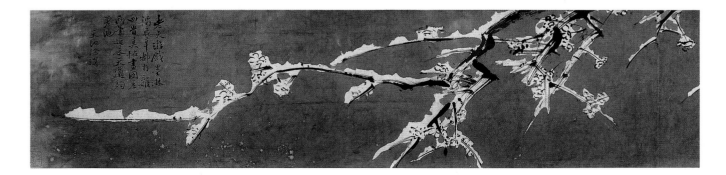

Catalogue No. 25
**Shen Shichong**

*Landscapes After Famous Song and Yuan Masters, 1616*

沈士充　　仿宋元名家册

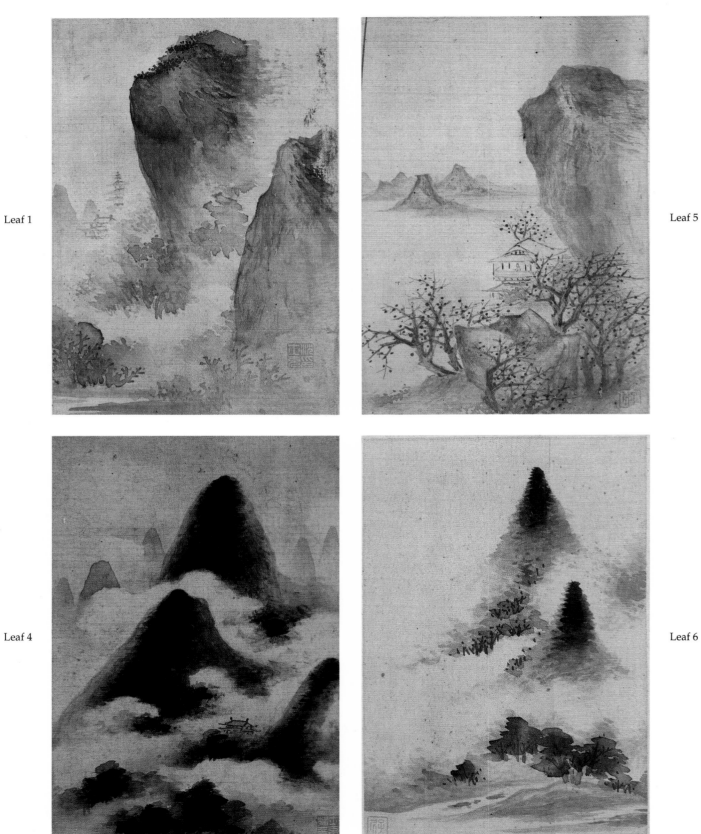

Leaf 1

Leaf 5

Leaf 4

Leaf 6

Catalogue No. 26
**Zhou Zhimian**

*Paired Swallows
and Mandarin Ducks*

周之冕
双燕鸳鸯图轴

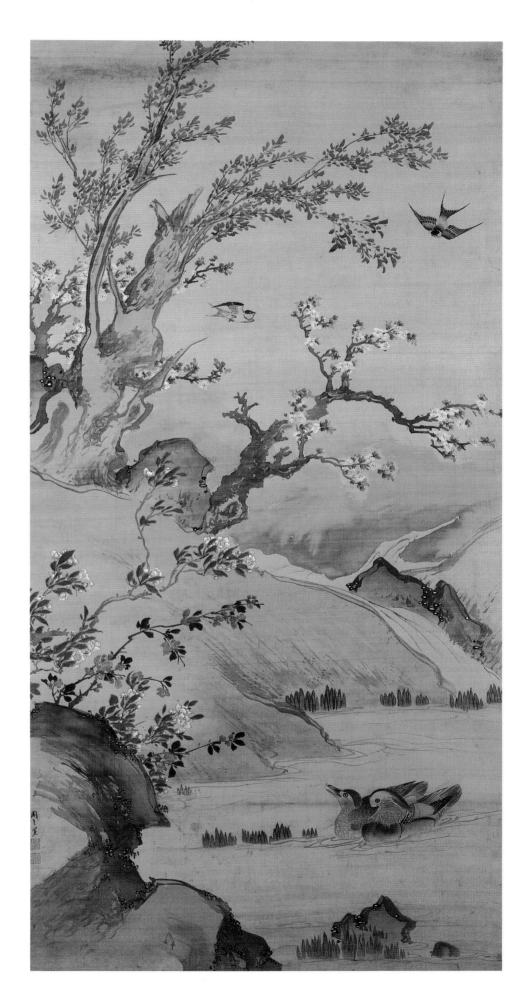

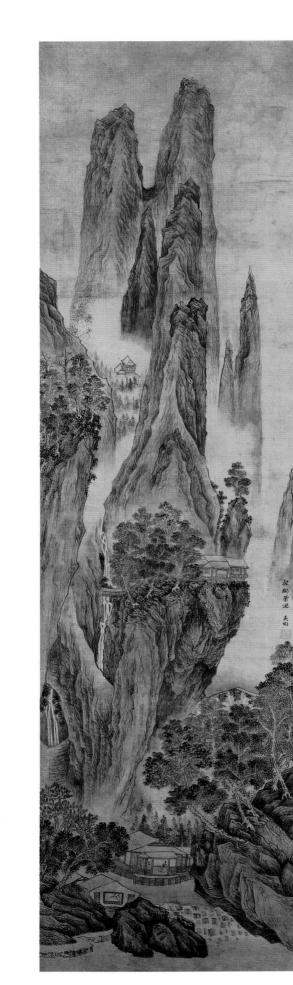

关山雪霁图卷　　董其昌

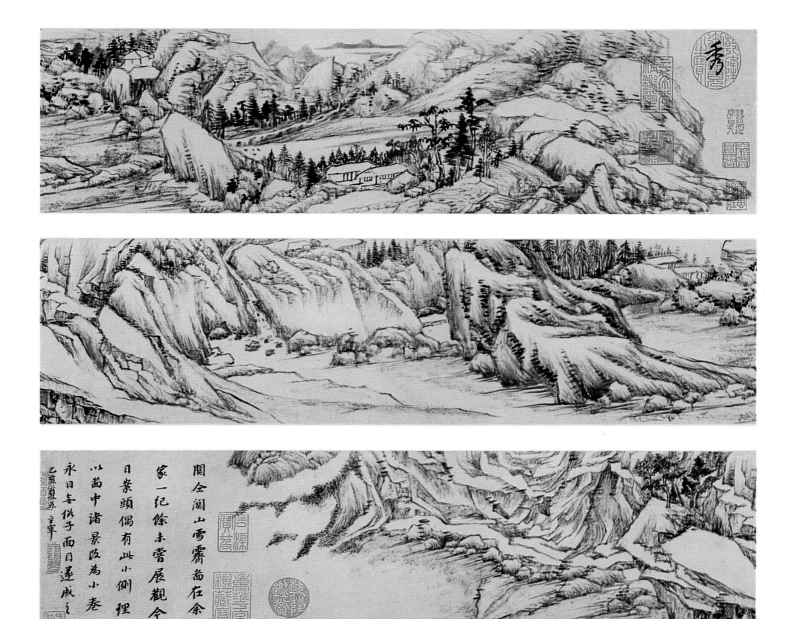

Catalogue No. 29
**Zhang Hong**

*Various Entertainments, 1638*

张　宏
杂技游戏图卷

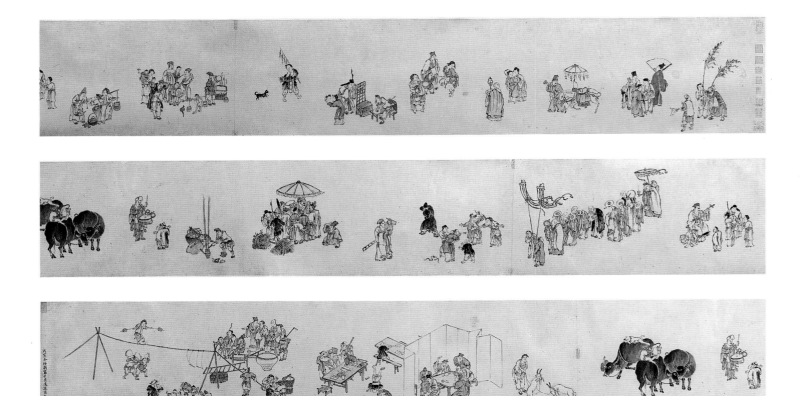

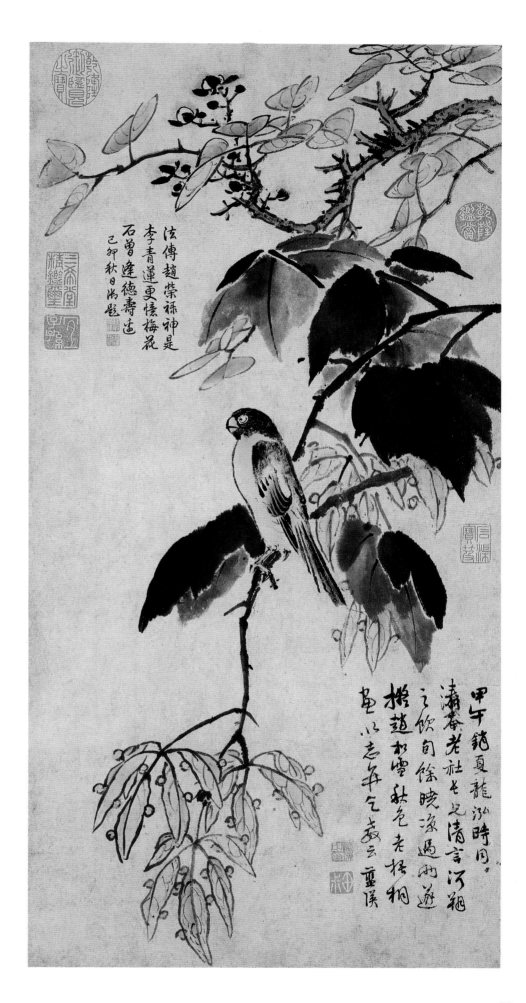

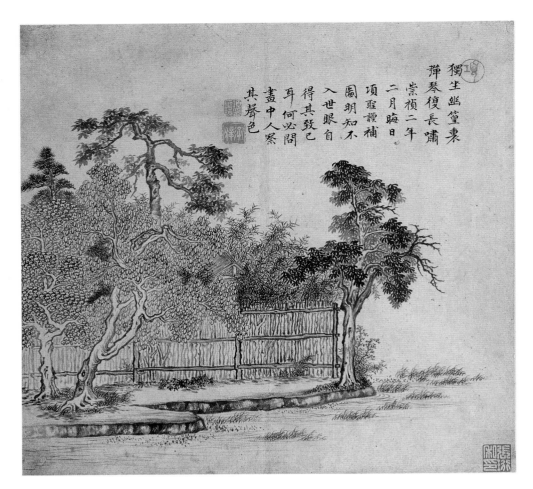

Catalogue No. 31
**Xiang Shengmo**

*Illustrations in the Spirit of
Wang Wei's Poems, 1629*

项圣谟
王维诗意图册

Leaf 1

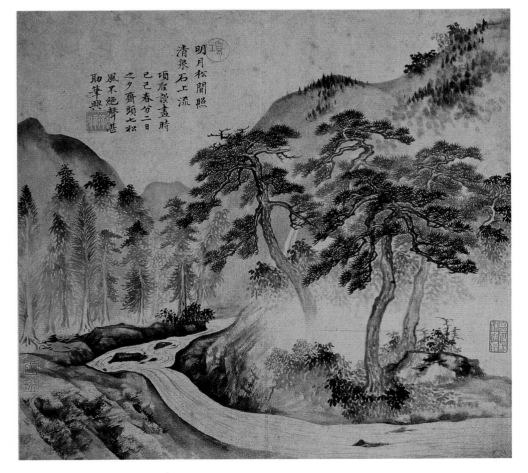

Leaf 16

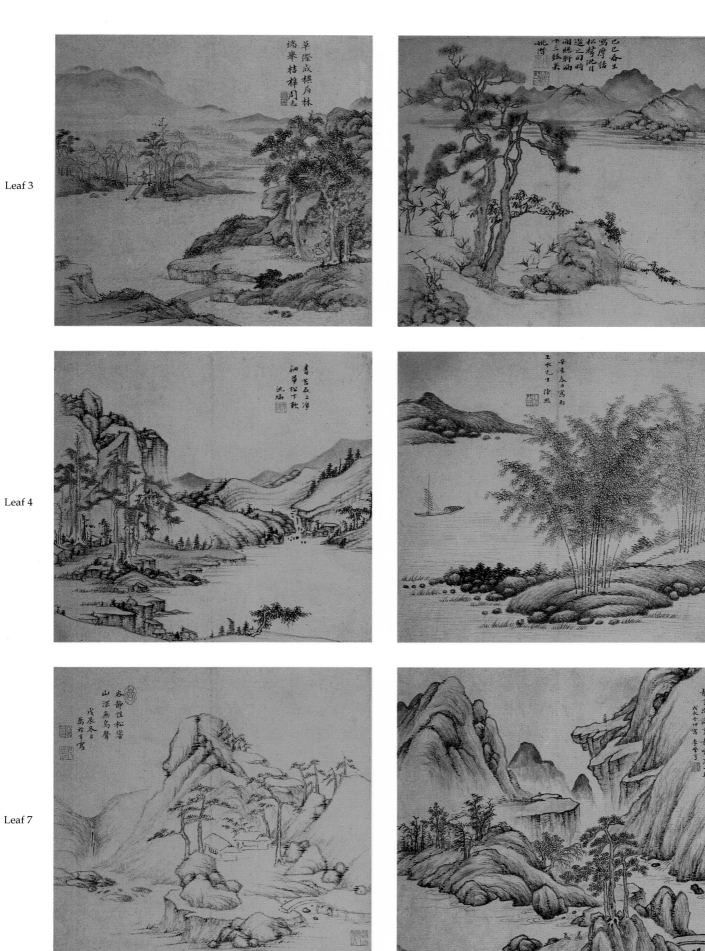

Leaf 3

Leaf 9

Leaf 4

Leaf 11

Leaf 7

Leaf 15

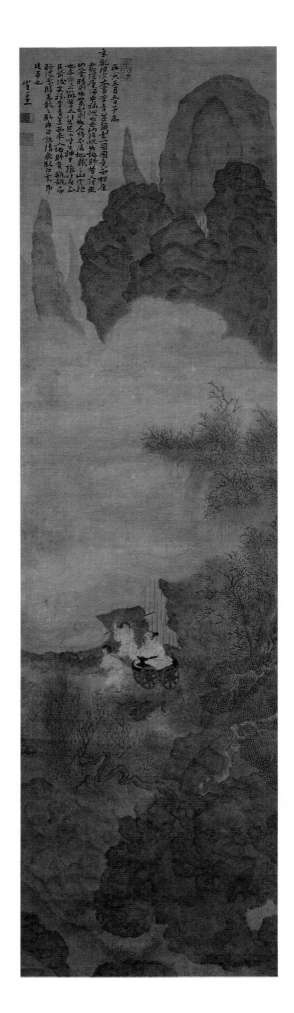

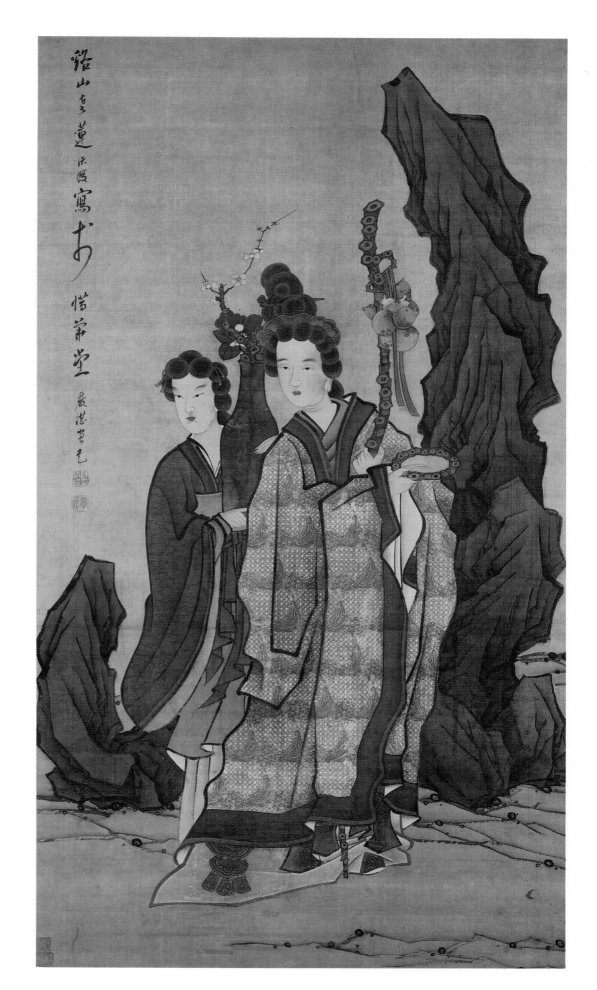

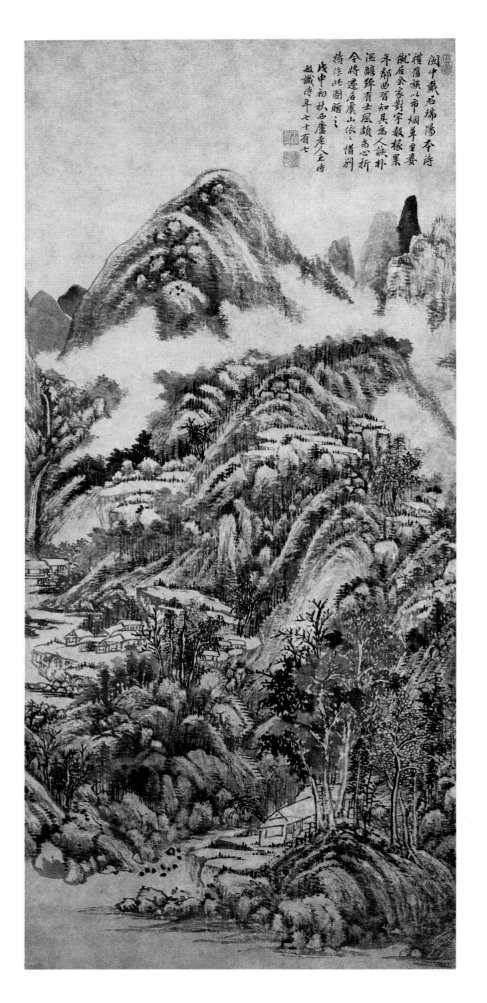

Catalogue No. 34
**Wang Shimin**

*Taking Leave for Yushan, 1668*

王时敏
虞山惜别图轴

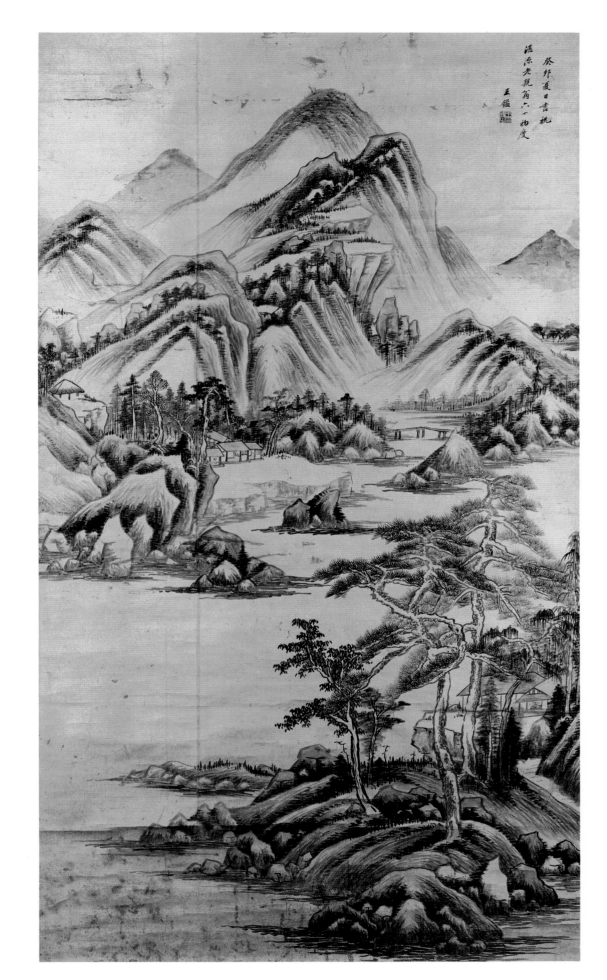

Catalogue No. 36
**Xiao Yuncong**

*Reading in Snowy
Mountains, 1652*

肖云从
雪嶽读书图轴

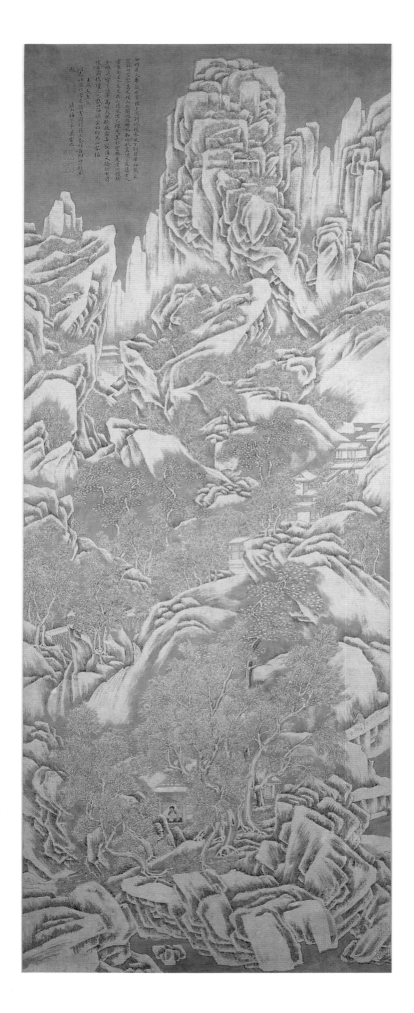

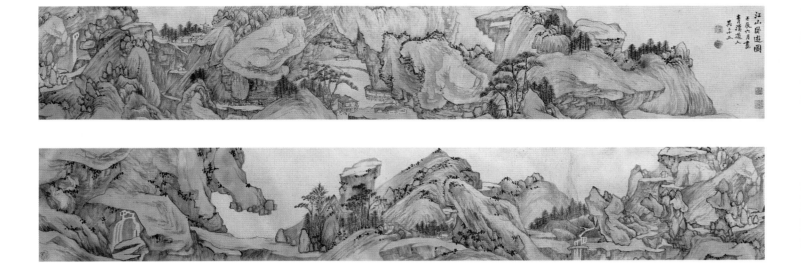

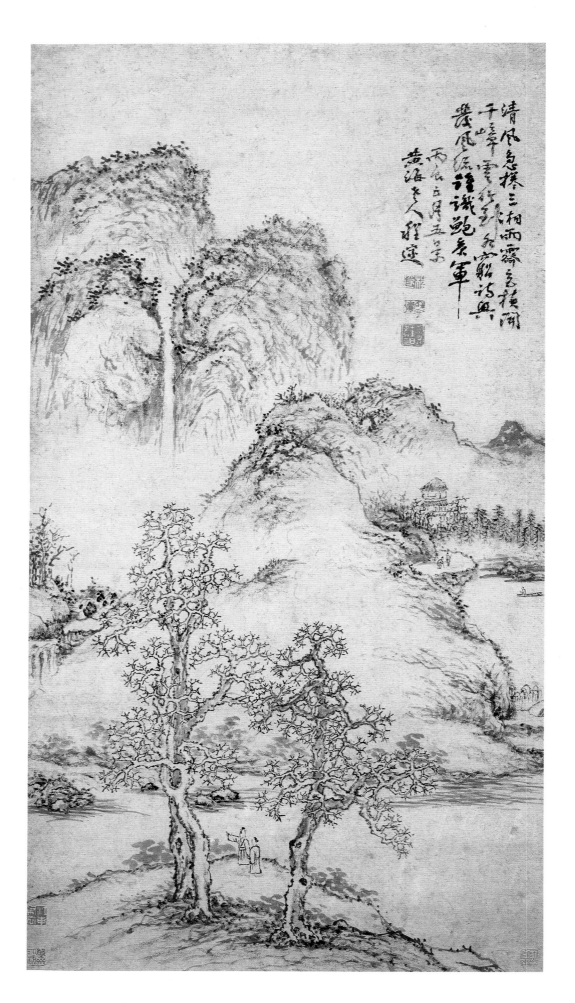

Catalogue No. 38
**Cheng Sui**
*Landscape, 1676*

程　邃
山水軸

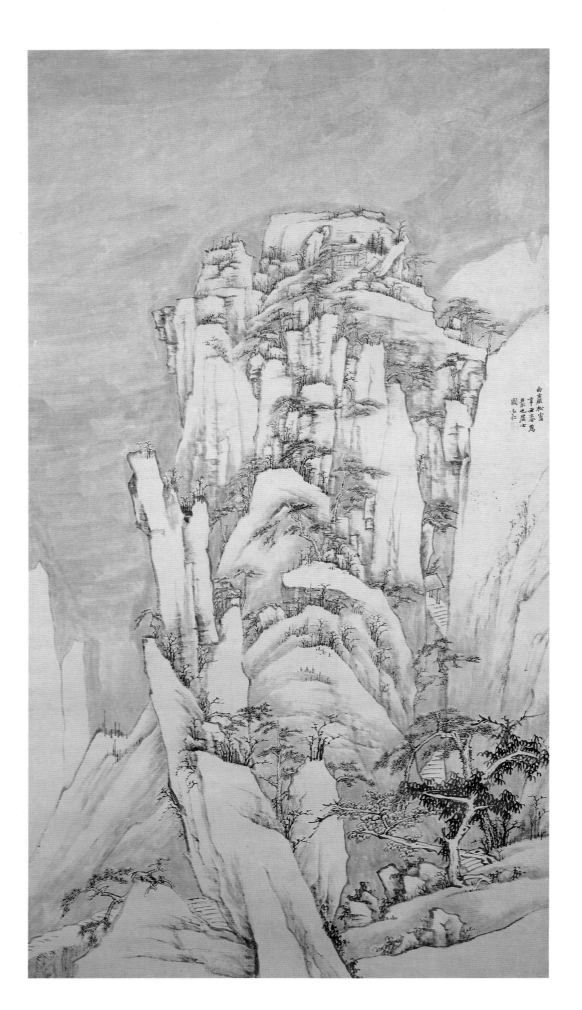

Catalogue No. 40
**Hongren**

*Snow on Pines at the
Western Peak, 1661*

弘　仁
西岩松雪图轴

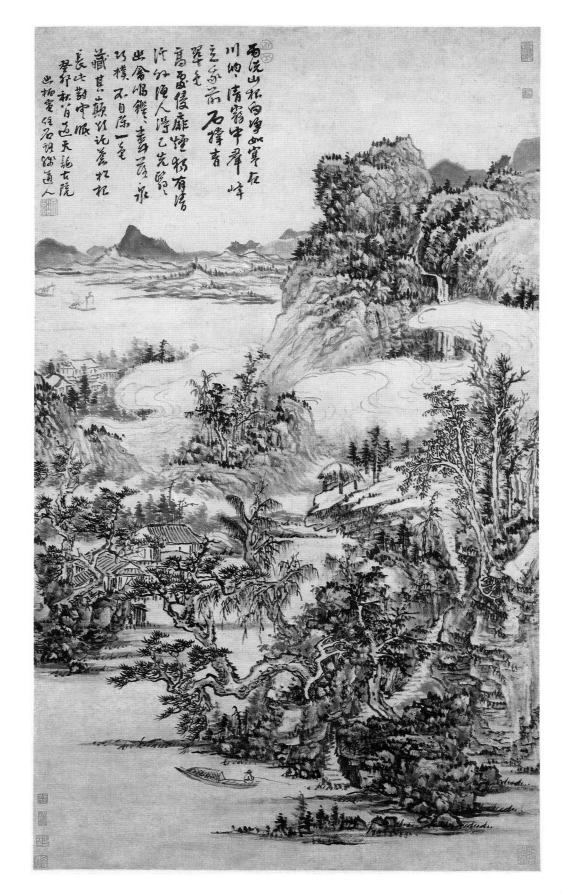

Catalogue No. 42
**Zha Shibiao**

*Buddhist Retreat
Between Two Peaks*

查士标
双峰兰若图轴

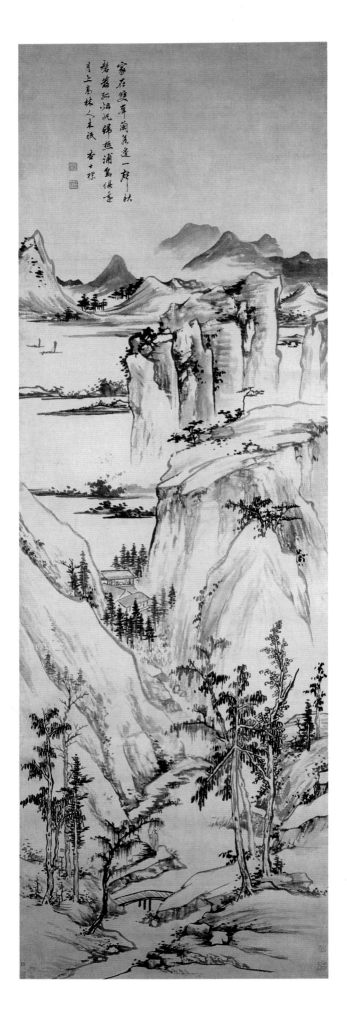

Catalogue No. 43
**Mei Qing**

*Lofty Mountains and
Flowing Stream, 1694*

梅　清
高山流水图轴

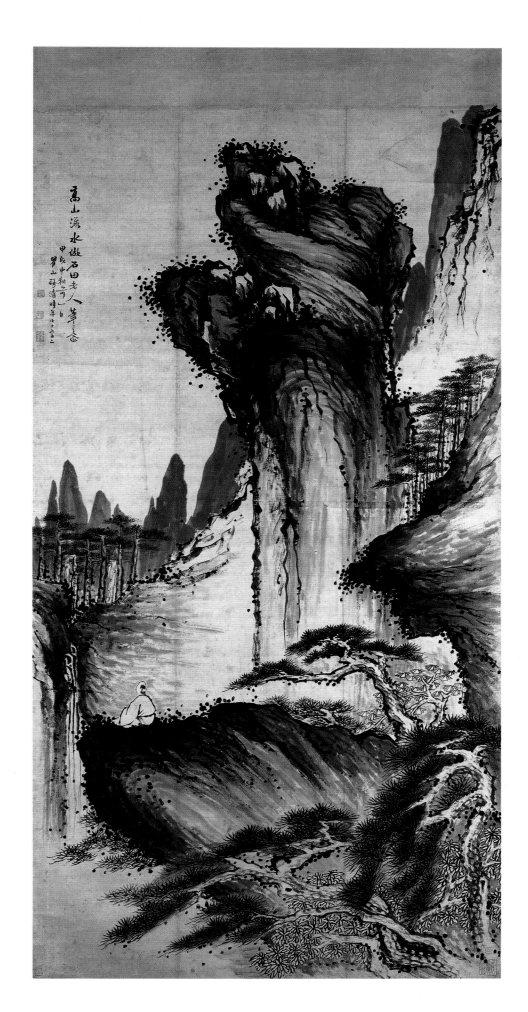

Catalogue No. 44
**Zhu Da**
*Flowers and Fruit*

朱　耷
花果卷

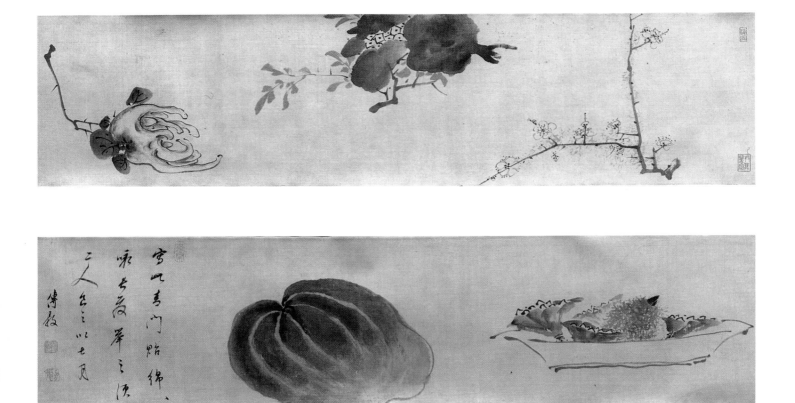

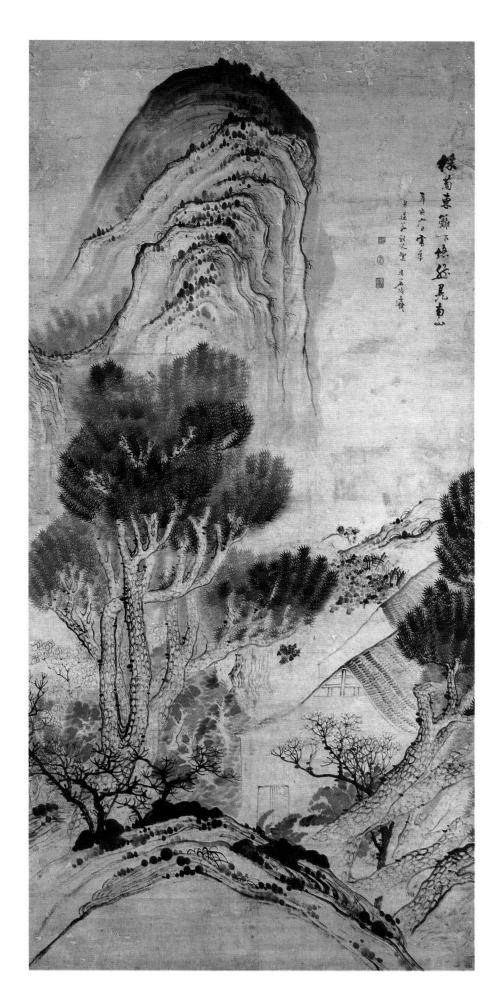

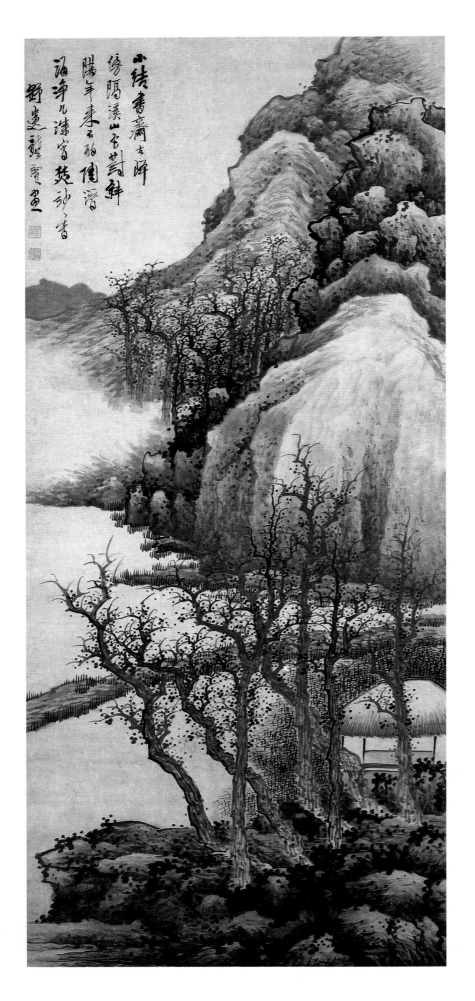

Catalogue No. 46
**Gong Xian**

*Mountains Beyond a River*

龚 贤
隔溪山色图轴

Catalogue No. 47 →
**Wu Hong**

*Travellers Among Rivers
and Mountains, 1683*

吴 宏
江山行旅图卷

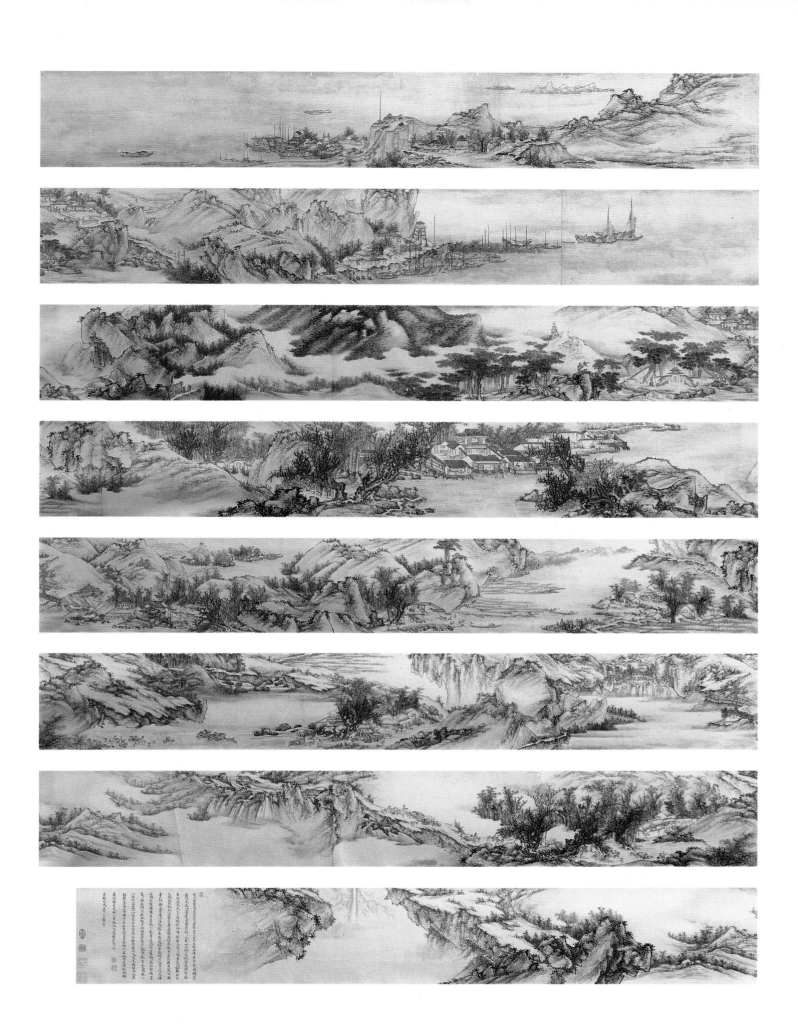

Catalogue No. 48
**Zou Zhe**

*Landscape, 1655*

邹　喆
山水轴

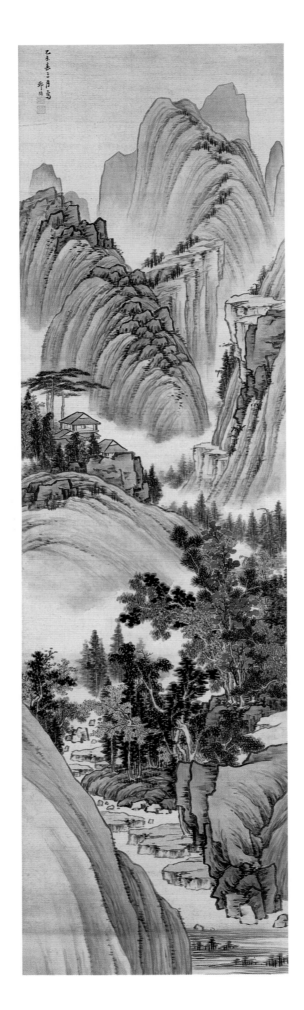

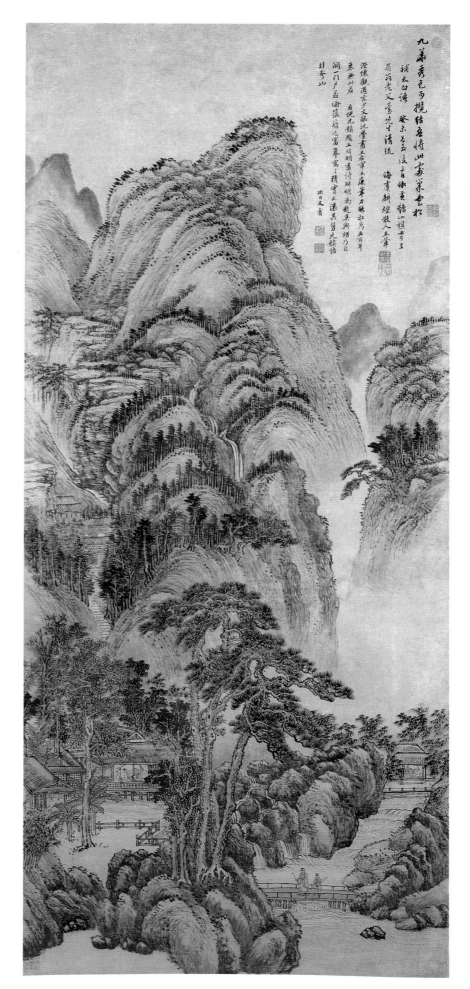

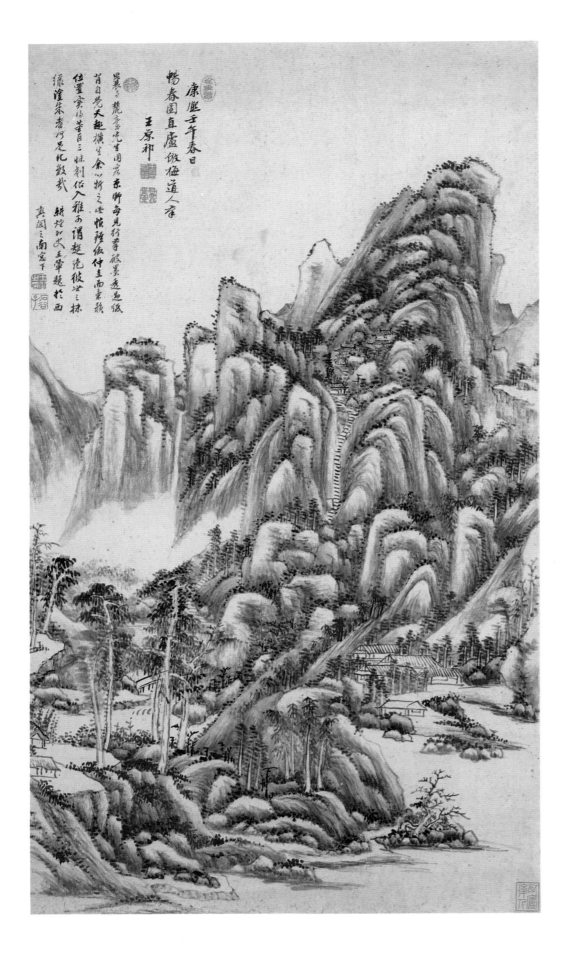

Catalogue No. 50
**Wang Yuanqi**
*Landscape After
Wu Zhen, 1702*

王原祁
仿梅道人山水軸

Catalogue No. 51
**Wu Li**

*The Continuing-and-
Rejecting-the-Classic-
Inheritance Landscape*

吴 历
拟古脱古山水轴

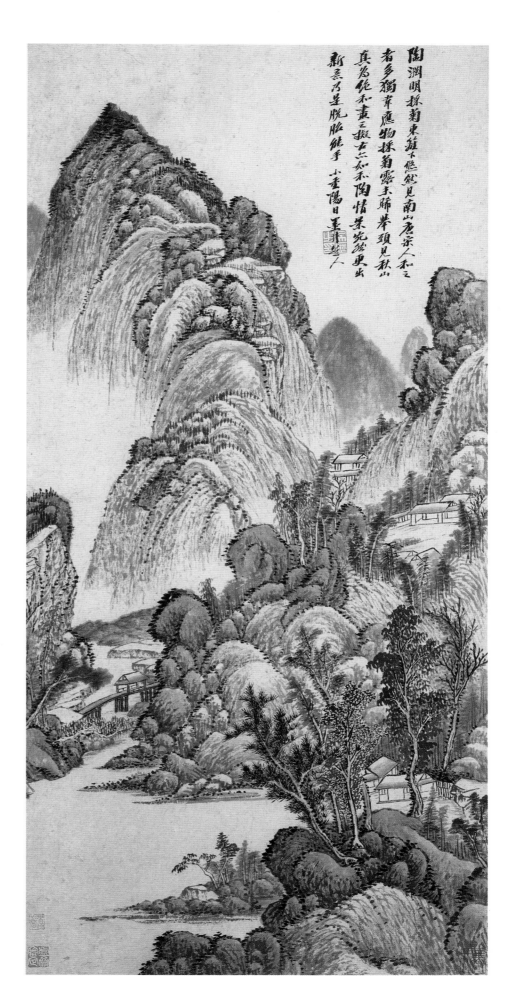

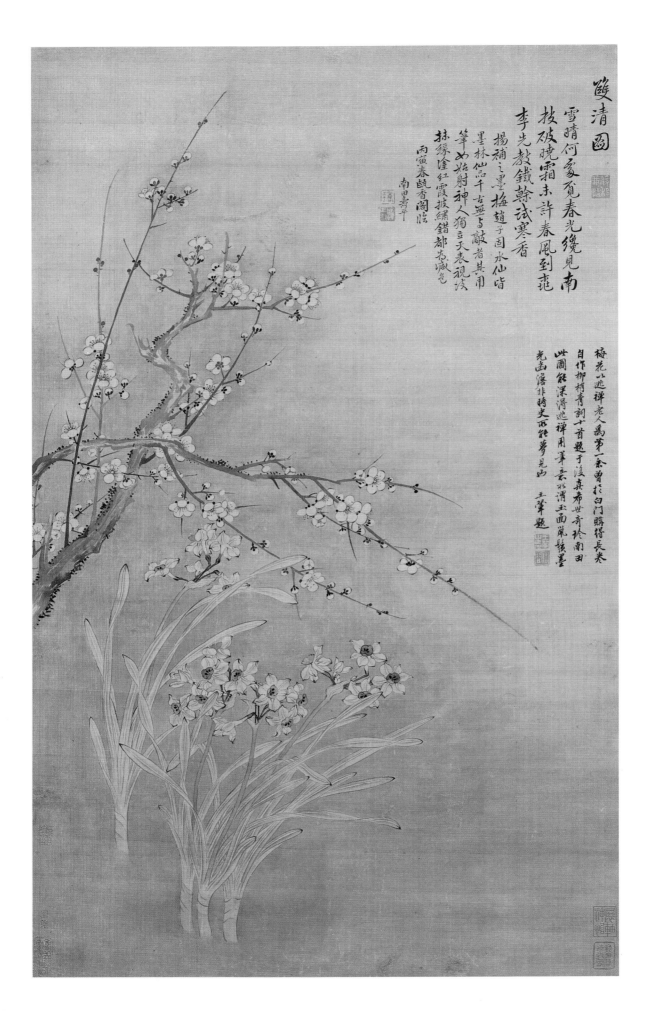

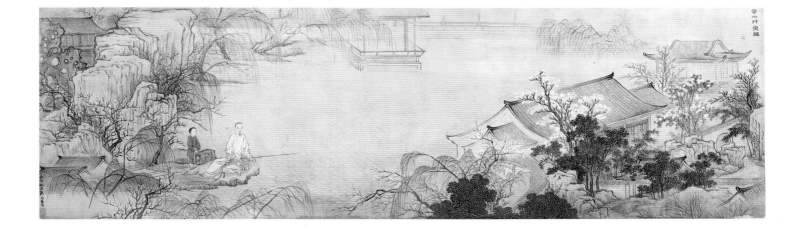

◄ Catalogue No. 52
**Yun Shouping**

*Paired Purities, 1686*

恽寿平
双清图轴

Catalogue No. 54
**Lu Wei**

*Landscape*

陆　昉
山水卷

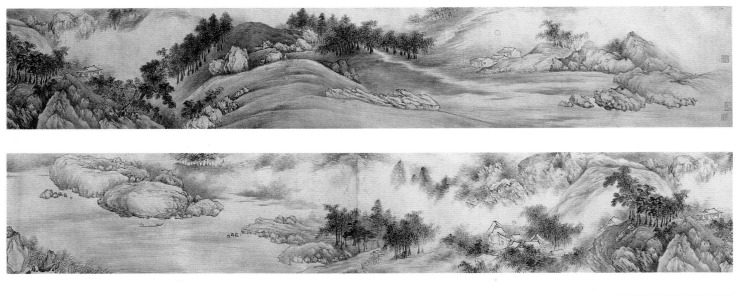

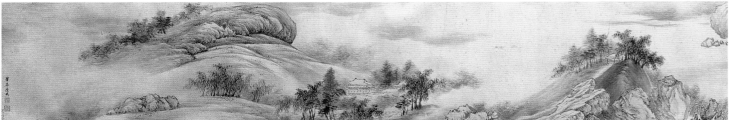

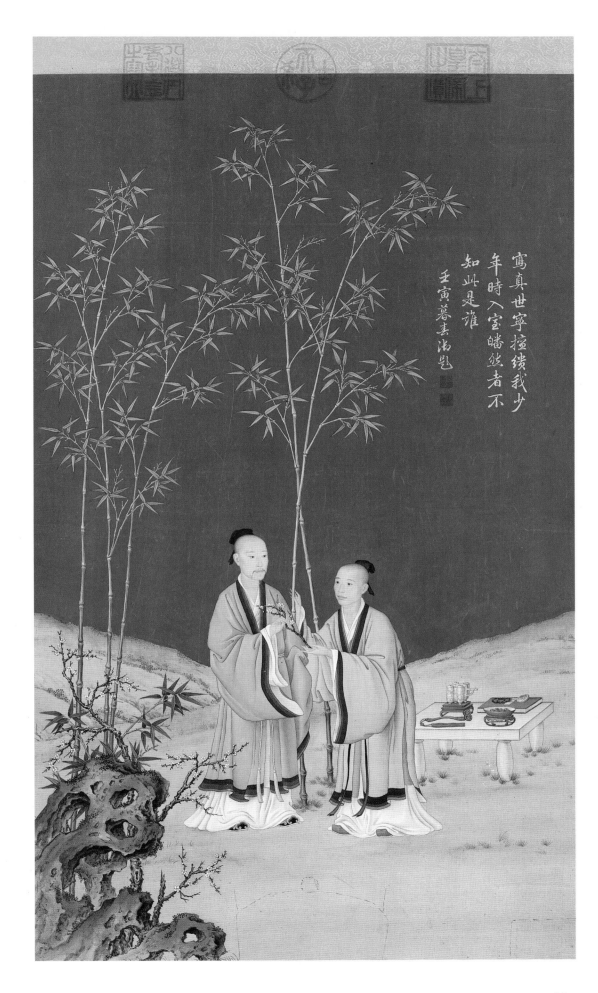

Catalogue No. 57
**Leng Mei**

*Two Rabbits Beneath
a Wutong Tree*

冷　枚
梧桐双兔图轴

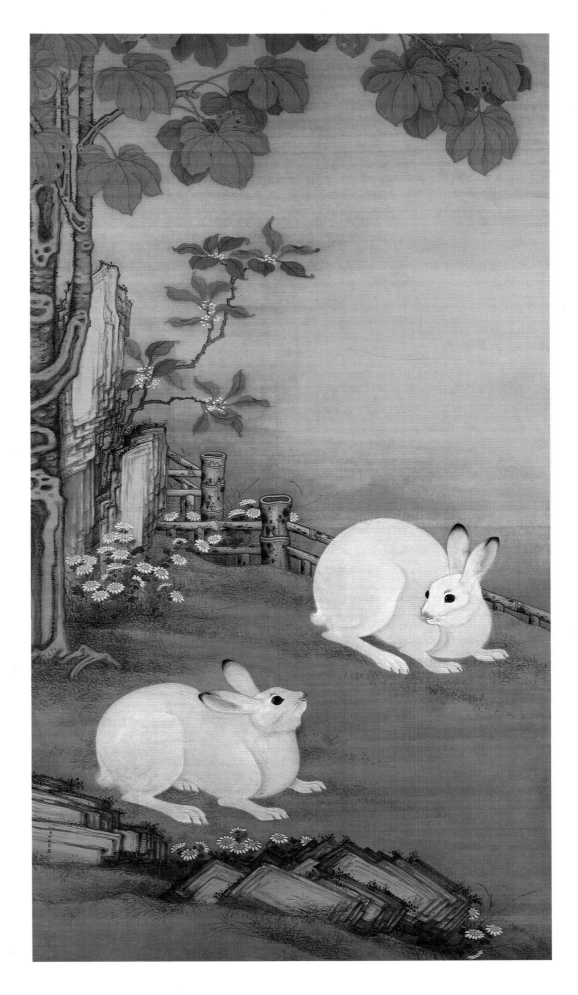

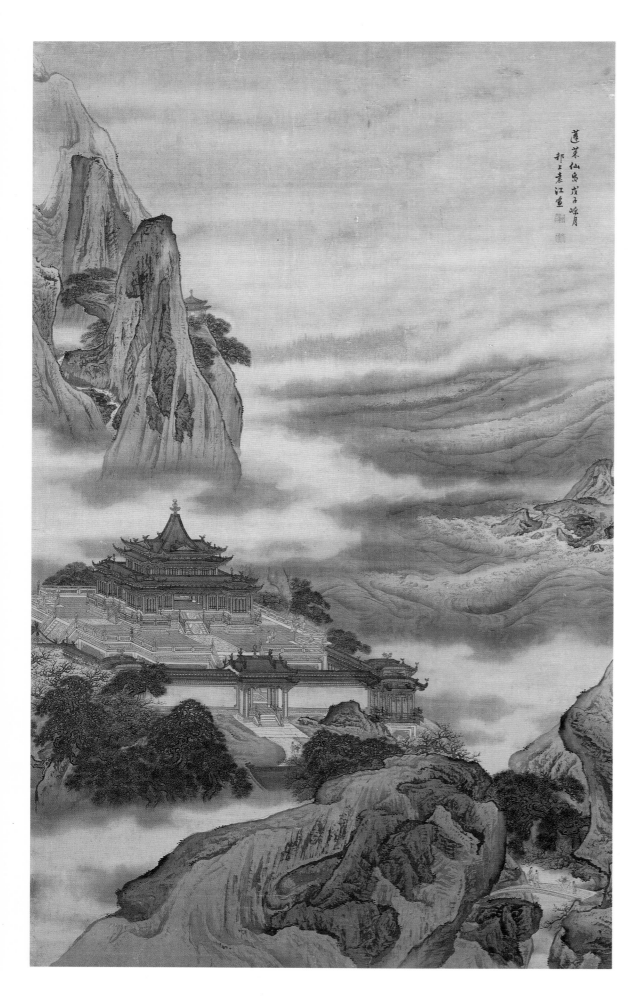

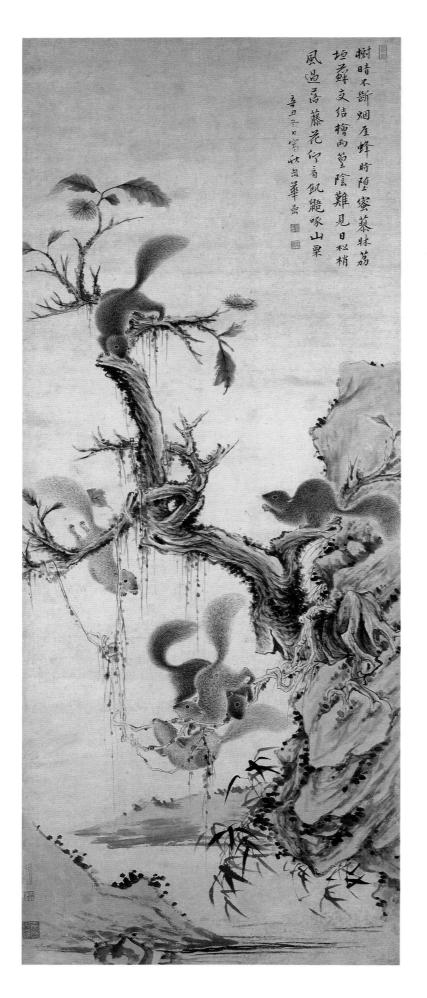

樹晴不斷烟厓蜂時墮蜜蕤林荔
坦莘蘚文結檜雨莖陰難見日松梢
風過蕃藤花仰首鼯鼪啄山粟

辛丑冬日寫於岩華喦

Catalogue No. 60
**Hua Yan**

*Squirrels Pecking at Chestnuts, 1721*

华　喦

松鼠啄栗图轴

Leaf 4
Leaf 1
Leaf 2

Leaf 5
Leaf 7
Leaf 6

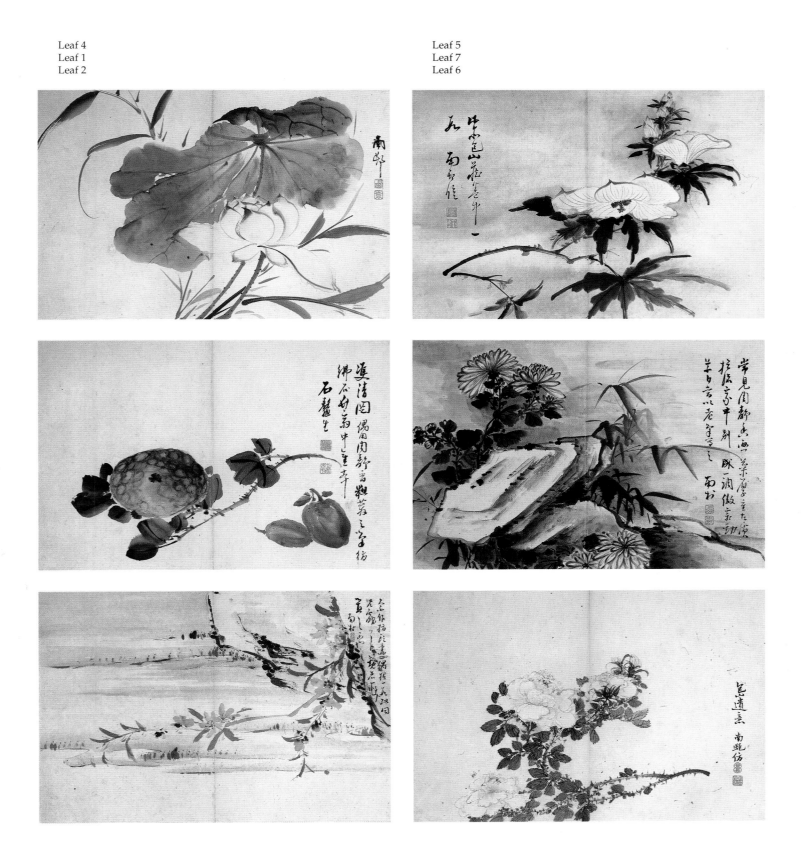

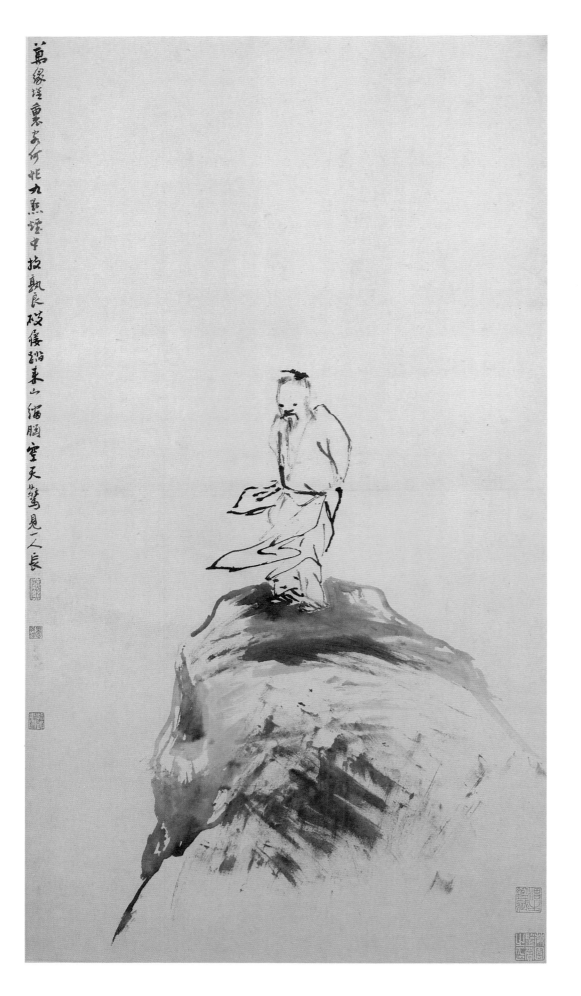

Catalogue No. 62
**Gao Qipei**
*Standing Alone
on a Lofty Ridge*

高其佩
高岗独立图轴

96

Catalogue No. 63
**Li Shan**

*Banana Palm
and Bamboo, 1734*

李 鱓
蕉竹图轴

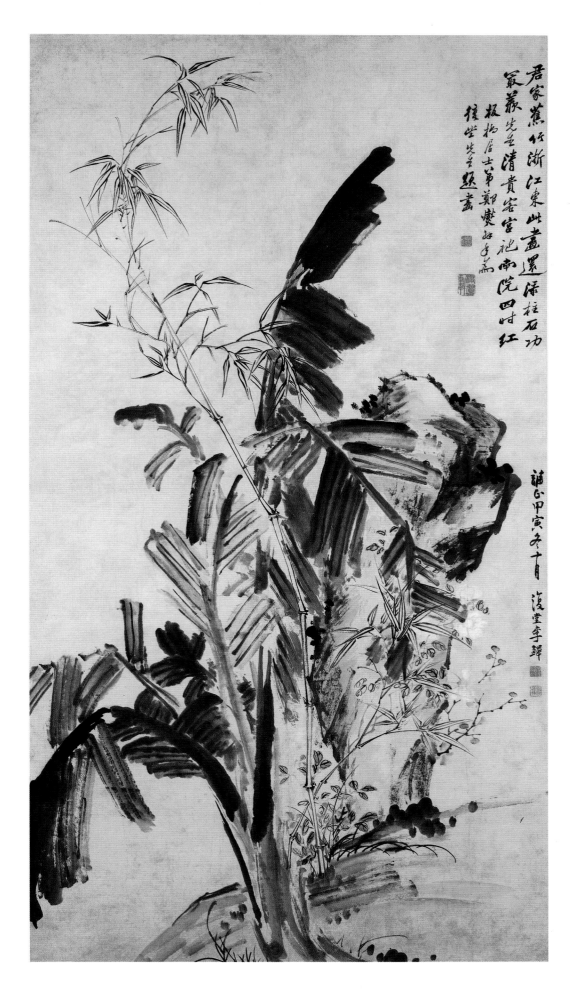

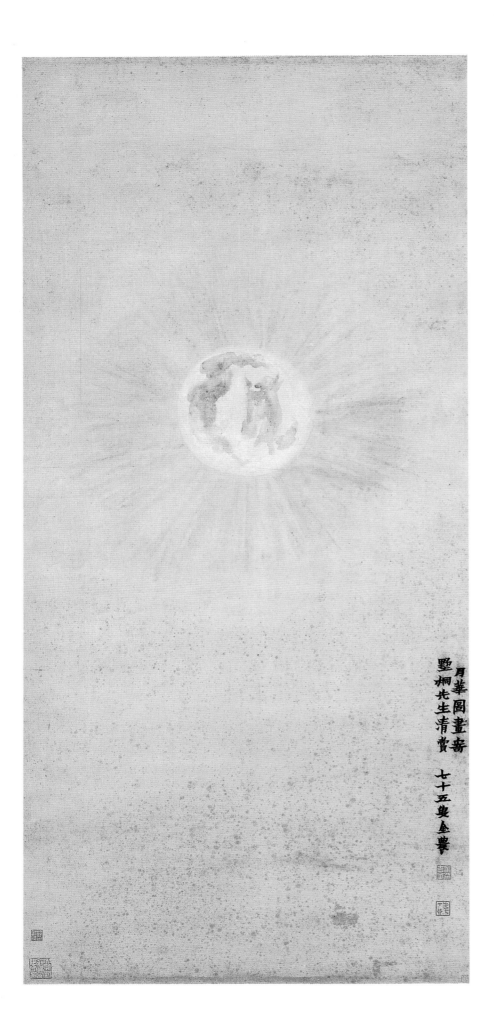

Catalogue No. 64
**Jin Nong**
*The Radiant Moon, 1761*

金 农
月华图轴

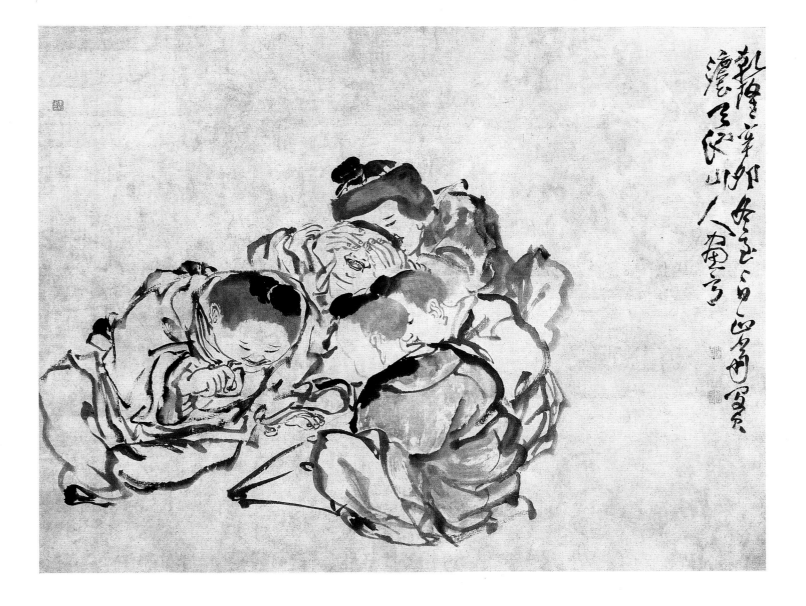

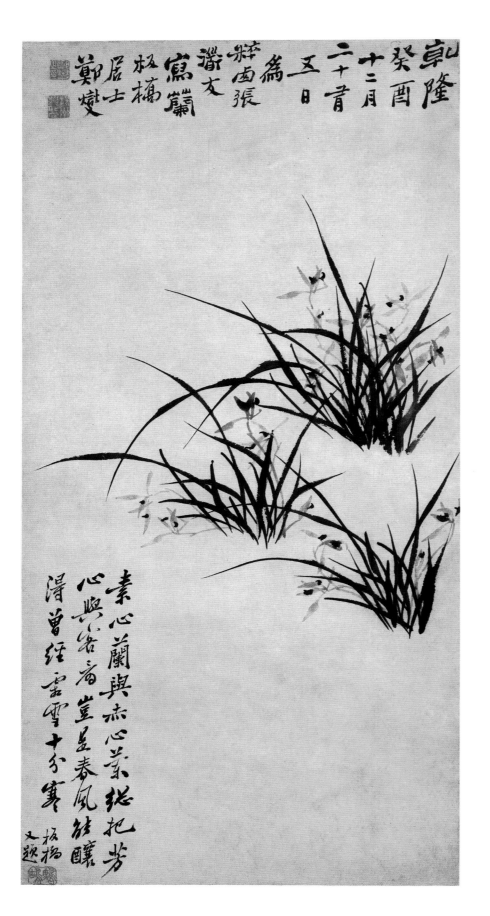

Catalogue No. 66
**Zheng Xie**

*Orchids, 1754*

郑　燮
兰花图轴

Catalogue No. 67 →
**Bian Shoumin**

*Wild Geese
and Reeds, 1730*

边寿民
芦雁图册

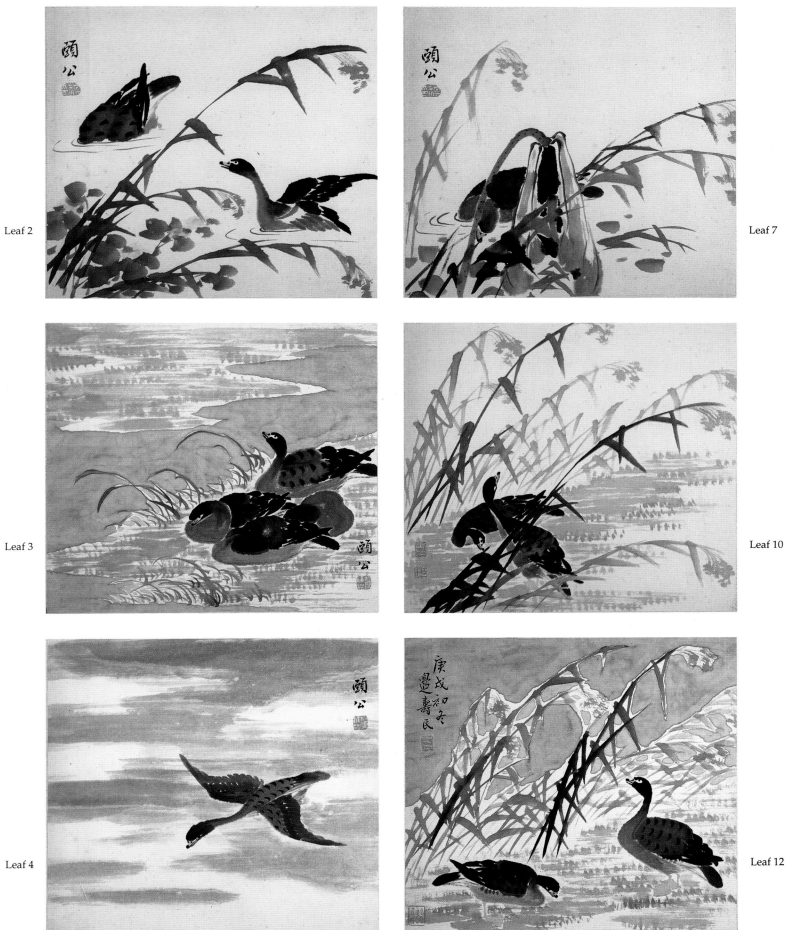

Leaf 2

Leaf 7

Leaf 3

Leaf 10

Leaf 4

Leaf 12

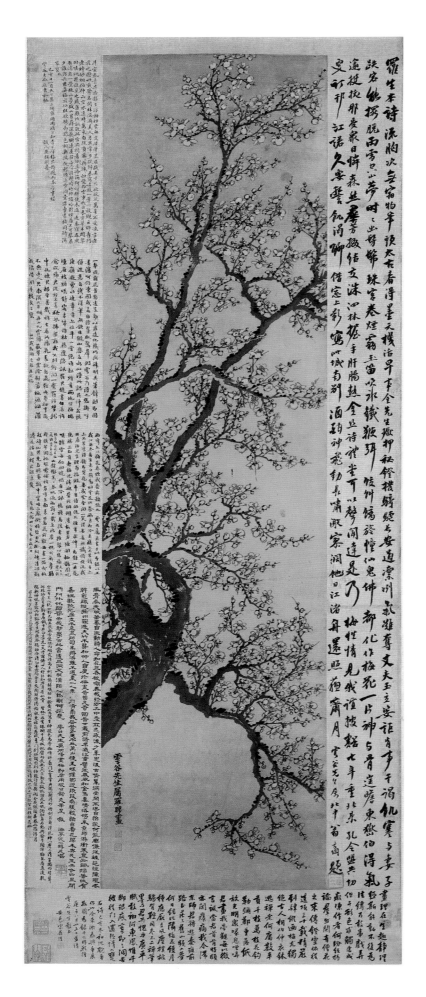

102

张　崟
京口三山图卷

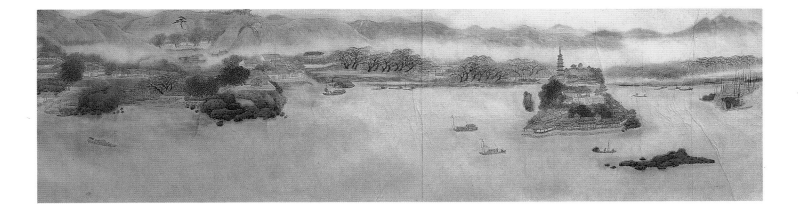

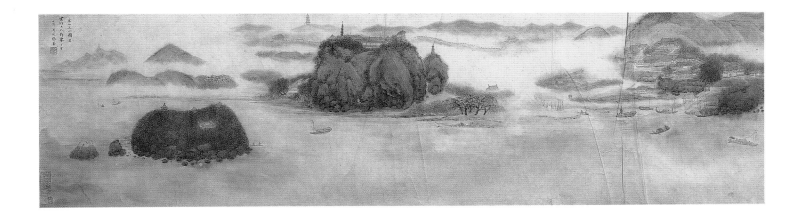

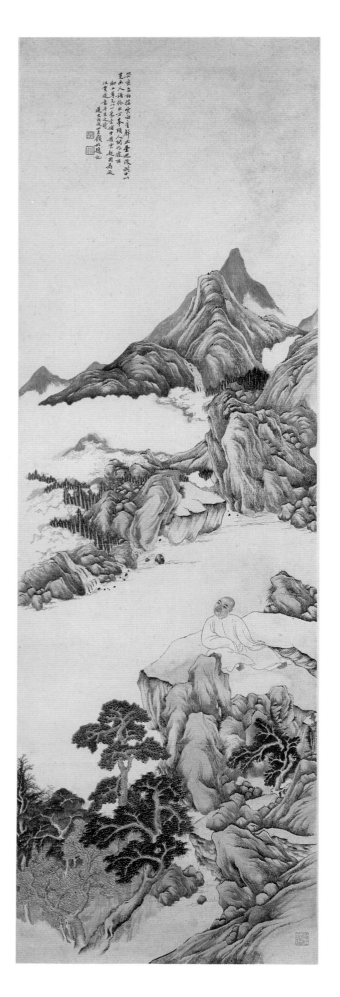

Catalogue No. 70
**Qian Du**

*Landscape Added to a*
*Portrait of Xiangshan Seated*
*While Watching Rising Clouds, 1838*

钱　杜
补湘山坐看云起像轴

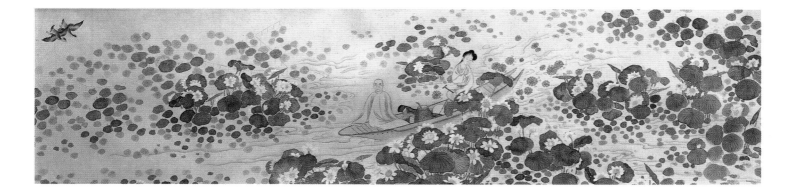

Catalogue No. 71

改 琦　　**Gai Qi**

采莲图卷　　*Plucking Lotus Blossoms*

Catalogue No. 72

**Dai Xi**　　戴 熙

*Recalling the Pines, 1847*　　憶松图卷

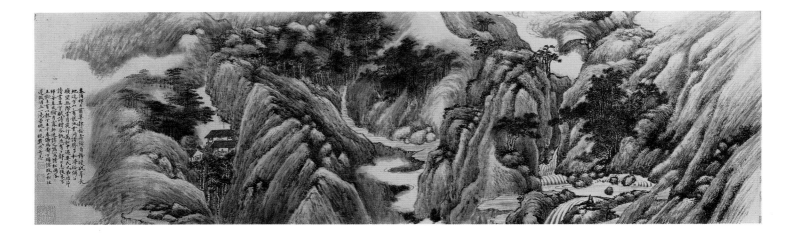

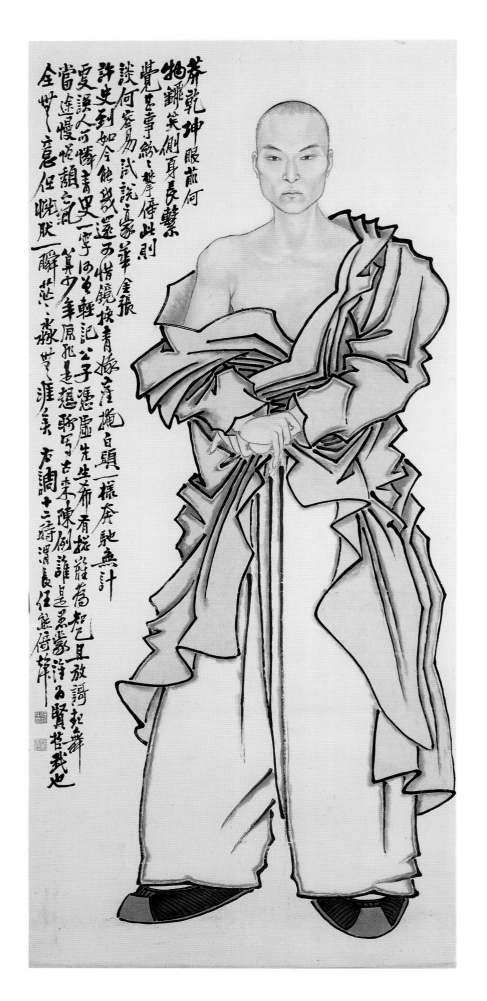

Catalogue No. 73
**Ren Xiong**
*Self-Portrait*

任　熊
自画像轴

106

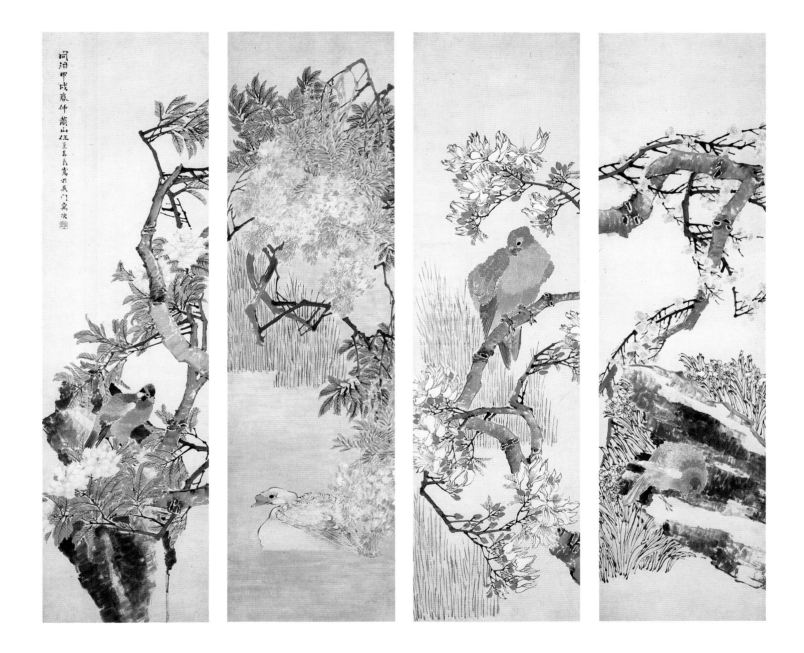

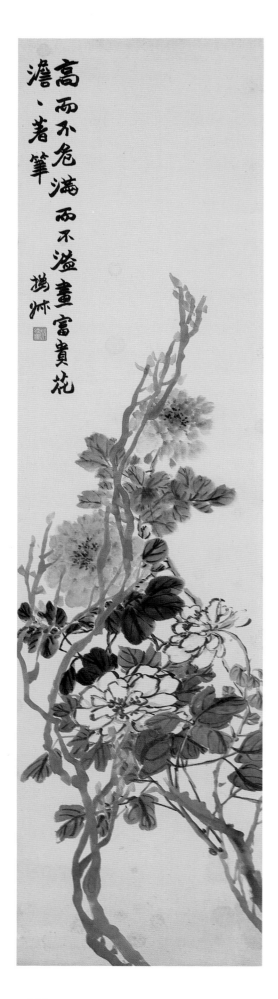

高而不危滿而不溢畫富貴花
澹澹著筆
撝叔

Catalogue No. 75
**Zhao Zhiqian**

*Flowers of the Four
Seasons, 1867*

赵之谦
花卉屏

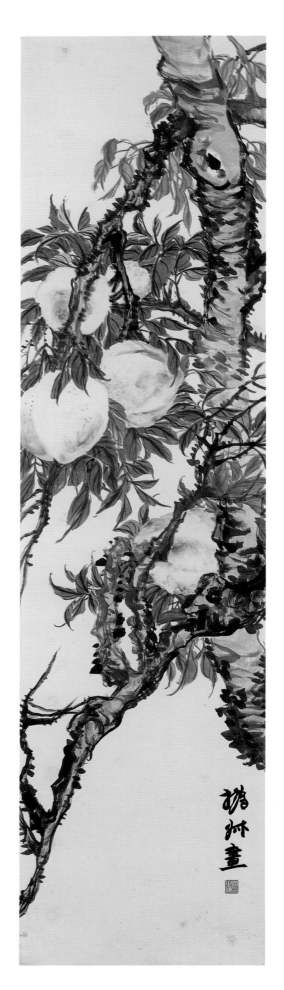

撝叔畫

108

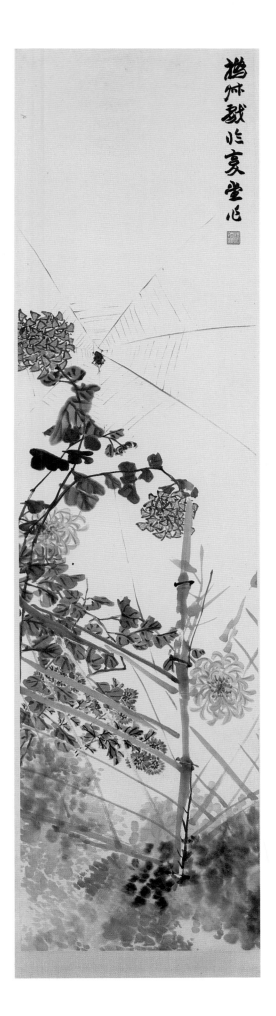

鶴邨戲作於寰堂世

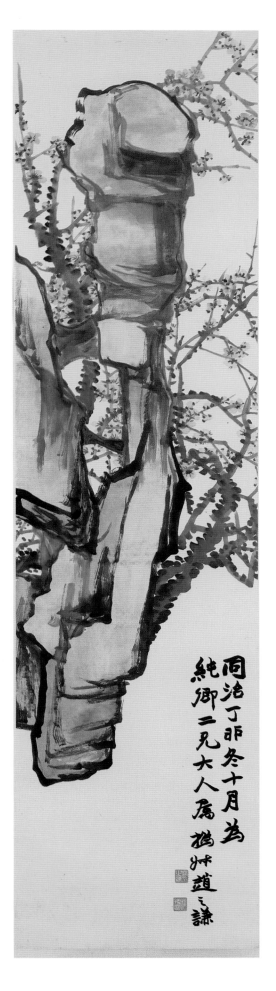

同治丁卯冬十月為
純卿二兄大人屬鶴邨趙之謙

109

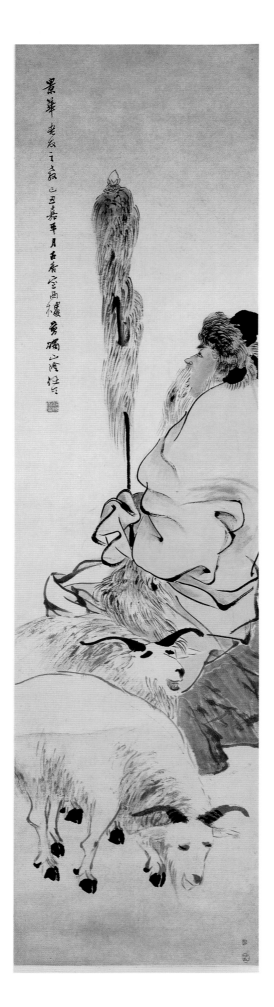

# Catalogue Entries

by

Howard Rogers

NOTE: The following entries are intended for the non-specialist reader. Thus scholarly impedimenta have by and large been dispensed with but, on the other hand, no effort has been made to avoid duplicating information and material generally available elsewhere. In all translations the Western numerical equivalent is provided for the Chinese cyclical year-dates, the proper names of artists have been substituted for other names, and place names have been given in their most easily recognizable forms.

Catalogue No. 1.
**Wang Fu** (1362-1416)
**Chen Shuqi** (fourteenth to early fifteenth century)
*Xiaoxiang Qiuyi Tu*,
"Autumn Thoughts on the Xiao and Xiang"
Handscroll, ink on paper, 25 x 569.5 cm.
No signatures or seals of the artists.
Colophon: by Huang Xing (1339-1431) dated to 1429
Collectors' seals: Geng Zhaozhong (d.1686), Liang
Qingbiao (1620-1691), the Qianlong emperor (r.1736-
1795), the Jiaqing emperor (r.1796-1820), the Xuantong
emperor (r.1909-1911)

It is fortunate that Huang Xing (1339-1431), an important
official and the connoisseur for whom this work was painted,
left a detailed account of the creation of "Autumn Thoughts
on the Xiao and Xiang," for the painting itself is not signed
and gives no other indication of authorship. According to
Huang's colophon of 1429, paintings illustrating a standard
series of "Eight Views of the Xiao and Xiang" had become so
commonplace that people tended to forget that the set titles
of the eight scenes were not simply elegant poetic phrases
but represented actual places in Hunan province, from the
confluence of the Xiao and Xiang Rivers to where they emp-
tied into Lake Dongting. Treating the entire panorama as a
series of eight separate scenes disrupted perception of its
continuity and true vastness; Huang also held that three of
the traditional titles – "Night Rain on the Xiao and Xiang,"
"Autumn Moon over Lake Dongting," and "River and Sky in
Evening Snow" – were illogical if unity of time and place
were to be upheld. Huang's solution, presented to his
painter-friend Chen Shuqi during one of their discussions on
art, was to meld these three scenes into one to be called
"Autumn Thoughts on the Xiao and Xiang" and to combine
it with the five remaining traditional scenes: "Wild Geese
Descending to Sandbar," "Returning Sails Off Distant Shore,"
"Mountain Market, Clear with Rising Mist," "Evening Bell
from Mist-shrouded Temple," and "Fishing Village in
Evening Glow." This would create a single continuous com-
position that would manifest the full scope of the subject as
well as its scenic highlights. Chen himself was dissatisfied
with his first effort, but before he had finished his second, the
present version, he fell ill and died.

In 1412 Huang Xing visited the capital, at that time still
Nanjing, and brought the unfinished scroll with him. On
meeting with Wang Fu (1362-1416), then serving the govern-
ment as drafter in the Central Drafting Office, Huang
showed the painting to the famous calligrapher and painter,
who said: "Truly this is a fine painting. I am sorry that it
wasn't finished." That regret soon impelled Wang to action,
for he then "took up his brush and completed it – everything
from 'Wild Geese Descending to Sandbar' onward."
Although Huang held that the finished painting looked as if
it had come from a single hand, differences in brushwork
show clearly that Chen painted less than the first half of the
scroll and Wang the balance. As it happens, the single easily
identifiable scene is the "Wild Geese" section with which
Wang's contribution begins.

Huang's scheme called for the traditional eight scenes to
be compressed into six, and for the six to be continuous

rather than separated. Such a presentation makes identifica-
tion of the scenes rather difficult, but the scroll appears to
open with the "Mountain Market" section, which then trans-
forms smoothly into the "Fishing Village" scene. This is fol-
lowed by "Returning Sails," and Chen's portion of the
painting then concludes with "Evening Bells," in which a
temple is depicted high up in the mountains. While this par-
ticular sequence appears to have no precedent, and does not
appear in Alfreda Murck's study of earlier versions of the
theme, it does alternate land-based scenes with those primar-
ily devoted to water, providing a visual balance between
open and closed, filled and empty. The next section,
"Descending Geese," is where Wang began to paint, and it is
here in the very beginning of the sandbar that Wang's brush-
work approaches most closely the rather dry and restrained
work of Chen. Soon, however, Wang's more characteristic
style appears and becomes increasingly evident towards the
end. If the identification of the other scenes is correct, this
concluding scene must be Huang's innovative "Autumn
Thoughts."

Chen Shuqi, the elder of the two artists, was born in
Fujian province but moved to live in Yongjia, Zhejiang
province. Huang Xing too lived in Yongjia, hence his state-
ment in the colophon here that "we knew each other for
more than twenty years and our relationship was good and
uninterrupted; we often visited one another and would
spend the whole day together before returning home..."
Early in the Yongle reign-era (1403-1425), Huang's son,
Huang Huai (1367-1449), became grand secretary, the highest
position in the bureaucracy, and subsequently patronized
many painters at court. While Chen himself never held any
official position, his pupil, Xie Huan, entered the court at this
time, very likely through the recommendation of Huang
Huai. Chen too became famous, for Huang Huai inscribed
many of Chen's paintings and presented them to his own
friends in the capital. The style of Chen's part of the present
painting relates him to the early Yuan tradition of Zhao
Mengfu as it had evolved in the works of Wang Meng and
Zhao Yuan.

Wang Fu, far better known today than Chen, was born in
Wuxi, Jiangsu province, also the home of one of his favorite
models, the late Yuan painter Ni Zan (1301-1374). Wang's
grandfather and father are said to have been scholarly reclus-
es, men who withheld their talents from the foreign Mongol
government. With the re-establishment of Chinese rule in
1368, an official career once again attracted the brightest
young minds. Wang passed the first and lowest of the three
examinations in 1376 but, apparently for some infraction of
the rules, lost his stipend and returned home. Wang married
around this time, and also associated with older literati,
many of whom had personally known Wang Meng and Ni
Zan of the previous generation.

In 1378, Wang responded to the government's call for
unemployed licentiates to work in the new capital at
Nanjing. Around 1380, he was banished to the far northern
area of Datong, perhaps because of involvement in the case
of Hu Weiyong (d.1380), the prime minister who was
accused of treason and executed. Over 40,000 people were
ultimately involved and many, including Wang Meng, died.
Wang Fu lived in the north for around twelve years, working

as a frontier guard and worrying about his ailing wife, who died while he was still in exile, and his two children. He was finally allowed to return home around 1393, perhaps because the emperor declared an end to the purges in that year; Hou-mei Ishida has also suggested that Wang adopted a son in Datong who took over his service, allowing him to return home.

For the next decade Wang Fu lived at Mount Jiulong, "Nine Dragon Mountain," near Wuxi and adopted Jiulong as his byname. While he may have worked as a teacher, he also spent a great deal of time at the Huishan Temple, famous for its pure tea water, where he met many like-minded scholars and artists, including Shen Cheng (1376-1463), the great-grandfather of Shen Zhou (cat.12). While Wang must have begun painting before moving to Mount Jiulong, none of his earlier paintings survive, and he seems to have been seriously concerned with painting only from 1393 onward. His early models in landscape painting were Wang Meng and Ni Zan; in bamboo painting, for which he seems to have been especially well known during his lifetime, he followed the Yuan master Wu Zhen (1280-1354).

Around 1403, on the basis of his skill in calligraphy, Wang Fu was appointed to serve in the Wenyuan Pavilion in Nanjing. Wang had not passed any of the higher examinations, so the position itself was unimportant, but it came as the result of recommendation by a high official, perhaps Hu Guang (1370-1418), which suggests Wang's public eminence by this time. He was also chosen to accompany the emperor's son-in-law on a trip to Sichuan soon after his appointment. A number of stories which illumine Wang's character date to his period of service in Nanjing. The first concerns Mu Sheng (1368-1439), the Prince of Qianning, who around 1408 "put forth gold and silk in seeking a painting from Wang Fu. Wang declined his offer but afterward suddenly did a scroll and gave it to a generous colleague. As he handed the painting over for him to pass on, Wang said: 'Because of the circumstances the Lord's will was blocked in this; don't say that I did it for him.'" While Wang could understand the passion of someone like Mu Sheng for painting – Mu was a patron of Dai Jin (cat.6), Li Zai (cat.3), and others –he could not abide the notion that his own paintings were commodities to be produced on demand for anyone willing to pay. "On a moonlit night Wang heard the sound of a flute coming from the neighbors. His inspiration rising, he painted a scroll of bamboo and paid a call to present it to the flautist. The man turned out to be a great merchant. Extremely pleased with the painting, he presented Wang with a roll each of wool and silk material and asked him to do a matching scroll. Wang declined the presents and ruined the painting by tearing it up."

The Yongle emperor decided to move the capital from Nanjing to Beijing and in the early years of his reign made several inspection tours to the north. Wang Fu was part of the retinue and was in Beijing in 1409-10. His work must have been more than satisfactory, for in 1412 he was promoted to drafter in the Central Drafting Office, not a high rank but, since he still lacked any higher degrees, a further mark of imperial favor. An extant painting of "Cranes and Bamboo" done jointly with the court painter Bian Wenjin bears an inscription with Wang's new rank and hence was

done in 1412 or early in 1413 before he again travelled to Beijing. Wang's latest years seem to have been spent almost entirely in the north. Another promotion came in 1414, the last year for which there are any dated paintings or any evidence of his activities. Wang died in 1416 while lodging in Beijing, after a short illness. He had had problems with his eyes already during the decade he spent at Mount Jiulong and the lack of recorded activity between 1414 and 1416 may be related to his physical condition. Wang Fu's portion of "Autumn Thoughts on the Xiao and Xiang" was done in 1412 before leaving Nanjing and, as a late work, displays his mature style. Most individual here is his method of texturing the mountain forms with fluent, complexly interwoven strokes which build substantial forms while yet animating the surface in a more formal sense.

Catalogue No. 2.
**Xia Chang** (1388-1470)
*Xiangjiang Chunyu Tu*, "Spring Rain on the Xiang River"
Handscroll, ink on paper, 31.2 x 523 cm.
Inscription: "Spring Rain on the Xiang River. Painted by Xia Chang, called Zhongzhao, of Eastern Wu."
Artist's seals: *Xia Shi Zhongzhao Yin; Youxi Hanmo*

Xia Chang, from Kunshan in Jiangsu province, was already studying calligraphy by the age of six. In 1414 he passed the second-level examination and in the following year passed the highest examination and received his *jinshi* degree. After entering the Hanlin Academy in Nanjing, he won first place in a palace calligraphy competition. Work on the new capital being built in Beijing was well under way by 1417, and around 1420 Chang was selected to write the inscriptions for tablets to be mounted on the new buildings. This work was finished by 1421, and in the same year Chang was appointed drafter in the Central Drafting Office. His surname then and at least from 1415 onward was Zhu, the imperial surname, which was probably granted him as a mark of imperial favor. His given name, Chang, was a character consisting of an element read separately as *yong*, meaning "long," placed next to one read separately as *ri*, meaning "day." During the early 1420s the emperor summoned Chang and said: "The sun is connected with the heavens, so it is more appropriate to add the *ri* on top of the *yong*," thus creating a new form for the character that Chang followed for the rest of his life and which continues today. Chang subsequently returned to using his original surname of Xia; an extant painting dated by inscription to 1422 is signed "Zhu Chang," which places the change of surname after that date, perhaps to the year 1426 when Chang left his post because of the death of his father.

Xia Chang is generally held to have studied painting with Wang Fu (cat.1) but, since Xia did not pass even his second-level examination until 1414 and Wang Fu died in Beijing not two years later, the direct association must have been of very limited duration. Xia did, however, know Wang Fu's paintings very well and made careful copies of several to learn the master's style. Another important influence on Xia was the official Chen Ji (1370-1434), who came from the

same area as Xia and was a specialist in bamboo painting. The son of the late Yuan master Chen Ruyan, and teacher of the father and uncle of Shen Zhou (cat.12), Chen Ji played an important role in continuing and establishing more firmly a specific cultural tradition for the Suzhou region.

Xia Chang was certainly painting throughout the 1420s and '30s, his work of 1422 was mentioned above, and around 1436 he painted a long handscroll for Dai Jin (cat.6), but it was not until after 1439, when he retired from his post as secretary in the Ministry of Personnel in order to care for his mother, that he turned seriously to painting. He served as prefect of Ruizhou in Jiangxi between 1448 and 1452, was in Beijing as vice-minister of the Court of Imperial Sacrifice in 1453, was made chief minister in 1457, but was permitted to retire as he was then seventy years of age. Most of Xia's dated paintings fall between the years 1439 and 1447, and it was surely during that period of secure retirement that he refined the style which brought him fame even beyond the borders of China and which led to the saying: "A single bamboo from Official Xia is worth ten taels of gold in far Western Liang."

Xia's handscroll "Spring Rain on the Xiang River" begins and ends with river passages in which the placement of forms creates fairly effective illusions of an actual river context. Having thus anchored his presentation to reality, Xia proceeded in the major central section to introduce much pictorial tension through deviations from and manipulations of his realistic premise. Ink tonality and space and size relationships are all governed more by formal than by naturalistic concerns, and this is undoubtedly the aspect of the painting Xia refers to in the legend of his *Youxi Hanmo* seal: "Taking Pleasure with Brush and Ink." The close-up view of bamboo growing along a stream was a compositional type pioneered by Wang Fu (Xia's rendition here is close enough to his model to suggest a fairly early date) but in Xia's work everything is flatter, more formalized, and more self-consciously painting than picture-making.

Catalogue No. 3.
**Li Zai** (active ca.second quarter fifteenth century)
*Kuozhu Qingfeng*, "Clear Peaks Over Distant Banks"
Hanging scroll, ink on silk, 165 x 90.5 cm.
Signature: "Guo Xi" (a later interpolation)

Li Zai was born in Putian, Fujian province. Several recent dictionaries give his date of death as 1431 but no documentation is provided. An extant handscroll in the Liaoning Provincial Museum, painted jointly with two other artists and dated to the year 1424, appears in fact to be an early work by Li Zai. There is also a recently excavated handscroll which contains a number of small paintings done for the recipient in 1446 before he left Beijing on a trip. Among the twelve painters who contributed paintings were Li Zai, Xie Huan (see Dai Jin, cat.6), and the two painters with whom Li is said to have worked in 1424. This suggests that Li did not die in 1431 but remained active until around mid-century.

Li is also said to have served at court as a *daizhao*, or painter-in-attendance, in the Palace of Humane Knowledge under the emperor Xuanzong (r.1426-1435). This emperor was a major patron who employed many artists during his reign, assigning some of them to that palace. In the case of other painters, however, their official titles and also the places of their employment sometimes appear in their inscriptions, while this is not so for any known painting by Li Zai. The one clear indication of his court status is the legend of a seal he used occasionally on his paintings: *Jinmen Huashi*, "Painting Master at the Golden Gate," since the Golden Gate was where, in the imperial palaces of old, the various *daizhao* awaited summons. This legend appears on the seals of a number of court painters, including, for example, Leng Mei (cat.57) of the Qing dynasty, but during the Ming period it was used by painters even more obscure than Li Zai, so its occurrence does not help to place him chronologically. The artists with whom Li Zai is said to have served, Dai Jin, Xie Huan, Shi Rui, and Zhou Wenjing, did not all serve the court during the Xuande era.

Several biographies of Li Zai mention that he travelled at some point to Yunnan province. Perhaps the main inducement for any painting master to visit Yunnan at that time was the hope of patronage from the Prince of Qianning, Mu Sheng (1368-1439). Mu was an important collector of classic art who also appreciated the work of such contemporary artists as Wang Fu (cat.1) and Dai Jin. A number of Li Zai's extant paintings, including the present "Clear Peaks Over Distant Banks," were modelled after the style of the great eleventh-century landscape painter Guo Xi, and Mu Sheng almost certainly owned paintings by or at least attributed to that Northern Song master. While some of Li Zai's paintings remain faithful to the original imagery of Guo Xi and even to specific paintings by this earlier master, others, including the present work, depend in style and composition on works by fourteenth-century followers of the Guo Xi tradition. Although "Clear Peaks Over Distant Banks" bears neither signature nor seal of Li Zai but rather a signature reading "Guo Xi" in the lower right corner, it can be attributed to Li Zai with complete confidence on the basis of its very close similarity to a signed landscape by Li also in the Palace Museum, Beijing. The construction of mountain forms, the expressionistic rendition of tree groups, and the very fine drawing of figures and architecture, betray a single hand, that of the master painter Li Zai. Later critics seem to have felt that Li paid too much attention to narrative detail and too little to the formal aspect of brushwork, which came to be the main criterion in evaluating paintings. However, Zhan Jingfeng (1528-1602) commented: "... Only his landscapes which follow Guo Xi's 'unravelled cloud' texture strokes fail to open people's eyes; they seem average, as though he were concerned only with the ordinary and commonplace, but if one views them carefully, the proper brushwork too is there."

If Li Zai did stay with Mu Sheng in Yunnan, it was during the 1420s or '30s. Mu was very influential at court and could have provided Li with a recommendation that would have ensured him some appointment. Li was still active in Beijing in 1446 and had become known enough to have attracted at least one pupil, Lin Guang, whose sole extant work is dated to 1500. Li Zai is also one of very few fifteenth century Chinese painters to have had an international reputation. The Japanese painter Sesshū (1420-1506) arrived in

China in 1468, remarked Li's style, and remembered his name in an inscription written in 1495 after his return home.

Catalogue No. 4.
**Lin Liang** (ca.1430-ca.1490)
*Xuejing Yingyan Tu,*
"Eagles and Goose in a Snowy Landscape"
Hanging scroll, ink on silk, 300 x 180.3 cm.
Signature: "Lin Liang"
Artist's seal: *Yishan Tushu*

The composition of this large painting is arranged around diagonal axis-lines which provide a stable framework for a very animated scene. In a design which balances filled against empty areas and near against far, the two fierce eagles and elusive goose, the only animate creatures in the scene, are in fact among the more staid and stable of the pictorial elements. The strong impression of kinetic energy is created largely by the agitated brushstrokes which outline and texture most forms and by lineament which features short strokes of rapidly changing direction. This type of diagonally oriented composition was a staple of earlier academic painting, and the subject too was common; what is new is the degree to which the painting is enlivened by an expressionistic manipulation of brush and ink. The eagle dominates the scene not by swift and powerful flight over stationary nature but, to the contrary, by its implacable stillness within a tumultuous environment.

The creator of this arresting image was Lin Liang, the first painter from the far southern province of Guangdong to achieve a nationwide reputation. Born in Nanhai, the modern Guangzhou or Canton, Lin was quick-witted and clever. When he was young, a position was bought for him as messenger to the provincial treasurer. The occupant of that position between 1455 and 1457, Chen Jin, once borrowed a famous painting and apparently hung it in the office for viewing. Lin, standing to one side, gave a critique of the work, pointing out its faults, which so angered Chen that he wanted to have Lin flogged. Lin then disclosed that he was himself a competent painter, a competency Chen tested by having Lin do a copy of the borrowed painting on the spot. The result was so wonderful that Chen regarded Lin as a genius, and from that time on Lin rose in reputation among members of the official class.

Lin had studied painting with Yan Zong (ca.1398-1454), who was known primarily as a landscape artist, and with He Yin, a *juren* or second-level degree holder of the year 1520 who specialized in figure painting, but it was as a painter of bird-and-flower subjects that Lin impressed his contemporaries. The high official Xiao Zi (d.1464) wrote of Lin in 1455: "During the Xuande era [1426-1435] the colored bird-and-flower paintings of Bian Wenjin were praised as unparalleled. In recent days Lin Liang used ink alone when he painted and often everything has a natural flavor..." Xiao Zi served only in the capital so it is likely that Lin Liang had been recommended to the court, perhaps by Chen Jin, in

1455. In any case, Lin's first appointment was to the Building Department in the Ministry of Works, a lowly position in which his artistic talents could hardly have been used to full advantage, but he was then transferred to the Imperial Household and ultimately held rank as a commander in the Embroidered Uniform Guard attached to the Palace of Humane Knowledge. Lin Liang may still have been active at court during the late Chenghua era (1465-1487) when Lü Ji (cat.5) was probably recommended for service, but the two certainly did not enter court service together as some records have it. Most standard biographical accounts of Lin's life in fact give the Hongzhi era (1488-1505) as the period when he received court appointment; however, since Lin Jiao, Lin's son, was given Embroidered Uniform Guard status and attached to the Palace of Humane Knowledge in 1494, it seems that those records confused father with son. More casual references to Lin Liang and Lü Ji draw a clear chronological distinction between them. Li Kaixian (1502-1568), for example, wrote that Lin Liang's "fame was initially greater than that of Lü Ji, so almost everything done by Ji was falsely inscribed with Liang's name. Later, however, [the situation] was different." A stylistic as well as chronological distinction was drawn between Lü and Lin by another near-contemporary, Li Mengyang (1473-1529):

"During the past 100 years in painting birds,
first there was Bian Wenjin, at the last there was Lü Ji;
These two masters were good at illusionism
but not at conception,
licking their brushes and straining their eyes
they distinguished the minutest hair.
When Lin Liang drew birds he used only ink,
beginning his composition with half-sweeps
of black wind and clouds;
The aquatic and terrestrial birds are all marvelous,
and when the painting is hung,
all within the hall are roused to passion."

Lin Liang's mature painting style is characterized technically by the use of ink monochrome and by freedom from earlier brush conventions, visually by a lack of artifice, and expressively by suggestions of tranquility even when strenous or violent activity was depicted. Emphasis on naturalness, on independence from established tradition, on quiet discipline, and on the interpenetrability of all phenomena are also basic characteristics of the philosophy of Chen Xianzhang (1428-1500), Lin Liang's contemporary and an important philosopher from Guangdong. Lin is recorded as having painted for Chen, who in turn praised Lin's style very highly. Chen wrote about a number of Cantonese contemporaries who painted, such as Liu Jian, Zhong Xue, and Chen Rui, but only the last received court appointment, and none equalled Lin Liang's fame during the 1450s and '60s.

Catalogue No. 5.
**Lü Ji** (ca.1440-ca.1505)
*Liukui Shouji Tu,*
"Pomegranate, Hollyhocks, and Rooster"
Hanging scroll, ink and color on silk, 170.5 x 105.7 cm.
Signature: "Lü Ji"
Artist's seal: *Siming Lü Tingzhen Yin*

The great popularity of Lü Ji's paintings during his life-time and yet today is due to certain basic characteristics perfectly exemplified by the present painting: a pleasing subject depicted naturalistically and with attractive colors, the whole arranged in a well-ordered composition of great decorative appeal. Judicious arrangement and overlapping of forms in the foreground create a shallow pictorial space within which the narrative elements are placed. This type of composition, as well as the meticulous detailing of natural form, was common in bird-and-flower painting from the tenth century onward.

While the painting was intended to be appreciated mainly for its sheer visual beauty, the pictorial elements did carry more specific connotations for its audience, the upper-class elite. Virtually all flowers, fruit, and birds carry symbolic weight in Chinese art and literature. Here the chrysanthemum is an emblem of autumn and symbol of joviality; the pomegranate fruit, because of its numerous seeds, symbolizes many progeny; and the magpie, whose very name in Chinese means "bird of happiness," is a most auspicious symbol. The focal point of the composition is of course the magnificent rooster, to which bird the Chinese have ascribed five characteristics: a literary spirit (his comb being associated with the tassel on an official's cap), a warlike disposition (from the spurs on his feet), courage (from his willingness to fight), benevolence (he calls the hens when he discovers grain), and faithfulness (for he never forgets to announce the dawn). For the culturally literate audience catered to by Lü, a given subject could thus convey an easily recognizable message. However, symbolic consistency is not invariably to be found. Here, for example, the single painting contains flowers which symbolize the sixth, the ninth, and the tenth months of the year. Further, the chrysanthemum is associated with a life of retirement from public affairs because it was the favorite flower of Tao Qian (365-427), but this connotation is in direct conflict with the office-holding associated with the rooster. Sometimes a painting is only a painting and not a visual text to be deconstructed.

Lü Ji was from Ningbo in Zhejiang province. The region was famed from the eleventh century onward for its specialists in bird-and-flower painting, and Lü Ji was a worthy heir to that tradition. When still a youth Lü is said to have followed the style of Bian Wenjin, a somewhat earlier court painter; Lü's work was then seen by a famous Ningbo physiognomist, Yuan Zhongche (1376-1458), who judged Lü's work superior to that of Bian and subsequently had the young painter come to live with him. Yuan had Lü copy famous works by Tang and Song dynasty masters, an exercise which led to great improvement in Lü's art. Several sources mention that Lü Ji sometimes added poems to his works, which would imply some degree of literary education, but only a single recorded painting, dated to 1489, bears

more than a simple signature. His artistry is thus almost without exception presented in purely visual terms, with naturalistically detailed and colored subjects appearing within strongly structured compositions of often very impressive size.

Probably during the Chenghua era (1465-1487) Lü was recommended to the court and was appointed to serve in the Palace of Humane Knowledge with other court-associated artists. The height of Lü's career was reached during the following Hongzhi era (1488-1505), when the reigning emperor, Zhu Youtang, appreciated not only his works but also his character and personality, which were described as being "moral, upright, and reverent." Under Zhu Youtang, Lü was promoted to his highest official rank, battalion commander in the Embroidered Uniform Guard. High rank was in itself no guarantee of a luxurious personal life away from the court setting of one's job, however. According to a poem written by Li Mengyang (1473-1529), "Lü Ji the white-head had a gold incense burner at his side, but at the end of the day he returned home without money for wine." Certainly the greatest honor for a court painter came from the possibility of direct association with the emperor himself. "When responding to imperial commands to undertake work, Lü for the most part conceived his theme so as to introduce some precept; despite undergoing some restriction, [the finished painting] still preserved the original reference." Zhu Youtang, himself a moral man and highly principled ruler, praised this unusual approach: "Lü Ji has the skill to manipulate his craft for the purpose of admonishment." The notion of the didactic value of painting was a very old one in China; its appearance at the court of Zhu Youtang was at least partially due to the emperor's desire to mold the character of the young heir apparent: "When the Wuzong emperor [Zhu Houzhao, 1491-1521] resided in the Eastern Palace [i.e., before he ascended the throne in 1505], Zhu Youtang addressed him saying: 'The paintings of Lü Ji marvelously surpass the wellsprings of Nature itself; such pictures as 'The Talented Listening to Admonitions' and 'Ten Thousand Years of Clear Purity' are very much concerned with administration and are worthy to be handed down as treasures.' "

Since Lü Ji is known today solely as a painter of bird-and-flower compositions, it is worth emphasizing that one if not both of the paintings recommended by Zhu Youtang to his son was a figure painting, as was one of Lü's most famous works, the "Ten Classmates of the Year 1464," painted in 1503 at the request of Li Dongyang (1447-1516), then the grand secretary. In 1499 Lü and a fellow court-artist, Lü Wenying, collaborated on a painting at the behest of Zhou Jing (1440-1510), then the minister of revenue, who invited nine of his friends to his Bamboo Garden in Beijing on the occasion of his sixtieth birthday. These associations confirm the statements of Lü's biographers that "the officials mostly respected him," but none honored Lü more than did Zhu Youtang: "When [Lü] fell ill, [the emperor] inquired after his health continuously. [Lü] himself said: 'To be so favored is difficult to bear, and this [portends] my death,' and indeed he did die." Having been born perhaps as early as 1440 in Ningbo, Lü Ji died in Beijing around the year 1505.

At least fourteen artists are said to have been influenced by Lü Ji's style of painting, and he should thus be regarded

as the founder of a major school of painting. His earliest follower was a fellow townsman named Xiao Zeng, who travelled to the capital with Lü, lived with him for some considerable time, and was eventually also granted rank in the Embroidered Uniform Guard. Lü's other recorded followers were all local painters, four from scattered provinces but at least nine, including six from several generations of his own family, from Ningbo. It is likely that members of this latter group produced most of the large numbers of decorative bird-and-flower pictures which circulated during the sixteenth century under the name of Lü Ji. At least 121 paintings attributed to Lü were in the collection confiscated from prime minister Yan Song (1480-1565), and large numbers of paintings from the school were also exported to Japan, where they played some part in the evolution of the Kanō school style. Wang Shizhen (1526-1590) noted the great popularity of Lü's paintings during the lifetime of the artist, the local school of painters which subsequently met the demand for Lü's work, and the ultimate decline in critical estimation of the style: "At that time [Lü's works] were extremely prized and valued but today, because of the changing taste of the times, they are in gradually decreasing demand."

Catalogue No. 6.
**Dai Jin** (1388-1462)
*Guanshan Xinglü Tu,*
"Travellers Through Mountain Passes"
Hanging scroll, ink and color on paper, 61.8 x 29.7 cm.
Signature: "Jing'an"
Artist's seal: *Wenjin*
Collectors' seals: An Chi (b.1683), Liu Shu (1759-1816), Pang Yuanji (1864-1949)

Dai Jin was born in Hangzhou, Zhejiang province. Generally acclaimed the foremost painter of his generation, his influence was such that he was later recognized as the founder of the Zhe school of painting, named after his native province. As with other major figures in Chinese history, anecdotal material for Dai is plentiful. According to an eighteenth-century historian of Hangzhou, Dai began work as a silversmith, but changed to painting when he saw another craftsman whose skill matched his own. Early in the Yongle era (1403-1424) Dai travelled to Nanjing. When a porter disappeared with his luggage, he borrowed paper from a nearby wine shop, sketched a portrait of the man, and was directed to the man's house by those who easily recognized him from the sketch. Dai was thus already an accomplished figure painter, and he may have gone to Nanjing in the hope of being selected to work at the Baoen Temple, a major undertaking begun under imperial auspices in 1407. Shen Zhou (cat.12) wrote later that Dai's teacher in painting had been Zhuo Di, an artist recorded as having worked at the temple.

Toward the end of the Yongle era Dai accompanied his father to the capital, again in search of a post. The capital in this case was likely Beijing, where by around 1420 or so there would have been great need of artists and artisans to decorate the newly built halls of the new capital. Although Dai's skill was already above the ordinary level, he was unsuccessful and returned home to apply himself even more seriously to his craft. Zhu Zhanji (1388-1435) was the first emperor since the Huizong emperor of the Song to have been a competent painter in his own right, and during his reign as the Xuande emperor (1426-1435) many artists were called to court and given rank within the emperor's personal bodyguard, the Embroidered Uniform Guard. Recommendation of candidates for such honored service was done mainly by high officials. Dai's opportunity came around 1426 when he was recommended by a eunuch defense commissioner named Fu, who submitted four paintings by Dai along with his recommendation. The most detailed version of the subsequent viewing states that before Dai was given an audience, the emperor looked at the paintings with his chief artistic adviser, Xie Huan. Xie skillfully killed the emperor's spontaneous enthusiasm for the paintings by intrepreting the subjects and Dai's presentation of them in ways that attributed subversive intent to the artist. The dynasty was less than sixty years old at that point, the emperor's grandfather had usurped the throne from his brother less than three decades earlier, and Xie's rather far-fetched constructions were thus taken seriously. The emperor ordered the beheading of eunuch Fu, who had merely recommended the artist for consideration. Dai Jin escaped the capital by night and returned to Hangzhou, where he hid in various temples, doing Buddhist and Daoist paintings that could still be seen many decades later. On learning that Dai was hiding in Hangzhou, Xie Huan sent men in search of him. But Dai had heard that the Prince of Qianning in Yunnan, Mu Sheng, was a connoisseur and collector of paintings and thus a possible source of assistance, and had already fled to Yunnan.

What motive could Xie Huan have had for his animosity toward Dai Jin? Jealousy must surely have been one motivation, for Xie was the former prodigy then at the peak of his career meeting his potential successor; Dai's talent could have carried him beyond Xie and so threatened Xie's prestige and position at court. Another account of the painting viewing in Beijing indicates that after Dai's failure to gain an appointment, he remained in the capital under great economic difficulty. Each day he would sit before the palace gate, alone and dispirited, and beg rice from the various painting masters. Xie Huan, responsible for Dai's plight, hired Dai to fulfill a commission he had received for a large painting to be given to a cabinet official. Dai's ghost-painting came to light when the four high officials who had given Xie the commission visited the house and found not Xie but Dai at work on it. Xie's position at court would have been greatly weakened if the emperor had learned that his chief adviser had first publicly condemned and then privately hired Dai Jin, so Xie had excellent reason to keep Dai as far as possible from the capital.

On arrival in Yunnan, Dai went to Mu Sheng's palace and there met Shi Rui, a fellow painter from Hangzhou who appreciated Dai's work very highly and saw to all his needs. Dai studied the paintings in Mu's collection, in effect broadening the stylistic foundation of his art; he made copies which in a few known cases are still regarded as originals painted by the master Dai was following. Given Dai's great natural talent for painting, these art-historical studies gave

him a stylistic range and repertoire unmatched in later Ming painting. Dai was back in Beijing in 1436 (Xia Chang [cat.2] did a painting for him in that year) for, although Xie Huan was still active, the Xuande emperor had died the previous year. The next decade or so seems to have been the most stable and productive of Dai's life. Although he still lacked an official position, his admirers and patrons included Yang Rong (1371-1440), Yang Shiqi (1365-1444), and Wang Zhi (1379-1462), who were among the most powerful officials of the land.

The present "Travellers Through Mountain Passes" is undated by inscription but can be dated by style to the early 1440s. The tripartite composition is of the stable, well-balanced, and monumental type so common in the early Northern Song period. As is true in general of Ming painting, however, the composition has been flattened, the pictorial space suggested by overlapping and gradients of recession belied by an overall uniformity of ink tonality. Standing in further contrast to the earlier model is the closeness of the view, with everything kept fairly near the frontal picture plane. The effect of these changes is to create an intimate mood that in its appeal to the emotions stands in polar opposition to the logical positivism of the earlier vision. Another result of bringing the scene closer to the viewer is that the brushwork becomes more visible; especially in the upper portion of the peaks, the strokes take on an abstract interest of their own apart from their roles in picture-making.

What must have been Dai Jin's final attempt to secure court apointment came around the mid-1440s during the reign of Zhu Qizhen, who ruled as the Zhengtong emperor (1436-1449). In order to identify the few artists with creativity as well as craft, Zhu Qizhen followed the precedent of the Huizong emperor in assigning a couplet as the set theme for all candidates to illustrate:

"On myriad green twigs, a spot of red;

To move men the colors of spring do not need much."
Most of the painters rather predictably illustrated the theme by daubing spots of color onto flowers. Dai, however, painted a flourishing pine and at its crown a white crane, which has a red-spotted head. This subtle evocation of the theme was appreciated by all, but Dai still did not win; that honor went to the artist who captured the erotic connotations of the couplet by painting a beautiful lady standing beneath banana palms, her lips just touched with red.

During the later 1440s Dai returned to Hangzhou, where he lived until his death in 1462. Several of Dai's biographers remarked that he ended his days in poverty, but that may be only in relation to what his staunch admirers felt was his due. At least eleven direct followers are recorded for Dai, including his son, his daughter, and his son-in-law, and almost all were from Hangzhou. Perhaps as many again are noted as having been influenced indirectly by Dai Jin, and their periods and places of activity suggest a widening of interest in Dai's approach to painting by the end of the century. This evolution culminates in the figure of Wu Wei (cat.7) who, though from neither Hangzhou nor even Zhejiang province, was a follower of Dai Jin and considered the second great master of the Zhe school.

Catalogue No. 7.
**Wu Wei** (1459-1508)
*Yule Tu*, "The Pleasures of Fishing"
Hanging scroll, ink and color on paper, 270.8 x 173.5 cm.
Signature: "Xiaoxian [The Small Immortal]"
Artist's seal: *Jiangxia Wu Wei Xiaoxian*
Collectors' seals: three, illegible

"The Pleasures of Fishing" is a traditional theme and one painted fairly often by Wu Wei. Although this painting is not dated, the well-organized composition and relatively controlled brushwork suggest a date of around 1490. The work is unusual in size and media; it is one of Wu's largest known paintings and was done on paper rather than the silk ground more usual for his large hanging scrolls. The swift-moving, undulating brushwork which textures and enlivens the forms is an important feature of Wu Wei's mature style and one which was influential on many other painters (see, for examples, the paintings by Tang Yin and Chen Daofu, cat.16 and 23). The high viewpoint here, which yields an unusually spacious composition, is reminiscent of certain tenth-century paintings while yet suggesting an actual view stretching into the far distance from some fixed vantage point. This impression of immediacy, of actuality, raises the possibility that the scene was based on the actual view from the Yellow Crane Tower, one of the most famous landmarks of Wuchang, the city of Wu's birth. This idealized evocation of the joy and freedom of rural life could not but appeal to Wu Wei's urban audience, many of whom were military men, embroiled in more pressing and more mundane affairs.

Wu Wei was born in Wuchang, Hubei province. His grandfather had served as prefect in a number of towns, and Wu's father too passed at least the first-level examination. Unfortunately, Wu's father seems to have been more interested in alchemy than in either scholarship or art and lost everything in the former pursuit. When the father died several years after Wu's birth, the family was destitute; Wu was taken in and raised by a provincial official from Suzhou named Qian Xin. Wu studied together with Qian's sons and probably began to practice calligraphy at that time. According to one account, Wu used his brush to paint on the floor. On seeing this, Qian asked him: "Do you want to become a painting master?" The answer must have been in the affirmative, for Qian then supplied Wu with proper brushes and paper for his study of painting. In addition to his natural bent for painting, Wu may also have been inspired by the example of his father, whose paintings and calligraphies were then still well esteemed in collecting circles.

At the age of sixteen, in 1475, Wu felt ready for greater challenge and travelled to the auxillary imperial capital of Nanjing "with the pride and sensitive temperament that come with youth. After he arrived he put his gown and cap in order, and... called on none other than... the Duke of Chengguo. The Duke saw at once that Wu was extraordinary and said: 'Is this not an immortal!' Because Wu's years were few, he called him the Small Immortal, and Wu then took what the Duke had called him as his byname... Duke Zhu received Wu as a live-in disciple and treated him almost as though he were a son..." Life within the household of Zhu Yi

(1427-1496) provided Wu Wei with a host of benefits as well as pleasures. Zhu was a major collector, in a position to buy old masterworks from such older families as that of Shen Zhou when rising taxes made such sales necessary. It was in part by studying paintings in his patron's collection that Wu learned the very refined *baimiao* ink-monochrome linear figure style of Li Gonglin that is featured in a number of his earlier paintings. A more immediate advantage to Wu was the opportunity to meet Zhu Yi's friends and associates; since Zhu was adjutant to the governor general of the province, these included not only the Nanjing nobility but also high-ranking officials, "all of whom invited Wu to be an honored guest. Wu's bearing was dignified, his manner polite, and his conversation confident and direct without flattery, so the various lords enjoyed entertaining him to an ever-increasing degree. Because of this, there was not one among the scholar-officials who did not wish to receive and make friends with him, and those requesting to see him waited at his door from morning to night..."

Among those Wu visited was the military official Chen Rui (1439-1502), the Earl of Pingjiang, who hosted Wu in Yangzhou and introduced him to Tang You (1446-1525), the capital garrison commander. Around the mid-1480s Wu Wei made his first visit to Beijing. Given his connections in Nanjing and Yangzhou it is not surprising that he was already well-known in the main capital city and that many were anxious to act as his host, including the well-known general Zhu Yong (1429-1496), Duke of Baoguo. The emperor, Zhu Jianshen, heard about Wu and summoned him to appear at court. Zhu was obviously pleased by the artist and appointed him to the Embroidered Uniform Guard and attached him to the Palace of Humane Knowledge along with the other court artists. Wu was not like the other professionals, however, and certainly was not accustomed to being treated as one, and it is perhaps significant that it is at this point that stories of his eccentric behavior begin. "Once Wu Wei was very drunk when he was summoned. With dishevelled hair and a dirty face, shuffling in broken black shoes, he staggered along with officials holding him up by his arms. On seeing him the emperor laughed aloud and ordered him to do a picture of pines in the wind. Wei knelt down and overturned the ink wash. Without hesitation he daubed and smeared until deeply moving wind and clouds were produced within the screen. The attendants changed color and the emperor said in astonishment: 'Truly is this the brush of an immortal!'" Wu's behavior at the Beijing court was generally such that he quickly antagonized all whose favor was essential to his continued tenure; powerful officials and nobles were treated with contempt and their requests for paintings summarily refused. Concluding that there was no reason to keep Wu in Beijing, the disgruntled court had him expelled and returned to Nanjing.

On his return Wu Wei is said to have stated: "I have now experienced officialdom and for the first time have travelled without hope." Wu's earlier travels, to Nanjing, to Yangzhou, and to Beijing, were all undertaken with hopeful anticipation of new thresholds to cross and of new laurels to be won. For a professional painting master there was nothing more prestigious than working at court in close proximity to the emperor himself, yet such service was obviously uncongenial to Wu Wei. With nothing to look forward to, Wu gave himself up to a life of dissipation: "Wei loved to sport and drink and would sometimes go for ten days without eating. When he was in the southern capital [Nanjing] every day the local gallants would invite him to drink until he was drunk. When they understood that he also liked prostitutes, and that providing him with drink without prostitutes was like using a net to catch a frisky horse, they competed with each other in gathering prostitutes with which to lure him." If that was the public view of Wu, a more private glimpse is given by a friend who was very close to the artist at the time: "Wu is said to be crazy, but his words are selected with great care and his speech is neither false nor foolish. It is because most people do not know what is in his heart that they only praise him for his calligraphy and painting..."

When Zhu Youtang succeeded to the throne in 1488, Wu Wei was again summoned to Beijing where he was promoted to higher rank within the Embroidered Uniform Guard. As further token of imperial favor, Wu was granted a seal whose legend, "The *zhuangyuan* of painting," equated Wu's achievement with that of the top performer in the highest level literary examination. Wu was still unhappy, however, and probably in the early 1490s requested leave to return to Wuchang to see to the graves of his ancestors. This request was granted, but within a few months a messenger appeared in Wuchang to summon Wu back to the capital, where the emperor sweetened his lot by granting him a house in a fashionable district of Beijing. Two years later, pleading illness, Wu was granted permission to return to Nanjing where he lived on the east bank of the Qinhuai River.

The final fifteen or so years of Wu's life were spent mainly in Nanjing, where he associated with such important collectors as Huang Lin and such artists as Xu Lin, a Suzhou painter who had moved to Nanjing. He also seems to have maintained connections with the Suzhou artists Shen Zhou, Wang Chong, Zhu Yunming, and Tang Yin. Wu also travelled at times, for one painting dated to 1505 is inscribed as having been done while in Wuchang, and wall paintings by Wu are recorded for the Linggu Temple in Hangzhou. Wu Wei was arguably the most famous painter of his day as well as the most popular, and he certainly trained some students during this period; no fewer than thirty-three Ming painters are recorded as having followed Wu's style, including Zhang Lu (cat.8), Zheng Wenlin (cat.11), Jiang Song (cat.9), and Wang Zhao (cat.10), although very few can be shown to have studied directly with him. One motivation in following his style is stated explicitly in the case of the Nanjing artist Li Zhu: "As a youth Li studied painting as a disciple of Shen Zhou. When his study was complete, he returned home and followed only the style of Wu Wei so as to sell his paintings. For in Nanjing at that time Wu's paintings were valued highly..."

In 1506 Zhu Houzhao ascended the throne as the Zhengde emperor and yet again a summons went out for Wu Wei to serve at court. Wu of course agreed to go but died while drinking before setting off with the envoy. One of Wu Wei's admirers, Li Lian, claimed in 1522 that "Wu was the top painter of our dynasty," which was high praise indeed. Li also quoted a saying then current in Nanjing, "A single picture by Jiangxia's Crazy Wu is worth a thousand in gold." Li's response to that was: "Even a thousand in gold for one of his paintings is nothing."

Catalogue No. 8.
**Zhang Lu** (ca.1490-ca.1563)
*Chuixiao Nuxian Tu,* 'Female Immortal Playing the Flute"
Hanging scroll, ink and light color on silk, 140 x 91.7 cm.
Signature: "Pingshan"
Artist's seal: *Zhang Lu*

On a river bank demarcated by rocks and pine a figure sitting beside a basket with giant peach plays a flute. Although there would appear to be no human audience, the river itself seems to sweep and crash in response to the musical notes. The strokes which texture the rocks and especially the trunk of the pine also have a wave-like movement and contribute to the varieties of tempos and rhythms which contrast with the calmness of the figure and so emphasize it. The garment of the flautist is defined by lines which are descriptive while yet possessing an abstract interest unrelated to their narrative role. The pine, the peach, and the fungus growing in the foreground are all emblems of longevity and are associated with the immortals of Daoism, hence the conventional title of the painting. However, the immortal whose emblem is the flute is not female but male – he is the young Han Xiangzi, the patron saint of musicians, who attracted birds and animals by his flute-playing and became immortal on falling from a supernatural peachtree.

The artist, Zhang Lu, was born in Kaifeng, Henan province. His earliest biographer, Zhu Anxian, recorded that Zhang died at the age of seventy-three. In a recent article, Shi Shouqian estimated that Zhang was born around 1490 and hence would have died around 1563. As a youth, Zhang was small in stature and was described as resolute, loyal, and generous, but also somewhat conceited. Coming from a family of some prominence, Zhang embarked on the normal course of study designed for success in the examinations and an eventual career as an official. After passing an initial examination Zhang entered the prefectural school and became an official pupil. He seems to have been fairly successful and to have earned the respect of his contemporaries, but his progress ceased after he entered the National University in Beijing. Zhu Anxian, who knew Zhang personally, indicated that Zhang entered the university on the basis of inherited right, which again suggests the high status of his family; later sources state that Zhang purchased his admission. After frequently failing to pass the higher examination, Zhang gave up and concentrated on painting.

Zhang's early interest in painting was evidenced while he was a student, when he would draw figures and sketch landscapes on the top of his desk and on his lesson-notes. His natural talent was developed by his study of old paintings, which were likely accessible to him through family connections. After Zhang gave up his academic endeavors and decided on a career in painting, he very intelligently began by modelling his style on that of the leading professional of the day, Wang E, then serving the court as battalion commander in the Embroidered Uniform Guard. This early style of Zhang Lu featured figures drawn carefully with a line so fine and graceful that it was characterized as "floating gossamer." Somewhat later Zhang came to admire and emulate the stronger, more unrestrained style of Wu Wei (cat.7). To the graceful freedom of Wu's style Zhang is said to have added

mass and substantiality and to have surpassed the earlier master; other critics, somewhat later and from the south rather than the northern area of Zhang's birth, criticised him for capturing only the strength and vigor of Wu's style while missing its elegant freedom. In any case, Zhang Lu's paintings were extremely popular during his lifetime, and officials in the north, many of whom knew Zhang personally, regarded his works as treasures.

One of Zhang Lu's earliest sponsors was Li Yue (1465-1526), who served in Beijing as vice-minister of the Ministry of War. Li invited Zhang to the official guest-house, where he was visited by a continuous stream of high officials and nobles. Zhang then travelled extensively in the eastern and southern regions. When some natural scene caught his eye and imagination Zhang would "study it for a long while and then lay out white silk and ink. After meditating and joining his spirit [with that of the thing to be depicted], an idea would come. Holding up the sleeve of his robe he would then raise and lower the brush, inexhaustibly producing objects like Nature itself."

When Zhang returned to Kaifeng he became a kind of recluse, like "a leopard hiding in groves and swamps, wandering abstractedly in plain cotton robe and straw sandals." Although Zhang was a professional painter, he disliked worldly affairs, including the courtesy visits to the highly placed who might have helped with his career, and neither did he give paintings in return for gifts. According to Zhu Anxian, those who wanted a painting from Zhang had to pay their respects at his simple house. Zhang's aversion to overt efforts to secure patronage is attested to by the eminent scholar-official Xue Hui (1489-1541), who also knew the work of Shen Zhou (cat.12) and Wen Zhengming (cat.15):

"How else could he feel about his incomparable art
     but mainly to begrudge its leaving,
  not accepting even a thousand in gold
     in exchange for a genuine work;
  High officials fly about and spread his fame
     but still do not easily get what they want,
  the visits of nobles with their requests
     are empty and without benefit."

Zhang did, however, enjoy painting for poets and scholars. As he once said: "Painting is simply the result of a gentleman taking pleasure in brush and ink; can one simply regard it as a commodity by means of which to secure a profit?"

All biographical sources agree that in his later years Zhang lived in retirement. The local gazetteer notes: "Although Zhang Lu was famed throughout the empire for his paintings, he lived in retirement with no way to carry on, and in the end his world was loneliness behind his door." While that suggests a lack of success for Zhang akin to that ascribed to Dai Jin (cat.6), Zhu Anxian states that the seclusion was intentional. Zhu, who was Zhang's neighbor, often listened to Zhang expounding on painting and connoisseurship well into the night, so the artist was not entirely without companionship.

The clearest indication of Zhang Lu's status in contemporaneous society is gained by consideration of his relationship with his neighbor and biographer, Zhu Anxian. Zhu was a great-great-grandson of Zhu Su, who was the fifth son of Zhu Yuanzhang, the founder of the Ming dynasty. Zhu Su,

who had been enfeoffed as the Prince of Zhou, based himself in Kaifeng, which his descendants continued to control. Zhu Anxian was thus a member of the imperial family, in direct line of descent from the dynasty's founder. That his daughter was given in marriage to Zhang Lu's youngest son is a sure manifestation of the eminence of Zhang's family. This status belies the image of Zhang suggested by a story recounted by the southerner Wang Shizhen (1526-1590). According to Wang, a high provincial official named Sun became very angry when Zhang did not visit him periodically. When Zhang did go to see him, Sun induced him to enter and then clamped his left hand into a wooden device designed to extract evidence from prisoners or witnesses in court. With his right hand Zhang was then forced to paint a picture of Zhong Kui and was released from his torture only on the intervention of another official. In view of Zhang's various associations and actual status, the story is rather unlikely and is in fact told also of Dai Jin in other sources. Zhu Anxian does mention an unnamed provincial official who expected to get a painting from Zhang by virtue of the fact that the official's status and authority were nominally superior to those of the painter. When Zhang refused to comply, the official angrily threatened him with legal action. Rather than being cowed, however, Zhang cheerfully waited for him to act since in fact – and this was the point of the story – the official could do nothing to him.

Zhu began his biography of Zhang Lu with the statement: "Master Zhang was a painting master from Daliang [Kaifeng]." The term "painting master," *huashi*, as used in reference to Zhang Lu, Dai Jin, and several other major painters of the fifteenth and sixteenth centuries may not have been a general descriptive term but a specific title, which at that time carried considerable weight and prestige. Later critics, especially those from the south, re-evaluated Zhang's works and, on the basis of a changed aesthetic, denied his very real achievement: "Northerners viewed Zhang Lu's paintings as precious as jade discs while connoisseurs did not include them among the elegant pleasures. In recent days their reputation and value have gradually diminished."

Catalogue No. 9.
**Jiang Song** (active early sixteenth century)
*Yuzhou Dushu Tu*, "Reading in a Fishing Skiff"
Hanging scroll, ink and color on silk, 171 x 107.5 cm.
Signature: "Sansong"
Artist's seals: *Gongjinggong Sun; Jiang Song Siyin*

Overhanging cliffs dominate the river on which glides a fishing skiff; an extended fishing pole is tended by neither servant nor reading scholar. The theme of the scholar as fisherman – not the fishing of a fisherman but rather that of a recluse – had a very long history in literature, beginning with Jiang Ziya of the eleventh century B.C., who was appointed chief counsellor by King Wen after being found fishing with a straight piece of wire as hook. From a Daoist point of view, the image connoted freedom from the difficulties and constraints suffered by an urban official. This painting would thus have had a strong appeal both to scholars still waiting

to be discovered as well as to officials who were already successful and now mourned their lost freedom. Another kind of freedom is suggested by the artist's treatment of natural forms; the painter offers neither dazzling illusionism nor even a convincing rendition of three-dimensional reality, but he does imbue his work with a strong sense of energy and vitality through purely formal manipulations of shape and form, brush and ink.

Jiang Song was born in the city of Nanjing, probably during the third quarter of the fifteenth century. The Jiang clan had a long and illustrious history, beginning during the Zhou dynasty with Boling, enfeoffed as ruler of Jiang in Henan province. One Tang dynasty ancestor of Jiang Song had been a provincial governor, and during the Song and Yuan dynasties the family produced a number of scholars and officials. A prominent ancestor from the early Ming period was Jiang Yongwen (1351-1424), an eminent medical doctor who served as personal physician to three emperors and received the posthumous title of Gongjing, "Reverent Healer." Jiang Song later used a seal whose legend, *Gongjinggong Sun,* honored his relationship with Yongwen. Considering the known dates of Jiang Song's grandfather, it might seem reasonable to assume that he was himself born during the first half of the fifteenth century; however, Jiang's son, Jiang Qian, seems on the basis of dated paintings to have been born around 1525 and to have lived until around 1610. Bearing in mind the possibility that Jiang Song's recorded relationship with either Yongwen or Qian may be in error, we will here suggest a birthdate of around 1470 for Jiang Song.

Nothing is said by any of Jiang Song's biographers of his early education, but considering his family background and the fact that he was later famed as a scholarly recluse in Suzhou, we may assume that Jiang Song possessed some knowledge of literature and even medicine, the family specialty. One uncle (or cousin), Jiang Yi (1439-1487), was a *jinshi* degree holder and an intimate of the Suzhou literati circle. While serving as an imperial censor in Nanjing, Jiang Yi was sued and subsequently imprisoned; he died at home at the age of forty-eight after receiving a pardon. That disaster may have involved the family and fortune of Jiang Song and necessitated his career as a professional painter.

Jiang is said to have begun his artistic career as a painter of fans, a format especially favored by the Suzhou school from Shen Zhou (cat.12) onward. Jiang's teacher in painting is not known but he was certainly influenced by the expressionistic style of Wu Wei (cat.7). Several aspects of Jiang's style are suggested by the *Jinling Suoshi* (preface 1610) record that Jiang "excelled in painting landscapes with figures, for the most part done with roasted ink and greatly pleasing to the eye of his contemporaries." A great majority of Jiang's extant paintings do depict figures – fishermen in boats or scholars beneath trees – placed within landscape settings, the whole rendered in richly varied tones and textures of ink. In accounting for the visual characteristics of Jiang's paintings, the late Ming *Wusheng Shishi* noted: "Jiang Song lived amidst the winding streams and layered hills of Nanjing. Since he was raised among their beauties, and because he had drunk deeply of the elegance of those hills and valleys, when he lowered his brush to paint he reached the realm of creation; it

was not Jiang Song's paintings which resembled the natural landscape but rather the natural landscape which resembled the paintings of Jiang Song."

Jiang's reputation was firmly established by the early years of the sixteenth century. His earliest biography, in the *Tuhui Baojian Buyi*, was written in 1519 or earlier, and in 1520 he was honored by a visit from the Zhengde emperor, Zhu Houzhao (1491-1521), who in that year spent several months in Nanjing and visited such other painters as Xu Lin (1462-1538). The emperor was so pleased with Jiang's paintings that he grasped his hand, an extraordinary honor according to Zhan Jingfeng (1528-1602), who recorded the event. Jiang's reputation was perhaps always highest in Nanjing, but one of the very rare poems written about his work was by Xu Wei (cat.24), which suggests some appreciation of his art beyond the borders of his native city:

"Tall reeds and short rushes
  dress up the verdant maple,
Ink is splashed, the brushwork wild,
  for wash he used roasted ink;
Half a cliff covered with wisteria
  imposes itself over the river's mouth,
Wind and rain fill the sky
  and hurry on the old fisherman.
Straw raincoats and bamboo hats seem heavy,
  the fishing poles are blurred,
Where the work is uncontrolled
  is where there is true skill;
Visitors to the market wrongly guess
  this is by 'Thousand Mile' Chen,
Only I recognized it as by
  'Three Pines' Jiang Song."

Although Xu Wei was writing of a specific painting, the general description could easily be applied to many other works by Jiang Song, a fact which points to the limited stock of compositions in which he presented his equally restricted repertoire of themes. The effect of this standardization is to emphasize the formal aspect of his work, his idiosyncratic use of brush and ink. Later critics, writing at a time when canonical artistic models had been established and orthodox modes of brushwork defined, would castigate Jiang for what they termed his coarse and undisciplined use of the brush and for straying from the standards proper to painting. Other critics compared Jiang Song to Mi Fu and Ni Zan, two earlier masters whose styles differed considerably from one another (as do both from that of Jiang Song) but are allied by their uniqueness, by their radical departures from generally accepted standards and norms. The two earlier painters were most often classified by critics as of the *yi* or "untrammelled" class; Jiang Song too created a personal style in which the brush and ink were non-derivative and used in compositions that were and are today unmistakably his own.

Catalogue No. 10.
**Wang Zhao** (active early sixteenth century)
*Qijiao Tu*, "Arising Dragon"
Hanging scroll, ink and color on silk, 167.5 x 100.9 cm.
Signature: "Haiyun"
Artist's seals: two, both illegible

The dragon, most potent of all Chinese symbols, stands for fertile, beneficent rain and is thus associated with thunder and lightning and with the clouds which bring rain. Dragons were said to live within the depths during the fall and winter months and to return to the heavens each spring. The present painting, in which a scholar attended by a servant pauses on a mountain path to view the ascending dragon, is thus of a seasonal subject, one which would be appropriate for spring display. The theme of metamorphosis is carried here by the forms themselves as well as by the subject, for the trees dance upward and the earth and rocks push outward to blend and meld with the wind-tossed clouds through which is glimpsed the muscular dragon. A comment made of an early example of this subject, entitled "Dragon in Spring Rising from Hibernation" and painted in the tenth century by Sun Wei, is equally true of this early sixteenth-century descendant: "The potency of the brush is extraordinary, the atmospheric effects are virile and free."

Wang Zhao, the painter, has been grouped with Dai Jin (cat.6), Wu Wei (cat.7), and Zhang Lu (cat.8) to form the "Four Great Masters of the Zhe School." He was possibly the youngest of the four and hence likely influenced by the others, but he did develop his own distinctive style of painting. Wang himself said that his brushwork turned and twisted with the airy grace of clouds over the sea and called himself, and most frequently signed his paintings, *Haiyun* or "Sea-clouds." Several of Wang's biographers state explicitly that he was an eccentric person as well as artist. According to a local Anhui gazeteer, the *Huizhou Fuzhi*, Wang was once put in jail for some offense. The jailer, surnamed Dongfang, wanted to see a painting by Wang, so the artist poured ink over white silk – which astonished Dongfang – then added water to the ink and brushed out a picture described as "Arriving Dawn" which he inscribed with the following poem:

"During the fifth watch of the night amidst wind and rain,
  closed in by clouds and mist in all directions,
The traveller would lose his way in it,
  were he not favored with light from the eastern quarter."

Since "eastern quarter" was the literal meaning of Dongfang's name, he felt obliged to respond to the painter's unique appeal for help. Saying, "Would not incarcerating this kind of talent for a long time be the jailor's crime?," he secured Wang Zhao's release.

Another story concerns a visit Wang Zhao paid to the city of Nanjing. Wang inadvertantly boarded a pirate ship whose crew was planning to attack and plunder the boat of the local prefect in the dead of night. Wang informed the pirates that he was an excellent painter; opening his case and extracting some blank fans, he painted a fan for each of his captors. Later, when they were all drinking wine together, Wang demonstrated his ability to drink wine without using his mouth – evidently by inhaling through his nose – and

encouraged them all in their revelry. When the pirate chief finally sank into an unconscious stupor, Wang was able to escape.

Wang Zhao was born in Xiuning, Anhui province. While his dates of birth and death are unknown, his main period of activity seems to have been during the first quarter of the sixteenth century. He Liangjun, in his *Siyouzhai Hualun* of around 1550, wrote that: "Wang Zhao... was among the painters of the Zhengde era [1506-21] not in the Painting Academy. His brushwork was capable and somewhat superior to that of the Academy masters." From the Zhengde era onward the court painters were in fact of little artistic importance and the major innovations in figure painting came from artists working in centers other than the capital. While Wang Zhao is known to have visited Nanjing, he seems to have lived and worked mainly in Anhui province. Zhan Jingfeng (1528-1602) was also from Anhui and recalled meeting Wang during the early 1530s when Wang visited Zhan's uncle, who was also a painter. Zhan wrote of Wang's paintings: "Although his rocks are bumpy with no interior divisions, his ink is rich and his colors fresh, and these too can move people. While his landscapes may seem forced, his fame shook the world for a time."

Catalogue No. 11.
**Zheng Wenlin** (mid-sixteenth century)
*Chunliu Yiqi Tu*, "Playing Chess Beneath Spring Willows"
Hanging scroll, ink and color on silk, 187.7 x 94.5 cm.
Signature: "Dianxian"
Artist's seal: *Dianxian*

Two scholarly figures sit at ease beneath willows, a *weiqi* chess board temporarily abandoned in favor of silent contemplation. The dynamic composition, which is organized around strong diagonal axes, creates a directed focus of attention moving from left to right, which suggests that the present work was originally designed as one of a pair of hanging scrolls, the right one of which would have provided formal contrast as well as a leftward-moving focal direction. While recognizably part of a natural setting, the trees and rocks of the painting are oddly formed in themselves and even more strangely related to one another. Ambiguous spatial relationships (note the steeply angled bank on which the figures sit and the flapping cliff surface in the upper right) create a bizarre environment which characterizes this as the land of the impossible and the two figures as immortals in human guise.

Standard biographical sources say about the artist, Zheng Wenlin, only that he was born in Fujian province. Even then he is listed not under his proper name of Wenlin but rather under his byname of Dianxian, "Fallen Immortal," the name with which he signed his paintings. Zheng lived and worked around the middle of the sixteenth century, a period when critical taste was forsaking the strong and emotive effects of earlier Ming painting (see Dai Jin, cat.6, and Shen Zhou, cat.12) in favor of fine detail and more delicate brushwork. Beyond mid-century it became almost fashionable for critics to compile lists of their "favorite" worst

painters. He Liangjun, writing in his *Siyouzhai Hualun* of around 1550, said of paintings by Jiang Song (cat.9), Guo Xu (cat.13), and Zhang Lu (cat.8), that: "I wouldn't even use them as dust rags for fear of disgracing my furniture!" While Zhang Lu and Jiang Song were almost always favored with such critical opprobrium, Guo Xu's name was dropped from later sixteenth and seventeenth century lists, which in turn added those of Wang Zhao (cat.10) and Zheng Wenlin. Typical of these later comments is that of Gao Lian (ca.1521-ca.1593) in his *Yanqian Qingshang Jian:* "Such as Zheng Wenlin..., Jiang Song, Zhang Lu, and Wang Zhao are all heterodox painters who indulge only in overbearing expression. None of their paintings is worth getting." Gao's book was written for collectors, and his comments here were clearly intended to prevent the neophyte from buying something then popular but unlikely to hold its value over time. Gao's attitude was similar to that of Cao Zhao, who in 1387 warned collectors away from the "vulgar" attraction of the newly popular underglaze-blue decorated porcelains. But whereas Cao was a reactionary, fighting a futile rearguard action, Gao Lian represented the future of critical judgment, and paintings by the so-called heterodox masters were not collected, treasured, and preserved as were the more refined productions of the later sixteenth century.

Zheng Wenlin was of course most unlikely to have been conscious of his critically assigned role of heterodox painter or of the overbearing quality of his style; Zheng was not an aesthetic guerrilla attacking established canons but rather a professional painter catering to the requirements and desires of his urban clientele. This might suggest a contemporary separation of high and low cultures, with painters like Wen Zhengming (cat.15) and his followers catering to high or scholarly taste and Zheng and his ilk appreciated only by the lower or merchant classes, but the numbers and the importance of known exceptions point to the dangers of such easy formulations. In the case of Zheng Wenlin, we may note the high esteem in which both he and his paintings were held by Ren Huan (1519-1558), a scholar who served as prefect of Suzhou. Ren visited Zheng's studio around 1552, which substantiates Zheng's activity at that time, and wrote a poem which suggests how Zheng was viewed by at least one of his contemporaries:

"The immortal nests in clouds
  and rides over jasper terraces,
 Deeply hidden within the city
  is his Daoist paradise Penglai."

The notions of withdrawal from practical affairs and of living in meditative seclusion were admired by and attractive to most scholar-officials, and it was further recognized that different types of withdrawal presented different degrees of difficulty. "The lesser withdrawal is to secret oneself among the hills or marshes; the greater withdrawal is to hide oneself within the court or market," wrote Wang Kangju. One could be a recluse in the midst of many because "withdrawal begins within, not outside of me," in the words of Liu Can of the Six Dynasties period. "Fallen Immortal" Zheng was thus presented by Ren Huan in a very favorable light: as an urban recluse and as an artist who may have been supported by the market but was not a merchant himself.

Catalogue No. 12.
**Shen Zhou** (1427-1509)
*Cangzhou Qu Tu*, "The Flavor of Seclusion"
Handscroll, ink and color on paper, 29.7 x 799 cm.
Inscription: "Using water and ink and trying for land-scapes whose forms resemble those of Dong Yuan and Juran is fashionable. Dong and Ju in landscape painting are like the herbs used by the [famous doctors] Cang and Bian. For if one first obtains the basic properties and then seeks for the form, everything will be very easy. Artists today all shout 'I am following Dong and Ju,' but that is to seek only for Dong and Ju and to abandon the land-scape. In this scroll I still do not dare to dream of Dong and Ju. Recorded by their later student, Shen Zhou."
Artist's seals: *Shen Shi Chi'nan; Zushiting; Chi'nan; Shitian*
Title: *Cangzhou Qu*, written by Liu Kai (fifteenth century)
Colophon: Li Dongyang (1447-1516)

Dong Yuan and his pupil, the monk Juran, were Nanjing painters active during the tenth century. Their style of paint-ing featured thick, skein-like texture strokes, lumpy accumu-lations of hillocks to build gently rolling hills and ranges, and repetitious dotting which unified the composition through the visual similarity of grass, foliage, and distant trees. Determinedly understated and insistently unspectacu-lar, the style virtually disappeared during the Song dynasty but was revived during the Yuan, and from then on was the most influential of all the early styles. The reason for its pop-ularity from the fourteenth century onward is linked to the basic nature of the brushwork associated with the style, for, unlike that of alternate styles, this could be "written" by literati masters trained in the art of calligraphy. The style was not created by Dong Yuan as a style *per se*, for he was con-cerned rather with the actual scenery in the Nanjing region, the appearance of which he captured by visual schemata that were later regularized and codified into the Dong-Ju style. It was a mistake, Shen argued in his inscription to the present painting, for any artist to take the style itself as his subject, for the style was only a means to an end, not the end itself, which was the representation of landscape.

In turning from Shen Zhou's words to his painting, we may be surprised by its highly formalistic nature. The view is close-up, as in the bamboo handscroll by Xia Chang (cat.2), so the upper parts of trees, hills, and even houses are cut off, concentrating our attention on the primary constructions of Shen's world. The pictorial forms and brushwork are simple, strong, and direct, all characteristics of Shen's mature style of perhaps the early 1480s. The basic vocabulary of forms and strokes is easily seen as having been derived from Dong Yuan and Juran; what becomes evident far more slowly are the changes from one section of the scroll to the next which in sequence call to mind and hence pay homage to the four great masters of the Yuan period: Wu Zhen, Wang Meng, Huang Gongwang, and Ni Zan. Although the present title was not assigned by the painter, its connotations are appro-priate for a painting by Shen Zhou, for Cangzhou is the generic name for the dwelling place of a scholarly recluse such as Shen was.

Shen Zhou was born to the north of Suzhou proper on the family's hereditary landholdings. Until he was thirty-five years old he had not only his father to look to for guidance but also an uncle, his grandfather, and his great-grandfather. The family had been established in that location during the early years of the Ming dynasty by Shen Liangchen, a collec-tor and connoisseur of art, a good friend of one of Shen Zhou's later models, the artist Wang Meng (1309-1385), and Shen Zhou's great-great-grandfather. Shen Cheng (1376-1463), the son of Liangchen, was the head of the family dur-ing much of Shen Zhou's early life; as such, his experiences and attitudes must have carried great weight with the young man. Shen Cheng, like his father before him, was a sometime painter and also a collector who owned a painting by Ni Zan (1301-1374), another of Shen Zhou's favored models. Early in the Yongle era (1403-1424), Shen Cheng was summoned to Nanjing to assist the governor of the capital district on a tem-porary basis. This was still close in time to the great purges of the 1370s and '80s, and in addition the reigning emperor had usurped the rightful place of his brother. Court service thus presented obvious disadvantages and even dangers, which would have weighed heavily in the deliberation of a member of a wealthy landowning family who had alterna-tives to such employment. When offered a permanent official position, Shen Cheng pleaded illness and spent the rest of his life at home, establishing a precedent that was followed by later generations of the family, none of whom seems ever to have sat for any of the examinations. Shen Zhou consistently declined all offers of recommendation or preferment, giving the health of his mother, who lived until 1506 and the age of ninety-eight, as his admirable and convenient excuse.

When Shen Zhou began his education it was natural that his father invited his own teacher's son, Chen Kuan, to tutor him. Chen was not only a painter himself but also a collector who owned paintings by the Yuan artists Huang Gongwang, Wang Meng, and his grandfather Chen Ruyan. The prefer-ence of Shen Zhou for the styles of the Yuan masters during his earlier years was thus a matter of course, for they were an intimate part of the cultural ambience in which he was born and raised. Zhao Tonglu (1423-1503), another Suzhou artist, is sometimes mentioned as a teacher of Shen Zhou, but the two men were close contemporaries and more likely fellow-students rather than master and pupil. Zhao's "instructions" seem in any case to have been limited to the invariable com-ment that the touch of Shen's brush was too heavy when he worked after Ni Zan, a fairly just criticism as can be seen from consideration of the final portion of the present scroll.

In light of his family heritage, the major preoccupations of Shen Zhou's life seem foreordained. He became a collector of painting and calligraphy and owned, for example, one of the masterworks of Yuan painting, the "Dwelling in the Fuchun Mountains" by Huang Gongwang. Shen's taste in painting was catholic and his collection was restricted nei-ther by period nor by style; he also owned paintings by such near contemporaries as Dai Jin (cat.6) and Xie Huan, whose styles were quite different from Shen's own. Shen was a more than competent calligrapher, whose primary model was the great Song calligrapher Huang Tingjian (1045-1105), several of whose works Shen owned. He was also a poet, whose first collection of poems was published in 1491, and others after his death. One anecdote suggests in fact an early concentration on poetry. At the age of fourteen Shen was del-

egated by his father to deliver the rice-tribute to Nanjing, a major undertaking since Suzhou was the heart of the rice-producing region. As a cultivated man the official in charge loved poetry; Shen thus presented him with a verse that was good enough to arouse the official's suspicions as to authorship. With Shen before him he set "The Phoenix Terrace," a Nanjing landmark, as a theme, and watched in amazement as the boy immediately picked up his brush and wrote without hesitation another beautiful verse. While the reliability of the story is weakened by the fact that the named official, Cui Gong (1400-79), apparently did not serve in the region until 1458, when Shen would have been thirty-one years old, the story concludes with Cui issuing an order to the local officials in Suzhou that Shen be exempted from further service as the tax collector, and there is in fact no further mention of the post in connection with Shen Zhou.

Around 1498, when Shen was seventy-one years old and well-established as a painter, the prefect of Suzhou, who between 1497 and 1499 was Cao Feng (1457-1509), needed a painter to decorate the walls of the judicial hall. Checking the register of local painting masters, he chose Shen Zhou, whose name had been interpolated by someone who disliked him. Cao was not aware of Shen's eminence and sent a clerk to hurry him on. Some of Shen's friends argued that the work was menial service and urged him to seek exemption through intercession by one of his highly-placed friends. Shen replied that he was obliged to do the work, and did so, to the great chagrin of Prefect Cao when he subsequently learned Shen's real status. The anecdote is sometimes adduced as evidence that Shen was listed in the population register as an artisan, but in the story it is stated clearly that Shen's name was falsely added to the artisans' section; in the local gazetteer Shen is listed with his ancestors in the scholar-official section, while in the official *Ming Shi*, or "History of the Ming," he is placed with neither officials nor artisans but in the section for recluse-scholars, which also includes Ni Zan. Shen's obligation to do the paintings at the prefect's behest was thus more a general obligation to obey a government official than the more limited, legal obligation to provide corvée labor. The paintings themselves were still extant in the seventeenth century, when a connoisseur saw them, noted that they were said to have been done by Shen Zhou, but reattributed them to a pupil of Shen's named Xie Shichen (cat.22) on the basis of style. The paintings were described as "Four Great Views of the Empire," and it is worth noting that in 1498 Shen did a series of four large handscrolls in the styles of Zhao Mengfu, Li Tang, Wang Meng, and Wu Zhen that were collectively called "Four Great Views of Heaven and Earth."

Who, one may well wonder, would so dislike Shen as to wish to humiliate him publicly? Certainly not the literati, for they were Shen's friends and, in any case, Shen lived outside the city and sought neither fame nor power. One possibility is that the unknown enemy was a professional painting master – one registered as such – who resented Shen's incursions into his area of specialty and means of livelihood. Increasingly toward the end of his life, some part of Shen's living depended on his painting. It is likely that rising land taxes necessitated selling not only his own works, for the production of which he established a small studio on the out-skirts of Suzhou proper, but also his collection of earlier paintings. His painting by Huang Gongwang was sold before 1488, and a scroll by the tenth-century painter Guo Zhongshu went to Zhu Yi (1427-1496), the important Nanjing official and patron of Wu Wei (cat.7).

While Shen Zhou made no long journeys to exotic places, he did travel extensively within his own local region. Those lakes and rivers, rolling hills and trees, country villages and towns, rice-paddies and fields, temples and houses provided the basic scenic elements from which a majority of his paintings were constructed. The style Shen used to render those elements changed in accord with shifts in the focus of his art-historical interest. According to Li Rihua (1565-1635): "... Shen Zhou got the methods of painting from his father and uncle, and of the various masters there were none he did not copy endlessly. In his middle years he took Huang Gongwang as his master. In his later years his heart was intoxicated by Wu Zhen and thus, drunken and without restraint, he fused and blended their styles until some of his could not be distinguished when mixed among old Wu's works..."

Shen Zhou was both experimental and innovative as an artist. He established the practice of painting albums with each leaf done in the style of a different earlier master. He also popularized the painting of folding fans, which came to be a staple of his followers. And Shen the painter was extremely interested in the materials of his craft; gold-flecked paper had been used earlier by calligraphers but Shen broadened its range by using it, and perhaps satin as well, as ground for his paintings. Shen was later credited as the progenitor of a Suzhou tradition of painting that was called the Wu School after the ancient name for the region of Suzhou; Wen Zhengming and all his students belong to that lineage. Shen was also later grouped with Tang Yin (cat.16), Qiu Ying (cat.17), and Wen Zhengming (cat.15) as "The Four Great Masters of the Ming." Wang Shizhen praised Shen's work as "the best of our dynasty" and Shen's student, Wen Zhengming, honored his master as "an immortal among men."

Catalogue No. 13.
**Guo Xu** (1456-1532)
*Pipa Xing Tu*, "Illustration to the Song of the Lute"
Hanging scroll, ink on paper, 153.5 x 46.3 cm.
Inscribed with the text of the *Pipa Xing* and signed "written and painted by Qingkuang."
Artist's seals: two, one reading *Renhong*

The long inscription written by the artist above the two figures is a transcription of the *Pipa Xing*, a poem composed by Bo Juyi (772-846) during his period of service as magistrate of Xunyang in Jiangxi province. One evening, when bidding farewell to a friend on the bank of a river, Bo was startled to hear the sound of a *pipa* lute, an instrument whose music he had not heard since leaving the capital for his provincial post. On immediate inquiry he found that the musician was a woman who in former and younger years had been the toast of the capital city. She had become the

wife of a small merchant who frequently left her alone on the boat while he was away on business; in her loneliness she dreamed often of bygone days and wept for sorrow. The conversation led the poet to think of his own plight as a former high official degraded to a lowly provincial post and to record the event in a poem. The poem was subsequently illustrated often by painters and seems to have been especially popular during the sixteenth century, when many artists sought to evoke the poignant mood of nostalgia so easily commanded by the original poem. The present version is unusual in that the artist omitted the river, the boat, indeed everything which usually provided some context for the main figures. Even the figures neither act nor interact as might be expected; the woman only holds rather than plays her bent-necked lute, and neither figure looks directly at the other. The figures themselves are very similar in style and presentation to those appearing in paintings by Wu Wei (cat.7) and may not have originated with the present artist, Guo Xu. What is creative here, apart from the splendid rhythms of Guo's calligraphy, is the juxtaposition of the two stock figures in such a way that they appear aware of one another yet lost in deeply personal reveries, the content of which was of course part of the written story. Although not an illustration in the usual sense, the painted figures are successful in eliciting a reaction from the viewer appropriate to the theme of the whole.

Guo Xu was born in Taihe, Jiangxi province. As a youth he held appointment as an official student but discontinued his academic studies before sitting for the final examination. According to the *Mingshan Cang*, one day "during a minor examination Guo laughed and abruptly set aside his papers. He then sighed and said: 'Chanters who follow the models very closely are honored in the markets today. Shall I then devote myself to broadening my viewpoint and to establishing a supreme art by pursuing extraordinary thoughts and roaming everywhere?'" After deciding to invest his talent in painting, Guo travelled extensively to various famous mountains and is said to have exclaimed: "What need have we for painting manuals; the paintings are here!" Guo's mode of creativity, and his implicit belief in the interchangeability of poetry and paintings as conduits for his inspiration, are suggested in the *Mingshan Cang*: "He thereupon impressed his hand to make a painting. When he was done painting he inscribed a poem, but before he had written the poem completely he again let himself go in painting, but before the painting was done he again exhausted himself in poetry." By the 1490s Guo was said to have been as famous as Wu Wei, Shen Zhou (cat.12), and Du Jin in painting and to have been beseiged by people seeking one of his paintings, for which they were willing to pay as much as one hundred taels in gold. That Guo gave up his literary studies with little concern for the future, and even more that he was educated enough to receive the original appointment, suggests that Guo's economic status precluded pressing need to sell his paintings and allowed him the freedom to treat even golden requests for paintings with disdain: "Guo might know the person but, unwilling even to look at him, would leap about madly and shout loudly as he went away."

Sometime during the Hongzhi era (1488-1505), Guo Xu's renown as a painter earned him summons to the capital for consideration as a court artist. The powerful eunuch Xiao Jing (1438-1528) offered to arrange an appointment for Guo in the Embroidered Uniform Guard, but the independent and irascible painter replied that he would not tolerate compulsion or restraint and immediately declined. While Guo's motivation in refusing court appointment seems quite in keeping with his general outlook and earlier behavior, his action in this case was given a moral coloration by such contemporaries as Li Mengyang (1475-1531), who praised Guo's purity and virtue as being as firm as those of earlier eremitic recluses.

A mark of Guo's eminence during the second decade of the sixteenth century was a request for a meeting with Guo from the Prince of Ning, Zhu Chenhao (1478-1521). Guo could not refuse a request coming from a member of the imperial clan, but he very soon expressed his regrets and took hasty leave of the prince and, soon thereafter, of the capital itself and left for the distant region of Hubei province. Guo's puzzling response to the meeting was fully justified when, in 1519, the Prince of Ning staged a rebellion from his base in the Jiangxi city of Nanchang. The prince, who somewhat earlier had enticed Tang Yin (cat.16) to join his staff, seems to have been particularly anxious to have Guo's support in 1519, perhaps because Guo was from Jiangxi and part of the gentry class essential to his success. An agent is said to have been sent to Hubei in search of Guo, but he could not be found and did not return until after the rebellion had been suppressed.

Guo's flight to avoid association with the traitorous prince earned him additional respect from his peers. But it would seem that a question concerning his loyalty lingered on, for Guo is said to have presented a painting to Wang Shouren (1472-1529), then governor of southern Jiangxi province and the military leader responsible for suppressing the rebellion in concert with the prefect of Guo's home district. The painting was inscribed with a poem intended to make Guo's ambition clear to Wang. While neither the painting nor the poem seems to be extant, a work of "Xie An and his Concubines" dated to 1526 may suggest the general character of the painting done for Wang Shouren, who is better known as the philosopher Wang Yangming. Guo's poem on the painting of 1526 reads:

"The two shoes of Dongshan walk within the real world, to serve in the capital requires political ability; The bevy of concubines who accompany him smile at each other, still superior to Huan Wen is the man behind the wall."

Huan Wen (312-373) was a military adventurer who deposed an emperor and contemplated seizing the throne for himself before his timely death. Xie An (320-385), the Dongshan of the poem, took office only reluctantly and sent his brother and nephew to deal with a rebellion while he himself remained at home playing chess. It is likely that Guo Xu viewed himself as a spiritual descendant of Xie An and other elegant eccentrics of the Six Dynasties period; disillusioned with the realities of the political world, they sought both refuge and justification in a self-consciously aesthetic world whose nature is suggested in the case of Guo Xu by the name he chose for himself: *Qingkuang*, "Pure and Crazy."

Catalogue No. 14.
**Zhou Chen** (d. ca.1536)
*Renwu Gushi*, "Illustrations to Historical Tales"
Album of 8 leaves, ink and color on paper,
33.7 x 64.5 cm.
(1) *Su Wu Muyang*, "Su Wu Herding Sheep"
(2) *Jiaoyin Bogu*, "Enjoying Antiquities in Shade of
   Banana Palms"
(3) *Xizhi Shushan*, "Wang Xizhi Writing on a Fan"
(4) *Yingxue Dushu*, "Studying by Light Reflected from
   Snow"
(5) *Linxuan Kezi*, "Teaching Boys in Riverside Pavilion"
(6) *Linxie Huangting*, "Writing the Daoist Classic on
   Riverbank"
(7) *Chengmen Lixue*, "Standing in Snow at the Gate of
   Cheng Yi"
(8) *Yuqiao Wenda*, "Dialogue Between the Fisherman and
   the Woodcutter"
Each leaf signed: "Dongcun Zhou Chen"
Artist's seal on each leaf: *Zhou Shi Shunqing*
Colophons on facing pages by Wang Guxiang (1501-
1568)
Collector's seals: Wu Hufan (1894-1968)

Zhou Chen was born probably during the 1460's in the
city of Suzhou. His neighbor, Qian Xian (1406-1496), was a
professional painter who had earlier been honored at court,
and it was from that experienced master that Zhou learned
his trade. Although Zhou Chen must have known Shen
Zhou (cat.12) and is reported to have collaborated with Shen
on one painting, his most usual style of painting was not
based on that of the Yuan dynasty literati masters favored by
Shen but rather on that of the earlier academic tradition: "In
painting landscapes he followed various masters of the Song
and Yuan dynasties but those he modelled on Li Tang were
the best. His brushwork was hoary and evocative of antique
elegance. While his work was short on sleek refinement, the
canonical forms of the ancients were all present." It is in fact
this conscious revival of especially the style of Li Tang that
distinguishes Zhou's style from those of other professional
painters, whose models were more often the masters who
immediately preceded them.

By around 1500 Zhou Chen was well established as a
painter in Suzhou and most of his extant paintings were pro-
duced during the following three and one-half decades until
1536, the date of his latest recorded painting and presumed
year of death. During this period Zhou Chen trained a num-
ber of students, the most important of whom were Tang Yin
(cat.16), Qiu Ying (cat.17), and Shen Shi. The latter artist, who
specialized in working in older styles, later moved from
Suzhou to live in Nanjing. According to Wang Shizhen (1526-
1590), Zhou Chen too worked in Nanjing on at least one
occasion: "In the beginning of the Jiajing era, when Zhou
Chen's paintings were at the height of their fame and Yan
Song [1480-1565] was in the Nanjing Ministry of Personnel,
Yan often asked Zhou to let him have some paintings, but
Zhou did not usually comply. It went so far that Yan ordered
one of his subordinates to go to Zhou and threaten him with
imprisonment. The pressure did not decrease until after
Zhou requested someone to intervene. Still, Yan forced Zhou

to go to Nanjing where he did two months of painting. Yan
paid nowhere near the value of the paintings, and Zhou
went home crushed." Since Yan Song served in Nanjing as
head of the Ministry of Personnel between 1533 and 1536, it
was most likely then, very late in Zhou's life, that he was
coerced by Yan to paint for him.

A majority of Zhou Chen's extant paintings are large
hanging scrolls done in his creative transformation of the Li
Tang style. His "Illustrations to Historical Tales" manifest his
later style and show also the kind of historical painting for
which he was admired by his contemporaries. In pre-Song
painting such illustrative works were the norm, but already
by the late eleventh century the inability of painters to work
in that style was decried by Mi Fu (1051-1107). During the
Ming period the notion that painting could and should pri-
marily be a vehicle for personal expression was widely
accepted, which led to a decrease of interest in subject-matter
for its own sake. In Zhou Chen's illustrations here, well-
known historical and literary themes are depicted using firm
brushwork and strongly textured strokes that derived from
an appropriately earlier period, yielding a visual harmony
between means and ends. Zhou Chen's classicism must have
been appreciated by the Suzhou literati, and he painted for,
and his paintings were inscribed by, such high officials as
grand secretaries Wang Ao (1450-1524) and Li Dongyang
(1447-1516). Colophons by calligraphers such as Zhu
Yunming and by other painters such as Tang Yin, Xie Shichen
(cat.22), Wen Zhengming (cat.15), and many of Wen's follow-
ers, also grace Zhou Chen's paintings, but virtually all of
them reflect on the creation rather than on the creator.

Beyond mid-century a change in critical taste led to re-
evaluation of even the art of Zhou Chen. According to Zhan
Jingfeng (1528-1602): "Suzhou men hold that Zhou Chen's
style approximates that of an artisan and thus denigrate him,
while those who understand painting still today place him in
the highest category. From Wen Zhengming onward, painters
in Suzhou sought softness and pleasantness, pursuing the
'eyes of the time' with delicate attractiveness, while Zhou
Chen modelled his paintings on those of the ancients..."

Catalogue No. 15.
**Wen Zhengming** (1470-1559)
*Pincha Tu*, "Tasting Tea"
Hanging scroll, ink on paper, 136.1 x 27 cm.
Inscribed, signed, and dated to the year 1534 by the artist
Artist's seals: *Zhengming*; *Zhengzhongfu Yin*; *Hengshan*

On April 7, 1534, the artist Wen Zhengming lay ill at
home in Suzhou, lamenting that, although the tea harvest
was in, he was unable to join his friends on an outing to one
of the local tea-producing areas. However, a thoughtful
friend brought back several types of tea for Wen to enjoy.
According to his inscription here, Wen then had "water
drawn from a spring and the tea brewed for him to sip, paus-
ing to evaluate its quality and to enjoy the feeling of quiet
seclusion..." The fundamental basis for the painting was thus
autobiographical: the artist portrayed himself seated in med-
itative solitude within his austere, grass-roofed studio. In a

smaller room placed at right angles to the first, a single servant carefully brews the new tea for his master to savor. The building, which is framed by a variety of deciduous and evergreen trees, is the artist's well-known "Jade Musical-stone Mountain Cottage," built after Wen's return from Beijing in 1527, and so called because its L-shape approximated that of a sounding stone and because its isolation was akin to that of the musical instrument when suspended.

The high mountains appearing in the painting are not found in the Suzhou district but appear here as visual barriers which limit the spatial recession and ensure that attention remains focussed on the scene below them. Another radical departure from naturalism is the total absence of color. These and other manipulations of natural appearance act to distance the scene from the immediate experience which inspired it. Wen's inscription records that while sipping the freshly-prepared tea he spontaneously thought first of the great Tang dynasty connoisseur of tea, Lu Yu (d.804), and then of the cycle of poems written by Lu on the subject of tea utensils. Wen's initial experience thus included historical and literary associations which could not be portrayed directly. His own separation in time and space from those aspects of his inspiration could be suggested only obliquely through the abstract or formal properties of the painting. Wen wrote "so as to manifest my inspiration of the moment, and then leisurely painted a small picture on which this is recorded." The painted image is thus rich in historical, art-historical and literary associations and allusions, while functioning simultaneously as a record of a specific event and a manifestation of a restrained and highly disciplined personality.

Wen Zhengming, originally named Wen Bi, was born in Suzhou in Jiangsu province. His long life is well documented by the inscriptions on his many hundreds of extant and recorded paintings and calligraphies and also by a number of biographies, the most important of which was written by his second son, Wen Jia (cat.19). Wen Jia mentioned first the scholarly tradition of the Wen clan and then his father's study of classical literature with Wu Kuan (1435-1504), Zhu Yunming (1460-1526), and Yang Xunji (1456-1544). Next he recorded Wen's study of calligraphy with Li Yingzhen (1431-1493), and finally his friendships with Du Mu (1459-1525), Tang Yin (cat.16) and Xu Zhenqing (1479-1511), known then mainly as poets. What the son, and undoubtedly Wen himself at the time, considered significant were only those subjects and people pertinent to his preparations for the examinations and for an official career. In view of Wen's subsequent life, conspicuously lacking in Wen Jia's account is mention of Shen Zhou (cat.12), Wen's teacher in painting.

In 1485, after nearly twenty years of study and association with some of the finest scholars of the day, Wen went to neighboring Nanjing and took the district examination. He failed, a result that was to be repeated nine times by the year 1522. By the time Wen was in his early 30s his closest friends had all achieved some degree of success in the examination system. While continuing to take the examination himself, Wen devoted even more attention to his study of ancient literature and of painting and to his earliest students. During the first decade or so of the sixteenth century Wen painted more frequently and established a majority of the visual and formal themes he would pursue and develop during the following half century. Wen Jia noted: "As my father's years gradually increased, his name became increasingly well-known. He met people from throughout the empire and these were mainly notables who all revered and stood in awe of him..."

In 1514 when Wen was approached by an emissary from Zhu Chenhao (d.1521), an imperial prince enfeoffed as the Prince of Ning, he adamantly refused the invitation and accompanying gifts, and thus earned admiration for his foresight when the prince openly rebelled in 1519. In 1522, after Wen had failed the examination in Nanjing for the tenth time, the governor of Jiangsu province recommended him for appointment at court at least in part as reward for his loyalty in refusing to serve the Prince of Ning. In 1523 the fifty-three year old novice was appointed to fill a vacancy in the prestigious Hanlin Academy. Wen complained from the beginning about the cost of living in the capital – "My official position is low; my salary is small. I cannot support myself. I am afraid I cannot stay very long," according to a letter written home in 1523 – and he had been forced to borrow money in order to buy a house in anticipation of his wife's joining him. Those financial concerns can only have exacerbated Wen's obvious difficulty in accommodating himself and his personal principles to the realities of power politics. His ultimate solution was to submit the first of several requests for leave to resign and return home, which he finally did in the spring of 1527, with his desire for an official career at an end.

On reaching home again Wen built the "Jade Musical-stone Mountain Cottage" to the east of his main residence and spent most of the remaining thirty-two years of his life working there. These were not restful years of retirement, however, but the busiest of Wen's life. Requests for Wen's writing, his calligraphy, and his paintings poured in from the four quarters of the empire, and Wen responded to them with unceasing vigor and care. There were some notable exceptions to this seemingly easy accessibility. First were the feudatory princes, members of the imperial family who, like the Prince of Ning, controlled at times semi-autonomous fiefdoms. Another group with which Wen tried to avoid all contact was that of high officials; merchants too had difficulties with him, or at least those who approached him so rudely as one recorded by Huang Zuo, a friend of Wen from his Beijing days. When a wealthy merchant offered Wen a cash payment of ten taels of gold for a painting, he was rebuffed with the statement: "I am not an artisan-painter; don't insult me like this!" Wang Shizhen (1526-1590) mentions four "eastern barbarians" (i.e. Japanese) who "presented gifts to the attendant for the Suzhou district [most likely to find out where Wen lived]. Looking toward the master's house they made obeisance and were very disappointed when they did not see him." This last story seems to have given rise to the idea that Wen refused to work for foreigners, but Wen Jia wrote rather proudly that his father's work was treasured even in distant Japan, and Wen Zhengming himself mentioned Japan in a poem, written on a painting done in 1543, and seems to have harbored no special animosity toward non-Chinese.

The biographies of Wen written by Wen Jia and Wang Shizhen differ somewhat in their presentation of Wen's post-Beijing years. While both accounts suggest that a screen of sorts existed between Wen and the outside world, the nature

of that filter changed over time. Wen Jia, writing as a member of the household, states explicitly that Wen's wife managed the economy of the household. "By nature my father scorned worldly affairs, so family business was all entrusted to my mother. She managed the two and three-year periods of mourning after deaths as well as the marriages for sons and daughters, the building of houses, and the buying of land, without giving the slightest anxiety to my father. He was thus able to concentrate his thoughts on literary studies and to pursue his high-minded goals. My mother was truly a help to him in this..." While this account of the working of the Wen household is somewhat idealized (Wen's letters to his sons from Beijing show that he was in fact concerned with the smallest details of the household) it does accord with the image that Wen presented to the outer world, as well as suggest the managerial role played by his wife. Madame Wu was born in 1470 and hence was the same age as Wen himself. Until her death in 1542 she may well have been the one who collected payment for the paintings and calligraphies Wen's visitors received from him. As Wen wrote to his sons from Beijing after being away from home for four months: "You can imagine why I made the decision to ask my wife to come up here; otherwise life is too difficult for me..."

Wang Shizhen, being younger and meeting Wen only after Madame Wu had died, described a system which must have evolved after her death: "All those who wished to get something from the master, but judged they could not, would buy at high prices from his direct students, his old friends, and his relatives by marriage. Of the master's calligraphies and paintings which are found throughout the empire and beyond the seas, often not even one in five is genuine, so those who lived around his house in Suzhou were enriched by his hand for nearly forty years." Given a situation where forgeries abounded, many collectors would prefer to pay more for a work which had a good provenance and came, if not directly from Wen, then at least from someone close to him. In distributing his work by this means, Wen could in addition help members of his extended family. As Wen Jia wrote: "To old friends, his children, and also to impoverished relatives he gave a great deal of assistance."

Another important activity of Wen's later life was the authenticating of antiques and especially early painting and calligraphy. Wen's training as historian, as connoisseur, and as artist made him an ideal choice of collectors seeking confirmation of purported value. Yet Wen had his own values, and at times these resulted in decisions to the disadvantage of the collector. In one instance recorded in the *Huangming Shishuo Xinyu*, Wen judged some paintings and calligraphies to be genuine when in fact they were not. He explained later: "All those who buy paintings and calligraphies are those with plenty to spare. This man is destitute and must sell the things before he can even light a fire [for cooking]. If I obstructed him with even a single word, his whole family would suffer difficulty."

A natural extension of Wen's historical interest led him into collecting, where his skill as a connoisseur allowed him to compete with those having far greater resources. Like any collector, Wen at times sold from his collection to his own advantage. Zhan Jingfeng (1528-1602) wrote at some length about a famous piece of calligraphy, the *Autobiography* written by the Tang monk Huaisu (737-ca.785), that was owned by Wen. A friend of Zhan had received some favor from Prime Minister Yan Song and wanted to buy the scroll in order to present it to the official. Two friends of the collector were deputed to "first deliberate with Wen and decide at what the scroll was to be valued. The two men set this at one thousand taels. Luo [the collector] thereupon sent a thousand taels and when Wen received it he set aside one hundred taels for the 'old age' of the two men." More important here than the obvious conflict of interest on the part of the two agents is the fact that the calligraphy itself (though not the colophons) was not genuine, or so Zhan was told later by another pupil of Wen who had discussed the problem with Wen Peng, Wen's eldest son. Peng, who at the time was making a copy of the Huaisu calligraphy for yet another collector, was said to have declared: "Genuine or fake – how does that concern me!" Some idea of the monetary values involved here can be gained by noting that Wen Zhengming's own paintings sold for between one tael, the most expensive hanging scroll then on the open market according to Zhan, and ten taels, the amount offered Wen directly by the unsubtle merchant for a painting. The one-thousand-tael price for the calligraphy was thus not cheap for even a genuine work, and outrageous for even the best of fakes. On the other hand, the purchaser of the scroll, collector Luo, wanted the scroll not for himself but for presentation to an official in payment for a political debt. The powerful and unscrupulous prime minister, who also owned no fewer than 110 paintings by Wen Zhengming himself, was not a connoisseur and was probably as satisfied with the copy as he would have been with the original. Wen Jia said of his father: "He did not talk about ethics but spoke only of purity of action." That is to say, Wen Zhengming was not concerned about abstract ethical principles but rather about the rightness of given actions in specific contexts; it was "right" to authenticate fakes when the action benefitted a needy family and equally "right" to send a fake to an unscrupulous man who collected not by eye but rather by ear.

Wen Zhengming was thus a very complex man. All of his biographers admired him tremendously and echo in one way or another the son's judgment that "in all ways he was superior to ordinary men." He must also have been a somewhat difficult man, for he became estranged from both Tang Yin (cat.16) and Chen Daofu (cat.23) and was sued by his nephew Wen Boren (cat.20). Even the son's analysis of Wen's character, which must have placed obvious characteristics in the best light possible, does not suggest a man easy on himself or on those closest to him: "Throughout his whole life my father was most strict about distinguishing between what was right and what was of advantage... If someone made a mistake he never once confronted him with criticism, but if that someone saw my father he was abruptly nervous, ashamed, and perspired continuously without speaking..." The self-discipline and utter self-control suggested by Wen Jia's account continued until the very moment of Wen's death at the age of eighty-nine. Wen had just finished a piece of writing for someone, laid down his brush, sat up straight, and passed away. The son's final comment: "My father always said of a man's life in the world that if he serves as an

official there is only going out to take office, advancing, and retiring; if he stays at home there is only filial and fraternal piety, loyalty, and faith. Today, after examining his life with care, I truly cannot add to his words."

Catalogue No. 16.
**Tang Yin** (1470-1523)
*Shiming Tu*, "Serving Tea"
Handscroll, ink on paper, 31.2 x 105.8 cm.
Inscription: "When days are long and you wonder what to do, lift up high your tea-bowl; perhaps, through a southern window, a pure breeze will fill your hair. Tang Yin of Wuqu."
Artist's seals: *Wuqu; Tang Bohu; Tang Jushi*
Collectors' seals: Geng Zhaozhong (1640-1686), the Qianlong emperor (r.1736-1795), the Jiaqing emperor (r.1796-1820), the Xuantong emperor (r.1909-1911)
Title: written by Wen Zhengming (1470-1559)
Colophon: the *Shiming Bian*, "Discussion on Serving Tea," written in 1535 by Lu Can

The essay by Lu Can which is now appended to Tang Yin's painting was not written until 1535, thirteen years after the painter's death. Since the title written by Wen Zhengming (cat.15) was clearly inspired by the essay, it was probably added to the painting at the same time as the essay.

In the painting two dark masses of earth frame the narrative portion and function as repoussoirs which thrust the idyllic pictorial world back and away from the mundane world of the viewer. Within that protected enclave, in an unpretentious yet ample establishment, sits a scholar at his desk. His book has been moved to one side and he no longer reads but sits in meditative posture with hands in sleeves. In the kitchen to the left a servant fans a charcoal fire in anticipation of preparing more tea to serve the approaching guest, whose servant carries a covered lute. The style of the painting manifests Tang's knowledge of the style of painting begun in the tenth century by Li Cheng, continued in the eleventh by Guo Xi, and known thereafter as the Li-Guo school style. Featuring contorted pines, strong contrasts of light and dark, and graded application of wash to create solid form, the style had been revived in the fourteenth century and developed further in the fifteenth by such artists as Dai Jin (cat.6). The pines here in fact resemble quite closely those appearing in a painting by Dai which bears a colophon written by Tang Yin, the handscroll entitled "Six Patriarchs of the Chan Sect." The bulbous shapes of rocks and peaks appear in paintings by such Yuan followers of the Li-Guo school as Li Shixing and Li Sheng, while the more calligraphic, scribbly texturing of those forms is characteristic of artists closer in time to Tang Yin, painters such as Wu Wei (cat.7), whom Tang very likely knew. Most distinctive in Tang's painting are the delicacy of touch, the great richness of ink textures and tonalities, and the restrained though highly skilled drawing of the figures. The texturing appears to be the unusual yet highly attractive result of blending the so-called "ax-cut" strokes associated with Zhou Chen (cat.14) with the longer "hemp-fiber" strokes of Shen Zhou (cat.12).

Tang Yin was from Suzhou, the son of a man who ran a drinking and eating establishment in the town. The father was determined that his son would rise in life and thus hired a tutor to see to his education. Tang proved to be brilliant but undisciplined, prompting his father to lament: "This boy will certainly become famous but it will be difficult for him to be successful." By the mid-1480s Tang had met Wen Zhengming, ten months his junior and his near opposite in temperament. Tang easily passed the first-level examination, made friends quickly with such as the calligrapher Zhu Yunming (1461-1527), and so impressed Wen Lin (1445-1499), Zhengming's father, that he introduced Tang to all his friends, to men such as Shen Zhou and Wu Kuan (1435-1504). Tang was already painting by 1486 and here too he progressed rapidly and seemingly with no effort. Tang's greatest fame at the time was for writing, and already in his twenties he received commissions for various types of commemorative texts. Notice of his marriage around 1486 completes a picture of an immensely talented young man with no limit to his potential for accomplishment.

The first serious blows to Tang's happiness and security came in 1493-94 when his father, his wife, his younger sister, and his mother died in rapid succession – the sister by suicide – leaving only Tang Yin and a younger brother. The emotional stress was such that Tang Yin's hair turned white and he apparently drank far more heavily than before. His good friend Zhu Yunming counselled him that he had to work if he wanted to achieve the goals he had set earlier; otherwise he could burn his books. Tang spent the next year in serious study and, in the provincial examination of 1498 held in Nanjing, took first place and henceforth used a seal bearing the legend "Number One at Nanjing." Wen Zhengming, who failed the same examination, may have been comforted by his father's prophetic words: "Given Tang Yin's talent it is right that his name was posted as number one, but as a person he is frivolous and unstable, and I am afraid that in the end he will achieve nothing. You, my son, will go far on another day and he will be unable to match you."

In 1498 Tang travelled to Beijing for the metropolitan examination, the third and final barrier to the highest realms of officialdom. After the death of his father Tang had little money and hence travelled to the capital and lodged while there with a wealthy Suzhou acquaintance, who was scheduled to take the same examination. Tang's reputation had preceded him and virtually everyone, including the examiners, expected him again to take first place. Tang and his friend were accused of prior knowledge of the questions, however; they and the chief examiner were arrested, tried, and convicted, though there is now little reason to think that Tang Yin was guilty – his sheer brilliance would seem to preclude any necessity to cheat. After around three months in jail, Tang paid a fine, was officially degraded to the lowest level of menial underling, and released. Declining an insulting offer of a job in Zhejiang province, Tang returned home in disgrace in 1499, with no hope of ever becoming an honored scholar-official.

The drastic change in Tang's expectations had immediate social repercussions. True friends such as Zhu Yunming and Wen Zhengming held firm, while others shied away from association with him. Tang himself reacted badly to the dis-

appointment and began drinking heavily again; he also divorced his second wife and alienated his younger brother who left the house to live independently. It is likely that Tang's immediate family and such close friends as Wen Zhengming were those to whom Tang had turned when in desperate need of money to pay his fine, and this may have exacerbated already strained relations. Tang's changed expectations also meant that he needed some immediate means to earn a living. Talented and already experienced in painting, he determined to sell paintings as well as his writings for his living and, around 1500, associated himself with the ranking professional painter of Suzhou, Zhou Chen. If Tang Yin learned the potential for self-expression through brushwork from Shen Zhou, he learned from Zhou Chen certain types of compositions and, more importantly, the brush schemata featuring ax-cut texture strokes that was associated with the name of the Song master Li Tang.

Tang Yin seems to have been moderately successful as a professional painter but spent his earnings freely and was often in debt. His production appears to have been determined largely by the immediacy of his need. For example, in 1505 Tang created a studio for himself on the Peach-blossom Embankment in Suzhou, using borrowed money. Between 1505 and 1509 Tang's paintings increase dramatically in number before falling off again around 1510. It was probably not until after around 1515 that Tang Yin's paintings came to be valued more highly than his writings; in 1512 it was his calligraphy that was requested by a Japanese visitor.

The relationship between Tang and Zhengming had continued to deteriorate, and around 1513 Tang wrote a letter to Wen that is sadly moving in its evocation of the distance that had come to separate the childhood friends: "... Although I am ten months older than you, I am willing to emulate Confucius [who also learned from those younger than himself] and take you as my teacher. I humble myself not just with words but also in my heart. In poetry and painting I can compete with you on an equal basis, but when it comes to scholarship and moral conduct I cover my face and leave. In studying with you I seek only one corner of the common seat so as to clarify my heart and not out of arrogant self-regard..."

In 1514 Tang Yin was invited to the court of Zhu Chenhao, an imperial prince based in Nanchang. The invitation was extended by a special messenger sent to Suzhou with a hundred taels in gold for Tang's travelling expenses. Wen Zhengming and Guo Xu (cat.13) were also among the many talented men invited by the Prince of Ning, but Tang Yin was one of the few who accepted. After around six months of residence and service on the prince's staff, Tang concluded that the prince intended to rebel against the throne; he extricated himself from this dangerous situation by feigning madness. Complaining, "Who said that Scholar Tang was worthy – he is only a crazy student," the prince sent Tang Yin home, where he was when the prince revolted openly in 1519, to be defeated in a forty-three day campaign led by the philosopher-soldier Wang Yangming (1472-1529).

During the final phase of Tang's life in Suzhou he became so famous that events from his life as well as fabricated associations began to be spun into the myriad stories and legends still told today about him. Tang's own writings attest to the number of people seeking his paintings, but note that despite low prices his actual cash sales were few. His poems betray little resentment of his situation and even suggest some measure of satisfaction with his ultimate lot, for example:

"My calligraphy, painting, and writing are not good at all, but it happens that the means for my livelihood lie within them; I would like to refuse pecks of grain but bags of cash are few, and even the grain can save me from a day of poverty."

By the time Tang died in 1523, probably of a lung ailment, he had fully lived up to his self-characterization as "The Number One Romantic Talent South of the Yangtze River."

Catalogue No. 17.
**Qiu Ying** (d.1552)
*Taocun Caotang Tu*, "Thatched House in the Peach-blossom Village"
Hanging scroll, ink and color on silk, 150 x 53 cm.
Inscription: "Made for Mr. Shaoyue by Qiu Ying, called Shifu."
Artist's seal: *Shizhou*
Colophons: on the painting by Xiang Yuanbian (1525-1590), on the mounting by Dong Qichang (1555-1636), and two others
Collectors' seals: Xiang Yuanbian, Geng Zhaozhong (d.1686), Liang Qingbiao (1620-1691), the Qianlong emperor (r.1736-1795), and Xu Shixue (modern)

Qiu Ying was born in Taicang but moved at an early age to Suzhou, where he lived and worked for the rest of his life as a professional painter. Born into very humble circumstances, Qiu lacked formal education and seems to have learned his cultural heritage mainly through association with the Suzhou artists and collectors who formed his circle of friends, peers, and patrons. The dates of Qiu's birth and death were not given by his early biographers and, since Qiu himself dated only a few of his paintings, his chronology is still best determined by consideration of the inscriptions written by Qiu's contemporaries on his paintings. These suggest that Qiu Ying died in 1552 or early the next year, possibly at an early age. Recorded and extant paintings with colophons by the Suzhou literatus Wu Kuan (1436-1504), by the calligrapher Zhu Yunming (1461-1527), and by the painter Tang Yin (cat.16), place Qiu Ying in Suzhou and as a practicing artist by around the turn of the century, leading some scholars to estimate Qiu's date of birth at around 1494, or ten years before the death of Wu Kuan. Qiu Ying's chosen byname, which appears on seals of even his earliest paintings, was Shizhou, or "The Tenth Region," a reference to the land of the Daoist immortals which lay apart from the nine traditional regions of China proper. Those who find it incongruous that a ten-year-old would present himself as from the land of the immortals might postulate an earlier birthdate for Qiu, but it is also possible that Qiu's byname, like the "Small Immortal" sobriquet of Wu Wei (cat.7), was given him by an older admirer of his art. In any case, Qiu clearly manifested his great talent for painting early on and became the pupil of

Zhou Chen (cat.14), the major professional master in Suzhou during Qiu's youth. Qiu's period of apprenticeship would logically precede his earliest paintings done as an independent artist and would thus fall immediately before and after the year 1500. Tang Yin, who was also associated with Zhou Chen around 1500, may have met Qiu Ying at that time and subsequently introduced him and his transcendent talent to such Suzhou luminaries as Wu Kuan, Zhu Yunming, the poet Wang Chong (1494-1533), and Wen Zhengming (cat.15).

Wen Zhengming and Qiu Ying met at least by 1517, for in that year Wen requested Qiu to add color to a figure painting Wen had just completed. While this suggests that Qiu's technical expertise was superior to that of Wen, Qiu's several attempts did not satisfy Wen, who in the end colored in the painting himself to accord with his own developed taste. Collaborative efforts between the two artists increased following Wen's return from Beijing in 1527, with Wen displaying his calligraphic skills in writing out texts that were illustrated by the master painter Qiu Ying. The range of Qiu Ying's styles and subjects is as impressive as the great technical proficiency with which he executed all his commissions. These included requests for facsimile copies of older paintings as well as for freer versions of traditional themes. Some of the newly-rich Suzhou merchants regarded paintings as among the proper accoutrements of their new stations, while older families, those whose hereditary wealth was based mainly on their holdings of land, were increasingly forced to divest themselves of old and treasured works of art. For the first group Qiu provided paintings of classical subjects done in wondrously classical styles; the mere possession of such works would have served to associate their new owners – in their own minds at least – with the great collectors of the past, all at a fraction of the cost of a genuinely antique painting. Qiu's facsimile copies, on the other hand, may well have been created for the true collectors of the age, commissioned by a seller as remembrance of a scroll unavoidably let go, by a buyer as an inducement for a collector to sell, or by a collector who feared the unrefusable demands of those in high positions. It is worth noting that Qiu Ying's most active period as a painter corresponded with the time when Yan Song (1480-1565) was using his political power to build up a very large collection of paintings, which raises the possibility that some of Qiu's copies may have been left unsigned and were actually intended for submission to the capital as antique originals.

The close relationship that existed between Qiu and his major patrons is suggested by the fact that he lived, according to Ellen Johnston Laing, with at least three of them for several years each: Chen Guan perhaps in the late 1520s, Zhou Fenglai in the late 1530s and early 1540s, and Xiang Yuanbian during the later 1540s. Xiang, the best known of the three, was a passionate collector whose major source for new material was the pawnshop he operated as part of the family estate. Xiang's collection and facets of his character were described by Xie Zhaozhi (1567-1624) in his *Wuzazu*: "In Master Xiang's collection are... priceless, out-of-this-world jewels... Involved with the world, he was rich and influential, one who did not begrudge high prices when buying [works of art]. Thus what had been collected and treasured by the old families of Jiangnan all entered his hands. In the world of

business he could be close, mean, miserly, and stingy, but within his home he was expansive..." During the several years Qiu Ying lived with Xiang he was able, according to Xiang's grandson, to see more than one thousand Song and Yuan paintings. Xiang clearly appreciated Qiu's approach to painting, for in addition to the paintings he got directly from Qiu he continued to acquire Qiu's paintings until he owned around one hundred scrolls. These were available for study by Dong Qichang (cat.15) when he entered Xiang's household as a young tutor. In his *Huachanshi Suibi* Dong traced Qiu's artistic lineage back to the Tang dynasty progenitor of the courtly style of painting and then noted: "Five hundred years later there were Qiu Ying and Wen Zhengming, who constantly praised and yielded to one another. In this style of painting Wen could not but yield to Master Qiu, and this was not praise intended to increase the value [of Qiu's paintings]. And when Qiu Ying was painting his ears did not hear the sounds of drums and pipes, of shouting and of hooves, for his art was that intense. I had lived for fifty years before I understood that it is definitely not practical to study this style of painting. Comparing [this approach] to Chan [Zen] Buddhist meditation, one would have to accumulate eons of time before becoming a Bodhisattva..."

That Dong held Qiu's approach to artistic creation unsuitable for himself did not prevent him from appreciating and enjoying Qiu's works; the present "Thatched House in the Peach-blossom Village" bears a colophon on its mounting by Dong that once again praises Qiu at the expense of Wen Zhengming: "Qiu Ying's copies of Song paintings can all be confused with the originals. Those among them in which he studied Zhao Boju especially manifest his ability to surpass his models. Even Wen Zhengming must yield, unable to match him..." Qiu's own inscription at mid left reads: "Made for Mr. Shaoyue by Qiu Ying, called Shifu." The intended recipient was thus Xiang Yuanqi, called Shaoyue, who was the eldest brother of Xiang Yuanbian. However, that insatiable collector was not to be denied yet another prize, and Xiang Yuanbian's inscription which appears just below that of Qiu suggests that the elder brother gave up his painting at some point: "Respectfully treasured by your youngest brother, Yuanbian." A seal reading *nian* placed at the extreme lower right of the mounting is a registry seal of Xiang Yuanbian. His storage was arranged on the basis of a version of the *Qianzi Wen*, the "Thousand Character Classic," that he owned. In that text each of one thousand individual characters appears only once, so the position held by the character *nian* in the text could be used to indicate where "Thatched House in the Peach-blossom Village" was to be placed in storage.

Qiu's painting, which is perhaps intended to present Xiang Yuanqi as inhabiting the mythical paradise of the Peach-blossom Village, is organized around the frame of the picture, with the forms anchored visually to the border and projecting inward. This type of composition had been used to similar effect by Wen Zhengming during the 1530s, but here, probably during the later 1540s, Qiu Ying constructed the picture with forms which are realistically detailed and skillfully modelled in ink before being overlaid with strong mineral pigments. This last characteristic supports Dong Qichang's judgment that Qiu Ying was a "reborn Zhao

Boju," for Zhao had been the foremost Song dynasty practitioner of this courtly style of painting. Qiu Ying advanced this tradition in paintings which embody to near perfection the classical ideals of balance, emotional reserve, rationality, and high technical proficiency.

Catalogue No. 18.
**Lu Zhi** (1496-1576)
*Huqiu Shan Tu*, "Mount Huqiu (Tiger Hill)"
Hanging scroll, ink and color on paper, 147.5 x 34 cm.
Inscription:
"The Golden Gate is ringed by ranges of peaks,
embraced by walls, one hill aslant;
springs drop to fragrant pools of snow,
    flowers brighten ornamented walls with sunlight.
Sword-like rays float on precious palaces,
    pagoda shadows purify golden sand;
for myriad *kalpas* of time in the heavens above,
the lofty empyrean will embrace
    kingfisher-blue royal pennons.
Lu Zhi from Baoshan."
Artist's seals: *Lu Shi Shuping*; *Baoshanzi*
Collector's seals: two of Qin Ziyong (1825-1884)

In the artist's poem the Golden Gate, or Jinchang in Chinese, refers to the Golden Gate Pavilion which originally stood outside one of the gates in the wall enclosing Suzhou. Jinchang later came to stand for the city itself, 'ringed by ranges of peaks, embraced by walls, one hill aslant.' The pagoda visible here is another characteristic feature of the city. The suggestion in the poem of royal splendor during some bygone era is intended to evoke the name and memory of King Helu, who established his capital in Suzhou and ruled there from 514 to 496 B.C. King Helu built the famous Gusu Tower in the city, and Suzhou was thereafter often referred to by that name. When he died, King Helu was buried on a prominence outside the Chang city gate; three days later a white tiger was seen crouching on the summit, hence the peak was called Huqiu Shan, or "Mount Tiger Hill," the conventional title of the present painting. The poem thus creates an image of the vanished glories of a Camelot-like city, an image sustained in the painting by the very high and distant viewpoint from which the viewer looks down on a city only partially visible and mainly inaccessible. The sensitively drawn, dry-brushed lines appear fragile and cast a transitory mood over the whole. Light and color are modulated to suggest the setting sun of a late afternoon, a time of reflection which evokes the nostalgia that is a major theme of the painting. The main stylistic features – the angular, faceted forms out of which the mountains are constructed, the dry-brush drawing, and the general air of elegant refinement – carry art-historical connotations which evoke the name of Ni Zan (1301-1374), the great Yuan master whose style was most influential on the present artist.

Lu Zhi was born in Suzhou, Jiangsu province. He or one of his immediate ancestors spent some time at Mount Bao near the town proper and hence in later years Lu called himself "Son of Mount Bao," or the "Mountain Woodcutter of Dongting," another name for Mount Bao. His father, Lu Ming (1456-1532), was well-educated and had many students of his own but, like Wen Zhengming (cat.15), failed the provincial examinations many times. At the age of sixty-five Lu Ming was awarded *gongsheng* status which allowed him to serve as an assistant teacher until his retirement, four years before his death. His obituary was written by Wen Zhengming. Lu Zhi, Lu Ming's eldest son, seems to have been educated mainly at home and with civil service as his ultimate goal. After a period when his activities earned him description as a "knight-errant," Lu settled down to study and passed the first and lowest of the three examinations. When Lu Ming was serving in Zhejiang province, Lu Zhi seems to have augmented his official rice allowance by working as a tutor. During the early 1520s he was living on the country estate of Chen Jian, the uncle of Chen Daofu (cat.23), by the lake which bore the family name. While Lu may have learned something of poetry from Chen Daofu, he was by that time an accomplished painter and calligrapher; he is said to have studied calligraphy with Zhu Yunming and painting with Wen Zhengming. Wen and Lu knew each other well, and Wen's colophons appear not infrequently on Lu's paintings, but Wen never refers to Lu as his student and Lu's usual mode of reference to Wen, "Mr. Wen the Academician," was correct and polite but distant. It seems that Lu was strongly influenced by Wen's painting style, especially during his early years, but was not an intimate member of Wen's circle of friends and followers.

Following the death of his father in 1532, Lu Zhi became head of the family and responsible for five minor dependents. He was also obliged to study for and retake the provincial examination at regular intervals, but throughout the 1530s and '40s he continued to paint and gradually matured as an artist. One indication of his associations during this period was recorded by Wen Jia (cat.19) in 1574: "On New Year's eve of the year 1543 (i.e. on January 23, 1544 of the solar calendar) I visited the house of Master Qiu Ying [cat.17] together with Wang Guxiang and Lu Zhi. Qiu showed his painting of Zhong Kui to Wang Guxiang, who praised it and would not give it up, so Qiu gave it to him. Lu Zhi too became inspired and added a background for the figure. We took it to show my late father, Wen Zhengming, who laughed with delight on seeing it and thus inscribed it..."

Lu's ever-increasing impatience with the constraints placed on his life by his government stipend was manifested in a series of petitions he submitted from 1553 onward requesting permission to resign. Finally, in 1557, he accepted appointment as a *gongsheng* with the understanding that he would be allowed to retire at once, which he did. That formal end to Lu's forced pursuit of bureaucratic status was preceded not only by his emotional withdrawal from the quest but also by his physical move to live in retirement at Mount Zhixing, west of the city of Suzhou. Zhixing, famed since antiquity as the home of the monk Zhidun (314-366), appears in Lu's inscriptions from at least 1550 onward. During the 1550s Lu made several fairly extensive trips – one to Nanjing, another to near Xiuning in Anhui province – but for the most part remained in his retreat at the foot of the mountain.

The most complete picture of Lu Zhi's life at Mount Zhixing is given by Wang Shizhen (1526-1590), who knew Lu

from the mid-1560s onward: "Lu's cottage was at the base of Zhixing. Cloudy mountains surround his land on all sides and flowing streams appear within. The fields are fertile and the threshing area broad, and the land is also suitable for an orchard. The gate of his humble house was so low it would not admit a carriage, but outside his cramped quarters everywhere there were the chrysanthemums famed in art, as many as several hundred thousand of them. The others were rare flowers and trees ordered from such far distant places as Yunnan and Guangxi, sent while they were still young and flexible, and planted, watered, and pruned by his own hands. He truly mastered the characteristics of their seasonal cycles. When a good friend came by he was received in the arboretum. Lu would produce enough home-brewed wine, sliced honeycomb, steamed bamboo shoots, and freshly caught fish to fill the table. Elegant conversation and songs would continue for the entire day and the guest would be unable to leave..."

Lu's idyllic life, which invites comparison with that of the most famous chrysanthemum fancier, Tao Yuanming, was threatened in his later years by uninvited and unwanted guests, especially after Lu's fame had been spread by his appearances as the honored guest at two Suzhou festivals in the late 1560s and early '70s. Wang Shizhen noted: "If the visitor were not the right kind of person and tried to force his presence, Lu would use a stone to block the gate and warn the servant to ignore any knocking."

All of Lu's biographers agree that he was very poor after moving to Mount Zhixing but that his motivation for painting was never economic gain. "When requested by a noble or official to do paintings for him, Lu declined very substantial gifts by saying: 'I paint for those who understand me – not because I am poor.'" It was thus also said of Lu's paintings that they "absolutely could not be obtained through compulsion, but if one did not insist they could perhaps be obtained."

Catalogue No. 19.
**Wen Jia** (1501-1583)
*Pipa Xing Tu*, "Illustration to the Song of the Lute"
Hanging scroll, ink and color on paper, 130.8 x 43.7 cm.
Inscription: "On the last day of the seventh month of the year 1563, Wen Jia."
Artist's seals: *Wen Jia Yin*; *Wen Xiucheng Yin*
Calligraphy: the text of the *Pipa Xing* signed "written by Sancheng, Wen Peng, on an autumn day of the year 1563."

"Illustration to the Song of the Lute" was painted by Wen Jia as a collaborative work with his elder brother. In the upper portion of the paper Wen Peng wrote out the complete text of the *Pipa Xing* composed by the Tang poet Bo Juyi (772-846). Unlike the abbreviated version painted somewhat earlier by Guo Xu (cat.13), Wen Jia here illustrated the climax of the tale wherein the narrator thinks longingly of the pleasures of the capital as he listens with a friend to a former courtesan playing the bent-necked lute while in the provincial region of Xunyang. The theme obviously fascinated Wen; other paintings by him of the same subject are recorded for the years 1558, 1559, and 1569. In comparison to the last work, the present painting is more concerned with pictorial effects, with unifying fore and backgrounds across the river expanse while creating some sense of spatial recession between them. The two paintings are alike in their very sensitive, dry-brush drawing and light washes of color, and they manifest similar manipulations of form for purely expressive purposes. Here the tree trunks thicken and thin in a somewhat unnatural manner and the spatial relations between riverbank and boat are decidedly ambiguous. These and other dislocations and ambiguities remove the scene from direct comparison with reality and create a pictorial world which emphasizes its spatial and temporal separation from the physical world of the Tang story and insists instead on the verities of poetry.

Wen Jia was born in Suzhou, Jiangsu province, the second son of Wen Zhengming (cat.15). Wen Jia and his elder brother, Wen Peng (1497-1573), were given their names by Shen Zhou (cat.12), the grand master of Suzhou painting and their father's teacher. According to a colophon written by Wen Jia for a painting done by Shen Zhou, "When I was five or six years old Master Shen Zhou came to our house and my deceased father requested that he name us. The Master said, 'The two characters *peng* meaning 'strong' and *jia* meaning 'commendable' are characteristics suitable for scholar-officials.' For my father hoped that my brother and I would become literary officials. Now it is more than seventy years later..." As the sons of Wen Zhengming and grandsons of Wen Lin, Peng and Jia were exposed from their earliest years to the highest levels of literati culture in Suzhou. Their education was undertaken mainly at home under the direction of their father but they studied also with Tang Zhen, a Suzhou scholar and poet admired by Wen Zhengming. Although in later years Wen Peng became known mainly for calligraphy and Wen Jia for painting, the *Mingshi* notes that "both were capable in poetry and skilled in calligraphy, painting, and seal-carving." During their formative years their primary artistic teacher and model would naturally have been their father and also, in calligraphy, their father's friend, Zhu Yunming (1461-1527).

Both Wen Jia and Wen Peng passed the first-level examination probably during the second decade of the sixteenth century. Extant letters written in 1523 to his sons by Wen Zhengming from Beijing frequently exhort Peng, Jia, and Tai (the last a third son born somewhat later) to study hard, to improve themselves, and not to fall behind their peers. However, neither Peng nor Jia ever passed any of the upper-level examinations, and it was not until relatively late in life, probably in the early 1560s, that both were awarded *gongsheng* status. Peng then became a lowly assistant director of education in Xiushui, Zhejiang, and was later an assistant instructor in the National University in Nanjing, while Jia served as assistant director of education in Jiangxi and Zhejiang before ending his rather disappointing career as director of studies in Hezhou, Anhui province. The award of this degree and their subsequent academic work took place after the death of their father in 1559, and it was only then that Peng, sixty-two, and Jia, fifty-eight, were freed of Zhengming's powerful influence. Before 1559 the pattern of

their lives seems to have differed little from their father's. Much time was devoted to study and to periodic attempts at passing the provincial examination; leisure was taken in the company of like-minded friends, most of whom were friends and/or students of their father, and collectors.

The degree of Wen Jia's involvement with painting also seems to have been governed by his father's activities. Wen Jia's earliest paintings were done mainly while Zhengming was in Beijing, and they decreased sharply in number after Zhengming's return home. Wen Jia wrote in 1535 that he had not painted at all during the previous decade or so. In 1541 Wen Jia gained his first student in painting, the highly talented Ju Jie (1527-1586), who somewhat later came to the attention of Zhengming and became his disciple. The volume of Wen Jia's paintings increased dramatically after his father died and it was then that he came into his own as an artist.

In 1565 Wen Jia was serving in Jiangxi province as instructor in the local school at Jishui. The possessions of Yan Song (1480-1565), who had served as grand secretary until his ouster in 1562, had been confiscated by the state and were in the process of being inventoried. Wen was dispatched to visit the three main establishments maintained by Yan Song at Nanchang, Yuanzhou, and Fenyi, and to list the calligraphies and paintings kept there. The full inventory was published as the *Tianshui Bingshan Lu*, while Wen Jia's personal notes were published as the *Qianshantang Shuhua Ji* with postface dating to 1569. There is a great discrepancy in the numbers of works recorded in the two texts and some scholars have concluded that in the former work the numbers were exaggerated by Yan's enemies to make his greed appear all the more reprehensible. In fact, Wen's notes are obviously incomplete, for they record only the handscrolls in Yan's collection and none of the hanging scrolls and albums. Even when the same work appears in both texts, Wen's notes for individual paintings differ from the inventory record in at least twenty cases. These shed some light on Wen Jia's abilities as a connoisseur, an area in which he was said by Wang Shizhen (1526-1590) to be the equal of his father. In eight of the twenty cases Wen reattributed the painting to an artist different from that recorded in the *Tianshui* inventory, but the surmised date of execution remained roughly the same; in four cases Wen reattributed a painting to an artist active later than the painter to whom the work was originally attributed; and in a surprisingly high eight out of twenty cases Wen reattributed a painting to an artist active earlier than the person to whom it was originally attributed. In a few of these cases the difference in time was fairly small, an anonymous Ming painting being called by Wen an anonymous Yuan painting, but in other instances the change was considerable: two Song paintings were called Tang dynasty works by Wen, and even two Yuan works were reattributed to the Tang masters Li Sixun and Yan Liben. Wen Jia also had what must have been the interesting experience of inventorying paintings done by his own father, by several of his father's friends and students, and even such works as the famous *Autobiography* calligraphy written by the Tang monk Huaisu that had been sold by Wen's father to Yan Song. Of the last Wen Jia commented: "In my view it seems that the colophons are superior," an opinion which supports the judgment recounted by Zhan Jingfeng (1528-1602) that *only* the

colophons were genuine and the calligraphy itself a tracing copy made perhaps by Wen Peng. The confiscated calligraphies and paintings recorded by Wen Jia did not remain long in government hands but seem to have been sold to two imperial princes, Zhu Xizhong (1516-1572) and his younger brother Zhu Xixiao (1518-1574). The Huaisu calligraphy mentioned above bears a colophon by Xiang Yuanbian (1525-1590), which indicates that he was the next owner and that the price he paid for it was one thousand taels of gold.

When Xiang Yuanbian bought the Huaisu calligraphy it is very possible that he was being advised by Wen Peng or Wen Jia. A number of Wen Jia's paintings from the late 1570s were done for the famous collector, and letters written by Wen Peng to Xiang suggest such a relationship. Wen Peng's comments to Xiang are those of a connoisseur, concerned mainly with authenticity and relative desirability and value rather than art-historical questions, and were obviously written with Xiang's limitations as well as his business needs in mind. Of a bronze horse, for example, Peng noted: "This is Han period, modelled in bronze after the so-called 'heavenly horses.' The craftsmanship is old and fine but there is nowhere you can use it." "'In a Bamboo Grove Playing *Yi*' is an extremely wonderful scroll, and Fang Feng, Tao Zongyi, and Qian Weishan [who wrote colophons] are all famous men. This is really to be coveted! But you don't know the rules of the board-game *Yi*, and I am afraid you will not truly appreciate this scroll's interest. A joke! A joke!" "This calligraphy of the 'Thousand Character Classic' in four script-styles is extremely fine. If divided and made into four separate works, each one could be worth ten taels... Tomorrow or the day after it will arrive at your house for your pleasure and perusal."

Wen Jia resigned from his final post as director of studies in Hezhou, probably around 1572, and spent the last decade or so of his life in retirement. According to Wang Shizhen in the most extensive biography of Wen Jia: "After Wen returned home, those seeking his writing, his painting, and his advice in connoisseurship came on one another's heels. Wen responded to them one by one, but when he became weary and depressed he could not bear up and thus died at the age of eighty-two. Wen was unable to be wholly natural like his elder brother and would analyze and discuss and decide only with difficulty. His eulogy says: 'His studies, his longevity, his skill in art, the lowness of his official rank, and the limited financial resources of his family, all were sufficient to his ambitions.'" Another record of Wen Jia left by Wang Shizhen says that he died at the age of seventy-nine, or in 1580, and only two works dated beyond that year are even attributed to Wen Jia.

Catalogue No. 20.
**Wen Boren** (1502-1575)
*Xueshan Xinglü Tu*, "Travellers Amidst
Snowy Mountains"
Hanging scroll, ink and color on silk, 146.4 x 64.6 cm.
Inscription: "On the fifteenth of the ninth month of the
year 1560, painted by Wufeng Shanren, Wen Boren."
Seals: *Boren; Wufeng Shanren*

Travellers on horseback cross a bridge in the foreground, travelling a snowy trail whose further ascent is marked in the middle ground by a group of horses. The vivid detail and movement of the lower section is accentuated by the massive and austere peaks which rise to dominance above. A series of diagonals, which recede visually as the eye follows their angular, upward movements, support the theme of travel up and through the mountains and, together with the repetitive tree forms, suggest the crisp and clear air of the high mountains. The far distant sky and foreground river were washed in completely by the artist, leaving the blank silk ground of the painting to suggest an even covering of snow. These dark areas, which tend visually to advance toward the picture plane, introduce an interesting element of spatial tension into the picture by presenting the empty areas – sky and water – as more solid than the receding areas of blank mountains. The ability to produce paintings seemingly without effort which have great formal as well as anecdotal appeal is one hallmark of Wen Boren's mature work.

Wen Boren was born in Suzhou, Jiangsu province, the son of the elder brother of Wen Zhengming (cat.15). Boren passed the lowest-level examination and both he and his younger brother, Zhongyi, became poets of some competence. However, it was as a painter that Boren was known in his own day and, in terms of technical facility, he had few peers. Boren was already painting by the early 1520s and it is assumed that his uncle, Zhengming, was his teacher. Boren's personality, however, seems to have been more strongly influenced by his father, Wen Kui, of whom it was said: "Throughout his life he was moral and upright and held himself superior; he did not bow down or humble himself before the rich and influential." Many biographers of Wen Boren have noted his arrogance, his short temper, and lack of consideration for others. Certainly he showed an impetuosity and recklessness when he sued his famous uncle in the provincial court. This probably occurred soon after 1536 and the death of Wen Kui. The nature of the dispute is nowhere mentioned but it is noteworthy that on the death of Wen Lin, father of Zhengming and Kui, it was Zhengming who took over leadership of the family, while Kui, the eldest son, moved out of the family house. The lawsuit may thus have been a drastic attempt by Boren to secure a different property settlement. Considering the age and local prominence of Zhengming, who had held office at the imperial court in Beijing, and the lowly status of Boren, a first-degree holder of no particular importance, the suit could have had only one conclusion: Boren lost, and was thrown into jail. "Boren then became very sick and, on the night when his illness reached its crisis point, he dreamed of a golden-armored spirit who called his name, saying: 'You do not have to worry so much. In a former existence you were Jiang Zicheng's disciple.

Whenever you painted images of the great Bodhisattva Guanyin you did not dare move the brush until you had fasted. Having accumulated that merit, surely it is fitting that in this life you shall become a famous painter.' When Boren regained consciousness he was extremely perceptive and his illness was immediately healed; moreover, the legal affair was also disentangled..." Though the court case was settled, however, there seems to have been no real reconciliation between uncle and nephew until the late 1550s, when Boren is recorded as painting in the studio of the elder master.

Wen Boren seems to have ignored the obvious lesson of the court case and to have improved upon his father's refusal to humble himself before the rich and influential by insulting them gratuitously. Again an anecdote from the *Jinling Suoshi*: "Boren was easily offended and would curse and sit in a sulk. People for the most part could not stand him... A man named Xu from Dongshan ceremoniously invited Boren to come to his house and to do paintings in a waterside pavilion which abutted on Lake Tai. The guest and host were conversing when they had some slight disagreement. Boren immediately raised his fists and cursed loudly. Unable to suffer in silence Xu said: 'Wen Boren, how dare you misbehave like this in my home! If I throw you into Lake Tai today, who would know?' Xu quickly called for the household servants and several came and bound Boren. Reckoning that there was no other way out, Boren prostrated himself and begged for forgiveness. Relying on his superior position, Xu took a large stone and pressed it against the top of Boren's head; enumerating the successive events of Boren's life, Xu spat at and cursed him. Boren could answer only 'Yes! Yes!' and nothing more. Xu then exempted him from acting as bait for fish and turtles." The hero of the story may be the Xu Jin for whom Wen Zhengming painted in 1533; Xu could thus have known in some detail the "successive events of Boren's life."

Perhaps because of the difficulty with his uncle, Wen Boren seems to have lived mainly outside Suzhou; much of his adult life was spent in either Beijing or Nanjing. The two stories recounted above were recorded in a book of anecdotes about Nanjing, and in the 1540s, '50s, and '60s Boren frequently styled himself as from Yanmen or Mount She, both near Nanjing. While Boren seems to have returned to live in Suzhou toward the end of his life, as late as 1572 he painted an album of "Eighteen Views of Nanjing." In 1541 Boren wrote that he had just returned from Yantai or Beijing, and between 1550 and 1553 he seems to have been there continuously. Wen's masterworks, a set of four huge hanging scrolls, were painted in Beijing in 1551 for Gu Zongyi (1523-1588), then attached to the court as a calligrapher. Wen also made at least one trip to Anhui province, where he produced a number of paintings which were influential on later artists active there. It was said of the early Qing Anhui painter Huang Lü, for example, that his paintings so closely approximated those of Wen Boren that dealers would at times eradicate Huang's signature and turn his paintings into more valuable works by Wen.

Wen Boren, like many of his Suzhou contemporaries, depended on painting for his livelihood. However, here too in comparisons with his contemporaries he does not appear to advantage. The judgment of Zhan Jingfeng (1528-1602), who studied with Wen Zhengming and must have had some

contact with Boren, was devastating: "Wen Boren's character was mean and vulgar. According to whether a customer gave few or many coins, the scenery done within a painting would be more or less. Thus, those of his paintings which have the disorderly roughness of common and inferior work, and which are not worth looking at, are those for which the customer gave only a few coins..." Mean-spirited and bad-tempered though he clearly was, Wen Boren is vindicated at least in art history by his immense talent, which even the contemporaries who suffered him ranked as equal to that of Wen Zhengming.

Catalogue No. 21.
**Qian Gu** (1508-1578)
*Xuehou Yuanlin Tu*, "Garden Grove After a Snowfall"
Hanging scroll, ink and color on paper, 69.5 x 30.5 cm.
Inscription: "In the twelfth month of the year 1541 I did this after viewing the snow at the Bamboo Hall. In the fifth month of the year 1565 I happened on it in a pile of papers and added some more dots and washes. Since my injury, my eyesight is dim and my morale has been falling. Can it be only in apprehension that I do not come up to what I was before? I grasp my brush and sigh deeply. Qian Gu."
Artist's seals: *Qian Shubao Shi*; *Chuxi Sheng* ("Born on New Year's Eve")

From an open shelter a hooded scholar gazes out at a courtyard filled with newly fallen, untracked snow. A servant entering the compound gate carries a pot of tea that will warm his master as he enjoys a day whose clear crispness is conveyed by the sharp contours of tree trunks and strongly patterned branches. Above the upper mountains, which are left in reserve, an irregularly washed sky suggests wintery wind. According to the artist's inscription, most of the painting was completed in 1541 after he visited a local temple to view the snow; fifteen years later, when the inscription as well as a few finishing touches were added, the artist mourned the weakening of the technical control and expressive strength exhibited here.

Qian Gu was born in Suzhou, Jiangsu province. In later years he used a seal whose legend – *Wu Yue Wang Yi*, "Descendant of the King of Wu Yue" – claimed Qian Liu (852-932) as his ancestor. Qian Gu's father was said to have been talented in literature and painting but to have been without discipline; the father ended as an alcoholic, leaving his wife and young son to fend for themselves. Most biographies of Qian Gu state that he was an orphan and that he did not learn to read until an adult; Wang Shizhen (1526-1590), who knew Qian well, recorded that after the father died the family was very poor, but that the boy loved to read and often travelled within the region in order to borrow texts from people. This continued probably until the late 1530s when his mother said to him: "You are growing up wrongly. Don't you know that Wen the Academician is living in Suzhou?" Qian then gave up those with whom he had been associating and sent the proper ceremonial presents to Wen Zhengming (cat.15) that indicated a desire to become his disciple. Wen was a very cautious and careful man, but he accepted Qian as a pupil and taught him calligraphy, poetry, prose, and painting. Qian excelled in everything, but for painting he had an intuitive understanding: "Painting is fused by means of spirit and modelled on the basis of nature. Breathing in and breathing out I wet the brush in my mouth, and brush both thickly and thinly with occasional blank areas between. Is it only me who directs the intention of the brush, or do I decide the painting method and the composition by adhering to *a priori* ideas?" Qian's answer to this question on the nature of creativity in painting would seem to be both, for his brushwork, type-forms, and even some compositions are closely related to those of earlier masters, especially Shen Zhou (cat.12) and Wen Zhengming, while the idiosyncratic use he made of them is recognizably his own.

Qian Gu also became well-known as a collector of rare books: his introduction to Wen Zhengming may have come via the bibliophile Qian Tongai (1475-1549). When Wen's library became available to him, Qian Gu spent long days reading, copying, annotating, and collating, and in later years he often pursued his bibliographic interests far into the night and even when ill. The names of Qian's sons also testify to his love of literature: the eldest was named Fu after the Music Bureau poems, *Yuefu*, of the Han period, and the second son was named Xu, meaning "in order" but also "preface." Both sons became painters, and Qian Xu contributed to the famous collective album conceived by Wang Keyu (see cat.31, Xiang Shengmo).

Qian's love of solitary study and reading meant that he often ignored those who wished to secure paintings from him as his reputation grew. This meant that he grew ever poorer, so that when Wen Zhengming visited him one day and saw the conditions under which Qian lived, he inscribed the characters "The Empty Pot" on the lintel of the door. Qian smiled and said, "That is by my own will."

Qian was ranked by Zhan Jingfeng (1528-1602) as one of Wen Zhengming's best painting pupils. The other, Zhu Lang, was known for his forgeries of Wen's work. In one anecdote from the *Huashi Huiyao*, a visitor to Suzhou from Nanjing sent a servant to Zhu's house with payment for a fake Wen Zhengming. The hapless servant went to Wen's house by mistake and presented his master's request. Wen agreed with a laugh and the proposition: "I'll paint for you a genuine Wen Zhengming so long as it can substitute for a fake Zhu Lang!" Given Qian's great technical skill and the closeness of his style at times to that of his teacher, it is worth noting that Qian's production of paintings increased greatly after Wen's death in 1559; in the following eighteen years Qian painted three times as many paintings as he had before. Late in the year 1578, while visiting Nanjing, Qian was shown an album he had painted five years earlier. Qian commented: "My illness is increasingly debilitating, and my eyesight is not what it was then. Viewing this now, I am overcome with happiness." He probably died shortly after.

Catalogue No. 22.
**Xie Shichen** (1487-ca.1561)
*Yueyang Lou Tu*, "The Yueyang Tower"
Hanging scroll, ink and color on paper, 249.5 x 102.3 cm.
Inscription: "The Yueyang Tower. Painted by the Useless Immortal, Xie Shichen."
Artist's seals: *Gusu Taixia Yiren*; *Xie Sizhong Shi*
Collectors' seals: the Jiaqing emperor (r.1796-1820), the Xuantong emperor (r.1909-1911)

One of Hunan province's most spectacular scenic areas is where Lake Dongting converges with the Yangtze River. A viewing tower erected at an advantageous site during the Tang dynasty was rebuilt during the Song, an event recorded by Fan Zhongyan (989-1052), a poet-calligrapher from Suzhou. Fan's description of the tower and the natural scenery conveyed images to many who never saw the actual place, and thus came to serve as the inspiration for many paintings. In the present work several visitors to the tower stand on the open terrace talking and gazing out over an enormous expanse of water, given scale by bands of clouds and rippling currents and waves. The more active foreground area, which features a boat being guided through rapids, balances the placid recession up and back to distant sailing boats on the lake. Strongly modelled land forms, whose oblique orientations contribute to the sense of forceful propulsion, project inward from the borders of the painting and thus emphasize the central area as one continuous plane which unifies the whole into a single powerful image.

Xie Shichen, according to the testimony of his own inscriptions and seals, was born in Suzhou in 1487 and died around 1561, the latest date found on his paintings. A painting recorded in the *Shichu Baoji Xubian* (1793) is sometimes cited as evidence that Xie was still active in the year 1567 but should almost certainly be dated a full cycle of sixty years earlier. Although little is known of Xie's early education, he referred to himself as a literary student as late as 1527 and often wrote extensively on his paintings. His poetic and calligraphic skills suggest a significant literary training and he may have aimed originally at an official career; most of his dated work was done from his fiftieth year onward, and he may have determined on a career in art relatively late in life. He had, however, begun to paint long before, possibly as a follower of Shen Zhou (cat.12). According to the *Tuhui Baojian Xuzuan*: "Xie Shichen, called Shuxian or 'Useless Immortal,' was from Suzhou. He excelled in painting landscapes, obtaining the conceptions of Shen Zhou but transforming them somewhat..." Another record, the *Pingsheng Zhuangguan* (1692), suggests that Xie's style was close enough to that of Shen for his work to be mistaken for that of the earlier master: "... In the Suzhou public office hall were wall paintings depicting 'Four Great Views of the Empire.' These have traditionally been ascribed to Shen Zhou, but close scrutiny reveals that they are by Xie Shichen, for in virile strength he yielded nothing to Shen Zhou." Xie also learned by copying the old masterworks to be found in local collections; his close copy done in 1524 of Lu Hong's "Ten Views from a Thatched Cottage," now in the Shenyang Museum, bears colophons by Wen Jia (cat.19), Wen Boren (cat.20), and by Lu Zhi (cat.18), who noted: "Now I know

that Master Xie's ability surpasses my own." This painting, done for the official Mao Bowen (1482-1544), together with the "Elegant Gathering of Lofty Scholars" from 1529, painted as Xie's contribution to a literary gathering in which he participated, mark the end of the period in which Xie appears to have been only casually involved with painting.

In writing about Xie Shichen in 1550, Wen Zhengming (cat.15) noted that Xie had travelled to Hangzhou, to Mount Tiantai in the east, and to the Xiao and Xiang region in the south. Some of these trips may have been made before Xie began to concentrate on painting, but others must have been undertaken in order to fulfill painting commissions. One of these latter was recorded by Zhan Jingfeng (1528-1602): "On the invitation of a certain provincial official in Hangzhou, Xie went and did paintings for which he was paid a high price. He too was a man who would follow a stinker." Zhan's allusion was to a legendary foul creature named Lü who even in exile managed to secure a following of his own. Xie was thus criticized not for painting professionally but rather for being willing to paint for simply anyone. Given the fact that the rapacious official Yan Song (1480-1565) owned no fewer than fifty-eight paintings by Xie, it is also likely that Xie, unlike the more particular Zhou Chen (cat.14), painted willingly for Yan over some considerable period of time.

In 1549 Xie Shichen contributed several leaves to an album produced jointly by friends and followers of Wen Zhengming in celebration of Wen's eightieth birthday, and from then on Xie seems to have had fairly regular contacts with Wen and others of his literati circle. While Xie is thus sometimes regarded as a student of Wen, they seem to have had little relationship until after Xie's style was already formed.

Xie Shichen's "Yueyang Tower" is typical of his mature works in both style and size. The theme would seem to have been popular with him, for another version of this composition is extant and a handscroll version is also recorded. Xie was celebrated for his ability to compose large hanging scrolls and he quite often produced sets of four scrolls, each with a different subject and each representing one of the four seasons. The present painting might be from such a series, perhaps the autumn scene, but it alone is sufficient to suggest the great visual impact of such sets when hung in the reception hall of some official or merchant. The painting accords perfectly with the critical judgment that "Xie especially excelled in painting water, and his rivers, tides, lakes, and seas of every kind were all marvelous..."

By the later sixteenth century critical estimation of Xie's achievements was falling. Zhan Jingfeng noted: "Because Xie's brushwork is heavy and strong, unlike the fineness and delicacy now fashionable in Suzhou, people there refer to him as a laboring craftsman and thus denigrate him..." One sixteenth century artist who disagreed was Xu Wei (cat.24), who had met Xie in Hangzhou as a young man and who had received four or five paintings from him: "Painters in Suzhou for the most part are sparing of ink whereas old Xie used a lot of ink. His neighbors were startled, but that is like dwarves at the back of the theater applauding without seeing. Eighty or ninety out of a hundred do not know that weakness in a painting does not depend on whether the ink is heavy or light but rather on whether it is lively or dead..."

The present painting can certainly be characterized as lively, and it also manifests an individual style appropriate to an artist who characterized himself as an unconventional painter from Suzhou; his inscription here is followed by a seal reading "The Untrammelled Man from Below Gusu Terrace," this last built on a mountain of that name southwest of the city of Suzhou.

Catalogue No. 23.
**Chen Daofu** (1483-1544)
*Yueyang Lou Tu*, "The Yueyang Tower"
Handscroll, ink and color on silk, 33.5 x 164 cm.
Artist's seals: *Baiyang Shanren*; *Dayao*; *Fu Fu Shi*
Colophon: "Record of the Yueyang Tower;" signed by Chen Daofu, dated to summer of the year 1541, and sealed *Baiyang Shanren* and *Chen Daofu Shi*.

The subject, the same as painted by Xie Shichen (cat.22), is the famous Yueyang Tower in Hunan province as described by Fan Zhongyen (989-1052). The painting proper is followed by a transcription of Fan's original text written in Chen Daofu's idiosyncratic version of the running-script style. Done contemporaneously with the writing and intended as a visualization of the text, the painting is not signed but does bear three of the artist's seals, including one whose *Dayao* legend gives the name of a village immortalized by the Song master Mi Youren (1074-1153). In addition to the pictorial beauty of the painting itself, this work offers also the more abstract beauties of calligraphy, the historical interest provided by the content of the writing, and the art-historical connotations provided by various connections with an earlier artist. The work is not an eclectic curiosity, however, but an aesthetic entity in which formal rhythms and brush conventions held in common unify the painting with the calligraphy.

Chen Daofu, whose original name was Chen Shun, was born into a prominent Suzhou family. His grandfather, Chen Qiong (1440-1506), served as the ranking vice-censor-in-chief around 1500 in Nanjing and shared a love of collecting with his friends Shen Zhou (cat.12) and Wu Kuan (1436-1504). Among the finest paintings in Chen Qiong's collection must have been the "Dayao Village" painted by the Song artist Mi Youren. Mi Youren had visited Dayao on the outskirts of Suzhou on a number of occasions to see his younger sister, and several paintings of that title were in circulation during the Ming period. The 1139 handscroll recorded in the *Shichu Baoji Sanbian* (1816) bears a colophon by Wu Kuan detailing the circumstances under which Chen Qiong acquired the painting. The painting came into the possession of Chen Yu (1464-1516), Chen Daofu's father, who then built a house on his estate in the same village depicted by Mi Youren nearly four hundred years earlier.

Chen Daofu thus grew up in a cultural ambience suited to foster either a scholarly or an artistic bent. While Chen did study at the National University, he did not pass beyond the lowest examination, and although he became an accomplished poet, it was as calligrapher and painter that he was best known. Chen may have begun to study both calligraphy

and painting with Shen Zhou but it was Wen Zhengming (cat.15) who was his main teacher, a relationship described by both men. In 1505, for example, Wen recorded a gathering at his studio that included both Chen Daofu and Chen's younger brother, Chen Jing; Wen referred to Daofu as "my disciple," and Chen studied not only painting and calligraphy with Wen but also poetry and classical literature. Several decades later, when Chen saw a very early work done by Wen in 1499, he noted in a colophon: "When I was young I entered Wen Zhengming's house as a disciple. His talent and virtue poured out to rouse the whole country, while in painting and calligraphy he became the best among both ancients and contemporaries. During the day he had not even a few minutes of leisure but his brushwork was never rough or arbitrary..." Around 1530, when Chen wrote this, Wen had not yet attained his later pre-eminent stature, and one may find here a false note, as if Chen were forcing himself to say something nice about his old teacher. The two men do seem to have had a falling out around this time. Wang Shizhen (1526-1590) records an occasion when Chen Jing, Chen's younger brother, apparently sensed something amiss and asked Wen: "Did Daofu once follow you and study calligraphy and painting?" Wen smiled and replied: "Our Daofu has set himself up as a teacher. His calligraphy and painting of course have a school connection, but he is not a follower of mine." Since the younger brother knew very well that Daofu had studied with Wen, his question must have been inspired by Wen's own disavowal of the relationship.

In discussing the evolution of Chen's painting style, Wang Shizhen noted: "Daofu's early works also followed the Yuan masters and were refined and skillful. In his middle years he suddenly settled on the style of Mi Fu, Mi Youren, and Gao Kegong..." Chen certainly learned the so-called Mi-style of painting from Wen Zhengming, for it was while Chen was Wen's student that the master was most interested in that style. It is noteworthy that after Chen began to concentrate on the Mi-style, Wen seems to have rigorously excluded it from his own repertoire. Chen's conscious decision to turn away from the Yuan styles espoused by his teacher may also have been occasioned by his family's ownership of Mi Youren's "Dayao Village" and by the fact that he was himself born in the village depicted in Mi's painting.

Chen's grandfather had died in 1506, his father in 1516; as the eldest son Chen Daofu inherited control of the family holdings. Overcome by grief at the death of his father, Chen neglected the administration of the estate built up by his high official grandfather and businessman father, separated himself from the world of affairs, and became particularly interested in philosophic Daoism. Probably around 1519 Chen travelled to Beijing to study in the National University. Management of the estate was entrusted to others, who lost much of it, while Chen devoted ever more of his attention and time to calligraphy, painting, and wine. Chen's younger brother, Jing, passed the second-level examination in 1528 and became an official, relieving Chen of that responsibility, but he still had to support his household, which included at least two sons who later became artists. From the late 1520s onward Chen seems to have depended increasingly on teaching, on writing, and on painting for his livelihood. Sixty-two scrolls by Chen were owned by the nefarious Yan Song

(1480-1565), suggesting that Chen may have painted directly for Yan at some point. By the end of his life Chen had trained a number of followers: his sons, Gua and Mei, his nephew, Zhang Yuanju, and his pupil, Chi Xun. His indirect followers included Sun Kehong and Zhu Duozheng, the latter a member of the imperial clan who followed Chen in both landscape and bird-and-flower painting. Zhu in turn was an ancestor of the early Qing individualist master Zhu Da (cat.44).

Towards the end of his life, when the "Yueyang Tower" was painted, Chen gave responsibility for his Suzhou establishment to a son and lived again in the countryside. Chen seems to have flourished in this free and unfettered environment and, despite the many demands on his time and talents, produced the most spontaneous and personal paintings of his career. The present work is less structured and far freer in execution than most of his landscapes; the vigorous lineament and unsystematized texturing of forms carry connotations of spontaneity and improvisation which imbue the picture with life while at the same time aligning it with the tradition of "ink-performances" begun by Mi Fu and Mi Youren.

Catalogue No. 24.
**Xu Wei** (1521-1593)
*Sishi Huahui*, "Flowers of the Four Seasons"
Handscroll, ink on paper, 29.8 x 1090.6 cm.
Title: *Yanyun Zhi Xing*, "Inspired by Mountains and Clouds," written by Xu Wei and signed, "Qingteng."
Inscription: "In my performance the ink is dripping wet, the flowers and grasses are mainly confused as to season; but do not complain that the painting lacks several strokes, for recently the Way of Heaven is bumpy enough. Tianchi Xu Wei."
Artist's seal: *Tianchi Shanren*

Considered solely as a series of flower studies, this painting might be considered mediocre at best. The images of peonies, grapes, banana palms, cassia, pine, bamboo, and blossoming plum are all identifiable, yet the lack of color, the omission of precise detail, and especially the exhibitionistic brushwork intervene between image and reality and prevent the former from functioning as an illusion of the latter. This result is of course precisely what the artist intended, for in his inscription he stated that this was a performance and, as with a muscial or theatrical performance, the proper standard for evaluating it is the degree of creativity with which the artist handles his raw material. Another painter might have adhered more closely to reality and provided illusionistic images of flowers demanding preconditioned responses, but Xu Wei insists both visually and verbally that his work is a painting and he gives us a dazzling performance in two dimensions with brush and ink manipulated with great dexterity to create pleasing, stimulating, even shocking visual structures. It is of little moment that the artist's floral sequence does not suggest an orderly temporal progression of the four seasons or that something might be gained from more detail; his spontaneous brush and inkwork imbue the forms with vitality and augment the visual tension inhering in these abstracted images of nature.

Xu Wei was the youngest of three sons born to a minor military official active mainly in the distant southwestern provinces. When the father returned from Yunnan to his home in Shanyin, Zhejiang, accompanied by a young wife, née Miao, he also took a concubine who became the artist's mother. The father died three months after Xu's birth in 1521 and the boy was subsequently cared for by Madam Miao (who had no children of her own and was far from her own family), by his natural mother, and by his considerably older half-brothers. By the time Xu began his formal schooling at the age of five, he already knew several hundred characters and soon became interested in Tang poetry. Two years later Xu began to grapple with the intricacies of the infamous and constricting "eight-legged" essay form of the civil service examinations. In 1530, at the age of nine, Xu was presented to the local prefect who praised the boy's achievements but advised him to broaden his reading beyond model examination essays. The same year Xu's natural mother was forced to leave, probably being sold, and Xu was separated from her for nearly twenty years. When Madam Miao died in 1534 Xu became dependent on his eldest brother. By the late 1530s he had earned a good reputation for writing and had studied the lute, swordsmanship, and painting.

In 1540 Xu passed the first-level examination. Having thus demonstrated his potential for future success, Xu became an elegible bachelor and was soon engaged to the eldest daughter of Pan Kejing, a specialist in criminal law. In 1541, at the age of twenty, Xu left his brother's household, went to Guangdong where Pan had been posted, and lived with Pan after marriage to his daughter. The entire Pan household returned to Shanyin two years later; even during that short period Xu made two extensive trips home, indicating his strong attachment to his native area.

The year 1545 marked the beginning of a period of bad luck for Xu but also of creativity in the arts and achievement in the practical world of affairs. His misfortunes began with the death of his eldest brother and the loss of the remainder of his family's holdings through a lawsuit. His first son, Xu Mei, was born in 1545, but his wife never regained her strength and died the following year. In 1547 Xu left the Pan household and, at the age of twenty-six, became independent for the first time. Xu supported himself, his infant son, and, from 1549 onward, his natural mother on what he could earn as a local teacher while living in a small house he named "The Single Twig Hall." Another lawsuit almost ruined him and he survived for a time only by living in a monastery, being supported by a generous friend and by a stipend granted him by the district. Despite these difficulties, Xu Wei was very active writing plays and songs; he also became one of the group of literati known as "The Ten Talents of Yue" and met such painters as Chen Hao and Xie Shichen (cat.22). Chen Hao (d.1560) is of particular interest for his possible influence on Xu not only as artist but also as role model. During his younger years Chen had served as a military commander but found that life so uncongenial that he developed a peculiar nervous disorder that went undiagnosed for seven years until Chen finally cured himself – by resigning, discarding his uniform, and donning the clothes of a mountain recluse.

During the mid-1550s Xu Wei was also involved with military affairs and participated in several skirmishes against Japanese pirates. Xu's strategic and literary skills soon came to the attention of Hu Zongxian (1511-1565), the military commander-in-chief of the armies defending the coastal region and headquartered in Hangzhou. Hu was already a controversial figure and Xu hesitated before accepting a position as Hu's secretary and informal adviser. Between 1557 and 1562 Xu often ghost-wrote memorials for Hu – one in 1558 on the submission of an auspicious white deer being especially notable – and was rewarded with Hu's trust and friendship, with introductions to such famous authors as Tang Shunzhi, and with a large and comfortable house named by Xu "Recompense-for-Words Hall." However, despite these suggestions of a settled and successful life, strong indications to the contrary come from attempts Xu made during this period to marry into another family. Xu himself noted: "In the summer [of 1559] I married into the Wang family of Hangzhou but that was very stupid. From the first I was mocked and misunderstood, so in the fall I got a divorce..." In a marriage of this type Xu Wei, at age thirty-eight and with an established reputation, would have given up his surname in order to perpetuate the Wang line. In the following year Xu became engaged to a Miss Zhang of Hangzhou and in 1561 married into her family. The same year marked the last of Xu's eight attempts to pass the second-level examination. Xu's second son, Xu Zhi, was born in 1562, but just when his family responsibilities were growing, Xu Wei refunded the betrothal money paid him by the Zhang family and returned to live in Shanyin. Xu's precipitous action may have been influenced by the arrest late that year of Hu Zongxian, who was charged by court opponents with what they termed his 'Ten Major Crimes.' Hu was cleared of all charges by the emperor himself but the perils of political involvement became very clear to Xu, who in 1563 refused an offer made by an old friend to secure him an appointment in the capital. New evidence against Hu Zongxian led to his re-arrest in 1565, and he died later that same year in prison, an apparent suicide.

Xu Wei may have feared the consequences of his long association with Hu Zongxian but, for whatever reason, in 1565 Xu embarked on a program of self-mutilation so severe as to suggest that he was trying to kill himself. After writing his own obituary, Xu shattered his skull with an ax, drove a three-inch construction nail into his left ear, and smashed his testicles with a hammer. If these actions, described by Xu himself, are not entirely convincing as suicide attempts they at least suggest an extreme degree of derangement perhaps brought on by a basic instability and possibly exacerbated by anxiety over the case of Hu Zongxian. Xu's illness became less severe that winter, but the following year, in 1566, his violence was turned outward and he beat his wife to death because she was "not true." For this crime Xu was condemned to death, but on the intervention of friends was sentenced rather to jail.

Incarceration proved salutary for Xu. His emotional life under control, with nothing more to fear from without, Xu was able to read and write while in jail and also began to paint with increasing frequency. The discipline of jail life was not all privation; for example, Xu's friends joined him to cel-

ebrate his fiftieth birthday, and on the death of his mother in 1568 he was granted leave to arrange for her burial. In 1573, through the intercession of the scholar-official Zhang Yuanbian, Xu was released to spend the final two decades of his life as a mostly itinerant painter and writer. Between 1573 and his death in 1593 Xu Wei moved frequently and seems to have been restless. Although a majority of his paintings were produced during this period, and even though he wrote much and taught often, he remained impoverished and in frequent poor health. During his last years he seems to have lived alternately with his two sons. Xu Wei died at the age of seventy-two while living in the house of the wife of his second son. Nearly thirty years earlier he had composed his own epitaph. While the full meaning remains obscure, the verses are still poignantly suggestive of Xu's inner world:

"He showed to perfection that even surrounded
    by sickness one can finish clearly,
  one can do without death, for trust is grieved by death;
He feared ties strongly and did not find peace, one can
    do without life, for what in life can be relied upon?
Fearing to drown he jumped in first with a laugh,
Wei finally shaved his head but he cut it too late.
What a pity his intelligence was so very small,
he served his wife and became comrade to madness.
Thrice and again before all men,
  his shame is now clear."

Catalogue No. 25.
**Shen Shichong** (paintings dated 1602-1641)
*Fang Song Yuan Mingjia*, "Landscapes after Famous Song and Yuan Masters"
Album of 20 leaves, ink and ink and color on silk,
19.2 x 13.2 cm.
Inscription: "On a winter day in the year 1616 I followed the brush conceptions of Song and Yuan masters and did an album of twenty small scenes. Shen Shichong."
Artist's seals: *Ziju; Shen Shichong Yin*

The twenty leaves of this album present a wide range of stylistic permutations and art-historical variations on the single theme of landscape. Ranging in technique from the dry and linear to the wetter and more painterly, and from ink-monochrome to color alone, the paintings can be enjoyed simply for their sheer visual beauty, but they also evoke in various subtle ways the styles of specific historical masters active from the tenth through the fourteenth centuries. As the literatus Chen Jiru (1558-1639) wrote of a similar series done six years earlier by the same painter: "Shen Shichong has penetrated deeply into painting studies. He presents us with the quintessence of the Five Dynasties, Song and Yuan masters..."

Shen Shichong was born in Songjiang, Jiangsu province. His birth and death dates are not known but his extant and recorded paintings suggest an active career between 1602 and 1641. Although Shen wrote several poetic colophons as well as a number of poems on his own works – indications of some degree of literary training – his subsequent fame was

based solely on his great talent in painting. He is usually recorded as a pupil of Song Moujin, another Songjiang artist, and a colophon written by Song on a painting done by Shen in 1610 includes the statement: "Although Shen Shichong was my student he himself is capable of beginning directly with the ancients." Song Moujin wrote colophons for two paintings done by Shen in 1610: the first a handscroll done after fourteen Song and Yuan masters, the second a "Peach-blossom Spring" handscroll, both done for the Songjiang official Qiao Gongbi. Other colophons were written for these scrolls by Zhao Zuo, another artistic mentor of Shen, by Chen Jiru, and by Dong Qichang (cat.28), the last two important collectors whose early masterworks functioned as primary source material for the young artist.

Dong was equally important in guiding Shen to a proper art-historical appreciation of early painting and to an understanding of the relative value of the various styles. Chen's relationship with Dong continued into the 1620s and '30s, when Shen's own contributions to Songjiang painting were clear to all. Dong Qichang expressed admiration for Shen's well-developed pictorial skills and couched his praise in terms of a perceived rivalry with the older Suzhou school of painting: "I look today at this scroll [done in 1628] by Shen Shichong and see that serried peaks and repeated ranges, tall pines in deep ravines, and extraordinary views from a mountain dwelling are all present. Painters from Suzhou ought to fold their hands and salute in surrender to our Songjiang [painters]." In another colophon on the same scroll Fan Yunlin (1558-1641) credited Dong with beginning the Songjiang school: "Our Songjiang has Master Dong Qichang whose every brush-stroke comes from an ancient model and who was the ax which 'opened the mountains' for our Songjiang painters." Dong himself saw his fundamental role as arbiter of art-historical excellence and, in a colophon on another painting done by Shen in 1628, he credited others with primary roles in painting: "In our Songjiang the Way of Painting began during the Yuan dynasty with Cao Zhibo... Afterwards there was no further successor or echo. In recent years eyes have all been put right and men no longer fall into the practiced airs of the Suzhou school. Because I selected Dong Yuan and Juran as models, there have consequently been a number of masters, among whom Zhao Zuo and Shen Shichong stand out like thumbs." In a colophon following Dong's, Chen Jiru amplified Dong's statement by discussing the qualities Songjiang painters possessed in contrast to the "practiced airs" of the Suzhou masters: "Painters have regarded a scholarly air as essential to painting ever since Dong Qichang of our district selected the orthodox lineage as the theme. At the same time Zhao Zuo and Shen Shichong took part in this and began by following the two masters Shen Zhou [cat.12] and Wen Zhengming [cat.15] and then continued on back to the Four Great Masters of the Yuan as well as Jing Hao, Guan Tong, Dong Yuan, and Juran, who all took Li Cheng as their teacher, and Li Cheng took Lu Hong as his teacher; this is the 'School of Scholarly Air.'"

These statements suggest that the Songjiang painting masters had a very close working relationship with Dong, the primary theoretician, and some sources record that Dong even used Shen and others as ghost-painters. A letter from Chen Jiru to Shen is frequently cited: "Dear elder brother Shen, I am sending you a sheet of white paper and three mace of silver for your agreeable brush. May I trouble you to paint a landscape of great-hall size? I will need it tomorrow. You need not inscribe it as I will want Dong Qichang to add his name." While it is not difficult to find a few paintings within Dong's extant *oeuvre* which are very close in style to those signed by Shen, it is well to keep in mind that a ghost-painter more usually adjusted his personal style to accord with that of the person for whom he was working; paintings ghost-painted by Shen for Dong should look like Dong's rather than Shen's works or else the point would have been lost. Shen's extant and recorded paintings are mostly dated; these indicate a rising curve of activity in the later 1620s and early 1630s, suggesting that any work he did for Dong would have been produced mainly during the 1610s and earlier 1620s.

One of Shen's most beautiful paintings, an album of garden scenes, was done in 1625 for Wang Shimin (cat.34). Another noteworthy work, from the previous year, is a set of ten hanging scrolls which present a continuous scene of the "Peach-blossom Spring." Shen's artistic activity is fairly well documented through 1633; beyond that year only a single album from the year 1641 is presently known. In 1637 Yang Wenzong (1597-1645) wrote a colophon on a painting done by Shen in 1628 for his student Jiang Ai: "In the Way of Painting in Songjiang Dong Qichang is regarded as Dong Yuan, so Zhao Zuo and Shen Shichong may be taken as Huang Gongwang and Wang Meng within the Southern School lineage..." A painting done by Yang Wenzong in 1640 bears a colophon by Shen saying: "Yang Wenzong graciously sent this scroll over from Jizhou. I casually composed two verses to thank him and also wrote them on his painting." Shen is recorded as the teacher of at least five younger Songjiang painters and he was also the stylistic progenitor for even later masters in the school such as Lu Wei (cat.54). As the local Songjiang gazetteer recorded of Shen: "For a time he was the most famous artist, and most of those within the district who painted followed him."

Catalogue No. 26.
**Zhou Zhimian** (active later sixteenth to early seventeenth century)
*Shuangyan Yuanyang Tu*,
"Paired Swallows and Mandarin Ducks"
Hanging scroll, ink and color on silk, 186.5 x 91 cm.
Signature: "Zhou Zhimian"
Artist's seals: *Zhou Zhimian Yin*; *Zi Fuqing*

Zhou Zhimian was born in Suzhou, Jiangsu province. By around the middle of the sixteenth century Suzhou boasted a bird-and-flower style that presented a literati alternative to the academy style represented by Lü Ji (cat.5). The Suzhou style is distinguished by somewhat softer forms, lighter colors, and by more self-conscious brushwork. Zhou Zhimian's Suzhou predecessors, Shen Zhou (cat.12), Chen Daofu (cat.23), and Lu Zhi (cat.18), are better known as landscapists; Zhou became a specialist whose style, according to Wang Shizhen (1526-1590), was a synthesis of the strengths

of the earlier masters: "Since the beginning of our dynasty there have been no specialists in flowers and grasses who were the equal of those from our Suzhou, and in Suzhou, after Shen Zhou, there have been none who were the equal of Chen Daofu and Lu Zhi. However, Daofu was marvelous without being truthful, while Zhi was truthful without being marvelous. Zhou Zhimian seems to be able to bring together and unite the strong points of the two masters..." Several biographers mention that Zhou had many followers, also that forgeries of his work abounded.

The dates of Zhou's birth and death are unknown. The compilers of the imperial collection catalog *Shiqu Baoji Xubian* (1793) state that Zhou passed the second-level *juren* examination in 1546, but this is not confirmed by other sources. Wang Shizhen hints at some difficulty that, since Wang died in 1590, must have occurred fairly early in Zhou's career: "... It was solely his addiction to drink which caused him to fail and not to be very honored by the world." Zhou's career as an artist can be documented by recorded and extant paintings from 1569 onward, with the majority dating between 1585 and 1602. Zhou also trained a number of painters including his nephew Yu Qiaozhi, who was already active during the 1590s, and Wang Weilie of the early seventeenth century.

A majority of Zhou's works are small-scale fan paintings; the present "Paired Swallows and Mandarin Ducks," which must date to the 1590s, is one of his very rare large-scale efforts. The painting manifests all the characteristics identified by earlier critics as hallmarks of his genuine paintings: a polished elegance, light and easy brushwork, and a sense of movement to the whole. Even apart from the obvious symbolism of its subject – mandarin ducks are standard emblems for conjugal bliss – the painting manifests a self-confident balance that is in full accord with that suggested by the legend of a seal used occasionally by Zhou late in life: "If one's brush is used to investigate the pure and good, one's whole life will be happy."

Catalogue No. 27.
**Wu Bin** (paintings dated 1568-1626)
*Qianyan Wanhe Tu*,
"A Thousand Cliffs and Myriad Ravines"
Hanging scroll, ink and color on satin, 170 x 46.8 cm.
Inscription: "From a thousand cliffs springs freely flow, within a myriad ravines trees wind and coil. Wu Bin."
Artist's seal: *Wu Bin zhi Yin*

Above a foreground scene, whose naturalness allows the viewer easily to enter the picture, rise tremendously elongated spires which balance precariously on unstable, undercut bases. The organization of the painting around a centrally placed mountain mass and with a spatial recession moving from fore to mid and background suggests that the artist was influenced by paintings of the monumental Northern Song type. Other potential influences on the style may have included natural scenery, which in the region of the artist's birth is said to be most unusual, and European prints, which were known at that time through Jesuit missionaries such as

Matteo Ricci (1552-1610). Whatever the varied sources of the visual elements, the image itself stands as a well-integrated and compelling whole; one of the greatest pleasures of the painting derives from the tension created by the great discrepancy between the realistic means and the fantastic ends.

Wu Bin was born in Putian, Fujian province. His earliest recorded painting, dated to 1568, was modelled after the style of Tang Yin (cat.16), who together with Wen Zhengming (cat.15) was a major influence on Wu Bin's art. Wu may in fact have studied in Suzhou for a time; on a painting dated to 1583 Wu signed himself as from Changzhou, which is part of the Suzhou region. Another link with Suzhou comes through Wu's friendship with Wang Yuanyao, the recipient of a painting done by Wu in 1599 and a direct disciple of Wen Zhengming and Wen Jia (cat.19).

Probably during the 1570s Wu Bin was called to serve at the imperial court. Wu, whose recorded skill in writing poetry suggests some degree of literary training, was first appointed drafter in the Central Drafting Office; the beautifully written *zhuanshu* or "seal-script style" titles written by Wu on some of his paintings also show his skill in calligraphy. He was later promoted to secretary of the Ministry of Works. Wu also served the Wanli emperor Zhu Yijun as painter. Probably during the 1580s or '90s Wu memorialized the emperor with a request: "'The southern hills and valleys seen by your servitor are limited to one region. He wishes to go to western Sichuan to see the splendors of the Jian Pass and the Min and Emei mountains. When he then lowers his brush to paint, there may well be new stimulation.' The emperor granted his request and, when Wu returned, his paintings were indeed yet more unusual." It is worth noting that Wu's friend, Wang Yuanyao, served in Sichuan as secretary to the lieutenant-governor of the province.

It is not presently clear for how long Wu Bin was associated with the court. Two paintings dated to the year 1591 were done while Wu was back in Fujian; in 1596 a monk visiting from Sichuan found Wu in the Qixia Temple near Nanjing. A majority of Wu's dated paintings from then onward were done while he was in various Buddhist temples, especially the Zhiyin Retreat of the Qixia Temple. Wu seems to have become a lay-follower of Buddhism; a number of his paintings are signed "The Untonsured Monk," "The *dhatu* [recluse or priest]," or "The Novice of the Zhiyin Retreat." In the late 1590s Dong Qichang (cat.28) was asked by Wu to look at his series of paintings of the "Five Hundred Lohan" done for the Qixia Temple. Dong commented: "They have the antique appearance of [Lohans painted by] Guanxiu but lack his weirdness; they have the fragility of [Lohans painted by] Li Gonglin but eliminate his repetitiveness." By the first decade of the seventeenth century Wu Bin was famed within Nanjing artistic circles and knew the important collector Xu Hongji. He also contributed designs for plum and bamboo paintings to the woodblock illustrated *Shizhuzhai Huapu* published in Nanjing by Hu Zhengyan in 1627.

"A Thousand Cliffs and Myriad Ravines" may be dated on the basis of style to around 1610. Satin, the medium of the painting, had been used earlier by such artists as Shen Zhou (cat.12) but it was not until the seventeenth century that its use became fairly widespread, and then it was especially

popular with artists who were calligraphers as well as painters. Satin is highly absorbent, a property which creates a rich depth of ink, with the ink suffusing slightly to both sides of a brushstroke, an effect which contributes to the range of tonalities and textures. The present work is of the type described so aptly by James Cahill: "Ostensibly done in imitation of early masters of the monumental landscape, they in fact introduce to painting a new element of fantasy, forcing geological formations beyond the bounds of possibility to a point where they can be experienced only as visions of a dream world, or an interior landscape."

At least by 1615 Wu Bin was in Beijing, where he stayed with and painted for the artist-official Mi Wanzhong (1570-1628) at his Shao Garden. The two artists first met in Nanjing in 1601; several of Wu's later paintings were dedicated to Mi and some of the latter's landscape paintings are extremely close in style to those of Wu. Mi Wanzhong was dismissed from office in 1625 after being denounced by a follower of the powerful eunuch Wei Zhongxian, who also ended Wu Bin's career. On seeing a decree issued by Wei on his own authority, Wu Bin criticized Wei Zhongxian and was then seized and imprisoned. Nothing is known of Wu beyond the year 1626.

One of the most perceptive comments on Wu Bin's art is that in the *Wuzazu* written by his contemporary, Xie Zhaozhi (1567-1624): "In recent days the masterworks of such famous artists as Dong Qichang of Yunjian and Wu Bin of Nanjing are unprecedented... Wu uses his mind to create the unusual, and he paints with wondrous skill... In later generations his works will certainly be valued higher than [the ransom for] two cities."

Catalogue No. 28.
**Dong Qichang** (1555-1636)
*Guanshan Xueji Tu*, "Clearing After Snow on Mountain Passes"
Handscroll, ink on paper, 13 x 143 cm.
Inscription: "Guan Tong's 'Clearing After Snow on Mountain Passes' has been in my collection for more than twelve years but I have never before unrolled and looked at it. Today I happened on it in a desk in a small side room. Selecting various sections from within the painting I changed them into a small handscroll. During the long day I did not see anybody's face and thus completed the painting. During the fifth month, summer, of the year 1635, Xuanzai."
Artist's Seal: *Dong* ---
Collectors' seals: An Qi (b.1683), the Qianlong emperor (r.1736-1795), the Jiaqing emperor (r.1796-1820)
Colophons: Gu Dazhong in 1663, Dai Benxiao in 1664, Shen Quan in 1667, Mao Xiang in 1690, the Qianlong emperor in 1746

Dong Qichang was born in what was then the small town of Shanghai into a family of some local standing but limited means. He was educated at home by his father, a local teacher, and then studied in the prefectural school in Songjiang, where he had moved to avoid taxes. The Songjiang prefect who took charge of Dong's education shocked him by ranking him second to his cousin, rather than the complacently expected first place, because of inferior calligraphy. Dong thus set out at the age of sixteen on the course which eventually earned him recognition as one of the greatest masters of calligraphy since Zhao Mengfu (1254-1322). He achieved this by following good historical procedure: study of primary rather than secondary sources, which in art-historical terms meant that he studied not such immediate predecessors as Wen Zhengming (cat.15) and Zhu Yunming or even Zhao Mengfu but rather the Tang masters Yan Zhenqing and Yu Shi'nan, and then the progenitors of the entire tradition, Zong You and especially Wang Xizhi.

During the 1570s and '80s, after passing the first-level examination, Dong continued to study for the upper levels, supporting himself by working as a private tutor in various wealthy households. In 1577, the year in which he began to paint according to his own testimony, Dong was living with Lu Shusheng (1509-1605), head of the Ministry of Rites and a poet and connoisseur of tea. Dong knew Chen Jiru (1558-1639) by this time and through Lu met the older painters and collectors Gu Zhengyi (active ca.1579-1597) and Mo Shilong (ca.1539-1587). In 1584 Dong was tutoring in the household of the most important collector of the day, Xiang Yuanbian (1525-1590), and was thus able to see many masterworks of painting and calligraphy. Like his close friend Chen Jiru, Dong became interested in Chan [Zen] Buddhism during this period and associated for a time with the master Zhenke (1543-1603). Given Dong's historical orientation he was surely conscious of the opportunity to develop a relationship with Zhenke comparable to that between Zhao Mengfu and Mingben (1263-1323), a Yuan priest admired by Zhenke.

Following unsuccessful attempts in 1579 and 1585 to pass the second-level examination, Dong was finally successful in 1588 and travelled to Beijing the following year to try the third and final barrier to official position. Dong's reputation had preceded him and one of the examiners, Wang Xijue, the grandfather of Wang Shimin (cat.34), predicted that Dong would pass as *optimus*. That proved wrong, but Dong did pass with honors and was complimented on his calligraphy. Dong's essays, deemed models of elegant form, became famous and marked the beginning of a forty-seven year period during which Dong's writing was in almost continuous demand. Although appointed initially to the prestigious Hanlin Academy, Dong seems very soon to have become dissatisfied with his progress or his future potential and in 1591 requested a leave of absence which lasted three years.

Wang Xijue had also returned home in 1591 and it was not until he and others were able to persuade the reigning emperor to declare Zhu Changluo the legitimate heir to the throne that Dong returned to Beijing, where in 1594 he became one of the tutors to the crown prince. Until 1599 Dong served in several other ways, but apparently nothing was offered that he felt was worthy of his talents or ambitions. "Losing his will to control the government, Dong was appointed assistant surveillance commissioner (rank 4a) of Huguang province but pleaded illness and returned home." Dong remained at home between 1599 and 1603, when he was "reinstated in his old position and directed the educa-

tional system of Huguang province. He was not influenced by improper requests and so was resented by the powerful families, who incited several hundred students and Confucian scholars into a riot which destroyed his public office. Dong then respectfully requested permission to leave but the emperor did not allow it and rather ordered the relevant office to investigate and punish the miscreants. In the end Dong was cleared of responsibility and returned home.." Dong remained in retirement from 1605 until 1622 despite offers of several different posts, all of which were in the provinces and of fourth or third bureaucratic rank.

Dong's career decisions were certainly influenced by such events as the deaths of Zhenke, who died in prison from a beating, and of Li Zhi (1527-1602), an independent philosopher of the day who committed suicide in prison four years after predicting a brilliant future for Dong. Dong would have judged the political situation in relation to his own potential for salutary and effective action; despite his fame, the positions alloted him were of secondary importance and hardly up to his capabilities. In art, on the other hand, Dong had already achieved much by the 1590s and could see that further effort in that area could ensure him a truly significant historical position. Nelson Wu's sensitive interpretation of Dong's life indicates that his trip to Beijing in 1589 was made with the financial assistance of friends, and the publication of his early work on calligraphy, the *Xihongtang Fatie* of 1603, was also made possible through the contributions of others. While this suggests that Dong was not yet wealthy, he had already become a major collector of classic painting and calligraphy. Dong would have had excellent opportunities to acquire works of art from the estates of such older collector-friends as Mo Shilong, Xiang Yuanbian, and Han Shi'neng, and commissions from his writing would have made such purchases increasingly possible; also, prices for Yuan paintings were not so high then as later. According to Wang Keyu (b.1587): "In his *Gubugu Lu* Wang Shizhen said that one ought to emphasize the Song dynasty in painting, but around thirty years ago suddenly Yuan artists came to be emphasized and, for paintings by artists from Ni Zan to Shen Zhou of the Ming, prices increased ten-fold." This change in relative evaluation of Song and Yuan painting occurred around 1600 and may be associated in particular with the taste and judgments of Dong Qichang.

Given Dong's training as a historian, his later activities as collector and connoisseur perhaps inevitably aroused his interest in art-historical evolution and the evaluation of aesthetic achievement. Although Dong's historical pronouncements and critical formulations were normally composed in response to specific works and occasions, he apparently planned to combine them into a text that would rival that of Mi Fu. According to Chen Jiru, Dong sent him the following letter: "The ones we will want to study are Jing Hao, Guan Tong, Dong Yuan, Juran, and Li Cheng [all artists active during the tenth century]. Genuine paintings by these five masters are especially scarce. Song painting from the south [i.e., from the Southern Song period, 1127-1269] is not worth critical appraisal and appreciation. I have had the pleasure of inquiring into this and have made a 'Record of What is Engraved on the Tablet of my Heart.' Those Song people can wait until your text is finished and joined [with mine] into a single volume, for one cannot collect simply on the basis of what one likes and we cannot let Mi Fu walk alone as the historian of painting." While a text done jointly by Dong and Chen that would rival Mi Fu's *Huashi*, "History of Painting," seems never to have been printed, Chen did publish what may represent Dong's contribution under the title *Huashuo*, perhaps a shortened form of *Yihua Shuofa*, "Expounding the Doctrine of Painting." Given the intellectual interest Buddhism held for both Chen and Dong, the Buddhist tenor of the title was natural, and in the text Dong used the Chan Buddhist lineage as an analogy to explain the historic development of landscape painting. The Northern School lineage of Chan ran in a straight-forward and linear fashion through the first five patriarchs, declined with Shenxiu, and came to an end with Puji and Daoxuan. Dong held that this was comparable to the tradition of painting that began with Li Sixun and Li Zhaodao, was continued by Zhao Gan, Zhao Boju, and Zhao Bosu, and declined with Ma Yuan and Xia Gui. The Southern School of Chan Buddhism stemmed from the Sixth Patriarch, Huineng, who contested successfully with Shenxiu of the Northern line for confirmation as the legitimate successor to the Fifth Patriarch. The subsequent lineage of the Southern School resembles the genealogy of a large and fertile family, with many subdivisions branching off the main trunk. According to Dong, the Southern School of painting was begun by Wang Wei "who used washes of light tone and entirely transformed the methods of outlining and texturing" and who also wrote a biography of Huineng and worked actively for his acceptance as the Sixth Patriarch. Transmitting the painting tradition were Zhang Zao, Jing Hao, Guan Tong, Guo Zhongshu, Dong Yuan, Juran, Mi Fu, Mi Youren, and the Four Great Masters of the Yuan. Dong noted that even when the styles of these masters derived from a single prototype, they still differed greatly from one another, and hence did not form a linear configuration as did artists of the Northern School: "Juran studied Dong Yuan, Mi Fu studied Dong Yuan, Huang Gongwang studied Dong Yuan, Ni Zan studied Dong Yuan – all studied Dong Yuan and yet each and every one is dissimilar to the others. When other men do this, their works are the same as copies, and how are such worthy to be handed down in the world?"

A significant part of Dong's Chan Buddhist analogy was intended to convey the necessity for exactly this kind of revolutionary change within the overall confines of a tradition, to stress the need of surpassing one's immediate predecessors while paying homage to the founder of the lineage by transmitting his legacy into the future. Dong stated that his Southern School of painting "is comparable to the following of the Sixth Patriarch, when the Mazu, Yunmen, and Linji sects prospered from son to grandson." Each of the three monks mentioned by Dong derived ultimately from Huineng, the Sixth Patriarch, but did so through different intermediaries, and hence in the Chan genealogy are not placed together. Their personalities also varied greatly, ranging from the urbane and sophisticated Linji to the rustic eccentric Mazu, hence their manners of expression were also readily distinguishable. This concept of individualism within a tradition was also utilized by Dong in his discussion of painters: "The texture methods of all masters from the Tang through the Song have each their gates and halls [of origin].

As in the lineages of the Five Masters of the Chan lamp, let one hear but a few words or a single phrase and one can determine in which sect he is a son or grandson."

Dong's analogical use of the Chan genealogy also explained the success of his Southern School of painting; each master of the school embodied the precepts of an earlier patriarch but then transformed them and produced innovative paintings that served as models, as *gongan* or *kōan*, for generations to come. The Southern School of Chan embraced a range from the sudden enlightenment of Mazu to the far more systematic and gradual procedure followed by the Caodong or Sōto lineage, so it cannot be held that Dong had a specific methodological approach in mind, but the ultimate goal of all Southern School painters was stated clearly by Dong: "How can one hope to be a patriarch of painting until one has travelled ten-thousand *li* of roads and read ten-thousand *zhuan* of books? It is this goal to which our class exerts itself and what is not to be hoped for by the ordinary masters." In their quest to become patriarchs of painting literati artists required not only broadening experience and deepening knowledge but also proper models to follow, and these were supplied by the orthodox lineage as codified by Dong Qichang.

The text referred to above as *Huashuo* was until recently held to have been the work of Mo Shilong, who was probably still alive when the text was composed. Virtually the same text – though entitled *Xianchuang Lunhua*, "Discussion on Painting at a Quiet Window" – was published in 1627 by Zheng Yuanxun, a relative of Cheng Sui (cat.38), with the following postface by Dong: "Wu Hongyu from Xindu came by my boat and saw my sketch-copies of various paintings as well as these *lunhua suoyan*, 'fragmentary discussions on painting.' He said: 'Writing a history of painting is far from an easy task.' Since Wu has achieved the untrammelled class in the Way of Painting, I asked him how it would be if we allowed my words to stand as evidence [of the truth of his assertion.]" It should be noted that the eighteenth-century catalogue *Shibaizhai Shuhua Lu* records the same text as a calligraphy handscroll dated to 1599 and entitled *Lun Shuhua*, "Discussion of Calligraphy and Painting," with a virtually identical postface save that the recipient was Chen Jiru. Dong's mention of sketches of famous paintings in conjunction with his comments on them raises the possibility that he originally intended to illustrate theoretical propositions with concrete visual examples in approved art-historical fashion. Such pedagogical impulses made Dong an extremely important influence on the younger generation of artists, many of whom, including Lan Ying (cat.30), Xiang Shengmo (cat.31), Wang Shimin, Wang Jian (cat.35), Cheng Zhengkui (cat.37), and Gong Xian (cat.46), studied with Dong at various times.

Another group of painters, including Shen Shichong (cat.25), were more intimately associated with Dong from the first decade of the sixteenth century onward. Qi Gong has identified nine artists, most of whom were trained in painting technique by Zhao Zuo or Song Moujin and in painting history and style by Dong himself, who assisted Dong in responding to an ever-increasing number of requests and demands for his painting and calligraphy. Zhou Lianggong (1612-1672) quoted Qian Qianyi as saying: "Dong was extremely heedful of his brush-and-ink work. When some-

one requested a work from him he usually engaged another to do it for him; on occasion, when he had finished a painting, a young servant would exchange it for a fake, upon which Dong would still be happy to inscribe his name without the least calculation. He had many concubines, each of whom kept silk ready to hand for when they sought a painting; when he became a bit weary they would sing and chant so he would continue. Those who bought genuine works mainly got them from his concubines."

This very pleasant and fulfilling life was interrupted by an event well-summarized by Fang Chaoying: "In April 1616 several women who came to [Dong's] home with grievances were beaten and insulted. The local populace became incensed and on April 30 a mob attacked his home, set it on fire, and pillaged for two days. He and his family escaped with their lives, but the house was razed to the ground. The case was settled when a few known miscreants were executed as ring-leaders of the mob, and several students were dismissed from the local school for their part in the demonstration. For his own loss, including many treasured paintings and other works of art, Dong was never compensated." In 1620 Dong's long period of retirement came to an end when his old student became emperor and summoned Dong to the capital to serve as vice-minister of the Court of Imperial Sacrifices and Director of Studies at the National University. However, Zhu Changluo died within a month and it was not until 1622 that Dong took up his appointment in the Court of Imperial Sacrifices. Dong was then made one of the compilers of the Veritable Records of the reign of the Wanli emperor and assigned to examining documents stored in the Nanjing archives. In 1623 Dong was made vice-minister of the Ministry of Rites and in 1625 chief minister of the Ministry of Rites in Nanjing, a ceremonial post of high prestige from which he resigned in 1626. Dong's withdrawal to Nanjing and subsequent resignation were later admired as far-sighted actions, for they absented him from the court during the accession to power of the infamous eunuch, Wei Zhongxian. In 1632 Dong was again recalled and served for two years as head of the Supervisorate of Imperial Instruction before being allowed to retire for good in 1634 at the age of seventy-nine.

The present "Clearing After Snow on Mountain Passes" is a major monument from the last full year of Dong's life. According to his inscription, the painting was based on one of the same title by the tenth-century master Guan Tong then in Dong's collection. The *Shuhua Ji* of the later seventeenth century indicates that the latter painting was attributed to Guan by Dong himself and disputes his judgment by saying that it was really painted by the eleventh-century artist Fan Kuan. Dong's own painting is far from the objective natural world of both tenth and eleventh-century painting and presents a pictorial construct whose forms respond to the distinctly non-physical forces of intellect and imagination. Four leftward-jutting escarpments divide the composition into a sequence of enclosed space-cells; movement from right to left is thus accompanied by progress from near to far and from bottom to top of the format. Presented within a restricted range of ink tonality, the brushwork captures our attention and holds it with variations from elegant to harsh in conjunction with a graded change from graceful curvilinear shapes

to harder, more angular ones. The painting was handed down to Dong's grandson, then, before passing into the imperial collection, was owned by the noted collector An Qi (b.1683), who commented: "The brushwork is lucid and strong; although modelled on the work of Guan Tong it is uncultivated and spontaneous, mature and untrammelled, for it transcends all known tracks and paths." The work manifests perfectly Dong's clearly drawn distinction between art and nature: "In terms of the rare wonders of a region, a painting is not equal to the landscape, but in terms of the refined subtleties of brush and ink, the landscape is absolutely inferior to painting."

Catalogue No. 29.
**Zhang Hong** (1577-1652 or later)
*Zaji Youxi*, "Various Entertainments"
Handscroll, ink on paper, 27.5 x 459 cm.
Inscription: "During late winter of the year 1638, drawn for fun at an inn in Piling by Zhang Hong."
Artist's seals: *Huachi; Zhang Hong; Jundu Shi*
Collectors' seals: Xiang Shengmo (1592-1658), Dai Zhi (19th c.)
Title: *Youxi Haoduan*, "Amusing Oneself with the Tip of the Brush," written by Gu Ling (mid-seventeenth century)

Isolated against a blank ground, the various vignettes which together make up this scroll lack both a coherent program and a defining context. Each is independent of the others and could easily be separated from them, fixed within a defining environment, and made the main theme of an independent painting. The scroll is thus an iconographic sketchbook rather than a polished painting, and as such it appears spontaneous and immediate. However, the genesis of the scenes was not actual events encountered by the artist but rather earlier paintings, for many of the individual themes are familiar from their appearance in pre-Ming painting. The most popular of these earlier images were subsequently simplified and codified into sketchbooks, much as complex oral literature was compressed into prompt-books for professional story-tellers. For later professional painters the sketchbooks provided first of all basic visual images, the copying of which was a primary means of developing technique. The images functioned later as a standard vocabulary of visual forms which could be combined or otherwise modified to suit particular expressive goals in the execution of given commissions. The imagery of "Various Entertainments" was thus common to the vocabulary of many professionals of the period, but this painting was not a commissioned work; its basic nature was recognized by the artist's contemporary Gu Ling, who called the painting "Amusing Oneself with the Tip of the Brush," a title which accords with the painter's own statement that he did it "for fun" while relaxing in an inn away from home.

Zhang Hong was from Suzhou, Jiangsu province. Beyond the basic fact of his existence and the comment that all the scholars of Suzhou revered him, standard biographical texts are mute concerning one of the truly creative artists

of the late Ming period. Zhang's own inscriptions on his paintings tell us that he was born in 1577 and that he worked at times with artists from Suzhou (e.g., Shao Mi), Hangzhou (e.g., Lan Ying, cat.30), and Nanjing (e.g., Fan Qi). Colophons on Zhang's paintings by such as Chen Jiru, Fan Yunlin, and Dong Qichang (cat.28) are evidence that contemporaneous critics knew and appreciated his work, but virtually none of them writes of Zhang himself. Zhang also mentions some of his earlier models – Dong Yuan of the tenth century, Wang Meng of the fourteenth, and Shen Zhou (cat.12) of the fifteenth – as well as the specific sites which inspired a number of his works, but nowhere does he reveal how he came into contact with Western art, whose novel approaches are sometimes manifested in Zhang's technical and expressive vocabulary for landscape painting.

Catalogue No. 30.
**Lan Ying** (1585-1664 or later)
*Qiuse Wutong Tu*, "Autumn Color on a Wutong Tree"
Hanging scroll, ink and color on paper, 66 x 32.7 cm.
Inscription: "Whiling away the summer of the year 1654 in the Long and Hong River region, I was north of the river drinking with Taoan, the old leader of our society, and my elder brother Qingyan. For more than ten days it dawned cold and we endured rain, so I imitated Zhao Mengfu's 'Autumn Color on an old Wutong Tree' in order to record my feelings and beg instruction [from my companions]. Lan Ying."
Artist's seals: *Lan Ying zhi Yin; Tianshu*
Colophon: poem by the Qianlong emperor (r.1736-1795)
Collector's seals: six of the Qianlong emperor

The title of the painting, which is mentioned in the artist's inscription at lower right, suggests a naturalistic interest which is belied by the strongly formalized image itself. A hooked-beak bird perches in strict profile on one of several gracefully arranged branches, while the leaves are varied in shape, color, and texture for design values rather than botanical accuracy. These manipulations of natural form did not originate entirely with the present artist, for his inscription mentions that a painting by Zhao Mengfu (1254-1322) was his model. Zhao was an important early exponent of the idea of pursuing formal values within a basically naturalistic framework, and although Zhao's work is not available for comparison, the general composition here could well have been borrowed. The artist further records that he had endured rain and cold for more than ten days on a summer trip and was making use of Zhao's autumnal image to manifest his feelings about the cheerless weather. Despite the various degrees of remove between artist and nominal subject, the painting does stand as a personal statement by the artist, Lan Ying.

Lan was born in Hangzhou, Zhejiang province. According to the Zhejiang gazetteer of 1684, Lan displayed his artistic talents at an early age as well as a determination to become a famous painter: "Lan was a precocious child. At the age of seven he accompanied someone into the Magistrate's Hall and drew on the floor with charcoal moun-

tainous streams, cloudy forms, forested hills, and precipitous peaks – a thousand miles were within a foot of painting. When it came to mastering the classics and establishing his household he said: 'The ancients had painting before writing, so how can I not become famous through painting?' Lan accordingly fixed his thoughts on painting..."

After perfecting his technique, Lan Ying travelled from the first decade of the seventeenth century onward in pursuit of the broadening experience and the patronage that were essential to his career as an artist. The *Tuhui Baojian Xuzhuan* of the later seventeenth century records: "By nature finding pleasure in landscape, he travelled to Min, Ao, Xing and Xiang, and passed through Yan, Qin, Jin, and Luo. Since he 'waded and hunted' through a great many experiences his outlook was broadened and deepened. Thus when he lowered his brush from top to bottom and from right to left, the ink-wash dripped like rain, his mountains and rocks were eminent and commanding, his upright trees unusual and antique, the roiling torrents as though flying, and the streams and springs seeming to sound." To that technical mastery and repertory of natural forms was then added the final ingredient requisite for artistic greatness in seventeenth-century China: art-historical knowledge of past painting styles. This was gained through contact with such literati luminaries as Sun Kehong (1532-1610), Dong Qichang (cat.28), and Chen Jiru (1558-1639), who shared their theories with the younger artist and opened to him their collections of earlier paintings. Lan seems to have been with Dong and his Songjiang followers quite often during the early years of the second decade of the century, but Lan already had students of his own and the beginnings of a flourishing professional and personal life in Hangzhou. Chen Hongshou (cat.33) studied with Lan from around 1610 onward and Lan's son, Meng, was born around 1614.

Recorded and extant paintings by Lan dated to before 1620 are very rare, suggesting that he was travelling extensively and more anxious to learn than to produce. From 1620 onward, however, he painted far more often and gradually learned to speak with his own voice while executing a repertoire of earlier styles which included the full range from Song academic to Yuan literati styles. "Beginning from Jin, Tang and the two Song periods there were no styles in which he was not well-versed and wondrous, and his copies and works done after various Yuan masters can all be confused with the genuine ones. In his middle years he established his own gate and hall and separated and distinguished between the Song and Yuan masters... with no omissions or errors whatsoever." The last decade of the Ming dynasty, from around 1634 to 1644, was a very productive time for Lan; he painted frequently, at times superlatively, and with great expressive ease. Lan's son, who was studying the classics with the Zhejiang scholar Ge Zhengqi (d.1645), was a fully trained painter by the 1640s and may have assisted his father on large commissions.

The overthrow of the Ming dynasty and the fall of Nanjing in 1645 to the invading Manchu forces mark an important change in Lan's life: the convivial, extroverted life suggested by his associations with many well-known people changes after 1645 to a more reclusive one, with known associations limited mainly to family and other professional artists. Some of Lan's activities during this important period are known today through a play, the *Taohuashan* or "Peach-blossom Fan," in which Lan appears as one of thirty or so principal characters. The play was completed by Kong Shangren (1648-1718) in 1699 after extensive research into events of the period and interviews with those such as Gong Xian (cat.46) who had lived through the events. In the play, translated by Chen Shih-hsiang and Harold Acron with Cyril Birch, Lan first appears late in 1644 on the road to Nanjing, where he will visit his friend, the painter Yang Wenzong. Lan meets Zhang Wei, a former commander in the Embroidered Uniform Guard who will soon become a Daoist recluse. Early in 1645 Ruan Dacheng and Ma Shiying, corrupt officials and the principal villains of the play, visit Yang, who is Ma's brother-in-law, and see there a snow landscape. Ma, a painter himself, admires the work as a Tang painting; Yang tells him it is by Lan, a friend who just came to town. Lan next appears while doing a painting of "The Peach-blossom Spring" in screen form for Zhang Wei. In a soliloquy Lan notes: "From early youth I have won fame as a painter..." Yang is appointed Governor of Suzhou and asks Lan to bring his collection of painting and calligraphy to Suzhou, but in the fifth month, as the military situation in Nanjing worsens, Yang decides to leave at once. Lan declines to accompany him saying: "My home is in Hangzhou, how can I go with you?" The heroine is then left without protection, so 'Uncle Lan,' as she calls him, takes her with him. "Yonder in the Clouds' Roost Hills east of the city, where few ever penetrate, is the retreat of Zhang Wei, who relinquished his command of the Imperial Guard to practice the Dao in seclusion. I have long wished to submit myself as his disciple. Let us journey there together and see what fortune has in store for us." Our last view of Lan is from the seventh month of 1645, when he has reached sanctuary with Zhang the Daoist and is painting in their rustic retreat.

Lan's appearance in the play belies any suggestion that his occupation of professional painter earned him only low social status. Both villains and heroes alike in the play had heard of Lan, and his fame was part of the versimilitude that moved the inaugural audience to tears as they watched and re-experienced the events. In paintings done from 1645 onward Lan at times signed himself "Lan the Daoist," and that too conforms to what is recorded in the play. Lan's measured withdrawal from society, which he maintained until the end of his life, may have had some specific motivation but could as well have been a general rejection of the base human emotions and actions so evident during those tumultuous months in Nanjing. Late in life, Lan also called himself the "Stone *dhatu*," or Buddhist recluse, and he seems to have known a number of Buddhist priests, including the famous Ḍuli (J. Dokuryū, 1596-1672), the Hangzhou calligrapher who emigrated to Japan in 1653 with the splinter group of Chan monks who refused to accept Manchu authority.

During the final fifteen years of his long career Lan continued to paint and seems even to have increased the rate of his production. He became more interested in bird-and-flower painting, especially after the death of his former pupil, Chen Hongshou, in 1652. During his lifetime Lan trained at least ten students in painting, including his son and two grandsons, Shen and Tao. All three were active as painters by

1660, the date of Lan Ying's latest known work. Biographers of Lan say that he lived to more than eighty years of age, or at least until 1664. Lan's son, Lan Meng, had passed the first-level or district examination but seems not to have proceeded to the provincial or national levels. However, at least by the early 1660's Lan Meng was in Beijing, and in 1664 he inscribed one of his paintings as follows: "On a Winter day during the year 1664, together with friends I authenticated a painting by Huang Gongwang. Just then a letter came from the old man of our clan requesting a painting for his eldest brother's ninetieth birthday, so I here followed the ideas of Huang Gongwang." Thus, in 1664, and four years after his own latest work, Lan Ying requested a painting from his son to give to his own elder brother, ten years senior to Lan himself. By the mid-1660's Lan Shen, one of the grandsons, had also passed the first-level examination as a classmate of Gao Shiqi (1645-1703) and was also active in Beijing. In full retirement after 1660, Lan Ying could look with well-earned pride and self-satisfaction on the life he had built on painting. The year of his death is unknown but was before 1669, when Wu Qizhen, according to his *Shuhua Ji*, visited Lan's house and looked at two beautiful paintings by Wu Zhen bequeathed to Lan's son.

Given that both Lan Ying and Dai Jin (cat.6) were from Hangzhou, that both achieved great fame as professional painters, and that they held certain stylistic models in common, it was natural for later critics to unite the two in formulations such as that of Zhang Geng's *Guochao Huazheng Lu* (1735): "The Zhe school of painting began with Dai Jin and reached its apogee with Lan; thus it is that connoisseurs do not prize his work." Zhang himself was a pupil of Wang Hui (cat.49) and an ardent practitioner of the orthodox style of painting which by the second quarter of the eighteenth century was accepted critically as the preferred style of painting. However, that judgment should not be applied retroactively to the seventeenth century; even Zhang wrote that Lan was highly admired during his own time, and in the early eighteenth century other evaluations were made of his achievements. For example, Gao Qipei (cat.62) wrote in 1708: "Successive generations of painters have flourished most in Zhejiang. Such masters as Dai Jin and Lü Ji were active during the Xuande and Hongzhi eras but that was long ago. During our Qing dynasty more heroes appeared here than in other provinces but today the men are gone and even their paintings are not numerous..." Gao then praised recent Zhejiang masters who were mainly followers and associates of Lan, as well as the master himself. Gao's perceptive conclusion on Lan was: "His ambition was to do the ancients his own way."

Catalogue No. 31.
**Xiang Shengmo** (1597-1658) and fourteen other artists
*Wang Wei Shiyi Tuce*, "Illustrations in the Spirit of Wang Wei's Poems"
Album of 16 leaves, ink and ink and color on paper, 28 x 29.7 cm.
Leaf 1: Xiang Shengmo, dated to 1629
Inscription: "I sit alone in the silent bamboo grove, pluck the lute and reply with a long whistle. On the last day of the second month of the second year of the Chongzhen reign-era (1629), Xiang Shengmo added this illustration knowing well that it will not accord with the eyes of the world. But if you already have the point of the poem, why ask someone to examine in painting its sound and appearance?"
Leaf 2: Wu Birong, dated to 1628
Leaf 3: Zhou Zhi
Leaf 4: Shen Ye
Leaf 5: Liu Shoujia, dated to 1628
Leaf 6: Dai Jin, dated to 1628
Leaf 7: Wan Zuoheng, dated to 1628
Leaf 8: Chen Yong, dated to 1629
Leaf 9: Yao Qian, dated to 1629
Leaf 10: Fan Gongliang
Leaf 11: Chen Xi, dated to 1631
Leaf 12: Xu Boling
Leaf 13: Shen Shilin, dated to 1629
Leaf 14: Xu Rong
Leaf 15: Li Zhaoheng, dated to 1628
Leaf 16: Xiang Shengmo, dated to 1629
Inscription: "The bright moon shines between the pines, the pure spring flows over the stones. Xiang Shengmo painted this on the evening of the second day after the vernal equinox of the year 1629. The wind blows through the seven pines before my studio without ceasing and is very helpful in inspiring my brush."

The first leaf of this album is notable mainly for what is *not* illustrated: the protagonist of the poem, who must be assumed as sitting in the thatched house whose roof peeks out of the encircling bamboo grove. A bamboo fence bars the viewer overtly; a more subtle barrier is created by the composition, which suggests a continuation of that private world well beyond the borders of the painting to the left. The composition is balanced by the written inscription, which is incorporated fully both as pictorial element and as verbal adjunct to the visual experience. In his inscription the painter accepts that the ordinary viewer may not find his work an appropriate illustration of the couplet, but such criticism, he states, implies a visual standard of comparison derived from first reading the poem. What the artist wishes to present are the restful yet lonely sounds and muted colors implicit in the poem.

Another leaf by the same artist, the last in the album, again seeks to make manifest that which cannot be portrayed directly. In this case a moonlit night is suggested by the silvery grey color of the ink and the smoothly flowing brook by the rhythmic undulations of the trees. During the painting of the scene the sound of flowing water was suggested to the artist by the sound of wind blowing through the pines in front of his studio; in the painting these concepts are blended into an almost auditory image of great evocative power.

The artist of these two leaves, Xiang Shengmo, was from Jiaxing in Zhejiang province. As the grandson of Xiang Yuanbian (1525-1590), he was a member of one of the most prestigious families of the region. Xiang's ancestors had settled in Jiaxing by the middle of the twelfth century, and in subsequent generations the family produced a number of

prominent scholars and officials, especially the famous military leader Xiang Zhong (1421-1501). The Xiang family was already wealthy by the time of Yuanbian, and his astute management of various family enterprises allowed him to indulge his collecting passion to the full without depleting the family holdings. During Yuanbian's lifetime the collection played an important role in the art-historical education of artists like Dong Qichang (cat.28) and continued to play this role in the next generation when the property had passed to Yuanbian's six sons.

Xiang Shengmo's father, according to Chu-tsing Li, was the fifth of the sons, Xiang Deda. Since Shengmo had at least one younger and two elder brothers, and since their father was not the head of the clan, one might have expected little pressure on Shengmo to prepare himself for anything more strenuous than the life of a cultured aesthete. Such was not the case. According to an inscription written by Shengmo in 1629, "Already when a tuft-haired boy I enjoyed playing with the brush. My late father had charged me with preparing for a civil service career and by day I had not even a half-hour of leisure to spare, so at night I had to use a shaded lamp as I concentrated on copying all manner of insects, grasses, trees, birds, animals, flowers, and bamboo. There was no kind of thing I did not produce and only when a resemblance had been produced did I stop..." This early emphasis on technique, on learning the basic pictorial devices for representing solid form on a flat surface, is apparent in Shengmo's earliest extant paintings of the 1620s and elicited from Dong Qichang the comment that Shengmo's paintings manifested "both a scholarly air and that of a specialist in the craft." This "scholarly air" was a result not only of Shengmo's study of literature and history but also of his art-historical study of earlier paintings, which were ready to hand in the family collection. In an inscription dated to 1628 Shengmo noted: "Our family's collection of paintings by Wang Meng is also said to be rich. This is a copy of one I made almost ten years ago. Looking at it today... is like facing the painting by Wang Meng."

This copy would have been made around 1618, also the date of the last mention of Xiang's formal academic career. Somewhat earlier Xiang had passed the first-level examination and had been recommended for admittance to the National University as a government student. In 1618 he travelled to Beijing, presumably to enroll for his courses, but he did not stay long and was soon back home again in his new career as scholarly recluse; it is possible that his father died at this time and the motivating factor behind his formal studies thus removed. From at least 1620 onward Shengmo devoted an increasing amount of time and effort to his painting. One of his earliest extant works, a hanging scroll of 1620 called by Xiang "Reading the Classic of Changes in the Pine Studio," is a highly complicated and detailed study done in the Wang Meng manner of a figure reading in a mountain cottage. The poem includes the lines:

"Among the roaming immortals he who reads the *Yijing*
erected a cottage beneath the pines.
Brush and ink convey his pride,
and his manner is naturally pure and free."

The painting is an early precursor for Xiang's famous series of autobiographical "Calling of the Hermit" paintings in

which Xiang examines the potentials and celebrates the joys of withdrawal from the mundane world of academic striving, politics, commerce, and social obligations – the very world into which he had been born. The "Calling of the Hermit" theme had had a very long history in literature and carried connotations of ideal worlds in which sage-kings sought out virtuous recluses with offers of high official appointments. Xiang, however, seems truly to have had no political aspirations and to have had a genuine call to a reclusive life in which spiritual and aesthetic refinement were the paramount goals.

Xiang's teachers in this endeavor included Dong Qichang, Chen Jiru (1558-1639), Li Rihua (1565-1635), Wang Keyu (1587-1643 or later), and other eminent literati of the previous generation. It is likely that through his family Xiang had come into contact with many of these men at a very early age (Li and Wang also lived in Jiaxing) but it was in the 1620s and '30s that he was closest to them. A handscroll recorded in the *Haogutang Shuhuaji* (1699), entitled "Four Sages Viewing Paintings," depicted Dong, Chen, Xiang himself, and the Jiaxing monk Zhixian (1558-1630). A hanging scroll composition painted in 1652 and titled by Xiang "Honorable Friends" depicted the same four together with Li Rihua and Lu Dezhi (1585-1660 or later), the last a disciple of Li Rihua and Xiang's friend and fellow painter; in Xiang's inscription Dong is identified as "my teacher." Wen Zhenheng (1585-1645), the great-grandson of Wen Zhengming (cat.15), left a record of a gathering in Suzhou which suggests other of Xiang's activities and associations at this time. Among the thirteen ink-stone fanciers who met that day at Wen's studio were Xiang, Chen Guan, Zhao Zuo, Song Xu, Shao Mi, Chen Guo, and Liu Yuanqi, all well-known Suzhou artists.

Collaborative paintings, especially albums but also handscrolls and hanging scrolls to which a number of artists contributed on the same occasion or in fairly close succession, functioned during the late Ming as manifestations or even proclamations of mutual concerns and shared aspirations. Participants in such events contributed knowingly, self-consciously aware of future interest not only in their individual creations but also in the interconnections revealed by the whole. As Wen Zhenheng remarked of the ink-stone society album of paintings: "When this album is transmitted to later days it can be regarded as a Veritable Record written by an unofficial historian" – a play on the formal records of imperial activities written by bureaucratic historians.

"Illustrations in the Spirit of Wang Wei's Poems" is one of the most famous of all late Ming collaborative albums. The album was conceived by Wang Keyu and recorded in his catalog *Shanhuwang Hualu* (1643). During the late 1620s Wang Keyu was living in the north, working for the Salt Commission in Shandong and serving also in Beijing. He conceived the idea of making a collection of paintings done after the poems of the famous Tang poet-painter Wang Wei (699-759) who was particularly admired during this period for his supposed "invention" of ink-monochrome painting, for being the progenitor of the so-called "Southern School" of literati painting, and, according to a popular saying, for being "a painter in whose works there was poetry, and a poet in whose works there were paintings." Wang Keyu thus

began to solicit paintings, usually two each, from artists he met in Shandong, in the capital, and after his return home. Not just any painter was asked to contribute, however, for Wang also conceived the album as the pictorial manifesto of what he called the "Jiaxing Chongzhen-era Painting Society." The album thus contained paintings only by artists from Jiaxing, who would have derived a sense of cohesiveness, of shared approaches and goals, from having contributed to the joint album in fulfillment of Wang's goal that "such early Jiaxing masters as Wu Zhen and Yao Shou will no longer be scattered and alone..."

The original album contained more than one hundred leaves, but already by the time Wang came to record it in his *Shanhuwang* catalog only thirty leaves remained, the others "let go because of the press of circumstances." The sixteen leaves of the present album include thirteen leaves recorded in the *Shanhuwang* but also three that were not, so they must have been part of the original group or were perhaps done later and added to the album after Wang made his notes that were later published. Of particular interest is the fact that of the fifteen painters represented in the present album only eight became famous enough for their names to enter standard biographical compilations; seven of the fifteen are known today *only* from their contributions to this album, and three of them are not included in even the most recent biographical literature. Considering that Wang Keyu solicited paintings only from Jiaxing artists, and only from those he happened to meet during a limited period, the quality of the paintings is astonishing, especially when it is remembered that only Xiang Shengmo and Li Zhaoheng (the son of Li Rihua and Xiang's close friend) had any real reputation for their skill in painting. The late Ming period was truly the heyday of the talented amateur painter.

From 1628 until very early 1629 Xiang Shengmo was in Beijing, where he had gone in response to an official summons, apparently to design the nine emblems traditionally painted on the emperor's sacrificial robes. Li Rihua, to whom Xiang was related through marriage and who contributed to Wang's album, had been chief minister of the Seal Office, the agency responsible for all imperial tallies and seals, and it is likely that Xiang's summons was related to Li's employment at that time. Xiang wrote later of the pleasures of his stay in the north – viewing the natural scenery, taking a trip to see the Great Wall – but he was home again by the second month of 1629 and lived for the rest of his life in retirement. That world, governed by aesthetic laws, with citizenship extended only to understanding friends, was forever shattered by the Manchu invasion which engulfed Jiaxing in 1645. His cousin (or brother) and many others died either in the vain attempt to defend the city or in despair of its imminent loss. Zhu Yizun (1629-1709), related to the Xiang family by marriage and frequent childhood visitor to the collection, recorded: "After the year 1645 those calligraphies and paintings that were not reduced to ashes were all dispersed to others. In recent days scholars of the family still love antiques but their house had suddenly become poor. In large part the original collection has not been returned."

Following the fall of his dynasty and the destruction of the basis for his material prosperity, Xiang expressed his new circumstances in his paintings. He painted far more often than earlier, probably because such work had become necessary to his livelihood. The more personal of his later paintings often affirm his loyalty to the Ming through such visual emblems as red leaves on trees or red skies, the character for cinnabar red also being the Ming imperial surname. One motif which appears both early and late and thus unites the two halves of Xiang's career is that of pines. Xiang obviously loved the trees themselves – his "Pine-wave Studio" was surrounded by pines he planted from 1614 onward, and he called himself "The Fallen Immortal of Pine-wave" – and in later years he must have especially appreciated the symbolic attributes of the pine: strength through adversity and steadfastness. Having continued in robust health through middle age, Xiang died rather suddenly in 1658 at the age of sixty-one.

Catalogue No. 32.
**Cui Zizhong** (1594/95-1644)
*Cangyun Tu*, "Hoarding the Clouds"
Hanging scroll, ink and color on silk, 189 x 50.2 cm.
Inscription: "On the fifth day of the fifth month of the *bingyin* year [i.e. on May 29, 1626, in the solar calendar], I write about Li Bo's Cangyun picture for Xuanyin of my clan. In the completed picture clouds give birth to several marshy places and vapor covers the level groves – like Mount Wu but also like Difei. Former people said that Mount Wu's clouds were like fluffy balls when the weather was clear and like people when the weather was changing and illusory but, in the end, they do not come up to those of Difei's peaks. The clouds themselves are indistinguishable from the grass and trees on the spring mountain peaks, but appear below the feet as one walks and from the sleeves as one sits; those who are travelling can see neither before nor behind them. Historians say that Li Po entered Difei in a chariot. Bearing jugs and pots filled with thick dark clouds, he returned again to release them, reclining within them as he daily drank from the green spring. 'Resting on the white clouds' refers to this activity. Cui Zizhong."
Artist's seals: *Huaxin; Qingyin; Jiazhu Sancheng er...bin*
Collector's seals: Liang Qingbiao (1620-1691), on mounting

Cui Zizhong was born in Laiyang, Shandong province, probably in the year 1595. His initial given name of Dan was soon changed to Zizhong. As a youth he was tutored in the classics by a Laiyang scholar named Song Jideng; Song's son, Mei, and nephew, Yingheng, remained close to Cui in later years when they had all moved to Beijing. Cui passed the first-level examination and was registered as a licentiate in the capital district, but gave up hope of holding office after several failures in the higher examination.

Although known as a poet and a scholar, Cui was famed as a painter, primarily of figural subjects with at times quite esoteric historical or religious connotations. The present "Hoarding the Clouds," which is the earliest of Cui's known dated works, depicts the Tang dynasty poet-official Li Bo (705-762) in the Difei or Zhongnan mountains near Chang'an

in Shaanxi province. The one-horse chariot in which Li rides was given only to honored statesmen, so Li was presumably at the peak of his career. According to Cui's inscription (translated here after that by Julia Andrews), Li has returned to the mountains with dark clouds that he will disperse and then 'recline on the clouds' himself. The latter expression means to retire and live in seclusion, and the Difei mountains were known in the Tang as a temporary refuge for scholars living in retirement from court duty and from whose ranks capable men were drawn for service when their true value was recognized. Cui's painting thus presents Li Bo as bringing his court-sullied spirit back to the purity of the mountains where he will revive and prepare himself for recall to duty and vindication. The subject was thus far removed from Cui's own time and place, and Cui visually communicates the idea of spatial, temporal, and psychic distance by the archaizing, pseudo-naive style of the painting. The coloring and strong sense of patterning are close to those of the thirteenth-century master Qian Xuan, whose style was based on those of Six Dynasties and Tang masters, so the viewing experience is enriched by art-historical as well as historical and literary allusions.

Cui's idiosyncratic approach to painting could never have appealed to a wide or general audience, but he was not a professional artist and painted only as and for whom it pleased him. "At times he would produce paintings and give them to those who understood him, but if ordinary people came and requested them in exchange for gold or silk he would turn his head and ignore them even if he were impoverished and starving." Cui's reputation as an artist was thus unsought but nonetheless grew until by the later 1620s he was an established painter; by the later 1630s he was being paired with Chen Hongshou (cat.33), the great figure-specialist from Hangzhou, as "Chen of the South, Cui of the North." In 1633 Cui visited Dong Qichang (cat.28), who had been called to Beijing to serve as tutor to the heir apparent. Dong, perhaps the most famous connoisseur of his day, judged Cui's painting, writing, and character to be most uncommon for that modern age.

Cui was as eccentric in life as in his painting style. He is said to have worn the rustic clothes of a Daoist priest and to have had the manner of an ancient recluse. Both Qian Qianyi (1582-1664) and Zhou Lianggong (1612-1672) described the circumstances under which Cui lived at this time. Located within the walled market area of the city, his dwelling was shielded by luxuriant plants; compacted dirt covered the outdoor seating mats, indicating that there were few visitors, while he planted flowers and raised fish as if in a bygone age. Together with his wife and two daughters, Cui lived in a simple house with wicker door and earthen walls, but all was kept spotlessly clean. His dress was spartan, rough wool for winter, rough bean-fiber cloth for summer. His wife's clothes were also plain, made by herself with great effort. The females of the family were literate and could expound on literary meaning and paint. Their days were not structured but peaceful and leisured. Zhou Lianggong noted Cui's aloofness from all but a few close friends: "Many of the statesmen of that time humbled their official positions in wishing to meet him but he ignored and avoided them all. He did not enjoy drinking wine but rather with two or three

old friends would meet over literary matters, talking the whole day so they were unable to leave. Scholars came from the four quarters, since they admired his character, but he would decline and not meet them..."

Two anecdotes suggest the rather complicated relationships the proud and independent Cui maintained with even his friends. "When his childhood study-companion Song Yingheng held temporary appointment in the Ministry of Civil Office he directed one of those selected for employment to present one thousand in gold to Cui 'for his old age.' When Cui next saw Song, he laughed and said: 'You remembered that I am poor but, instead of taking out what is in your own wallet and giving it to me, you forced those who live with me to accept gold from the one you selected. We studied together when young, but you still don't understand Cui Zizhong's kind of face!" Even direct assistance, correctly offered and hence accepted, did not always alleviate the deprivation suffered by Cui and his family. "When his good friend Shi Kefa [1601-1645] returned to the capital from Anhui, he stayed at home for a day and called on Cui Zizhong. Noting that Cui's gate was deserted and bleak and that the smoke from the morning cooking fire was intermittent, Shi left the horse he had ridden over on as a present and returned home on foot. Cui then led the horse to market, where he sold it for 140 taels of silver. He then invited all his closest friends to drink and eat with him saying: 'This wine came from master Shi Kefa; it is not from the polluted stream!' The money was gone within a single day and, once again, Cui was without food as before." It is clear that style was as important in Cui's personal life as it was in his art; Shi's impulsive and magnanimous gesture required an equally spontaneous and generous response. Such actions were of course criticized by some people, but Cui's life seems to have been organized around concepts of heroism and comradeship emanating from the third-century period of the late Han and Three Kingdoms era: "Social intercourse flourishes when friendship associations are established, as can be seen by examining the period of the late Eastern Han dynasty." Cui, Song Yingheng and many other of Cui's friends were members of the Fushe, "Revival Society," which sought politically to reform and revitalize modern society by reviving earlier values and attitudes through study of ancient literature. Cui's entire mode of life, including the subjects of his paintings and the style in which they were rendered, is thus in some sense part of the revival movement.

According to Zhou Lianggong, Cui became sick and almost died when he was fifty by Chinese count. Shortly thereafter he became enmeshed in the rebellion of the bandit Li Zicheng, who entered the capital on April 25, 1644. Cui hid himself and his family in a poorer district of the city but, since his already meager subsistence had probably depended on a government stipend, he now had absolutely nothing on which to live. Qian Qianyi recorded that Cui then relied on a friend, who already had several dependents of his own. Although the resulting burden was far too much for a single person, the friend never said a word to Cui. When Cui perceived the true state of affairs, he was adamant about leaving. His friend's heroic generosity demanded an equally heroic rejection of it and, for Cui, the ultimate gesture of self-sacrifice. Unwilling to become a refugee, facing the imminent

arrival of the Manchu troops, Cui carved his final home from the soft loess soil and there let himself starve to death. Although Cui was not a military man, some would find in his principled departure from life the same nobility that characterized Shi Kefa's glorious defense of Yangzhou and his ultimate death after refusing to surrender to the Manchu troops, for Cui too chose death rather than life under the invaders.

Catalogue No. 33.
**Chen Hongshou** (1598-1652)
*Nuxian Tu*, "Female Immortals"
Hanging scroll, ink and color on silk, 172.5 x 95.5 cm.
Inscription: "Hongshou, called Laolian, from Xishan, painted this at the Fond-of-Flowers Hall. Yan Zhan painted the color."
Artist's seals: *Chen Hongshou Yin*; *Zhanghou*

Two women, the taller, more imposing figure holding a staff with gourds and a wood-ringed tray, the smaller attendant holding a semi-transparent glass or crystal vase with branch of blossoming plum, stand in a desolate environment defined by seemingly organic rocks. The drawing in firm, virtually unmodulated lineament lends an air of stiffness and angularity to the figures which suggests that they rather than the rocks are composed of adamantine substance. Much attention has been given to the textile patterns: continuous cloud-scroll on the robe of the attendant, cloth garlands hanging from floral medallions on the robe of the larger figure; these last are set against a background diaper pattern. Rather than enhancing a naturalistic interpretation of the figures, the textile patterns are arranged without regard for the natural fall of the cloth and hence, being flat, visually deny the substantiality of the figures themselves.

Precise identification of these figures is difficult but the painting must have been created for presentation on some specific occasion. For example, images of Xi Wangmu, Queen Mother of the West, were given to women on their fiftieth birthday, while paintings of Magu were presented to couples on their silver and golden wedding anniversaries. Supporting an identification as Magu are the long, talon-like fingernails, the branch of blossoming plum – her name is also given as "Plum-blossom Girl" – and the garlands of cloth. Edward Schaffer has noted of Magu that "she had 'seen the Eastern Sea thrice become mulberry fields' – a catastrophe which made it possible to walk dryshod to the holy island of Penglai." Schaffer also mentions that Yan Zhenqing in the 8th century "observed that rock formations near a Daoist sanctuary on Mount Magu, where the goddess had achieved divine powers, contained the shells of gastropods and oysters."

The artist, Chen Hongshou, was born in Zhuji, near Shaoxing in Zhejiang province. His grandfather had served as an official in Shanxi and Guangdong provinces and his father studied for the examinations until his untimely death when Chen was only eight years old. Growing up within a scholarly context Chen too naturally pursued an official career; he passed the first-level examination in 1618 and

attempted the second-level provincial examination in 1623 and in 1638. Failing in both those attempts, in 1642 Chen purchased a senior licentiate position which allowed him to bypass the second-level examination and qualified him for relatively low-level employment. He accepted a position as drafter but was put to work making copies of imperial portraits and resigned after only three months. The academic side of Chen's career was thus a disappointment, to himself as well as to others, for he certainly accepted his society's definition of the obligations of his class and of the relative social values of various occupations. However, his real talent lay elsewhere and he seems to have been temperamentally better suited to the less structured life of an artist than to the self-disciplined endeavors of a bureaucrat. In a recent article Kohara Hironobu has pointed to the tensions that invariably arose between these different potential roles and also called attention to a possible role model, the sixteenth-century master Xu Wei (cat.24), who had been a friend of Chen's father and in whose former house Chen lived in 1644-45 after returning from the north.

According to Zhu Yizun (1629-1709), Chen's natural talent in painting surfaced at the age of four, when he painted a ten-foot image of Guan Yu, the god of war, on a freshly plastered wall of the home of his future father-in-law, the scholar Lai Sixing. About a year or so after his father died Chen began to study with the foremost Hangzhou painter of the day, Lan Ying (cat.30). Another Hangzhou artist, Sun Di, who often collaborated with Lan, remarked after seeing Chen's work: "When his painting style is mature, Wu Daozi [of the Tang] and Zhao Mengfu [of the Yuan dynasty] will both have to face northward [in obeisance], and how will such as we even dare to raise our brushes!" Chen's technique had developed enough by the time he was thirteen that his paintings could be sold in the market. This income was probably essential to Chen's well-being, for his elder brother inherited the family property on the death of their grandfather in 1615. Despite his need, Chen would undoubtedly have preferred to have been known solely for his scholarship and for his relationships with such literati as Liu Zongzhou (1578-1645), with whom Chen studied around 1615, Chen Jiru (1558-1639), and Zhou Lianggong (1612-1672). In 1626 Chen wrote of his shame that his paintings and calligraphy were circulated in the world.

Yet despite those feelings, which arose from the discrepancy between what he was in fact and what he himself as well as the surrounding world held as the only worthy goals, Chen had high ambition in art and made no attempt to submerge his talent in the ever lengthening shadow of past achievement. To the contrary, Chen seems to have been concerned from the beginning with developing a distinctive style of his own, with a creative transformation of the past that would mark him as an artist to be reckoned with. According to Zhou Lianggong: "Chen studied painting as a child, so he was not inexperienced in representation. He crossed the Qiantang River and took rubbings of the stone engravings in Hangzhou done after Li Gonglin's 'Seventy-two Worthy Disciples of Confucius.' Closing his door, he copied them for ten days; when they were all completed he brought them out and showed them to people, saying: 'How are they?' and they answered: 'They are alike' and he was

then pleased. He again copied for ten days, and brought those out to show to people, saying: 'How are they?' and they replied: 'They are not alike' and he was then still more pleased. So in the several copies he transformed his models – changing the round into square, changing the whole into parts – so that people could not recognize them." Zhou Lianggong also noted that Chen's work was thought strange by many of his contemporaries, by those who lacked the sensitivity to appreciate the classical foundation from which he had begun: "People only exclaim at his strange extravagances and know not that his every brushstroke has its historical precedent. He passed the Water-Land Retreat in Pingyang and saw several tens of genuine works by Wu Daozi. On returning home he said to people: 'You all say that I am unclassical, but now you will become aware that Wu Daozi prefigured me. Was Wu then also unclassical?" Other endeavors of the 1630s which could not but focus attention on his activity as well as creativity in his natural role of artist included the designing of woodblock illustrations to the *Xixiang Ji*, "Romance of the West Chamber," and playing-card designs based on characters from the novel *Shuihu Zhuan*, "Water Margin."

Chen stayed in Beijing from 1640 until 1643, renewing his friendship with Zhou Lianggong and forming a poetry society. His reputation as an artist continued to grow, and it was probably at this time that he came to be paired with Cui Zizhong (cat.32), another friend of Zhou Lianggong, as "Chen of the South, Cui of the North." Perhaps the only benefit Chen derived from his brief period of court service was the opportunity to study paintings in the imperial collection. According to Zhou Lianggong: "During the Chongzhen era he was summoned to enter service as a drafter. Sent to copy the 'Portraits of Emperors of Successive Dynasties,' he was thus able to view freely the paintings in the Great Inner Court. Consequently his paintings became increasingly advanced..." In leaving office after only several months and returning home Chen had good historical precedent, the poet Tao Qian (365-427), who returned home after serving for only eighty-three days, saying that 'he could not crook the hinges of his back for five pecks of rice a day.' On several occasions Chen painted illustrations to Tao's "Home Again" masterwork written on the joys of retirement, and that model may well have been in Chen's thoughts on his return home.

Chen first lived in Xu Wei's old house and then, on the fall of Hangzhou to the Manchus in 1645, took refuge, as did his old teacher Lan Ying, in a temple. Chen then called himself the "Yunmen Monk," also Huichi, "Regretful Too Late," and Laochi, "Old and Remiss." The sentiments expressed by the last two names are common to many men approaching the age of fifty and increasingly aware of opportunities forever lost; the downfall of his dynasty would have given Chen additional causes for regret over what he and his contemporaries had done and failed to do. Perhaps still attempting to organize his life according to an outer ideal, Chen borrowed money from friends and built a mountain retreat where, in theory, he should have lived out his days as had Tao Qian, surrounded by his loving family, which in Chen's case included six sons, three daughters, one wife, and one concubine. However, by this time Chen was a thoroughly professional painter and required easy access to the urban

markets, and Chen was in any case a very urban man. According to the *Yuehua Jianwen*: "Chen by nature was boastful and loved women. If there was not a woman at his seat he did not drink, and at night in his bedchamber if there was not a woman he could not sleep, and those who brought a woman when seeking a painting met with instant agreement. He once went to a brothel in Nanjing and a courtesan set up drinks and food for their entertainment. When the wine had intoxicated him, she demanded a painting and he happily called for a brush. Afterward all regarded this as custom, and those people who wished to obtain his paintings strove to get them from the courtesans, so the gold coins gathered by the prostitutes were incalculable..."

During the last few years of his life Chen was often assisted by his fourth son, Chen Zi, and by Yan Zhan, who worked on the present painting. Whereas Gao Qipei (cat.62) used assistants for line work but insisted on applying the color himself, Chen let others add color to his own wondrously drawn linear structures, as had Wu Daozi before him. In his last years, Chen surveyed his profession and its practitioners and analyzed the strengths and weaknesses of various approaches and schools: "Men of today do not study the ancients but rely on a few themes to establish their careers through plagiarism. When those of empty fame for delicate fineness wield the brush and do paintings, their brush and ink do not discharge their duties, and neither do their forms and likenesses compare [with those of their subjects]. Alas! Seeking after fame by making points to people and by ridiculing or criticising one's successful elders is what I am most dissatisfied with in the currents of the famous... Those contemporary specialists who study Song painting lose out to craftsmanship. How so? They do not bring in the models of Tang. Those who study Yuan painting lose out to rusticity, for they do not search out the Song origins... I would like the famous current of painters to study the ancients, extensively inspecting Song painting and just into the Yuan; I would like the specialists to model themselves on Song men and entreat them to bring in the Tang..." In 1650 Chen had his final meeting with Zhou Lianggong, who described the artist at work: "We met one another again at the Dingxiang Bridge. He said with great joy: 'This is the time for me to do paintings for you,' and hurriedly ordered silk and paper. Sometimes he would select yellow-leafed vegetables to go with the deep black brew of Shaoxing, sometimes he would ask Xiao Shuqing to lean on the railing and sing but then, after only a few notes, abruptly tell her to stop, sometimes he would use one hand to scrape the dirt from his head, sometimes he would use two fingers to scratch the toes of his feet, sometimes he would stare fixedly without speaking, sometimes his hands would grasp but his mouth did not speak as he dallied with the maidens – for the most part there was not even ten minutes of peace and quiet. From the Dingxiang Bridge we moved to my lodgings, from my lodgings to the lake shore, to a Daoist temple, to a boat, and to Zhaoqing, where we reached my ancestor's river pavilion carrying only brush and ink. Within eleven days all told he did for me a total of forty-two large and small horizontal and vertical scrolls..." Zhou also recorded a letter sent to him by his friend Zou Zhe (cat.48), whose complaint about Chen illumines another side of his production: "My friends

all praise Chen's 'Scenes of Intimate Play' as wonderful illustrations beyond compare, but I think that the line from the Buddhist sutra, 'A painter's portfolio is completed by ingenuity and craft, but contained within are the offensive, the putrid, and all manner of impurities' was said because of this sort of thing. I was not aware that Chen had sunk into such evil pleasures as these are. I am not willing to look at them." In 1652, at the age of fifty-four, Chen Hongshou died, according to some from the effects of medicine taken to increase his virility.

Catalogue No. 34.
**Wang Shimin** (1592-1680)
*Yushan Xibie Tu,* "Taking Leave for Yushan"
Hanging scroll, ink on paper, 134 x 60.2 cm.
Inscription: "Master Dai Ruiyang of Fujian comes from an old literary clan. In order to market tobacco he came to Lou and rented a house of several rooms facing mine in which to live. After many years of being neighbors, I know him to be honest and sincere as a person, broad-minded and generous, and liberally endowed with a scholarly air; I am very fond of him. Now he is going to move to Yushan and I am very reluctant to part with him. During early autumn of the year 1668, Wang Shimin, called Xilu Laoren, inscribed this at the age of seventy-six."
Artist's seals: *Zhenji; Wang Shimin; Xilu Laoren*

The rather crowded and complex composition is yet immediately comprehensible due to the clear ordering of all parts in relation to the whole. The remarkable consistency and hence visual unity is the result of an extremely logical system of construction in which larger pictorial structures are all composed of units of rather similar size and shape, which are in turn built up from a limited repertoire of brush strokes. The long rope-like or "hemp-fiber" texture strokes as well as the lumpy "alum-head" configuration of the mountain peaks was derived from the tenth-century styles of Dong Yuan and Juran, while the tree types and cubistic structure of the mountains are visual references to one of their major fourteenth-century followers, Huang Gongwang. The present artist, Wang Shimin, admired Huang over all other classic masters and followed him in well over half of his known paintings.

Like most of Wang's finest pictorial achievements, this painting was done for presentation to a close friend. The recipient was a Fujian merchant who had come to the village in which Wang Shimin's estate was located in connection with the highly lucrative tobacco trade. Introduced into China during the late sixteenth century, probably from the Philippines, tobacco rapidly became used by even young children and was banned during the Chongzhen era (1628-1644); its cultivation and use continued to spread, however, for the economic return was very high. Wang Shimin was a major landowner in the district and his relationship with Master Dai may thus have been commercial as well as personal.

Wang Shimin was born in Taicang, Jiangsu province, into one of the most distinguished families of the south. His father, Wang Heng, passed the third-level examination in 1601 and was appointed to the Hanlin Academy, but died in 1609 at the age of forty-eight. Shimin was thus raised mainly by his grandfather, the famous grand secretary Wang Xijue (1534-1611), with whom Shimin lived until his marriage in 1608 at the age of sixteen. Xijue, who had retired in 1594, was an early admirer of Dong Qichang (cat.28); following his own retirement in 1605 Dong assisted his old mentor in Shimin's literary and art-historical education. Xijue was so delighted with his grandson's progress in painting under Dong's tutelage that he bought paintings for the boy to study through copying. In later years Shimin too would become an important collector and patron, and one of the earliest works dedicated to him is a scroll painted in 1612 by Ding Yunpeng, an important contemporaneous painter of Buddhist figures and a friend of both Dong and Chen Jiru (1558-1639).

For several years following Xijue's death Shimin was occupied in writing a chronological biography of his grandfather and in preparing his grandfather's writings for publication. In 1614 Wang Shimin took advantage of hereditary privilege awarded him in recognition of his grandfather's merit and, without ever having taken an examination, received an appointment to the Seal Office. On the death of his wife, whose three sons had all died in infancy, Wang returned home in 1615 and during the subsequent period of mourning prepared his father's literary works for publication. A portrait of Wang painted in 1616 by the important portraitist Zeng Qing shows the sensitive twenty-four-year-old dressed as a Buddhist adept and seated cross-legged on a straw mat, a fly-whisk in one hand and the other in a *mudra*.

Between 1617 and 1627 Wang was almost continuously in Beijing, although his position involved frequent journeys to visit the princely establishments maintained in the provinces by imperial sons. In 1624 he was promoted to the fairly high rank of chief minister of the Seal Office. Wang's family responsibilities continued to grow with the birth of his eldest son in 1619; by the end of his life Wang had fathered nine sons by five concubines. The earliest of Wang's extant paintings date to the 1620s and appear the result of renewed contact from 1623 onward with his old teacher, Dong Qichang. Wang's paintings of this period often bear inscriptions written by Dong and Chen Jiru, both of whom highly praised the young artist. Wang continued to patronize other artists himself, for example in 1625 he commissioned an album of garden scenes from Shen Shichong (cat.25). Even more importantly, Wang began to build a small but very fine collection of classic works of art. A significant number of these had been owned by Dong Qichang and sold directly to Wang or had gone first, especially in the late 1610s when Dong had severe financial problems, to a collector named Cheng Jibo, who was Wang Shimin's neighbor in the capital during the mid-1620s. Wang assessed his acquisitions as follows: "I used the whole of my life's blood in bringing together sixteen famous works of the Song and Yuan and treasured and cared for them not less than for the eyes of my head or the marrow of my brain..."

It is sometimes reported that Wang Shimin's mother died when he was only a year old. However, while Madame Feng, the wife of his father, was the legal mother of all her

husband's children, Shimin's natural mother, surnamed Zhou, lived with him even in Beijing until her death in 1628, when Wang again returned home to observe a period of mourning. Around this time financial pressures led Wang to dispose of his collection of paintings: "For several years now I have been feeble and sick, encroached upon by those seeking absurd taxes, and will soon be impoverished. Being unable to hold on to my paintings, I dispersed them one by one to enthusiasts. My household is now empty, and not a single one is still preserved. I feel desolate and lonely, like a fish that has lost its water..."

Wang's consolation during his later years was an album named *Xiaozhong Xianda*, "The Great Revealed Within the Small." This still-extant album of twenty-two leaves, which reproduce in reduced size the famous scrolls owned by Wang Shimin, is not signed and has been attributed variously to Dong Qichang, to Wang Jian (cat.35), and to Wang Shimin himself. It was most likely painted for Wang by Chen Lian, however, who is said to have ghost-painted for Dong and who was the recipient in 1612 of one of Dong's own masterworks. In a colophon to another of Chen's paintings Wang Shimin wrote: "Chen Lian's paintings are elegant and refined, unassuming and peaceful, for they assuredly were brought forth from within his innermost self. In the beginning he took Zhao Zuo as his teacher and then came to my house where he freely looked at many genuine Song and Yuan works. Being thus enlightened, his attainments became still more profound. He copied for me various famous pictures, taking long and huge hanging scrolls and reducing their scale to make a square album. He was able to cause his brush and ink to be extremely similar to the originals and did not lose so much as one hair... It is unfortunate that he passed away at the age of fifty before seizing the standard and red flag within Suzhou as the compass for later generations." This account is confirmed by an inscription dated to 1662 by Wang Jian: "Wang Shimin once took the genuine works by great Song and Yuan masters that he owned and commissioned his old friend from Huating, Chen Lian, to reduce their scale into an album." The *Xiaozhong Xianda* album is provided with inscriptions written by Dong Qichang on the facing pages; although composed for the original, full-scale paintings by Dong at various times between around 1598 and 1627, they were rewritten by Dong at the request of Wang Shimin for the completed album painted by Chen Lian. An inscription dated to 1681 by Wang Shimin's grandson, Wang Yuanqi (cat.50), indicates that the work remained in the family and continued to spread the gospel according to the orthodox school: "Huating's Dong Qichang inscribed the title page of 'The Great Revealed Within the Small' and also re-inscribed each leaf with the words of his original colophons of appreciation and connoisseurship so as to introduce his ideas on origins and transmission..." Chen Lian's album, which provides some idea of what Dong may have had in mind for an illustrated *Huashuo*, was very important in the evolution of the orthodox school, for it provided stylistic models that could be studied and emulated even in the absence of the original monuments themselves. Wang Jian, for example, stated that he borrowed Chen's album from Wang Shimin and made his own copy of it, and Wang Hui too may have made use of Chen's album as

primary visual material during his art-historical education at the home of Wang Shimin.

Between 1636 and 1639 Wang worked as vice-minister of the Court of Imperial Sacrifice, the highest office he was ever to hold. Although the official reason given for his resignation in 1639 was ill health, – a peculiar condition which kept Wang very close to home for the remaining forty-one years of his life but impeded in no observable fashion his active social and intellectual life – Wang's reasons for withdrawal were undoubtedly related to the political situation of the day. Neither Wang nor his teacher Dong Qichang were active partisans of either the liberal Fushe, "Revival Society," or its opponents, but they did work with and became friends of some of the leaders of the latter group, especially Wen Tiren and Zhou Yanru. Dong presented a Song painting from his collection to Zhou when the latter was leaving Beijing after his impeachment by the Fushe faction, and soon left the capital himself; Wang Shimin left office the year after Chief Grand Secretary Wen Tiren's fall from power and death. In Wang's case the situation was likely exacerbated by his position of great wealth and prestige in Taicang, the town in which Zhang Pu founded the reformist Fushe in 1627. Wang's divestiture of his famous collection of paintings may have been intended to blunt local criticism of such conspicuous consumption, and perhaps he, like Ni Zan of the late Yuan, foresaw the beginning of a period in which wealth would become not a bulwark against but rather a target for the forces of disintegration. In any case, in 1642, the Wang family sought to broaden their local base of support by establishing a charitable organization for the distribution of food to the needy and also paid taxes of ten thousand gold taels even though this necessitated pawning many of the family possessions. In 1644 the Prince of Fu canonized Dong Qichang and invited Wang Shimin to join his court as chief minister of the Court of Imperial Sacrifice, but Wang wisely declined to join his fate with that of the last serious contender for succession to the Ming line and stayed at home. By the early eighteenth century the Wangs of Taicang were again in power, for Wang Shimin's eighth son rose to be grand secretary under the Kangxi emperor and his grandson became a favored painter of that monarch.

In later years Wang devoted his energies almost exclusively to his family, his estate, and his friends. Perhaps remembering his own close relationship with Wang Xijue, Shimin spent much time in teaching and encouraging Wang Yuanqi. Wang also derived considerable enjoyment from adding various buildings and pavilions to the family estate and in 1663 had one of the gardens redone by the famous Zhang Ran, who later worked for the imperial court in Beijing. Wang foreshadowed another imperial practice by keeping a troop of young male actors, in his case one trained by the renowned teacher of acting and singing, Su Kunshan. Wang also spent many pleasurable days with such artist-friends as Wang Jian and Wu Weiye; Bian Wenyu lived with Wang for a time as did the younger master Wang Hui (cat.49), who was praised by the elder Wang on innumerable occasions. On an album of landscape paintings done by Dong Qichang, for example, Wang Shimin inscribed the following words in 1668: "Truly this is able to evoke the simplicity and understatement of a lofty person. I bought this for

my collection more than twenty years ago. Just now Wang Hui came by my humble studio and looked at it. Sighing in admiration, he could not set it aside, so I gave it to him, not only because his own tall peaks and flowing rivers are praised by those who know him but also because they are exactly like Dong's in taste." No gesture is more telling of Wang's role as a true conservative, one who preserved the best of the past and enriched it before transmission to the future.

Catalogue No. 35.
**Wang Jian** (1598-1677)
*Shanshui*, "Landscape"
Hanging scroll, ink on gold paper, 155.3 x 86.9 cm.
Inscription: "On a summer day in the year 1663, done for the sixtieth birthday of my old relative Zhanyuan. Wang Jian."
Artist's seal: *Wang Jian zhi Yin*

This landscape was painted on the gold-coated paper used more frequently by calligraphers; the ink is not readily able to soak into such paper and remains on the light-reflective surface which highlights the quality of the individual brush strokes. The result is highly cerebral, almost an icon of orthodox school landscapes, whose essential characteristics have been analyzed by James Cahill as follows: (1) compositions are typically built up of units of limited variety in size and shape; (2) the compositional instabilities of Dong Qichang are usually eschewed in favor of more static compositions; (3) depiction of atmosphere is usually limited to patches of mist and there is relatively little attempt to render space and distance convincingly, or light and shadow; (4) type-forms are used extensively, sometimes modified by the manner being followed; (5) texture strokes tend to be applied very uniformly and often have a directional function; (6) brushwork generally remains within the confines of a special, definable mode of blending wet and dry strokes, darker over lighter, overlaid to build up a contour or define a surface; (7) color generally follows the formalized warm-cool system used by literati landscapists from the Yuan onward.

Wang Jian was born in Taicang, Jiangsu, into the family of the influential writer-official Wang Shizhen (1526-1590), the most important family in the region after that of Wang Xijue. Shizhen and Xijue were good friends and the families remained close into the generation of Wang Shimin (cat.34), grandson of Xijue, and Wang Jian, great-grandson of Shizhen. Wang Jian lived in Suzhou during the early 1630s, and passed the second-level examination in 1633. While Wang may have met Dong Qichang (cat.28) in Beijing at that time, he recalled on several later occasions his meetings with Dong at the latter's home in 1636 and seeing the classic works then still in the master's collection. Dong of course had words of advice for the young artist: "In the study of painting it is only by frequent imitation of the ancients that one's mind and hand are matured and one can become famous." Dong seems to have encouraged Wang's early efforts – "When I first studied painting I followed Huang Gongwang and those paintings for some reason were appre-

ciated by Dong" – setting the young man on the course he would follow in art for the rest of his life.

Wang Jian served in one of the Beijing ministries until around 1638 when, like Wang Shimin, he was perhaps affected by the fall from power of Wen Tiren. Wang Jian then took advantage of hereditary privilege granted on the basis of his great-grandfather's merit and was appointed prefect of Lianzhou in Guangdong province. While in the south Wang became concerned about the numbers of mines being opened and unsuccessfully petitioned his superiors to stop the practice. After serving from around 1639 to 1641 Wang resigned and returned home, perhaps in response to the same forces that besieged Wang Shimin at this time, never to hold office again. After his return Wang Jian built a two-room studio to the north of Mount Yan on the family estate. "It would only admit one's knees, but outside the windows all was planted in flowers and bamboo for use in painting. Wang Shimin came by and wrote a tablet inscription for it which read: *Ranxiang*, 'Imbued with Fragrance,' a phrase from the *Lengyan Sutra*. From then on I excluded everyone and every day sat on a rush mat, lit cedarwood incense in the incense burner and did nothing more."

Among Wang's other activities was certainly the enjoyment of whatever paintings he had inherited from Wang Shizhen. According to the *Wusheng Shishi*, "Wang Shizhen's collection of famous works with their gold labels and jade rollers are not to be valued less than the sovereign of a hundred cities. Because Wang Jian unrolled and studied them for long, his spirit melded with the paintings and there was an intuitive understanding. What he received from them was profound, so his thirsty brush and ink had their sources." Wang Jian shared these treasures with his close friends, especially Wang Shimin, and with such students as Wang Hui (cat.49), who introduced himself to the famed artist-collector in 1651. Wang Jian also knew the poet Wu Weiye (1609-1671) in his later years and was included in Wu's famous poem *Huazhong Jiuyou*, "Song of My Nine Friends in Painting." Those mentioned in the poem, Dong Qichang, Wang Shimin, Wang Jian, Li Liufang, Yang Wenzong, Zhang Xuezeng, Cheng Jiasui, Bian Wenyu, and Shao Mi, very likely all knew one another as well as Wu, but they painted in different styles and did not constitute a group in that sense.

In the year 1674 Wang Hui brought his student, Yang Jin, to visit Wang Jian and the two younger men collaborated on a portrait of the old master. Wang Hui signed the painting "your disciple," Yang Jin wrote "your later student," and Wang Jian recalled a pearl of wisdom from his own teacher: "Dong Qichang often said that there are things in the world which seem easy but in reality are difficult, but none are like the brush and ink-work of painting. Today painters are as numerous as the sea of clouds but among them I esteem only Wang Hui, and he too agrees with the accuracy of Dong's words... In the past Gu Kaizhi [ca.344-ca.406] wished to paint Yin Hao's portrait but Yin declined because of his eye disease. I have had a stroke and present a very ugly appearance, but Yang Jin hid the ugly and vile crookedness and depicted the spirit lying beyond the forms. Could the other painters of today see this even in their dreams?"

Catalogue No. 36.
**Xiao Yuncong** (1596-1673)
*Xueyue Dushu Tu,* "Reading in Snowy Mountains"
Hanging scroll, ink and color on paper, 124.8 x 47.7 cm.
Inscription: (after a four-stanza poem) "During the summer solstice of the year 1652, I did this 'Reading in Snowy Mountains' picture for my society brother Yizhi. At that time I wrote some verses with a good rhyming scheme that I append here as a small song and ask for his instruction. Xiao Yuncong, his younger brother from Meixia at Zhongshan."
Artist's seals: *Xiao Yuncong*; *Yuncong Long* ("Dragon Followed by Clouds")

Warm tints of color identify areas of human habitation and animate life within an otherwise stark and somber natural setting. The impression of seclusion and security of these oases is heightened by the visual contrast with the angular, faceted, and contorted forms of the mountain peaks. The painting relates in terms of style and technique to works by Suzhou artists (see cat.20, 21), and the strongly vertical composition which fills the format with evenly distributed forms relates to paintings by Wen Zhengming (cat.15) of the same school. An earlier model for the angular rocks topped by close-cropped shrubs and trees is the eleventh-century master Fan Kuan, whose extant attributed snowscapes include imitations produced in the sixteenth and seventeenth centuries and likely available to somewhat later artists such as Xiao Yuncong. "Reading in Snowy Mountains" is related to paintings by Xiao recorded in the catalog *Shibaizhai Shuhua Lu* (eighteenth century) and *Bixiaoxuan Shuhua Lu* (1839). Both sources record the same poem and inscription as appear here, save that the first does not mention Yizhi and the second indicates two missing characters where the name of Xiao's society brother would have been written.

Xiao Yuncong was born in Wuhu, up-river from Nanjing in central Anhui province. The night before he was born, his father, a man of some status in the town, dreamed that the great tenth-century artist Guo Zhongshu appeared at his door and said: "The Xiao family is about to flourish greatly; I will act as your heir." Xiao himself would later commemorate that auspicious beginning by using a seal whose legend referred to himself as the reincarnation of the earlier master. Xiao and his two younger brothers all received a classical education and studied for the civil service examinations. Xiao's natural talent seems to have been for painting, also for music, in which he became a noted authority on pitch and notational theory. In the course of his studies Xiao travelled to Beijing and the secondary capital of Nanjing, where he lived on the Qinhuai River at Peach-leaf Ford. In his home town of Wuhu, Xiao built a house near the Dreaming-of-the-Sun Pavilion erected by Wang Dun (d.324). Xiao named his house "Plum-blossom Dwelling" after the trees he planted around it. It is clear that Xiao was painting during this period but he did so only for his own pleasure and was unwilling to work for any but close friends.

Much of Xiao's time and energy during the late 1620s and '30s must have been consumed by the very lively intellectual-political life of Nanjing. Both he and his brother, Yunqian, were members of the politico-literary Fushe, or "Revival Society," and his brother was signatory to the so-called Nanjing Manifesto of 1639 which denounced a major political opponent of the society. Xiao Yuncong tried in 1636, 1639, and 1642 to pass the second or provincial-level examination, but the best he achieved was only first on the supplementary list of candidates. Both of his younger brothers earned higher degrees, Yunqian a second-level degree in 1639 and Yunlu possibly a third-level degree in 1642. These auguries of eventual prosperity for the Xiao family were proved wrong, however, by the Manchu invasion of 1644 which marked the end of Ming rule; Yangzhou's brave defenders were massacred after its fall in the fourth month of 1645, Nanjing capitulated the following month, and Wuhu surrendered shortly after.

When Xiao returned to Wuhu in 1647 he found his home there in shambles. "In former days I had a small house at East Bank very near the pond of Wang Dun's Dreaming-of-the-Sun Pavilion. Sometime after the year 1644 it was seized by the occupying troops who ruined it by stabling their horses there. Not until the fall of 1647 was I able to bring my sons and clean the book-boxes and mats of dirt and filth and repair the walls enough to ward off wind and rain to live within. Forced by the chaos to leave for other places, relatives and friends became exhausted and broken, offended by their circumstances and injured within. Suddenly my grief and anger are aroused against these miseries and tribulations and by the evils which come without end. Besides, I am now old, sick, and capable of nothing; without resources my sun is setting..." Beginning in 1648, Xiao frequently used a seal whose legend, "Old Man from Mount Zhong," carried a range of telling connotations. Mount Zhong was located near Nanjing, which during the Liang dynasty (502-557) had been the capital of a dynasty founded by the Xiao clan. Immediately prior to 1648, Xiao Yuncong had been living in Nanjing and was included in Nanjing local histories as a distinguished sojourner. Finally, Mount Zhong was where the founder of the Ming dynasty was buried, hence the legend of Xiao's seal indirectly presented him as a loyal descendant of the Ming, whose sun had already permanently set.

Unwilling to serve the Manchus, Xiao had little except painting by which to earn his living. One of his first commissions following his return from Nanjing was from a prefectural judge, who was to be transferred from the district and wished some permanent visual record of Taiping prefecture, which included Wuhu, Dangtu, and Fanchang districts. Xiao produced forty-two illustrations of specific locales plus one panoramic view of the entire prefecture, and these were then reproduced via woodblocks with a preface and annotations provided by the judge, Zhang Wanxuan. The album made good use of Xiao's literary as well as artistic skills, for each scene was accompanied by a verse composed by some illustrious poet of old and was painted in a style based, however loosely, on that of individual masters active from the Tang (Wang Wei and Wu Daozi) through the Ming dynasty (Shen Zhou [cat.12] and Tang Yin [cat.16]). One of the scenes is entitled "Dreaming-of-the-Sun Pavilion" and probably includes a portrait of Xiao's recently refurbished house. The wide circulation of the block-printed illustrations of the "Landscape of Taiping Prefecture" as well as other, similar publications – Xiao's "Illustrations to the 'Songs of Chu'" were completed

by 1645 – must have spread his fame and increased the demand for his work.

By the late 1640s Xiao had re-established a stable life, and his inscription on a painting done in 1649 gives a clear picture of his state of mind: "Painting may be a playful affair but melancholy feelings can also be associated with it. When I was young and had time to spare from studying for the examinations I was very devoted to painting and in neither summer nor winter did I set it aside. However, in recent years I have wandered about, moving from place to place, and my teeth are falling out and my eyesight is dim. Although only fifty years old I repeat myself like an old man of eighty or ninety. Thus when I grasp the brush I have to contend with roughness and unevenness. Whenever there is someone who wants a painting I entrust the commission to my nephew Yiyun. Although Yun is only in his early twenties he has travelled to Zha and Zhao [in Zhejiang province] and crossed Mt. Heng to the Xiang River [in Hunan province]. He was already known for his painting and after he returned to me he strengthened his determination, so his door already has an iron threshold [necessary because of the numerous students who pass over it]." Xiao trained his three sons, Yiqi, Yiqian, and Yicun, as well as three of his nephews, Yang, Yun, and possibly Xiao Chen (cat.39), in the art of painting. One biographer noted that "He taught as many as several hundred students and disciples," but that figure, even if it includes students of subjects other than painting, seems inflated.

During the 1650s and early '60s Xiao was often in Nanjing and Yangzhou and met the poet Tang Yansheng, the scholar-official Song Luo (1634-1713), and the painter Sun Yi, with whom Xiao is often grouped in historical texts. Some of Xiao's most famous paintings were done in 1662 under circumstances very similar to those encountered earlier by Shen Zhou (cat.12). "In the days when Hu Jiying was Prefect of Taiping he greatly admired Xiao Yuncong's ability in painting and called on him three times. Xiao declined to see him, so Hu became incensed. Restoration of the Taibo Tower at Caishi had just been finished, so Hu inserted Xiao's name into the labor records. Xiao was brought to the site and sent into the tower with the order: 'When the wall-paintings are done, you must then write an explanation for them.' Xiao was already more than seventy and had just been ill in bed, but there was nothing for it but to paint personally the four great mountains of Kuanglu, Emei, Taidai, and Hengyue. The paintings were completed after seven days of work, and they were masterpieces. Even today visitors who climb the tower sigh in admiration, and the paintings will be handed down [as treasures] along with the tower itself. Xiao's experience was very similar to that of Shen Zhou."

According to this record Xiao was at least seventy years of age in 1662 and hence could have been born no later than 1592, a birthdate which is also given in the *Huayou Lu* of 1795. Xiao's original name is said to have been *long*, "dragon," which appears on a number of Xiao's later seals, including the *Yuncong Long* seal on the present painting. The literal meaning of *yuncong* is "cloud follower," a phrase used in the *Yijing* to describe the movement of a dragon through the clouds. The names thus postulate rapid advance and soaring success for the holder and might be held particularly appro-priate for someone born in the year of the dragon, which during the period of Xiao's birth was the year 1592. However, Xiao's inscriptions and seals on extant and recorded paintings suggest a birthdate of 1596. All sources agree that he died at the age of seventy-seven, which would fall in either 1669 or 1673. Only two paintings dating to beyond the year 1669 are even attributed to Xiao, and, if genuine, they might in fact have been done a full cycle of sixty years earlier.

Late in life Xiao Yuncong came across a painting he had done many years before and added the following comment: "I remember painting this scroll around thirty or more years ago. At that time my spirit was strong and flourishing and I painted freely to please myself. This year I am seventy-three years of age, and I meet with my painting again... Who says that a painting master must get old before he gets good!" It is reported that on his deathbed Xiao grasped the hands of his attending disciples and said: "The way of life resides in the six classics, and ethical behavior originates in the five human relationships; seek them even aside from times of peace and leisure and continue to abide by their mandates." Xiao exerted considerable influence on later artists through his original paintings and through woodblock reproductions of them; the reproductions were especially influential in Japan on such masters of the Nanga school as Taiga (1722-1776), Gyokuran (1728-1784), and Chikuden (1777-1835). In China Xiao's paintings became especially popular in the southeast region, where a painter named "Wang Hong made copies of Xiao's paintings as fakes for double profit. Those one sees today with dry and uneven brushwork and not much wash or texture are Wang's productions..."

Catalogue No. 37.
**Cheng Zhengkui** (1604-1676)
*Jiangshan Woyou Tu*, "Dream Journey Among Rivers and Mountains, Number 25"
Handscroll, ink and color on paper, 25.8 x 305 cm.
Inscription: "Dream Journey Among Rivers and Mountains. Painted during the sixth month of the year 1652 by the Daoist of Qingqi. This is (number) twenty-five."
Artist's seals: *Zhengkui Yin; Cheng*
Title: "Dream Journey Among Rivers and Mountains" written by Li Shen in 1876
Colophon: written by Ji Huai in 1739

Cheng Zhengkui was born in Xiaogan, Hubei province, where his ancestors had moved from Anhui during the late Yuan period. The family had produced a number of important scholar-officials, and Cheng's father served as vice-director of the Ministry of Revenue; Zhengkui received an excellent education and in 1631 passed the highest level examination. He was appointed compiler in the prestigious Hanlin Academy and met many of the leading politicians of the day. Not all were pleased with the new addition to the Academy; Huang Daozhou (1585-1646), for example, said of Cheng: "Although his years are few he is brash and outspoken; dismiss him." Others, such as Dong Qichang (cat.28), the newly appointed tutor to the heir apparent, admired

Cheng. According to the *Wusheng Shishi*, "Master Dong greatly appreciated Cheng and poured out his heart in teaching him all the secrets of painting and the principles of calligraphy as though he were transmitting the robe and bowl [of a Chan Buddhist patriarch to his chosen successor]." Dong had been the examiner when Cheng's father passed the examination, hence the latter considered Dong as his teacher, and Cheng Zhengkui seems to have worked directly under Dong on a Ming history project. Cheng would later be an important collector of old master paintings and his emphasis on the four great masters of the Yuan, especially Huang Gongwang, suggest that his taste and values were strongly influenced by those of Dong.

Cheng eventually offended some high official and a pretext was found for transferring him out of the court; rather than accept a menial position, Cheng then moved to Nanjing and established a residence on the Qingqi, "Pure Stream," a tributary of the Qinhuai River, and henceforth called himself "The Daoist of Qingqi." Recalled to Beijing in 1642, Cheng served first as head of the Messenger Office and then as chief minister of the Seal Office, a post held only a few years earlier by Wang Shimin (cat.34). When the rebel-bandit Li Zicheng attacked Beijing in 1644, Cheng was ordered to Nanjing, where he was when the dynasty fell later that year to the Manchus. While serving the Chinese court established in Nanjing in 1644-45 as compiler and reader in the Hanlin Academy, Cheng became close to Zhou Lianggong (1612-1672), who would later write his biography, and to his kinsman, Cheng Sui (cat.38). The latter warned Cheng against close involvement with Ma Shiying and Ruan Dacheng (see cat.30, Lan Ying) after he met Ma at Zhengkui's house. Both Cheng Zhengkui and Zhou Lianggong eventually decided that opposition to the Manchus was fruitless and accepted office under the new rulers. Cheng served in a wide variety of posts: in the Court of Imperial Entertainment, in the Great Court of Revision as the chief judicial minister, in the Court of Imperial Stud, and finally as senior vice-minister in the Ministry of Works. Cheng was in this last, lofty position in 1656 when he was impeached and deprived of office; he then returned home to Nanjing and spent the remaining twenty years of his life in pursuit of aesthetic experiences and goals.

Cheng himself said that he began to paint around the age of five, and he was certainly an accomplished artist by his late twenties when he studied with Dong Qichang. However, it would appear that Cheng did not turn seriously to painting until 1649, when he left Nanjing once again for service in the north, and that it was around that time that he began the series of scrolls later given the generic title *Jiangshan Woyou Tu*. According to Cheng's inscriptions, he decided in the fall of 1651 to paint a series of one hundred such scrolls; only twenty were complete by the following spring and the series was still not finished by early in 1658. According to Zhou Lianggong, however, Cheng had completed around three hundred scrolls by the early 1660s and had determined to paint a total of five hundred. These numbers correspond in a general way to Cheng's known political activity, with far more time being available for painting after his dismissal from office in 1656. What remains somewhat unclear is the relationship of the assigned numbers to the given paintings and the significance of the series as a whole.

The paintings can hardly have been numbered consecutively – numbers 30 and 435 were both done in the year 1674, numbers 20 and 180 in 1670 – and neither do the numbers refer to chronological order within a single year. The evidence from Cheng's writings suggests that he worked in spurts of activity as time permitted and as the spirit moved him. These paintings were not all signed, numbered, and dated at the time of their execution, and some were inscribed only at the time of their presentation to a friend or acquaintance; this means that the number need not correspond with the inscribed date and could have been assigned arbitrarily. The idea of numbered variations on a set theme might seem very modern, but Cheng wished to de-emphasize the importance of the objective subject and to concentrate viewer attention on the formal aspects of the painting.

Frequently translated as "dream journey," *woyou* means literally "to travel while reclining" and denotes a range of experiences from the visionary to the more mundane one of an armchair traveller who enjoys the beauties of rivers and mountains without physical exertion. Cheng's paintings were also intended to remind viewers of purely aesthetic and art-historical values. In an inscription dated to 1652 Cheng said: "Those who live in Beijing suffer three hardships: the lack of landscape which can be enjoyed, the lack of calligraphy and painting which can be bought, and the lack of collectors from whom one can borrow. I have thus decided to do one hundred *Jiangshan Woyou Tu* scrolls for circulation in the world, to relieve the sufferings of those worthy [officials] on horseback [in the north]. I have completed approximately thirty scrolls but all have been taken away by enthusiasts. Coming across this one in a desk I inscribed and sent it to Wugong. He lives in the mountains, so sending him my clouds and mists is very much like sending water to someone on the banks of a river..." In addition to reminding the viewer of southern river scenery, Cheng's scrolls were also intended to fulfill the need of connoisseurs for art-historical reference. This he provided by varying the style of his rivers and mountains to suggest those of Wen Zhengming (cat.15), Shen Zhou (cat.12), Mi Fu (1051-1107), and most frequently Huang Gongwang (1269-1354). In 1645 Cheng wrote of the paintings he owned by each of the four great Yuan masters but noted that he had not yet been able to afford the two best by Huang Gongwang: "Dwelling in the Fuchun Mountains" and "Scenic Views of Rivers and Mountains." Cheng ranked the latter as the very best painting by the Yuan master and it is likely that the initial idea for his own series came from his personal imaginary wanderings through the rivers and mountains painted by Huang Gongwang.

The present painting, which is dated to 1652 and hence fairly early within Cheng's *oeuvre*, can be thought of as a study in the manipulation of abstract form and space. Interior shading and modelling create almost tactile solid forms which have been abstracted and simplified from those found in nature. These forms were then recombined into visual structures which defy the laws of gravity and deny the logicality of space. However, the fluency with which the eye moves across the animated surface is evidence of a well-calculated composition, one which perfectly exemplifies Cheng's own dictum on quality in painting: "Among the thousand hills and myriad valleys of Northern Song paint-

ings is not a single stroke that is not simple, and in the old trees and desiccated stones of Yuan paintings is not a single stroke that is not complex."

During his later years Cheng Zhengkui came to know many of the major artists of the day; Gong Xian (cat.46) and Kuncan (cat.41) were his friends, and Zha Shibiao (cat.42) was strongly influenced by his style of painting. According to Yang Xin, Cheng left Nanjing permanently in 1673 and returned to Xiaogan, while other sources record that he retired to Anhui, where he had many relatives. One of many favorable judgments on Cheng's art was that of Da Zhongguang (1623-1692), an important collector, theorist, and artist: "Su Shi said: 'I regard Cai Xiang as being the best of this dynasty in calligraphy. A thousand years from now men will begin to believe these words.' I say that among painters of this dynasty one must regard Cheng Zhengkui as number one. But with him we need not wait a thousand years, for already there are those who understand what I say."

Catalogue No. 38.
**Cheng Sui** (1605-1691)
*Shanshui*, "Landscape"
Hanging scroll, ink on paper, 78.8 x 42.5 cm.
Inscription: "The sharp wind drove and whirled the Sanxiang rain, against the clearing sky are silhouetted a thousand cliffs in clouds; Walking down to the water's edge poetic inspiration arises, who will understand my romanticism save for Adjutant Bao? On the fifth day of the fifth month of the year 1676, painted by Cheng Sui, the old man from Huanghai."
Artist's seals: *Cheng Sui*; *Muqing*;
*Anpin Bashinian Zixin Ruyiri*; *Jiangdong Buyi*

In what would appear to be an illustration of the appended poem, the poet and his understanding friend stand on a river bank enjoying the inspiring view of clearing peaks around them. The elation experienced by the poet is given an appropriate visual analog in the spontaneous brushwork, which is more suggestive than fully descriptive. Clusters of dots model the forms, while stippling along contours creates lateral rhythms. Gradients of ink-tonality function to suggest spatial recession, while the scene is given coherence by the rich and tactile brushwork and also by the charcoal-like application of dry or roasted ink throughout the whole.

The artist, Cheng Sui, was born into an eminent scholar-official family that had lived in Shexian, Anhui, since the Song dynasty. Old settlers such as the Chengs had long since partitioned the best of the land by the time the economic boom of the mid-sixteenth century brought increased commerce and population to the region. One of Cheng Sui's uncles was Cheng Dayue who, under his business name of Junfang, published in 1606 the illustrated *Chengshi Moyuan* to advertise the wares produced in his famous ink factory.

Cheng's early education was obtained in the clan school. In later years he would be well-known as a connoisseur of bronzes and jade vessels as well as of painting and calligra-

phy, and study of the family collection must have played a large part in developing these skills. Cheng is regarded as the founder of the Wan or Hui school of Anhui seal-carving and his epigraphic skills were initially developed by deciphering the inscriptions on the bronzes and stone stele owned by the family. Cheng also knew most of the major collectors of his day and continued his family tradition by becoming a collector himself. In writing of the dispersal of the collection of Xiang Yuanbian (1525-1590) after 1645, Zhu Yizun noted: "Cheng Sui of Huangshan was most covetous of antiquities and was especially fond of painting and calligraphy. Those that go to him are fortunate. Unfortunately the price [of the remainder of Xiang's collection] was a full million and Cheng's resources were insufficient to purchase them."

Around 1624 Cheng left the district school he had been attending and travelled to Beijing, where he soon became a disciple of Huang Daozhou (1585-1646). In 1625, when Huang left Beijing in protest against current misgovernment, Cheng Sui accompanied him to Fujian and was with him again in Hangzhou during the early 1630s. From around 1635 onward Cheng Sui lived in either Nanjing or Yangzhou, and his connections in both cities were admirable. In Nanjing lived his kinsman, Cheng Zhengkui (cat.37), and Zhou Lianggong (1612-1672), a collector and admirer of Cheng Sui's seals and paintings. In Yangzhou too Cheng Sui's activities centered around relatives, in this case his maternal uncles and cousins who owned three of Yangzhou's most famous gardens. Best known of the gardens was the Yingyuan, "Garden of Images," established by Cheng's cousin, Zheng Yuanxun. The name of Zheng's garden, derived from the characteristic shadows of willow trees and hills within the garden and from the reflections in the garden's pools, was selected by Dong Qichang (cat.28), who visited Zheng and discussed the theory of painting with him.

During the late 1650s and '60s Cheng Sui was preoccupied in painting with the artistic problem of reconciling the demands of spatial or three-dimensional depiction with a strong planar or two-dimensional emphasis on shape and texture. One of his solutions was based on the styles of Xu Ben and Wang Meng, of whom Cheng wrote: "The loftiness and profundity of Xu Ben's paintings almost surpass those of Ni Zan's..." and "In his painting method Wang Meng relied solely on the uncultivated and the unstudied in his pursuit of antiquity. Roughly tangled in complicated interweavings as if the strokes could not be separated, that was his method..." Cheng Sui was also influenced by his friend Kuncan (cat.41), from whom he learned to use roasted ink, and by Cheng Zhengkui, about whom Cheng wrote: "In the past I saw the brush and ink work of Cheng Zhengkui and that improved my own ordinary work."

During the last twenty years or so of his painting career Cheng Sui did not follow a single stylistic direction but rather created variations on themes developed in his earlier paintings and pushed certain of them to their stylistic extremes. He also broadened his artistic contacts and was closely associated in the early 1670s with the circle of Wang Shimin (cat.34). In the best of his works from this late period, such as the present painting of 1676, influences from a variety of sources are harmoniously integrated to produce picto-

rial structures whose already considerable authority is enriched by rhythmic and delicate touches of the brush. These works belie Cheng's own modest statement that he painted only during leisure from his primary art of seal-carving, and validate Cheng's honored position in the pantheon of artists from Anhui.

Catalogue No. 39.
**Xiao Chen** (ca.1645-ca.1715)
*Yangliu Guimu Tu,*
"Herdboy Returning Home via Willow Embankment"
Hanging scroll, ink and color on silk, 67 x 44 cm.
Inscription: "I built a house on the river bank, in the riverside fields are many trees and rice; When autumn comes I read the *Lisao* poems of Chu, and drinking deeply have no empty days.
This picture is presented to Master Hengshi so as to receive his noble instructions and inscribed so as to benefit from his widely learned corrections, by his younger student from Lanling, Xiao Chen."
Artist's seal: *Xiao Chen*
Colophons: Wang Moulin (1640-1688), Liang Qingbiao (1620-1691), Liu Zhonggui in 1707, and three others.

Against a backdrop of distant, mist-shrouded mountains is set a foreground scene redolent with rural tranquility; a herdboy drives a water buffalo home across a bridge over the river which irrigates the fields and beside which stands a house beneath tall willows. The somewhat awkward size relationships obtaining between the house, trees, and figures lend an impression of charming naivete to the work and thus support the poetic and pictorial theme of bucolic bliss. While the artist's inscription is not dated, the colophon written for the painting by Wang Moulin indicates a date of execution no later than the 1680s.

Xiao Chen was born in Yangzhou, Jiangsu province. He was known as a good poet and hence must have received some literary education, but the exact circumstances of his upbringing are unrecorded in standard sources. At some point during his life Xiao lived with woodworkers and was himself hired to do carpentry. Those for whom he worked and who got to know him treated Xiao as a poet rather than as an ordinary artisan, recognizing him as an equal and even friend.

As a painter Xiao was known especially for works done in Tang and Song dynasty styles, and he was particularly famous for his snowscapes. Several extent paintings purportedly of early date seem in fact to have come from the hand of Xiao Chen, which indicates either that later collectors or dealers removed Xiao's signature in favor of a more illustrious and hence valuable attribution or that Xiao himself catered at times more directly to antiquarian taste. Xiao was clearly active well before his earliest biography in the *Tuhui Baojian Xuzuan* of around 1680, and he trained at least one student, Chen Nong, who continued his historically evocative and visually delightful style.

Catalogue No. 40.
**Hongren** (1610-1664)
*Xiyan Songxue*, "Snow on Pines at the Western Peak"
Hanging scroll, ink on paper, 192.8 x 104.8 cm.
Inscription: "'Snow on Pines at the Western Peak.' Painted during the Spring of the year 1661 for Xiangye. Hongren."
Artist's seal: *Jianjiang Seng*

This large and impressive painting features the rectilinear and multi-faceted cliffs and the elongated, spreading pines characteristic of the famous Huangshan or Yellow Mountains of Anhui province. Aligned along the rising diagonal from lower left to upper right are segments of the path and steps by which the visitor climbs to reach the monastic halls built very near the summit of the mountain. A deep covering of snow over those crystalline forms is suggested by leaving them largely in reserve, with the background sky washed in rather heavily and unevenly for contrast. Hongren was a major master of the Xin'an school of painting which in its most general sense included also Xiao Yunzong (cat.36), Cheng Sui (cat.38), Mei Qing (cat.43), and Zha Shibiao (cat.42); Hongren, Zha, Sun Yi, and Wang Zhirui were referred to as the "Four Masters of Xin'an." In general, artists of this school took the Yellow Mountains as their subject and worked in variations of a linear and spare style intended to capture the almost geometrically fissured forms and surfaces of the actual mountains. In the present work Hongren combines that naturalistic aim with an architectonic system of structuring the landscape forms which began with Huang Gongwang (1269-1354) and was systematized by Dong Qichang (cat.28). The result is a well-unified image which combines the abstract strength of the simplified forms with the complexity of a fully three-dimensional and monumental structure.

Hongren, a monk-painter whose original secular name was Jiang Tao, was born in Shexian, Anhui. Although the Jiang family was well-established in the province, Hongren's father died young and the boy supported his widowed mother by doing manual labor and, later, by his writing skills. The boy liked to read and studied the classics diligently with a local scholar named Wang (or Zhang) Wuyai. By the late 1630s or early '40s Hongren had passed the first-level examination. Continued study would certainly have taken him to Nanjing, where lived Sun Zixiu (d.1654), an artist who was known for his paintings of blossoming plum and who was mentioned by Zhou Lianggong (1612-1672) as a strong influence on the art of Hongren. This period in Anhui was marked by famines and by civil unrest, and the situation worsened when word reached the south that the emperor in Beijing was dead. Hongren's mother, to whom he was strongly devoted, had died somewhat earlier and, while there are some reports that he had married and had a son, the reliability of those records is weakened by the fact that his purported son, Jiang Yuyi, is also recorded as Shi Yuyi, the son of an artist named Shi Yanjie.

In any case, in 1645 an unencumbered Hongren accompanied his teacher to Fujian province, presumably in support of the court of Zhu Yujian (1602-1646) who reigned from 1645 to 1646 as the Longwu emperor. Hongren may have changed

his name from Jiang Tao to Jiang Fang at this time in order to protect his relatives from the consequences of his political actions. By late 1646, however, all effective resistance to the Manchus had ended. Hongren travelled to Mount Wuyi where he met the Chan master Guhang (1585-1655), who initiated Hongren into his order as a monk. From this time onward the secular names Jiang Tao or Fang were no longer used and the artist was known by his monk's name of Hongren or his new byname Jianjiang, the name of a river in his native Anhui. While Hongren was back in Anhui in the year 1652, he did not become active as a painter until 1656, the year following Guhang's death.

A great majority of Hongren's paintings were produced in the eight years between 1656 and his death in January, 1664. These were painted while he was resident in various temples and monasteries of the Shexian region and also during visits he made to Nanjing, Hangzhou, Yangzhou, and Mount Lu in Jiangxi province. According to Xiao Yunzong, who was also mentioned as Hongren's teacher in painting, Hongren built a hut in the Yellow Mountains, and he is known to have made periodic visits to the mountains which provided the subject matter and inspiration of many of his paintings. Hongren's way of life at this time seems to have been modelled after those of the great priests and reclusive poet-scholars of the third and fourth centuries. As he himself stated: "My way is that of the pre-Yixi [405-418] era." Another model was Ni Zan (1301-1374), who had given up his estate and left his family for a reclusive life during the turmoil of the late Yuan. Hongren's later calligraphy as well as his painting style was based on that of the Yuan master.

Hongren's various trips as well as his friendships with such well-known artists as Cheng Sui and Mei Qing helped to spread the popularity of his elegantly reserved style. Zhou Lianggong recorded that the "People of the Jiangnan region [of Anhui and Jiangsu provinces] regarded possession of a painting by Hongren or the lack thereof as determining one's refinement or vulgarity, which is like the esteem in which Ni Zan was held in former days." Zhou also remarked that after Hongren's early death, "His paintings were valued still more highly. His disciples and students made a great many forgeries but those gave the framework and that is all." Although Hongren is generally held to have become a monk more for political than for religious reasons, his involvement with Buddhism did run deep and long. While visiting Mount Lu in 1662, for example, he said that he "felt the voice and shadow of the monk Huiyuan [334-416] still to be there," and on his deathbed he is said to have cried out: "My Buddha is the Tathagata of Guanyin!" – apparently in reference to the Buddha Amida, who appears in the crown of the Boddhisatva Guanyin and to whose kingdom access was gained by calling on his name. When Hongren was buried at the Wuming temple his friends cleared the area, erected a pagoda in his memory, and planted several dozen blossoming plum trees in keeping with his request.

Catalogue No. 41.
**Kuncan** (1612-1675 or earlier)
*Yuxi Shan'gen*, "Rain Washes the Foot of the Mountain"
Hanging scroll, ink on paper, 103.2 x 60 cm.
Inscription: poem by the artist, signed "During the eighth month, autumn, of the year 1663, while passing by the old retreat at Tianlong, by Youxi Dianzhu, Shiqi, called Can Daoren."
Artist's seals: *Shiqi; Jieqiu*
Collector's seals: He Kunyu

From a high and rather distant viewpoint is seen a temple compound nestled among trees on a river embankment. The steep bluffs overlooking the broad river are of a rounded type associated in painting history since the tenth century with the city of Nanjing. The heavy, well-defined areas of mist and clouds, the extreme informality of presentation, and the dry and discontinuous line are all characteristic of one of Nanjing's greatest seventeenth-century artists, the monk Kuncan. As is usual with the artist, the brushwork does not conform to any discernible pattern but rather varies continuously so as to yield strongly tactile forms possessing something of the disorder of nature. While much of this approach was based on direct observation of nature, other elements suggest the influence of the Yuan master Wang Meng, whose "Forest Dwelling at Juchu" was seen by Kuncan this same year at the home of his good friend Cheng Zhengkui (cat.37).

Kuncan, whose secular surname was Liu, was born in 1612 on the Buddha's birthday (the eighth day of the fourth lunar month) in Wuling, Hunan. His mother is said to have envisioned a monk as her son was born, and by the time the boy was nine years of age he too understood that in a previous incarnation he had been a Buddhist priest. He liked reading religious texts and was greatly cherished by Long Renyan, a local Chan Buddhist and Confucian scholar. Kuncan's initial desire to withdraw from society as a monk did not meet with parental approval. When he was around eighteen years old his parents tried to force him to marry, but he refused, and also gave up studying for the civil service examinations. Kuncan's religious calling seems to have been very strong; he is said to have read only highly moral books and to have had nothing to do with women. After his mother died, according to Zhou Lianggong (1612-1672), and when he was nineteen, according to Cheng Zhengkui, "his younger brother bought for him a felt cap to keep out the cold. Kuncan took it, put it on his head, and looked at himself in the mirror over and over again. Suddenly he picked up scissors and cut the hat to pieces, and also cut off his hair. Going out the door he left directly and joined the Sanjia Retreat at Longshan. He subsequently underwent various exercises, sought instruction, and was enlightened..." Another account of the circumstances under which Kuncan became a monk was given by Qian Chengjin, another friend and biographer: "In the year 1638, when he was twenty-six years old, Kuncan was chanting the sutras while living at home but he found it difficult to cast off his bonds. One night, after weeping without ceasing, he picked up a knife and shaved his head, causing blood to flow over his face. Prostrating himself before his father's bed he asked forgiveness for his unfilial behavior. His father then understood the strength of his determination

and agreed to his wishes. Master Long was overjoyed when he heard of this." The year in which Kuncan became a monk was given as 1631 by Cheng Zhengkui and as 1638 by Qian Chengzhi; both writers were good friends of Kuncan and knew him well, and it may be that the early date is when Kuncan left home as a self-declared monk and the later date is when he was ordained. Both accounts agree that after an initial period of study in Wuling he travelled to Nanjing. According to Qian: "When he arrived in Nanjing he had no place to lodge, so he stayed with an old monk who asked him how he came to leave his home for the priesthood. The monk said his own case was identical but that the great master Yunxi had shaved his head for him when he became a monk. Kuncan then asked for a portrait of Yunxi and offered incense and the ceremonies proper to a teacher..."

In 1640 Kuncan returned to Hunan where "Master Long pressed him from morning to night. After a long time he was suddenly enlightened and his moral nature clarified. Throughout his whole life Kuncan had no real teacher, either within or without the secular world, so the one who brought him to this state of completion was Master Long and no one else..." During the dynastic upheaval of 1644-45 Kuncan withdrew even further into the wilds of the Peach-blossom Spring area of Hunan, at one point living like a wild creature for around three months. The next decade in his life was primarily a period of spiritual and intellectual development, and his reputation continued to grow in religious circles.

When Kuncan re-emerged into the public eye in 1654, he was back in Nanjing and at the famous Baoen Temple which had wall-paintings by Dai Jin (cat.6). Kuncan was placed in charge of the sutra library and the important work of restoring the collection to its pre-war condition. The Chan priest Daosheng (d.1659), then abbot of the temple, came to have great admiration for Kuncan. In 1658 Kuncan visited Daosheng at the Tianjie Temple and was anointed as the master's chosen successor. Daosheng then transferred him from the Baoen to the Zutang Temple where he lived in the Youxi or "Lonely Roost" Cell. "In the year 1659 Daosheng died while in the Tianjie Temple and Kuncan hastened there from the Zutang. Daosheng's assembled disciples took his handwritten sutras and chants together with his bamboo *ruyi* scepter and in accordance with his will transferred them in front of his memorial shrine. Kuncan made obeisance but put them away without opening them, having accepted them only to return them to the Qingyuan sect and not to keep for himself." Kuncan's action indicates that he declined to continue as Daosheng's successor within the hierarchy of their sect, probably because of both religious and political schisms within Chan Buddhism at that time. Several of Kuncan's biographers mention disagreements he had with the monks of the Zutang Temple and these problems must underlie his decision to absent himself for a time during which he travelled within Zhejiang and Jiangsu provinces. He also visited Huangshan for some time before returning to Nanjing late in the year 1660. Rather than returning to his home temple, however, he built a hut for himself in a deserted area near the Zutang Temple. He explained his decision to live alone in positive terms: "It is not to get away from others that I live in isolation but rather because I want my inner being to become lofty and profound and my vision to be clear and insight-

ful..." Freed from ecclesiastical responsibility and inspired by the natural scenery he had seen during his travels, Kuncan then entered the most productive period of his career as an artist, producing more than one hundred paintings between 1660 and 1663, in contrast to the seven known works dated before 1660.

During the final decade of his life Kuncan was often ill and painted far less often, but he did maintain his close friendship with Cheng Zhengkui and made at least one final trip home to Wuling. Kuncan's date of death is not known but beyond the year 1670 are presently known only two attributed paintings, both dated to the year 1674; he thus probably died no later than 1675 and, depending on the authenticity of the two latest works, possibly somewhat earlier. Following his death, in accord with his wishes, his ashes were scattered over the Yangtze River from the Swallow Jetty in Nanjing.

Catalogue No. 42.
**Zha Shibiao** (1615-1698)
*Shuangfeng Lanruo Tu,*
"Buddhist Retreat Between Two Peaks"
Hanging scroll, ink on paper, 243.2 x 78 cm.
Inscription: "The house is between two banks,
    beside a Buddhist retreat,
  the only sound an autumn chime,
    rising from lonely mist;
  Sails return to the furthest shore,
    birds are all distant,
  the moon rises over tall groves,
    people do not yet sleep. Zha Shibiao."
Artist's seals: *Zha Shibiao Yin; Meiheshi Yiziyue Erzhan*
Collector's seals: Xu Zonghao (1880-1957)

Between steeply rising cliffs a zigzagging stream connects fore with middleground. Roofs rising above trees at the junction of stream and river mark the Buddhist retreat and house mentioned in the artist's poem. The painting is an exercise in restraint, in the intentional limitation of the range of ink-tonality, of texture, and of forms, to the point where simple changes take on significance and small variations are noteworthy. Although extremely sparse, the work does not appear sketchy but rather to be the essential structural framework remaining after a highly disciplined visual analysis and reduction of an originally complex image. This degree of simplification does yield the desired quality of blandness, of understatement, but does not interfere at all with perception of an implicit quality of richness.

The creator of this intriguing image was Zha Shibiao, who was born in Xiuning in Anhui province. Zha passed the first-level examination but gave up hope of an official career after the fall of the Ming dynasty. His family must have been quite prosperous since they had a large collection of Shang-Zhou dynasty bronze vessels as well as calligraphy and painting by Song and Yuan masters. Zha was able to develop a reputation as a connoisseur as well as calligrapher and painter. It is not impossible that he met Dong Qichang (cat.28) before the latter's death in 1636; his calligraphy in

particular was influenced by that of the older master, a debt that Zha recognized and honored in his use of the name "Born in the following *yimao* year," chosen because he was born a full cycle of sixty years after Dong.

In later years Zha would be grouped with Hongren (cat.40), Wang Zhirui, and Sun Yi as the "Four Masters" of their home region in Anhui and it was in Zha's earliest works that his style was closest to that of Hongren. Zha seems to have spent most of his adult life in either Nanjing or, especially, Yangzhou, already in the late Ming period a major cultural center for Anhui salt-merchant families. During the Qing dynasty Yangzhou was made the administrative center for the government-controlled salt trade of the entire Liang-Huai region and hence attracted even more merchants, scholars, and artists. Although Zha must have begun painting at a fairly early age, it was not until the early 1660s in Yangzhou that he seems to have turned seriously to that art. Several sources record that "he saw and liked Wang Hui's paintings; inviting Wang to his house he begged him to do in 'splashed ink' style works after the four Yuan masters Cao Zhibo, Ni Zan, Huang Gongwang, and Wu Zhen. These provided Zha with resources on which he could draw." Zha certainly knew Wang Hui as well as Wang's close friend Da Zhongguang from at least the early 1670s onward, but the suggestion that Zha depended on Wang for his knowledge of earlier styles is weakened by the fact that Zha's family were collectors of some note.

In Zha's late years he melded the Ni Zan style, with which he began, with the styles of Wu Zhen and Dong Qichang. This late style was described as "not using very much brushwork and as sparing of ink as if it were gold. In spirit his paintings are relaxed and carefree and in expression desolate and cool. They are of the untrammelled class..." The broad, relaxed outlines of the present painting mark it as a product of the 1680s or so and relate it in many ways to the late style of Shen Zhou (cat.12), who in his maturity was also drawn to the style of Wu Zhen. The late works of Zha Shibiao would seem to provide visual substantiation of the statement by one of Zha's biographers that "by nature he was careless and lazy and loved to lie around. On some days he would not get up until afternoon. He also dreaded entertaining guests, and if they wanted something he would flee..." Those who knew Zha's peculiarities would approach him "in deepest night when he did not regard painting as misery and his brushwork became yet more surpassing..." Zha's friends and acquaintances included Yuanji (cat.45), Gong Xian (cat.46), Kong Shangren (1648-1718), author of the "Peach-blossom Fan," and governor Song Luo (1643-1713), who wrote a biography of the artist and a preface for his collected poetry.

Catalogue No. 43.
**Mei Qing** (1623-1697)
*Gaoshan Liushui Tu*,
"Lofty Mountains and Flowing Stream"
Hanging scroll, ink on paper, 248.5 x 119.6 cm.
Inscription: "'Lofty Mountains and Flowing Stream,' done after the brush-conception of Old Man Shitian

[Shen Zhou]. One day before the mid-autumn festival of the year 1694, painted by Mei Qing called Qushan at the age of seventy-one."
Artist's seals: *Quxing Qing*; *Yuangong*; *Laoqu kanshan Yanbeiqing*; *Tianyan'ge Tushu*

Powerfully modelled and precariously balanced forms are held in firm visual balance by a compositional framework constructed around vertical, horizontal, and diagonal axes. The more crowded right side of the painting is balanced by a far deeper recession on the left, which is given further emphasis by the isolated figure on the middleground bluff who gazes in that direction. The quiet, contemplative mood suggested by the meditating scholar is given point by the energized forms and tensions of his surrounding environment. In his inscription the artist mentions Shen Zhou (cat.12) as his inspiration; there is much here which can be related to those works done by Shen in the manner of the Yuan master Wang Meng, but here those derived elements are recast in forms, especially the elongated pines, which identify the more immediate inspiration as Huangshan, the famous Yellow Mountains of Anhui.

The painter, Mei Qing, was born in Xuancheng, Anhui province. His family had moved there from Jiaxing during the late Tang and in subsequent generations produced numbers of scholars and artists, including the famous Song poet Mei Yaochen (1002-1060). During the late sixteenth and seventeenth centuries the clan became famed for its literati; Mei Qing was thus born into and raised in an environment which placed high value on scholastic and artistic achievement. Although Mei's father died early, the family was able to live in moderate comfort in the countryside. Mei and his four brothers went to school there and began to write poetry and to paint. As a youth Mei Qing studied diligently and sometimes read throughout the night. In the late 1630s he passed the lowest level examination, returned to live in Xuancheng, where he met Xiao Yuncong (cat.36), and began to form what ultimately became an extremely large circle of friends. Mei's first collection of poems was published in 1642 as the "Collection from the Farmer's Garden." Several years later Shi Runzhang, one of Mei's biographers, commented: "My friend Mei Qing has accumulated knowledge and is skilled in poetry. The poems in modern style he has had published have been known for long and praised throughout the empire."

At the time his poetry collection was published Mei had recently moved from the city to his Farmer's Garden on the outskirts of town: "When young I was pleased by the topography of these fields and did not enjoy living in the clamorous city... Although this area is near the suburbs, the lanes are narrow and winding. The old trees seem remote and quiet and hills enclose it all around, separating it from the world of men..." In retrospect the move was exceptionally well-timed, for Mei and his family thereby avoided the turmoil of the downfall of the Ming dynasty. Several years later, Mei moved further away from the city and seems to have turned even more to poetry and painting. In 1649 Qian Guangxiu wrote: "This year I passed by his retreat at New Fields. The distant peak had the seat of honor and swift streams were at the gate. Shadows from the trees and the

songs of birds confused what was up and what was down. There was no place he did not paint and no time he did not compose poetry."

This period of seclusion was ended by Mei's decision to sit for the higher degree examination in a continuing quest for official status, even if under a foreign dynasty. After passing the second or provincial level examination, Mei attempted the highest level examination at least four times with no success. Mei thus visited Beijing a number of times; for six years following his final attempt in 1666 he also travelled widely from Mount Tai in Shandong to Huangshan in his home province. Another collection of Mei's poetry was published in 1671; the preface by Shi Runzhang suggests that Mei's poetry, still more important to him than his paintings, was in fact pictorial in nature: "On reading his poems one can determine their times and verify their places. In times of leisure from chanting and singing his verses he did landscapes. What he painted has a very unusual air..."

Throughout the 1670s and '80s Mei Qing travelled often to Nanjing, Kunshan, Hangzhou, and Yangzhou. He had met Yuanji (cat.45) during the early 1660s and saw or corresponded with him often in later years. Mei knew many other artists, including Wang Hui (cat.49), Cheng Sui (cat.38), and Gong Xian (cat.46), and also such important patrons as Xu Qianxue (1631-1694) and Wang Shizhen (1634-1711). Towards the end of Mei's life Wang Shizhen wrote: "Mei Qing is famed throughout Jiangsu for his poetry. He paints landscapes of the excellent class and his pines are of the divine category." Perhaps a majority of Mei's paintings were done within the last decade of his life, especially after publication of his final poetry collection in 1691. Remaining mainly at home, he painted often, including several sets of eight or more hanging scrolls which, when hung in sequence, presented a continuous landscape. When Wang Shizhen heard the news of Mei's death he wrote: "In the year 1697 of the Kangxi reign-era I was in Beijing and heard that Mei Qing had passed away. His marvelous paintings which penetrated the soul of their subjects are henceforth ended forever."

Catalogue No. 44.
**Zhu Da** (1626-1705)
*Huaguo*, "Flowers and Fruit"
Handscroll, ink on silk, 22.3 x 185.8 cm.
Inscription: "I paint here what was presented from the Green Gate, continuously we chant through the long summer; Lifting it requires two people, eating it seven months.    Chuanqi."
Artist's seals: *Mozhai; Shi Chuanqi Yin; Ren'an*
Colophon: Zhou Zhaoxiang (1880-1954)

Five isolated images of flowers and fruit – blossoming plum, pomegranate, Buddha-hands, a well-laden fruit bowl, and melon – are shaped and arranged so as to create a unified, rhythmic progression from right to left. This lateral sequence is maintained by judicious positioning of directionally oriented shapes; visual stimulation is provided by the changing spatial orientation of those shapes and by the contrasts of angular with curvilinear, of dark with light, and of

specific detail with generalized forms. What initially may seem haphazard in arrangement and spontaneous in execution will be found to be stringently composed, down to the vertical lines of the inscription which close off the composition and echo the vertical with which the sequence began. The content of the poem seems to have been inspired solely by the melon which immediately precedes the verse. The original Green Gate was in the city wall of the Tang capital of Chang'an and received its popular name because of the superb melons grown just outside. The artist-poet here was in fact a Buddhist priest, who by virtue of his calling would occasionally chant through the long summer days even when tempted by the cool reality of the objects presented here.

Recent research suggests that the original name of the artist generally known today as Zhu Da or Bada Shanren was Zhu Yishe, a ninth generation member of the Yiyang branch of the Ming imperial family. This branch, which was registered in Nanchang, Jiangxi province, boasted a number of painters in the generations preceding Zhu Da. Of particular interest is Zhu Duozheng, active in the late sixteenth century, who "loved to travel... When he asked after local customs and spoke with regret of the past, he would become melancholic within himself and sometimes sing and sometimes weep, and no one could fathom the cause..." Zhu Duozheng was recorded by Zhan Jingfeng (1528-1602) as a follower of Chen Daofu (cat.23), and his descendants continued to follow the Suzhou tradition of Shen Zhou (cat.12), Wen Zhengming (cat.15), Lu Zhi (cat.18), and Zhou Zhimian (cat.26) in bird-and-flower painting. It is thus very likely that Zhu Da was early exposed to that expressionistic approach to still-life painting.

As a member of the imperial clan Zhu Da received a traditional education; he passed the first-level examination probably in the early 1640s. He was forced to flee from his home when the Qing troops captured Nanchang and in 1648 entered a Buddhist temple as a novice. Five years later he became a disciple of the Chan master Hongmin (1607-1672) and took Chuanqi, the name with which the present work is signed, as his priest's name, with Ren'an, which appears on one seal here, as his byname. In 1657 Zhu Da succeeded his master as head of the Lantern Temple after the latter had moved to a temple in Fengxin on the other side of Nanchang. Zhu's earliest extant painting, an album dated to 1660, was painted while in his Lantern Temple. In 1672, when Hongmin died, Zhu Da travelled to Xinchang where he stayed with the poet Qiu Lian, whose father-in-law was Hu Yitang, the local magistrate. He returned to Fengxin in 1673. A portrait of him painted in the following year bears his seal reading "Imperial Descendant of the Yiyang Branch in Jiangxi," a clear indication that he no longer felt any threat because of his lineage. Three years later, in 1677, Zhu returned to the Lantern Temple but soon decided to exchange his settled existence for that of an itinerant priest-artist such as the Tang poet Qiji and the tenth-century painter Guanxiu. As Zhu said to his friend Rao Yupu, "You may from now on simply view me as Guanxiu or Qiji." During the following three years Zhu did travel often but lived for much of the time in Linquan with Hu Yitang, who had been prefect there since 1676.

Although few of Zhu Da's paintings from the 1660s and

'70s are known today, his reputation at that time was suffi-
cient to earn him entry under his priest's name in the *Tuhui
Baojian Xuzuan*, completed around 1680: "The monk Xuege is
from Nanchang. He excels in expressionistic flower paintings
which are very, very strange; on a huge scroll there might be
no more than a single blossom and leaf. He is very skilled in
using ink to compose his pictures." The present painting,
whose *Mozhai* or "Ink Studio" seal suggests a more artistic
than religious orientation, is probably to be dated to the early
1670s. Zhu Da's growing dissatisfaction and frustration with
the course of his life came to a head in 1680; after hysterically
crying and laughing for some time, he tore off and burned
his monk's robe, left Linquan, and retreated to Nanchang,
where he wandered the streets until he was recognized and
taken in by a nephew.

From 1681 until the end of his life Zhu Da lived a secular
life and hence no longer used his priest's name. Zhu Da, a
name associated with the artist by Zhang Geng in his
*Guochao Huazheng Lu* of 1735, means "Droopy-ear" Zhu and
was probably applied to him by others. The best-known
droopy-eared man in Buddhism had of course been
Sakyamuni who, like Zhu, had given up a princely estate for
religion. Between 1681 and 1684 Zhu often called himself Lü,
meaning "donkey," a common term for the baldheaded
monks, or Lüwu, "Donkey's House." Zhu's emotional crisis
may have been brought on in part by overwhelming regret
for the lost world of his youth, and his decision to leave the
priesthood may have been taken so that he could marry and
extend his line into the future. In any case, the 1680s were
clearly a period of momentous change in Zhu's life as he
struggled simultaneously with the intellectual, emotional,
and economic demands of his new status.

In 1689 and '90 Shao Changheng (1637-1704) was in
Nanchang and met Bada Shanren, the name adopted by Zhu
Da in 1684 which he used consistently for the rest of his life.
Shao recorded that Bada one day wrote the character *ya* or
"dumb" very large on his door and from then on would
laugh and drink with people but not talk to them. Impulsive
laughing and crying had also been characteristic of Zhu's
great-grandfather, Zhu Duozheng, and one of Zhu's uncles
seems to have been physically unable to talk, but here the
symptoms suggest another crisis, perhaps brought on by the
loss of his family, an event mentioned by another visitor of
the late 1680s, Chen Ding. Zhu Da's emotional state makes
interpretation of his poems written at the time problematic,
for one cannot be sure which of several potential readings is
the one intended. In 1689, for example, Zhu did a painting of
a round autumn moon whose circularity is emphasized by
juxtaposition with an irregularly-shaped watermelon. On the
painting a poem was inscribed:
"To the eye a cake has only one surface,
  the moon is full like a watermelon when it rises;
  Everybody refers to moon-cakes,
  donkeys look forward to the harvest of ripened melons."
On one level the poem points to the visual difference
between a flat circular shape and a cubic hemispherical form,
a distinction which underlies the visual tension of the paint-
ed image, and ends with the humorous aside that "donkeys"
like Zhu himself would rather eat melons than look at cake-
shaped moons. On a deeper level the poem could refer to the

popular uprising which ended the foreign domination of the
Mongols, a rebellion begun on the day of the mid-autumn
festival by those who carried moon-cakes as symbols of their
participation. Zhu Da also was writing and painting on the
day of this festival and a political interpretation is not impos-
sible but, in the end, we may prefer to stand with Zhang
Geng's statement: "His inscriptions have many unusual con-
notations and I don't understand them very well."

Catalogue No. 45.
**Yuanji** (1642-1707)
*Caiju Tu*, "Plucking Chrysanthemums"
Hanging scroll, ink on paper, 206.3 x 95.5 cm.
Inscription: "'Plucking chrysanthemums by the eastern
fence, in the distance appears South Mountain.' On the
ninth day, during the year 1671, painted for the pleasure
of the old Daoist and elder in poetry by Ji, called Shitao,
from Ao Mountain."
Artist's seals: *Ji Shanseng; Laotao; Yiru Buyou*

Yuanji was born into the Ming imperial clan as Zhu Roji.
In his mid-eighteenth century *Guochao Huazheng Xu Lu*,
Zhang Geng erroneously reported Yuanji's priestly name as
Daoji, the name by which he is best known today; Yuanji's
biography was further obscured by the existence of a monk
named Shitao, a byname Yuanji also often used. While some
details of Yuanji's life remain unknown, the publications of
Wen Fong and, most recently, Wang Shiqing have clarified
many problems. Yuanji was the son of Zhu Hengjia, then the
Prince of Jingjiang in Guilin. In 1645, when Nanjing fell to
the Manchus and the Prince of Fu – proclaimed emperor
there in June of 1644 – was captured, Zhu Hengjia, a direct
descendant of the Ming founder's eldest brother, declared
himself emperor in Guilin. Other claimants reacted against
this usurpation; Hengjia was arrested and transported to
Fujian, where he was executed together with his followers
the following year. At the age of four Yuanji's world was
thus destroyed and his life placed in danger both from oppo-
nents of his father and from the Manchu invaders.

Taken in by a family friend called Hetao, Yuanji was
spirited to safety in neighboring Quanzhou, where he must
have lived incognito. By the age of nine Yuanji had become
enamored of old calligraphy and was learning to read it;
someone suggested that he study the style of Dong Qichang
(cat.28), then very popular, but eventually the boy found he
preferred the style of the great Tang master Yan Zhenqing.
Yuanji also began painting at this time and did landscapes,
figures, and bird-and-flower paintings, works that were
praised by the people of that southern region. During his
teens, still accompanied by Hetao, Yuanji began travelling
slowly north and eastward, moving up along the Xiang River
painted earlier by Wang Fu (cat.1), past Lake Dongting, and
finally to Wuchang, home of Wu Wei (cat.7), where he
remained at least until 1662. Yuanji was described as being
"strange and temperamental, one who on encountering the
unusual could explain it immediately, and one who spent
money as soon as he got it, saving nothing."

As Yuanji continued travelling he passed by Mount Lu

and may have resided there for a time; he then travelled to Songjiang, where around 1663 he became a Buddhist monk under the instruction of Benyue (d.1676). After seeing Hangzhou's West Lake and Dadi Mountain, Yuanji retraced his steps to Xuancheng, Anhui, where he lived at the Guangjiao monastery on Mount Jingting, calling himself the Xiaocheng Ke, "Guest of the Lesser Conveyance [Hinayana Buddhism]." During the fifteen years Yuanji lived in Xuancheng he visited Huangshan, the famous Yellow Mountains, as well as Nanjing, Yangzhou, and other places, staying most often at local Buddhist temples. At this time Xuancheng was the center of a poetry and painting society whose members, poets such as Shi Runjang and painters like Mei Qing (cat.43), welcomed the monk warmly. Their examples may have contributed to the evolution of Yuanji's art during this period, a time when in calligraphy he sought ever earlier and more germane models. Another important influence on Yuanji were the mountains of Huangshan, which he first visited in 1667 and where he stayed for several months in 1669. As an artist Yuanji was struck in particular by "the strange pines and unusual rocks, by the thousand transformations and myriad distinctions for which even ghosts and spirits could not set limits." For the magistrate of Huizhou, Yuanji painted seventy-two scenes, each illustrating one of the famous peaks of Huangshan, and each inscribed as having been done after a famous painter of the Song or Yuan dynasty. However, Yuanji's paintings are said to have been based entirely on his own ideas, done as the spirit moved him during the act of painting, and not in conscious accord with any earlier master.

"Plucking Chrysanthemums" dates to this earliest period of Yuanji's extant works; its large size is especially unusual – his other paintings done at this time were all small-scale albums or handscrolls – and perhaps manifests his desire to capture in painting something of the scale of the Yellow Mountains. The strict verticality of the earth and rock forms is here enhanced by the prominent foreground pines, which also fan out exuberantly to suggest an expanding surge of energy. This carries our eyes along the rising diagonal to the main subject of the painting, the reclusive Tao Qian or Tao Yuanming enjoying his chrysanthemums in splendid mountain solitude. That the composition here might be considered somewhat unsuccessful is far less important than the fact that virtually nothing in the painting, from the brushwork to the architecture, was based on earlier styles; at the age of twenty-nine Yuanji was already determined to reinvent Chinese painting.

In 1680, several days before leaving the monastery, Yuanji gave away all his old paintings and calligraphies and arrived in Nanjing with nothing. During the following five years Yuanji stayed mainly in his Yizhi Ge or "Pavilion of a Single Post." In 1684 Yuanji met the Kangxi emperor in Nanjing during his first Southern Progress, at the Changgang or Baoen Temple where Yuanji was living. Such a meeting was not exceptional; the emperor's father had been very involved with Chan Buddhism and had entertained a number of abbots of the Linji sect in the capital, including Daomin (1596-1674), the teacher of Yuanji's religious master Benyue. A major purpose of the Southern Progress was for the emperor to see his subjects and they him, and Yuanji harbored no personal animosity toward the new rulers; it was not they, after all, who had executed his father and left him an orphan but rather his own relatives. Yuanji remained in Nanjing until late in 1689, often travelling to Yangzhou, where he met such other famous masters as Gong Xian (cat.46) and Zha Shibiao (cat.42).

In 1689 Yuanji met the Kangxi emperor again, this time in Yangzhou during the Southern Progress illustrated by Wang Hui (cat.49), and met in the emperor's entourage the Manchu nobleman Boerdu. It was likely due to the latter's encouragement that Yuanji travelled to Beijing for a visit that lasted until 1692. There he was introduced to a number of officials, also to two of the most famous artists then in Beijing, Wang Hui and Wang Yuanqi (cat.50). The former was likely a student of Qu Shisi, who had originally arrested Yuanji's father, and the latter was a primary exponent of an approach to painting directly opposed to that espoused by Yuanji. Although at Boerdu's behest Yuanji collaborated with each of those orthodox masters, he had little in common with them and there is no evidence of further contact. Wang Yuanqi's comment on the meeting was polite but somewhat condescending: "One surely must praise Yuanji as the best painter from south of the Yangtze; there are certain aspects in which neither I nor Wang Hui are his equal."

While in the capital and in contact with artists of the orthodox school, Yuanji must have heard a great deal about the need to follow ancient styles and models. His most immediate reaction is suggested by an inscription dated to the year 1692: "Before the ancients established their models, we do not know what kind of models those still more ancient followed. But after the ancients set up their models, later men have not been allowed to go outside those ancient models. For more than a thousand years it has been so, hence later men have not once taken over the lead from the ancients. Studying the footsteps of the ancients, they do not learn the minds of the ancients, so it is fitting that they are unable to take over the lead from the ancients. But what a pity!" Yuanji thus posed a basic question for those who found all artistic inspiration in ancient models: what inspired the ancients *before* there were models, for that was surely more germane. The then popular analogy between the historic evolution of painting and Northern-Southern School Chan Buddhism must have seemed immaterial, indeed amusing, to a Chan monk, for the closest parallel to the insistence of many Southern School critics on memorizing an orthodox canon of styles was in fact the Northern School Chan belief that enlightenment was best approached through disciplined study and meditation, which gradually purified the self. In refusing to impose conscious control and rational limits on his creative impulses, and in approaching the creative act directly, dispensing with any mediating layer of tradition, Yuanji most truly followed a course analogous to the sudden enlightenment of Southern School Chan.

On his return to Yangzhou in 1692 Yuanji began work on what would be his final dwelling, the Dadi Tang, or Hall of Great Cleansing, a name derived from that of the Daoist mountain near Hangzhou. While the Dadi Tang was under construction Yuanji made a final visit to Anhui. In 1697, the year in which his close friend Mei Qing died, Yuanji ceased "waving the duster, wielding the priestly staff, shouting and

crying to men and *devas"* and withdrew from the Buddhist community to live for the remainder of his life as a secular, professional painter in Yangzhou. He probably made the decision leading to these momentous changes while yet in Beijing, when he completed a full cycle of sixty years by Chinese count; that he painted for Boerdu after he returned to Yangzhou suggests that it was such patronage and perhaps the prospect of more that encouraged him to leave the safety of the *sangha*. Perhaps a majority of Yuanji's paintings were executed during the last decade or so of his life. These works often manifest the creative exuberance and spontaneity of a new beginning, characterized also by the public declaration of his Ming imperial antecedants and occasional use of his rightful secular name of Roji. In 1699, in writing to his distant kinsman Zhu Da (cat.44), Yuanji requested: "Don't write of me as a monk for I am now a man with hair and a hat..."

Another aspect of Yuanji's new beginnings was the final crystallization of his views on the nature of painting and on creativity itself; these were formulated and presented in the eighteen sections of his *Huayu Lu*, "Record of Sayings on Painting." This title, which is Buddhist in form, suggests that part of Yuanji's intent was to provide students with ideas and formulations that would stimulate, even compel, their own enlightenment in painting. Many of the themes in the text, which is characteristically forceful, direct, and original, represent expansions of ideas appearing earlier in individual inscriptions. The first and most theoretical section presents Yuanji's ideas on the nature of *fa*, an important concept with a wide range of meanings. One basic meaning of *fa* is "that which is held to," hence translatable as "law" or "standard;" it is the Buddhist *dharma*. Laws and standards can also be prescriptive, hence extended meanings of *fa* include "model" or, as a verb, and with special relevance to orthodox school practice, "to imitate." Finally, the term included the manner in which something was imitated, and hence is translatable as "style," or "fashion." Assuming that Yuanji was addressing an audience consisting primarily of artists, in the following *fa* is translated as "style" with the caveat that the other connotations are operative as well.

"In remote antiquity there was no style because the original substance had not yet been differentiated; as soon as it was differentiated, styles were established. On what basis were styles established? They were established on the basis of the first stroke. The first stroke is the origin of everything there is, the root of the myriad images. What is used by the spirits is also innate in humans, but ordinary people do not know this, so I established the style of the first stroke. Establishing the style of the first stroke meant creating a style from what lacked style, and stringing together all styles by means of that style." According to Yuanji here, painting is, among other things, the progressive subdivision of the format; style, the manner of subdivision, does not have an *a priori* or independent existence as the orthodox school would have it but comes into being only during the act of painting, which begins with a single stroke that lays the foundation for everything that follows. Yuanji continues with a discussion of the mechanism or the process by which that first stroke comes into being. "Now, painting is a function of the mind. With such visual phenomena as the delicate ornamentation of mountains, rivers, and human figures, the characters and personalities of birds, animals, grass, and trees, and the shapes and sizes of ponds, pavilions, towers and terraces, if one's mind cannot penetrate to their innermost principles and exhaust the details of their appearance, then it will never acquire the vast scope of the first stroke. As when travelling far or ascending high, one begins with the first inch. This first stroke embraces what lies beyond even the undifferentiated cosmos, and even if requiring billions or trillions of brush-strokes, there is nothing which does not begin with this and end with this."

The third section of the text examines the value of the past and the proper relationship that should obtain between an artist and the past. "The ancients are a means to knowledge. Those who transform that knowledge recognize it as a means and not the end; using antiquity as a means to creation is not to be seen among the ancient sages themselves. I have often felt sorry for those who are mired down by antiquity rather than transforming it, for their knowledge restricts them. Knowledge which limits one to being similar is not profound. Thus a sage will only take from the past what can be used to create in the present. It has been said: 'A sage has no method.' But that is not to be without a style, for the style that has no style is simply the perfect style. In all things where there are constants there must be variables as well, and where there is style there also must be transformation of style. As soon as one understands the constants, one must transform the variants, and as soon as one understands a style, one must work at transforming it. For painting is the great *fa* or law to which all beneath the heavens accomodates itself... Some think that if they are able to follow the ancients they will become one with the ancients and they with them, but such people know only the ancients and not themselves. My creations are my own and naturally I too am within them. The beards and eyebrows of the ancients cannot grow on my face and the lungs and bowels of the ancients cannot naturally enter my abdomen and intestines. My work reveals my own lungs and bowels and unveils my own beard and eyebrows. Should it happen that my work touches on that of a given artist, it is he who follows me and not me who intentionally works after that artist, for my work comes naturally. How could there be any among the ancients I would study and not transform?"

Catalogue No. 46.
**Gong Xian** (1619-1689)
*Geqi Shanse Tu*, "Mountains Beyond a River"
Hanging scroll, ink on paper, 163.3 x 71.2 cm.
Inscription: "A small thatched study stands beside old trees on the riverbank, beyond the river mountains face the slanting rays of the sun; For several years now I have not drunk of Tao Qian's wine, on a clean table in the dead of night I burn some incense. Painted by the Rural Recluse, Gong Xian."
Artist's seals: *Gong Xian*; *Zhongshan Yelao*

A thatched house stands by a grove of leafless trees on the bank of a river; from the further shore rise timbered

slopes to beyond the borders of the picture. That simple listing of pictorial elements of course does no justice to the visual impact of the ghostly, man-made structure which seems emphatically empty, even uninhabitable, in contrast to the strongly animated trees and mountains which appear to glow from within and to exude the breath of inner life. By requiring the viewer to accept such reversals of ordinary, experiential knowledge, the artist warns of even deeper mysteries to be encountered on entering his compelling visual world.

Gong Xian was born in Nanjing into a family registered in Kunshan, Jiangsu. Gong was brought up in comfortable circumstances on an estate, which survived the fall of the city to the Manchus in 1645, and in a house, the *Saoye Lou* or "Sweeping Leaves Tower," which survived into modern times as a tourist attraction. While Gong's later literary activities and skill in poetry and calligraphy indicate a good education, he seems never to have sat for any of the examinations, perhaps because of the rampant corruption and factional disputes that characterized the government in the decades of his youth and early manhood. Gong Xian took early to painting, beginning to study at the age of twelve or so, and certainly benefited from his acquaintance with Dong Qichang (cat.28), with whom he studied during the early 1630s in company with Yang Wenzong (1597-1645), the good friend of Lan Ying (cat.30). A later poem by Gong Xian paid tribute to a number of his early artistic influences: "In my lifetime I have had the good fortune of meeting Dong Qichang; the two Li, Yun and Zou, are also men of whom I especially approve." The two Li were most likely Li Rihua (1565-1635) and Li Liufang (1575-1629); Yun Xiang (1586-1655) was the uncle of Yun Shouping (cat.52) and Zou Dian the father of Zou Zhe (cat.48).

Gong's poem of 1674 continues: "In my later years I became exceedingly fond of the two Guizhou painters." The only two artists from Guizhou of any significance at that time were Yang Wenzong, Gong's fellow student and one of Wu Weiye's "Nine Friends in Painting," and Ma Shiying (1591-1646), Yang's brother-in-law. It would thus appear that during the political infighting and maneuvering that prevented effective resistance to the southward thrust of the invading Manchus, Gong was associated, however peripherally, with the opponents of the Fushe, or "Revival Society," the group responsible as well for the withdrawal from public service of Wang Shimin (cat.34). Soon after the fall of Nanjing in 1645, Gong's wife died. Leaving his children in the care of his neighbor, the collector Zhou Lianggong (1612-1672), Gong spent the next fifteen years in the area of Shanghai, where he worked as a tutor, at home in Nanjing, where he lived mainly in seclusion, and in Yangzhou, where his social relationships appear to have been quite extensive.

During the late 1650s Gong Xian began using a seal whose legend, *Chen Xian*, "the servitor Xian," suggests that he had by then accepted Manchu rule and could proclaim himself a servant of the crown; Wang Hui (cat.49) in the early 1650s and Yuanji (cat.45) in the early 1690s when he was at court used similar seals. In Yangzhou Gong painted for the police commissioner, the famous poet Wang Shizhen (1634-1711), who also hosted such artists as Cheng Sui (cat.38) and Wu Weiye at various gatherings. Gong gained his most

prominent pupil, Lü Qian, at this time and began a thirty-year-long friendship with Zha Shibiao (cat.42). One of Gong's main preoccupations during the early 1660s was compiling a selection of poetry by mid to late Tang poets. According to Zhou Lianggong: "Gong loves intensely the mid and late Tang poets and assembled and arranged poems by more than one hundred masters, for some of whom most people had not seen a single verse." Gong's interest in Tang *shi* poetry allied him closely with Wang Shizhen, who began his study of that subject before the age of ten. Both Gong and Wang held that the Tang masters epitomized the height of *shi* poetry, and that serious students who wished to become masters themselves could do so only by first mastering the orthodox tradition of the past by copying and imitating approved works by those exemplars.

Gong's theoretical and pedagogical interests at this time were also manifested in the annotated albums known today as *Banqian Getu Huashuo*, "Gong Xian's Talks on Painting for Students." His aim here was much the same as that which motivated his compilation of Tang poetry: to make available to advanced students material that would increase their understanding of their subject and help to refine their techniques in pursuit of specific effects. Gong's painting albums might in fact be characterized as how-not-to manuals, for they were concerned primarily with contemporaneous infractions of rules established in the Northern Song period by such artists as Guo Xi. Gong Xian's treatment of light, his emphasis on the seasonal and temporal aspects of nature, and his analysis of the technical means best suited to achieve effective characterization of times and seasons were all based fairly directly on Guo's formulations. Similar too is Gong's use of nature itself as the constant reference point in his comments; relationships between trees, the structure of rocks, and the fall of light on forms are all discussed with reference to their occurrence in nature rather than in earlier paintings. Gong moves furthest into art history in his discussion of *cun* texture strokes, but he generally assumes prior knowledge of their actual appearance and illustrates only those that he himself favored at the time.

In addition to the rather specific and technical concerns that appear in the sketchbooks, Gong Xian was also interested at this time in more general aspects of theory and expression. "'Painting has six standards'; those were the words of Xie He of the Southern Qi dynasty. But in my opinion there are not six standards but rather four desiderata. First is brush; second is ink; third is hills-and-valleys; and fourth is spirit-resonance. Brush method should be antique; ink spirit should be rich; hills-and-valleys should be stable. When these three are attained, then spirit-resonance will be among them. Brush method needs ripeness as well as antiqueness; if it is only antique and not ripe, then it is dry. Concerning the richness of ink, be clear that this does not mean simply wet. Hills-and-valleys is a general term for positioning and arranging [composition]. Compositions should be natural, but they *must* be surprising, for naturalness in combination with the unsurprising is no better than naturalness alone. The natural and the unsurprising come from the practiced hand; the surprising and the unnatural come from the untutored hand. Today there are the two schools of professionals and scholarly practitioners. The paintings of professional

specialists are natural but unsurprising; the paintings of scholars are surprising but unnatural. How can those I have called practiced hands be raised to the level of the untutored hands? If one can increase antiqueness, then ripeness will be increased; the riper the more rich; the richer the more natural; and the more natural the more surprising. This is painting's highest grade and is reached through high natural endowment and long, efficacious work. Within there should be the imagination of poetry, the grammar of prose, and the spirit of philosophy. Ah! How could anyone slight this ability!"

Gong returned to Nanjing in late 1666, around the same time as one of his major supporters, Zhou Lianggong. Among the artists then active in Nanjing Gong Xian had the greatest admiration for Kuncan (cat.41) and Cheng Zhengkui (cat.37). Zhou Lianggong recorded Cheng's judgment of Gong's work around this time: "When Cheng Zhengkui discusses painting there are few among modern men of whom he approves. But on a painting by Gong Xian he wrote: 'In painting there is complexity and simplicity, which refer to brush and ink rather than to the theme. In the thousand hills and myriad ravines of the northern Song masters there is not one stroke which is not simple, while in the dry branches and lean rocks of the Yuan artists there is not one stroke that is not complex. The one who has understood this is Gong Xian.'" In 1669 Zhou hosted a gathering in Nanjing which brought together most of the artists known as the *Jinling Bajia*, or "Eight Masters of Nanjing," as well as such other artists as Wang Hui, from whom Gong requested a portrait of his Nanjing retreat, the Half-acre Garden at Crouching-Tiger Pass.

The decade beginning around 1667 and Gong's return to Nanjing found him perhaps at the height of his creative powers; in his biography of Gong written around 1667 Zhou Lianggong recorded a statement and a challenge issued by the painter: "Precedent have I none, nor shall followers come." That clarion call to individualism in art is more than amply supported by Gong Xian's paintings of this period, which display complete mastery of difficult and demanding techniques, compositions that are monumental in conception and profound in scope and, most characteristically, visionary flights that force consideration of both the world in the painting and the world of the painting. Gong's stated credo does not suggest any desire to withdraw to some interior world far from the social, political, economic, and artistic strands from which his personal environment was woven, but rather a determination to actively manipulate those strands to provide for his own needs and purposes. At this time Gong was deeply concerned with art history, with his artistic heritage, and with certain aesthetic concepts, and it is these which provide the firmest basis for discussion of the expressive qualities of his style.

"Untrammelled artists are unemployed sages without office to hold, so we are bound to call them scholars of painting." With that statement Gong began his clarification of the true significance of the term scholar-official painting and a spirited attack on the then current notion that paintings by scholars were the same as what Gong termed paintings by scholars of painting. "Today, when connoisseurs and critics see superlative brush and ink work they say: 'This has a scholarly air.' But when that phrase of judgment and praise is applied to ordinary and commonplace work it suggests ridicule and satire. They also say: 'This is scholar-official painting,' but brilliance in painting is not the business of scholar-officials and scholar-officials are not in the class of painting specialists. If one [knew only the paintings of Yan Liben and Wang Wei of the Tang but] did not know that Yan Liben was the Tang emperor Li's prime minister and Wang Wei an assistant minister in the imperial household, would they then not be considered scholar-officials? If one fixes superlative brush and ink as the criterion for scholar-official painting, then would Ni Zan, Huang Gongwang, Dong Yuan, and Juran also be in the ranks of court officials?" Gong thus attacked a tendency originating with Dong Qichang and his followers to draw close correlations between given social, economic, and artistic traditions. Gong's motivation in opposing that trend seems very clear: if the literati tradition of which he clearly felt himself a part were expropriated by those who emphasized Yuan styles over the Song and earlier styles he himself followed, and if that scholarly tradition became confined to those who were wealthy amateurs or holders of office while he himself was dependent on painting for his livelihood, then there would soon be no place within that tradition for such as Gong Xian.

In 1686 Kong Shangren (1648-1718), author of the play "Peach-blossom Fan" (see cat.30, Lan Ying) was appointed to assist in river conservancy work; until 1689, when he was recalled to Beijing, Kong was mostly in the southern region around Nanjing and especially Yangzhou, and soon became a close friend of Gong Xian. The two talked late into the night when they first met and soon met again at a poetry gathering attended also by Zha Shibiao and Yuanji. In late summer of 1689 Kong visited Gong in Nanjing and the artist began work on a painting depicting the poet's studio in Shandong. In mid-autumn, before completing the painting, Gong Xian died. Kong Shangren made arrangements for the children of his second marriage, collected the artist's books and papers, and arranged for his burial. Gong Xian is remembered today as a loyal servant of the Ming, as an artist of compelling and visionary imagination, and as an individualist for whom there was no precedent and no possible follower –which is the way Gong saw himself, and lived.

Catalogue No. 47.
**Wu Hong** (paintings dated 1637-1683)
*Jiangshan Xinglü Tu*, "Travellers Among Rivers and Mountains"
Handscroll, ink and color on paper, 23 x 1243 cm.
Inscription: "In my younger days I loved to paint the green mountains. Without realizing it I have become old; and as for my brush and ink work I am ashamed of myself. In my whole life I have been unable to see into the central mysteries of Jing Hao and Guan Tong... During the eighth month, fall, of the year 1683 of the Kangxi reign-era, Wu Hong, called Xijiang Zhushi, painted this within the thirty-six peaks [of Huangshan] between Baima [in Jiangsu] and Yunlin [in Shandong]."
Artist's seals: *Luoluo Baiyunjian; Wu Hong zhi Yin; Yuandu*

Title: "Travellers Among Rivers and Mountains" written by Zheng Fu (1622-1694)
Colophons: by Cao Rong (1613-1685) in 1683, by Wang Pian in 1686, and by Gong Han in 1686

Opening with an expansive view of a wide river with fishing villages on either shore, the painting then presents a contrasting section of strongly modelled mountains whose bases are masked by clouds. This alternation between land and water, between heavily populated and more isolated regions, and between close-up detail and distant haze is continued to the final section where the earlier intimate views of human beings and their varied activities give way to the majesty of untainted nature. Small figures on river boats, in village shops, riding on roads, and hiking on mountain tracks encourage the viewer to enter the painting empathetically and then to experience the delights of this microcosm of complex reality. This degree of attention to narrative detail had not been common since the tenth and eleventh centuries, and the accumulations of discrete texture and modelling dots on the mountain peaks as well as the strongly outlined and leafless trees recall the style of Fan Kuan, a major artist of the eleventh century. The artist's inscription mentions Jing Hao and Guan Tong, two of the greatest tenth-century masters, and that too makes clear his intention to revive certain aspects of that monumental style. And despite his claim to have failed in the effort, the painting itself displays a compelling artistic vision made manifest by well-honed technical skills, the hallmarks of a mature style.

Wu Hong's family was registered in Jinqi, Jiangsu province but, according to his close friend and biographer, Zhou Lianggong (1612-1672), Wu "was born and raised in Nanjing. He has loved painting since childhood and in that art, being unwilling to settle down behind another's fence, he has opened up a path of his own. During the years 1653 and '54 he crossed the Yellow River and visited the Xueyuan [Snow Garden of Hou Fangyu in Henan province]..." While visiting in the north Wu Hong met the scholar-connoisseur Song Luo (1634-1713), later to become governor of Jiangxi province, and was able to study the collection of old master-works bestowed by the Shunzhi emperor (r.1644-1661) on Song Luo's father, Song Quan (1598-1652). Song Luo also introduced Wu Hong to the even more famous collector Liang Qingbiao (1620-1691), who commissioned Wu to copy some Yuan-period works in his collection. Wu was also introduced, by Zhou Lianggong, to Song Wan, another major collector-connoisseur of the north. The mid-1650s thus marks a major turning point in the art of Wu Hong, for his later paintings manifest a new and strong interest in the northern tradition of landscape painting. This marked change was noted also by Zhou Lianggong: "When he returned home his brush and ink work were completely transformed; free and spontaneous, rich and elegant, his works synthesize the merits of all the earlier masters but present them in terms of his own ideas... Fan Kuan was called *Kuan*, 'wide,' because of the breadth of his mind and Wu too is named *Hong*, 'broad.' He is a fine figure of a man and he and his paintings have richness to spare, lacking even a speck of the usual petty attitudes. The cases of Fan and Wu argue that among those artists whose brush and ink work are admired throughout

the world are none who are not broadminded. The names of Wu and Kuan will be transmitted to posterity together..."

While Wu Hong today is generally held to be a lesser master than Gong Xian (cat.46), their contemporaries seem to have regarded them as at least on a par. Huang Yuji (1629-1691), who helped write the official history of the Ming dynasty, described Wu in a poem:
"By nature Wu Hong is heroic and magnanimous,
  his jaw is square, his mouth wide,
    his speech a flowing stream;
  Like a frosted branch his old brush freely waves about,
    while Suzhou's silk-makers busily throw the weaving shuttle."
In later years Wu Hong moved to another district in Nanjing and became a neighbor of Gao Cen. He also travelled to Yangzhou and, in 1672, painted a portrait in the manner of Li Cheng of the house of Qiao Lai, who in later years would patronize such artists as Yuanji (cat.45) and Yu Zhiding (cat.53). The other participants in that gathering of 1672, all of whom inscribed the mounting of Wu's painting, included such scholarly and artistic luminaries as Zha Shibiao (cat.42), Liang Qingbiao, Zhu Yizun (1629-1709) and Cheng Sui (cat.38). The present painting is further evidence of Wu's wide circle of friends in that it bears a colophon by Cao Rong, a friend of Cheng Sui and Cheng Zhengkui (cat.37), and by Gong Han, the younger brother of Gong Xian. Cao's colophon is of interest for its commentary on the evolution of Ming to early Qing dynasty painting: "Painting is something which changes over time, but it also manifests the spirit of place. First there was Master Dai Jin in Hangzhou and then Master Wu Wei in Jiangxia. In the middle years Suzhou in particular flourished and the robe and bowl [of succession] were handed down from generation to generation and students of the school were everywhere in Jiangsu and Zhejiang. It remained like this for one hundred years but today Nanjing must be considered the successor. Zhou Lianggong has spoken of this glory and of the eight who have become famous..." This colophon by Cao is the earliest known mention of a group of painters known as "The Eight Masters of Jinling [Nanjing]." Zhang Geng in his *Guochao Huazheng Lu* of 1735 lists the names of eight artists but includes Xie Sun, a Nanjing painter who seems never to have been mentioned by Zhou Lianggong in any context. While the present group of eight thus may not be identical with the original, Wu Hong, both a major Nanjing painter and a good friend of Zhou Lianggong, was certainly among the earliest grouping.

Catalogue No. 48.
**Zou Zhe** (paintings dated between 1641-1684)
*Shanshui*, "Landscape"
Hanging scroll, ink and color on silk, 200.8 x 50.7 cm.
Inscription: "During the third month, spring, of the year 1655, painted by Zou Zhe."
Artist's seals: *Zou Zhe Yin; Fanglu*

The very tall and narrow format filled with mountain forms and also the attractive color here are reminiscent of

sixteenth-century Suzhou painting, and the present artist was indeed born there. Most striking about this seventeenth-century work, however, and the way in which it differs most from its predecessors, is its insistence on the logical ordering of three-dimensional forms in pictorial space. The sure handling of spatial recession, the skillful use of complex rock and mountain shapes to ensure compositional unity, and the masterful use of tree groups and vibrant line to vitalize the whole, mark this as a fine and very rare example from the middle period of the artist's life.

Zou Zhe's father, Zou Dian, was born in Suzhou and was a close contemporary of his painter-friends Ge Yilong (1567-1640) and Wei Zhihuang (1568-1646?). Zhou Lianggong (1612-1672) recorded that Zou Dian "travelled to Nanjing and subsequently resided there. His brush conceptions were lofty and pure and, having expunged both sweetness and vulgarity from his work, he could look down on other painters." Zou Dian, whose extant works bear dates between 1631 and 1646, was praised by Gong Xian (cat.46) as "one of whom I especially approve." Seemingly an introvert, Zou Dian nevertheless maintained close friendships with a number of prominent Nanjing painters and scholars. "In the usual case when a guest arrived," according to Zhou Lianggong, "he would doff his cap and draw water and set out the tea-bowls himself. The Eastern Garden where he lived was on the river's bank. His friend Hu Nianyue built a small pavilion for him. Zou inscribed the tablet with the characters *jiexia*, meaning 'pure mist' [or even 'moral radiance'] and wrote the poetic line, 'Even in light of day the bramble door is shut,' to express his desire. He did not randomly take up with people... I became acquainted as well with Zou's second son, Zou Zhe; thus did I obtain his large and small scrolls of landscapes and still-lifes in large numbers." The fall of Nanjing to the Manchus in 1645 may have intensified Zou Dian's desire for seclusion and the disaster would certainly have encouraged him to draw closer to his surviving friends.

Zou Zhe thus grew up in a home poor in material comforts but rich in artistic and scholarly potential, and in a group of his paintings dated between 1641 and 1648 he can be seen to have already matured as a painter. According to Zhou Lianggong, Zou Zhe "followed his father in painting and his pictures of pines in particular are extraordinary and elegant. He attended to the pavilion of Moral Radiance, respectfully served his father's friends, and carefully managed the household..." His father probably died in the late 1640s; later, "when his mother passed away, Zou Zhe was able to observe the full proprieties; assembled for the burial were many famous scholars." That only three paintings, including the present one from 1652, are known for the years between 1648 and 1655 suggests Zou's withdrawal during those years from both art and society. In one poem Zhou Lianggong noted that "Master Zou built a hut on the riverside; its four walls of hanging wisteria are purely green," and in another poem he admonished Zou Zhe to cease longing for the past and face the present reality by returning to painting:

"By plank bridge between flowers cultivating
    mulberry and hemp,
Mister "Woven-sandals" frets and frowns

about his home;
Knowing only former friends truly is he
    solitary and alone,
he should have known that beauty's aftermath
    cheapens to vulgar show.
Moved by the shining moon and a thousand
    miles distant from people,
pass your eyes over mist and clouds and
    paint one handful;
Choosing to admire your 'eastern neighbor,'
    your pot's bottom burns,
having a 'cold gate' already now for long,
    your lofty pines are obscure!"

"Eastern neighbor," *donglin* in Chinese, may refer obliquely to the late-Ming *Donglin*, "Eastern Grove," the academic-political society of which some of Zou Dian's friends were prominent members. Zou Zhe's mourning for those bygone days apparently took precedence over earning his living and resulted in lonely poverty. Zhou's counsel – given as a pun on the name of Zou Zhe's studio – was for Zou to return to painting the pines that were his specialty.

Zou Zhe evidently heeded this advice, and between 1665 and 1684 produced the majority of his dated paintings and trained his son, Zou Kun, to continue the family tradition in painting. Zou had known Gong Xian, Fan Qi, and Gao Cen previously and in 1669 was present with them and other Nanjing artists at the "retirement" celebration held by Zhou Lianggong that has provided historians with the roster of names from which the "Eight Masters of Jinling [Nanjing]" were chosen.

Catalogue No. 49.
**Wang Hui** (1632-1717)
*Jiuhua Xiuse Tu*, "The Beauties of the Jiuhua Mountains"
Hanging scroll, ink and color on paper, 133.5 x 57.5 cm.
Inscriptions: "'The beauties of Mount Jiuhua can be seized and crystallized, from this place I will take the cloud-dwelling pines.' Three days after the solstice of the year 1703, I supplemented these words from Li Bo with the brushwork of Wang Meng for presentation to the venerable old master Meiweng for his pure pleasure. Wang Hui, called Gengyan Sanren, from Haiyu."
"With pure heart he contemplates the way and follows Zong Bing, approaching the ink-stone he studies the calligraphy of Wang Xizhi; Marquis Wang's strength of brush can lift a bronze tripod, there has not been his like for five hundred years.'
These couplets were written by Ni Zan on a painting by Wang Meng. Wang was Zhao Mengfu's nephew but he opened up his own gate. If we speak of cultivated and refined richness and of subtlety in following models, then Wang truly does not yield to his uncle. Ni Zan's words ('Wang Meng could not see this even in a dream') are not to be endured. Inscribed by Wang Hui again the following day."
Artist's seals: *Haiyu; Cangjiang Baifa; Wang Hui zhi Yin; Shiguzi; Gengyan Yelao Shinian Qishiyouer; Laiqingge; Shigu*

The forty-eight peaks, fourteen cliffs, five caves, eleven ranges, seventeen streams, and two springs of the Jiuhua Mountains in southwestern Anhui were famous at least since the Tang dynasty when the poet Li Bo compared their layered forms to that of a sculpted lotus blossom. Those natural forms entered the realm of art here via brushwork and typeforms derived from the fourteenth-century master Wang Meng. The present artist's two inscriptions involve four different temporal and spatial contexts: the present, the year 1703, when he painted the work for his elder friend, Meiweng; the fourteenth century and Wang Meng's relationships with Zhao Mengfu and Ni Zan; the eighth century, when the great poet Li Bo confronted the actuality of the mountains themselves; and the fourth and fifth centuries when Wang Xizhi and Zong Bing established artistic traditions whose potency continued into the eighteenth century.

The creator of this highly subjective visual-verbal construct was Wang Hui, who was born in Changshu, Jiangsu, into a family which for the three preceding generations, back to the time of Shen Zhou (cat.12), had produced men known as painters. At Wang's birth the fragrance of ink is said to have filled the room for several days. His earliest recorded painting, of an old tree with withered trunk and branches, was painted on a wall with charcoal when he was five. There is some evidence that Wang Hui, like Wu Li (cat.51), was born into a Christian family – many years later Wu would write to Wang in terms that suggest he was a lapsed churchgoer – and Qu Shisi (1590-1651), mentioned in the earliest of Wang's extant inscriptions, was a Christian teaching in Changshu until 1644; Qu died in 1651 using Western-supplied cannon in the defense of Guilin against the Manchus.

On the fall of the Ming dynasty Wang Hui determined on a career in painting and, from the age of fifteen when he began study with the local master Zhang Ke, until his death seventy years and thousands of paintings later, Wang seems never to have wavered in his dedicated study and practice of that profession. A number of important events punctuate his unparalleled sequence of triumphs. The first and most important occurred in 1651 when Wang heard that Wang Jian (cat.35) was coming to visit the Yushan neighborhood in which he lived. After carefully painting a fan he had a mutual friend present it to Wang Jian, who was so impressed that he accepted the youth as his disciple. Wang Jian first set him to reading literature and to practicing his calligraphy; only several months later did he give him old paintings to copy as learning exercises. Around 1654 Wang Jian made a trip to Beijing and introduced his young protégé to Wang Shimin (cat.34), who responded to Wang Hui's work with awe and admiration: "He has no need to study with me; to the contrary, I should study with him!"

Wang Hui thus acquired another mentor, one who would prove extremely helpful to his later career. On an album of copies done in 1655 Wang Hui noted: "A certain old gentleman [Wang Shimin] loved to collect old masters and most of the famous works throughout the empire came from his collection. I am here with nothing to do so I slowly imitated the brush conceptions of various Song and Yuan masters. After several tries I carefully painted the best for presentation and judgment. In the old gentleman's household this will be like a single wave on the ocean." An extant

album painted by Wang Hui in 1660 – which bears a title written by Wang Shimin, *Xiaozhong Xianda*, "The Great Revealed Within the Small," and which reproduces the original inscriptions written by Dong Qichang (cat.28) – is almost certainly Wang's copy of the album of reduced-size copies of the famous paintings in Wang Shimin's collection painted for Wang by Chen Lian before their dispersal (see Wang Shimin, cat.34). Part of Wang Hui's study material was thus not the original masterworks but late Ming copies of the originals. This is also true of several well-known copies Wang Hui made of Huang Gongwang's "Dwelling in the Fuchun Mountains," a scroll he did not see in the original until after 1690 in Beijing; his earlier versions were based on a copy then in the collection of Da Zhongguang, a copy also probably painted by the unheralded Chen Lian.

Throughout the 1660s and '70s Wang Hui's circle of artist and collector friends continued to grow. He was very close to Yun Shouping (cat.52) from around 1649 onward and soon had students, such as Yang Jin (1644-1728), of his own. He also knew Zha Shibiao (cat.42) and Wu Weiye very well, and it was the famous scholar-official Qian Qianyi who wrote Wang a letter of introduction to the important collector Zhou Lianggong(1612-1672): "Wang Hui is content with his poverty and keeps to a simple life. His basic disposition is relaxed and quiet and he has distanced himself far from the usual vulgarities and vileness." Some time after Wang Hui had met Zhou and presented him with a painting bearing a colophon by Wang Shimin, Zhou declared: "He is the finest painter of the past one hundred years."

It was around this time that Wang Hui may be said to have achieved his *dacheng*, or "great synthesis," to use Wen Fong's translation of the term. The expression was first used by Mencius in reference to Confucius, who embodied to perfection all the virtues of earlier sages. As applied to an artist, the term implied a thorough study and mastery of all earlier styles, each of which contributed something to a whole that was essentially new. It is in this sense that Wang Hui differed from a mere copyist, a painter such as Chen Lian whose own personality remained submerged in that of the artist being copied; a painting done by Wang Hui after whatever earlier master is still recognizable as a work by Wang Hui. Consciousness of having achieved a kind of perfection must have given Wang a great deal of self-confidence and independence, evident from a series of inscriptions written on a painting of "Red Trees by Mountain Streams, after Wang Meng," brought to Wang Shimin in 1670. Wang Shimin wrote on the scroll: "Wang Hui brought this to show me... and I at once wanted to keep it. I knew that in his opinion too it was a gem but I could not forbear snatching it away." Shimin was forced to relinquish the painting, however, and the story is continued by the next colophon, by Yun Shouping: "This summer Wang Hui came from Suzhou. I found this scroll in his luggage and was so startled I almost died. Wang is very satisfied with himself and gives the impression of being unwilling to exchange it for the ransom of fifteen cities... Wang Shimin estimated it highly but Wang Hui was unable to cut himself off from what he loved..." Thus neither the loyalty owed his teacher nor the love given his friend was sufficient cause for Wang Hui to part with the painting, which bears a third and final colophon written by Yun toward the

end of the same year: "I happened to pass by Mr. Xu's river pavilion and found that this scroll is now owned by Mr. Pan of Jinsha... How will Wang explain this to Shimin and me!"

Wang's travels and associations with a broader range of acquaintances gave him a good grasp of the variety of art-historical currents of his day: "The Way of painting is in a state of daily decline, a decline which began with the corrupt practices of the recently separated schools... In recent generations taste declined evermore quickly, general practices are increasingly vulgar, and the theory of branch schools arose. From Dai Jin [cat.6] and Wu Wei [cat.7] onward the Zhe school could not be disregarded, and after Wen Zhengming [cat.15] and Shen Zhou the school of Suzhou flourished. Dong Qichang arose in an age of decay and grasped the essence of Dong Yuan and Juran, but the style of his later followers became extravagant and they stupidly regarded Yunjian as a school to talk about. The two masters Wang Shimin and Jian rooted their art in the Song and Yuan and matched the beauties of former sages. Painters both near and far strove to imitate them and thus the Loudong school was born. Other, secondary currents continue to their ends, when everyone becomes a master and the schools cannot easily be counted on the fingers... I am happy that I will not again be misled by these currents and schools and to some extent can believe in myself."

The second and highly successful Southern Progress of the Kangxi emperor in 1689, the same on which that monarch met Yuanji (cat.45) in Yangzhou, may have inspired Wang Hui to test himself in a final arena, that of court circles in the capital. By 1690 Wang's two teachers and his close friend Yun Shouping had all died and he himself was staying in a Beijing guesthouse. Wang met the Manchu collector Boerdu, and in 1691 was brought together with another newly arrived visitor, Yuanji, with whom he painted jointly. In the same year Wang Hui was asked to participate in the most important artistic project of the day, the set of handscrolls illustrating the Kangxi emperor's journey, called collectively the *Nanxun Tu*. Two officials who figured prominently in the project were Wang Shan (1645-1728), the eighth son of Wang Shimin, and Song Junye (1652-1713). While Wang Shan undoubtedly played some part in the recommendation of Wang Hui for this prestigious work, Wang Hui was not the only artist to be summoned: "Skilled artists of lofty talent from throughout the empire were brought together in the capital. After grinding their ink and moistening their brushes, they spread out their white silk and looked at one another; racking their brains and not daring to begin painting, they waited for Master Wang Hui to speak. The master shuffled forward in his grass robe and took the seat of honor. Fixing his eyes he meditated for a long while and then gave them his creative ideas, saying: 'Place the towns here, the mountains and rivers there,' and likewise for the people watching the imperial progress, the members of the formal entourage, the imperial resting-places, and on occasion the imperial chariot. He directed the twists and turns of several thousand *li* of the general circumstances, and when the draft was fixed the artisans followed his composition, paying heed only to the master, who merely added a few strokes to lend some refinement. When the painting was complete it was submitted for presentation to the emperor..."

Two of the other painters working on the *Nanxun Tu*, Yang Jin and Gu Fang, were Wang's direct disciples, who of course would wait on their master before doing anything at all. The project brought Wang Hui close to the official Song Junye, who invited Wang to stay with him and became his pupil in painting. The project also brought Wang to the attention of such famous scholar-officials as Zhu Yizun, Liang Qingbiao, Song Luo, and Gao Shiqi; Wang painted industriously for all of them, often working jointly with his disciples and students, who formed a large group in Beijing during the decade of the 1690s. Wang is said to have been presented with an inscription by the emperor (other sources say by an imperial prince) whose legend, "Landscapes of Purity and Brilliance," Wang later used on one of his seals. Judging by the scope and number of Wang's other activities during the period, his part in the imperial project was finished in 1691. Although he remained in the capital until 1698, working on private commissions, he declined appointment to the court academy and returned home triumphantly at the head of his own entourage of followers.

Having accomplished so much in the first sixty-six years of his life, Wang might be expected to have slackened his pace somewhat after returning from Beijing, but he added at least another five hundred paintings to his *oeuvre* during the final nineteen years of his career. During these years Wang likely served as artistic adviser to the young merchant-collector An Qi, whom he had met in Beijing around 1698. Using a fortune earned by his father and himself in the salt trade, An brought together an excellent collection of old masters, many of which had been owned previously by Liang Qingbiao and Bian Yongyu. Wang Hui of course knew all the major collectors of his day and, more importantly, he knew what should be bought. When he died in 1717 at the age of eighty-five he had two sons, five grandsons, and eight great-grandsons; he was grouped with his two teachers as the Three Wangs (and together with them and Wang Yuanqi as the Four Wangs) and was generally recognized throughout the country as the greatest painter of his day.

Catalogue No. 50.
**Wang Yuanqi** (1642-1715)
*Fang Meidaoren Shanshui*, "Landscape after Wu Zhen"
Hanging scroll, ink on paper, 94 x 53.3 cm.
Inscription: "On a spring day in the year 1702 of the Kangxi reign-era, painted after the brushwork of Wu Zhen by Wang Yuanqi in a hut attached to the Changchun Yuan, 'Garden of Everlasting Spring.'"
Artist's seals: *Saohua An; Wang Yuanqi Yin; Lutai; Xilu Houren*
Colophon: by Wang Hui (1632-1717)
Collector's seals: the Ministry of Education (on mounting)

Wang Yuanqi was born in Taicang, Jiangsu, into a famous family of scholar-officials. His grandfather was Wang Shimin (cat.34), his father Wang Kui (1619-1696), an upper-degree holder who declined to take office. A natural talent for painting manifested itself at an early age: "When a youth,

he happened to do a small landscape which he pasted on the wall of the study. When Wang Shimin saw it he exclaimed in surprise: 'When did I do this?' When he had found out about it he said: 'This lad will end up my superior!' He would then elucidate to Yuanqi the essentials of the six standards of painting and analyze the differences and similarities of artists from ancient to modern times." Another important feature of Wang Yuanqi's artistic upbringing was the number of famous painters he met frequently at his grandfather's house. As Zhang Geng noted in 1735: "Throughout his life Wang Shimin thirsted after talent as though he were parched and did not look up and down according to the customs of the world; for this reason those skilled in painting came from the four quarters on one another's heels to his gate. Those who received instruction from him all became famous, beginning with Wang Hui [cat.49] of Haiyu." Zhang Geng was later taken to task for having referred to Wang Shimin as a "leader of our Qing dynasty's painting garden," but those who took exception to the statement assumed that the "painting garden" was the imperial Painting Academy, rather than the private academy Shimin operated on the estate on which Yuanqi was raised.

In spring of the year 1677 Wang Yuanqi painted an album of landscapes after six great masters of the Yuan. "My grandfather saw it and allowed that I was teachable; he inscribed this album with four characters..." The four-character title given the album by Wang Shimin was *Lingxin Ziwu*, "The Intelligent Mind Enlightens Itself." Already in 1670 Shimin had expressed his hope for Yuanqi's future: "You are fortunate in having passed the highest level examination; you should now concentrate your mind on painting studies so as to continue my teachings." In 1677 Wang Shimin presented his grandson with one of his most treasured possessions: the *Xiaozhong Xianda* album (see Wang Shimin, cat.34). According to Wang Yuanqi: "In early summer of the year 1677 my grandfather unexpectedly gave this album to me, for his expectations and hopes for me were very deep." The gift of the album would seem to have been Shimin's acknowledgment of his grandson's already proven accomplishments in painting and his great potential for future development.

Wang Yuanqi's initial government appointment was to the Board of Civil Affairs. In 1681 he became first an assistant examiner for a provincial examination and then magistrate of Renxian in Zhili. After serving as magistrate with distinction for four years, Wang was brought to the capital as a censor and there met Wang Hui in 1690. In 1691 Wang Yuanqi collaborated with the monk Yuanji (cat.45) on a painting for the Manchu Boerdu. The last fifteen years of Wang Yuanqi's life seem to have been spent almost entirely in Beijing save for one year in mourning after the death of his father in 1696. During this long period of service Wang rose steadily in rank: secretary in the Supervisorate of Imperial Instruction in 1700, then expositor, reader, and finally chancellor of the Hanlin Academy, and in 1712 he was appointed senior vice-president of the Ministry of Revenue, a post he held at his death in 1715.

Wang's bureaucratic assignments often made use of his knowledge of connoisseurship, art history, and the art of painting. In the year 1700, for example, Wang was granted a sinecure in the Supervisorate of Imperial Instruction so as to free him for the important task of authenticating calligraphy and painting then in the imperial collection. His success in this, as well as the Kangxi emperor's growing interest in art, was manifested by his appointment in 1703 as one of the supervisors of the compilation of the most complete work written to that time on earlier calligraphy and painting; published in 1708, the *Peiwenzhai Shuhua Pu* has one hundred chapters in which the material culled from 1,844 different sources is presented in such clear and logical fashion that the book remains an important reference yet today. It was probably on the successful completion of that project that the emperor presented Wang with a seal whose legend read: "His paintings and pictures will be handed down for people to view." The final project on which Wang worked was also the most ambitious: the *Wanshou Tu* of 1713, intended to commemorate the sixtieth birthday of the emperor, an undertaking so complex as to require the creation of a special bureau. Administrators with expertise in artistic matters were found close to hand among the five editors for the earlier literary project. The original designs were to have been done by Song Zhunye, who had learned about such joint works when assisting Wang Hui on the *Nanxun Tu*; when Song died in 1713 Wang Yuanqi assumed responsibility for the draft version on paper and a final version on silk, which was completed in 1716 and signed by Leng Mei (cat.57). Given Wang Yuanqi's executive responsibilities it is all the more remarkable that he is one of the few artists of that day to have equalled Wang Hui's rate of production during the last decades of their lives.

Wang Yuanqi in fact complained not infrequently about the weight of his many responsibilities but also suggested that he found the act of painting, when not in response to imperial and imperious demands, relaxing and self-improving. In 1707 he wrote: "For several years now I have been in one office like a hanging gourd; with brush in hair, antler-like, day and night I have been on duty and my family has no rice for the steamer. By day within the city of sorrow and sea of distress, there is nothing with which to relieve my worries; but, when I play with the pliant brush and enter into and leave the styles of various masters of the Song and Yuan, it is like being face-to-face with the ancients themselves. Although I cannot imitate exactly their forms and spirit, to some extent a single encounter is still model enough for lodging conceptions and broadening the heart."

Given Wang Yuanqi's wide knowledge of the earlier theoretical literature on painting, it is natural that he too analyzed the basic principles of his art. The results of his thoughts were organized into ten sections and presented as the *Yuchuang Manbi*, "Desultory Jottings at a Rainy Window." In his text Wang discussed the art of landscape painting largely in terms of such abstractions as *longmo*, or "dragon-veins," *kaihe*, or "openings and closings," and *qifu*, "risings and fallings." These terms originated in geomancy and hence described characteristics of actual mountains; at some fundamental level, then, Wang advocated an art based on natural principles, even if the resulting image was most unnatural. "Dragon-veins are the source of the energy-profile of a painting. Whether they are slanted or straight, complete or incomplete, discontinuous or continuous, hidden or revealed, they

constitute the essential structure. An opening and closing movement extends from above to below, with main and subsidiary sections arranged in proper order. Sometimes the movement brings everything together, and sometimes it disperses and drains away. The turning of peaks and winding of roads, the gathering of clouds and dispersal of water – all are produced in accord with this movement. A rising and falling movement extends from near to far with front and back distinguished clearly. Sometimes this movement surges high, sometimes it is level and distant, and it leans or inclines in response to what is called for. When the top, the middle, and the foot of the mountains down to the smallest detail are in balance, this is called deployment." "In doing a painting one need pay heed only to the energy profile and the silhouette of forms. One need not seek for beauty in the scene nor is it necessary to hold fast to the models of old. For if one understands the truths of opening and closing and rising and falling, and the energy profile and the silhouette of forms are themselves in accord, then as the veins and arteries pause and begin again, turn around and fold back, natural and wondrous scenery will spontaneously be produced and be in covert agreement with ancient models."

Various aspects of his "Landscape after Wu Zhen" can be used to summarize Wang's life and career. One of the seals, *Xilu Houren*, identifies him as a "Descendant of Xilu," or Wang Shimin, his grandfather and teacher in painting; the colophon by Wang Hui reminds us of the artistic context in which Yuanqi was raised; the work was painted in the favorite private garden of the Kangxi emperor who Wang served so assiduously; and by 1702, the date of the work, his style and theories had matured and hence mutually support and augment one another. The essential structure defined here by the dragon- veins is clearly visible beneath the local detail, and the major formal themes of opening and closing, rising and falling are also readily apparent. That Wang's style here is derived from that of Wu Zhen and that his theories relate to those of Huang Gongwang of the Yuan period are further manifestations of the conservative creed, defined by Robert Nesbit in terms which apply also to the goals of Wang Yuanqi: "The very function of tradition is to bring past, present and future into one, to stimulate hope in and desire to work toward the future through commemoration of the past and its extension into the present."

Catalogue No. 51.
**Wu Li** (1632-1718)
*Sigu Tuogu Shanshui*, "The Continuing-and-Rejecting-the-Classic-Inheritance Landscape"
Hanging scroll, ink on paper, 65.5 x 31.2 cm.
Inscription: "Tao Yuanming's line 'I plucked chrysanthemums at the foot of the Eastern Fence, in the far distance South Mountain could be seen' was often responded to in rhyme by Tang and Song poets. But only Wei Yingwu's line 'I plucked chrysanthemums on which the dew was not yet dry, raising my head the autumn peaks appeared' was truly an extraordinary rhyme. Imitating the ancients in painting is like matching a rhyme by Tao; changing the model as a matter of course by putting

forth new ideas is to be a free and competent hand. On the tenth day of the tenth month, by the Ink-well Daoist."
Artist's seals: *Wu Li zhi Yin*; *Mojing*
Collector's seals: Pang Yuanji (1864-1949)

The brushwork, the configuration of the mountains, and even the simple houses of this painting are similar to those in the painting by Wang Shimin (cat.34), who was Wu Li's teacher. Neither painter mentioned a specific prototype for the style of his painting, but both include visual references to the tenth-century masters Dong Yuan and Juran and to their fourteenth-century followers, that is, to the orthodox tradition defined by Dong Qichang (cat.28), Wang Shimin's teacher. Despite their common origins, however, these paintings by Wu Li and Wang Shimin are very distinctive in style, a variety dependent on their individual transformations of the received tradition. Wu Li elsewhere compared painting to a game of chess, in which the classic styles of Song and Yuan masters functioned as the pieces to be manipulated in the course of the creative struggle. His inscription here makes clear his insistence that the inheritance be creatively transformed. The present painting is clearly a mature work from the artist's latest period of activity and probably was done while he was in his early seventies, when, as is also true in the late work of Shen Zhou (cat.12), the blunt and restrained style of Wu Zhen came to dominate the expression.

Wu Li, originally called Wu Qili, was born in Changshu, Jiangsu. His father, a government official in charge of grain-tax shipments on the Grand Canal, died while working in the north when Wu Li was only a few years old. Wu and his two elder brothers were thus brought up by their mother. Exceptionally gifted, Wu progressed rapidly in a number of artistic and literary fields. His talent in music was developed through study with Chen Min, a master of the lute as well as a poet and painter. Wu and Wang Hui (cat.49) were exact contemporaries and both studied painting with Wang Jian (cat.35) and then with Wang Shimin. The latter is said to have shown his collection of Song and Yuan masterworks, or at least copies of them, to Wu, who produced his own copies in smaller scale. The high quality and sensitivity of these copies suggested to Wang Shimin that a special affinity existed between his pupil and the ancient models. Another admirer of Wu's copies was the important Changshu scholar-official Qian Qianyi (1582-1664), who also advised Wu on the art of writing poetry. The young scholar was also introduced to the major intellectual currents of his day through study with the neo-Confucian philosopher Chen Hu (1613-1675) and through his friendship with the Buddhist monk Morong, who was often visited by Wu at the Xingfu Monastary.

Wu Li's involvement with Christianity, the religious force that dominated his life from around 1670 onward, began with his baptism while a boy. Since the earliest missionaries to Changshu had established themselves as neighbors to the Wu family, there is a strong possibility that his parents were among the earliest local converts to Christianity and had their children baptized at birth. According to the *Haishang Molin*, Wu Li passed the first-level civil service examination but seems to have had no further inclination to employ his talents in government service. There was little in

his experience to suggest that such was a wise or even honorable course of action; his painting teachers, Wang Shimin and Wang Jian, had both withdrawn from government service after encountering difficulties; Wang Hui's teacher, Qu Shisi (1590-1651) had died fighting the Manchu invaders; and his mentor in poetry, Qian Qianyi, was condemned by many as a traitor for having served both Ming and Qing dynasties. Wu thus turned to painting in order to support his mother, his wife, and his two children, though he seems never to have derived the same level of personal satisfaction from painting as did Wang Hui.

The increasingly divergent careers of the two artists born into relatively similar circumstances is instructive. They began as close friends but, in his *Guochao Huazheng Lu* of 1735, Zhang Geng mentioned an event which led to a rupture of the friendship: "Wu Li and Wang Hui were painting friends when young and each was the other's closest intimate. Later, Wu borrowed Wang's copy of Huang Gongwang's painting 'Steep Torrents in Dense Groves' and did not return it; consequently they parted ways." The original work by Huang was in fact greatly admired by Wu and he may well have been unable to part with his friend's copy of it; but, in any case, by 1703 Wang could write of Wu: "The Ink-well Daoist [Wu Li] and I were fellow students of the same age and from the same neighborhood. Ever since he withdrew into the lofty and transcendent, I too have travelled the four quarters and was gone in the north for a long while. Yet whenever I saw his ink marvels, in which he went from Song into Yuan styles, ascending their peaks and advancing to their limits, I would often clasp them to my breast so as not to lose them. This painting... was done twenty years ago yet he was able to free himself from the beaten paths of the day. It is like facing a superior person or a recluse, imbued with a profound harmony and quietude and pure both within and without."

Christianity began to have an ever increasing attraction for Wu Li and eventually claimed virtually all of his time and energy. The process seems to have begun around 1670 when Wu accompanied a Christian censor named Xu Zhijian on a trip to Beijing in celebration of an imperial order upholding the loyalty of the German missionary Adam Schall von Bell (1591-1666). During his year or so stay in the capital, Wu met many officials and some of the missionaries active there. On his return to Changshu the deaths of his Buddhist friend Morong in 1673 and the neo-Confucian Chen Hu in 1675 may have accelerated Wu's disillusionment with the world in which he lived and made the eternal life described by Father Francois de Rougemont (1624-1676) all the more attractive. Following Rougemont's death in 1676 – shortly after he had received a painting from Wu in return for gifts of tea-leaves and money for wine – Father Philippe Couplet (1624?-1692) assumed responsibility for the Changshu district and Wu served as his catechist. In 1680 Couplet was called to Rome and Wu, whose mother and wife had died and his children married, decided to accompany him. Leaving Changshu in 1681, they travelled to Macao, where Wu stayed when Couplet boarded a ship for Holland in 1682. Wu remained in Macao for some months while church authorities determined whether a man who had children and who had been married twice could be admitted into the Society of Jesus, known as the Jesuit order. On being granted permission, Wu first returned home to arrange family matters before returning to enter the Jesuit seminary in 1682 with the Christian name of Simon-Xaviar a Cunha. Six years after entering the novitiate, in the year 1688, Wu Li was ordained a priest by Lu Wenzao, the first Chinese bishop in the Catholic Church.

Following this religious training Wu Li was sent to Shanghai as a missionary. In his detailed study of Wu Li, Lawrence Tam quotes a letter sent in 1690 by Mgr. Gregory Lopez to the Propaganda Fidei in Rome: "Simon-Xaviar, as formerly mentioned by me to have been preaching in Shanghai, is devoted and performs his duty well. During my stay in Shanghai for two months I had the opportunity of visiting the various centers together with some European missionaries. I inspected the diocese ministered by him at Shanghai and found that he was respected and loved by the faithful and they are glad and comforted to have him with them." In 1695 Wu Li took his final vows of perpetual poverty, chastity, and obedience to God and to the Society, after which he ministered mainly in Jiading, north of Shanghai, as head of the local mission. Wu's true piety as well as his understanding of the potent Christian image of the good shepherd are well expressed in his "Song of the Shepherd:"

"Fording the Huangpu [at Shanghai]
    I left the city to shepherd,
  but what can one do when the sheep are all dispersed?
The fat ones are almost a flock,
    but how can the lean ones be so many more?
The grass is poor and the pasture distant,
    and it seems the shepherd came late,
  but the faults of these sheep are known only to me;
Leading them onward by singing songs
    I neither tire nor slacken,
  guarding their pen and driving off wolves
    I often do not sleep.
I only hope that through the long year
    I can persevere in shepherding,
  to the east and south from dawn
    and the west and north by sunset."

From 1704 onward Wu Li was mainly in Shanghai, where he died at the age of eighty-six and was buried in the Catholic cemetery. His tombstone bears the following inscription: "'The Tomb of Master Wu from Yushan, a Priest of the Heavenly Learning.' The master, whose given name was Li and religious name Simon, was from Changshu. In the year 1682 he entered the Society of Jesus and in the year 1688 he was registered as an Inciter to Virtue [ordained as a priest] and propagated his faith in Jiading and Shanghai. In the year 1718 he fell ill and died in Shanghai on the feast day of St. Mathias at the age of eighty-six."

Catalogue No. 52.
**Yun Shouping** (1633-1690)
*Shuangqing Tu*, "Paired Purities"
Hanging scroll, ink and color on silk, 88.2 x 54.4 cm.
Inscription:
"Paired Purities.
  When the snow clears where
    shall I look for spring radiance?
  Only after seeing it on a southern branch
    shall I break through the morning frost;
  Not yet allowing the spring breeze
    to reach the peach and pear,
  first the iron-hard trunk must be tested
    for wintry fragrance.
Yang Buzhi's blossoming plums done in ink and Zhao Mengjian's narcissus are of the transcendent grade within the groves of ink painting. For a thousand years none have been their peers, for they used the brush like immortals from the Daoist mountain Gushe and stand alone beneath the firmament. If you are looking for daubs of green and smears of red, the vapor here covers the embroidered ornament which diminishes everything in beauty. During the spring of the year 1686, painted in the Ouxiang Studio by Shouping, called Nantian."
Artist's seals: *Jiangyi Woqing; Shouping; Yun Zhengshu; Ji Yueyun*
Colophon: by Wang Hui (1632-1717)

The Chinese narcissus, which blooms in February, is associated especially with the beginning of the lunar year, while the Chinese plum blooms when snow and ice are still to be found. The seasonal associations of these 'paired purities' is referred to in the poem written by the artist who then adds an art-historical dimension by mentioning the most famous Song-dynasty specialists in these subjects. While the blossoming plum had already had a long history in China by the Song, the narcissus was then a recent import grown only in the coastal areas of Fujian. In the present painting the amorphous environment out of which the flowers emerge evoke the proper season as well as suggest the subtlety of the blossoms' fragrance and beauty.

Yun Shouping was born Yun Ge in Wujin, Jiangsu, the third and youngest son of Yun Richu (1601-1678). The father was still a student in the National University when Shouping was born; in that year Richu made the "honorable mention" list at the second-level examination and went to the capital where his older brother, Yun Benchu (1586-1655) was serving as a drafter. Both brothers became active members of the Fushe, or "Revival Society." In 1641 Ruchu drew up a five-point plan for border defense; when it was not implemented he decided that nothing could be done to ward off Manchu aggression, returned home, gathered up his three-thousand volume library, and together with his younger sons withdrew into the Tiantai Mountains. After the fall of Beijing and then Nanjing to the Manchus in 1644-1645, the Prince of Lu, who had established himself in Shaoxing, urged Richu to join him; he refused, moving first to Fuzhou in Fujian and then to Guangzhou as the Manchus advanced southward. In 1647 Richu agreed to help the loyalist leader Wang Qi in attacking Pucheng, the first stage of a plan to retake Fujian province.

Due to a bad storm in which horses and men became mired in mud, the attack failed and Richu's eldest son was killed. The following year the Manchu general Chen Jin (d.1652) led 60,000 men against the loyalist stronghold in Jianning; Wang Qi was killed, the second of Richu's sons disappeared, and the third son, Shouping, was captured by the Manchu forces and held at their headquarters.

When Chen Jin's wife desired some new jewelry she had craftsmen submit sketches, but none suited her. Someone said that the young prisoner, Yun Shouping, was a painter, and he was brought before the wife. Yun was evidently a comely youth and, having been able to recite verses from the Lotus Sutra at the age of seven, was clearly very intelligent, as well as talented in painting, in which both he and his father had been trained by Yun Benchu, known later as Yun Xiang. Chen Jin and his wife had no son and decided to adopt the fifteen-year-old boy. Yun Richu had meanwhile returned home to Wujin where he thought continuously of his two missing sons. One day, in Hangzhou, he saw his youngest riding as part of Chen Jin's entourage and started planning to secure his son's return. He learned that Chen and his wife greatly esteemed Abbot Dihui of the Lingyin Temple; Richu, who had become a monk himself some years earlier, was a friend of Dihui and able to enlist his help. It happened that the women of the region were scheduled to come to the temple to offer incense to the Buddha, after which they were to be presented to the abbot. When Chen Jin's wife brought her adopted son before him, Dihui commented on the boy's obvious intelligence but observed that the lad was fated to die young unless he became a priest. Loving the boy as she did, Yun's foster mother had no choice but to leave her son at the Lingyin Temple; here he studied poetry and calligraphy with the abbot until Chen Jin's death. Yun was then free to return to live with his father at the east garden in Wujin, where the father supported them by working as a teacher. As Yun Shouping grew older he too began to contribute to their livelihood by selling his paintings, which he normally signed with his byname Shouping rather than his given name Ge.

By the very late 1640s or early 1650s Yun had met Wang Hui (cat.49), who became his lifelong friend. According to Yun's great-grandson, "Yun Shouping became friends with Wang Hui of Yushan. Wang's landscapes were very similar to those of Yun. Yun looked at them and said with a grin: 'Two sages do not get on well with one another. You, my lord, will dominate all beneath the heavens with your landscapes; how can I too devote myself to the subject?' and he then did flowers, plants, and drawings-from-life." While Yun continued to paint landscapes until the end of his life, he in fact become known primarily for his bird-and-flower paintings. He was not as successful as Wang, however, for he refused to curry favor with influential collectors and potential patrons. He thus lived simply throughout his life – the houses in which he lived were all borrowed from friends, and his burial had to be paid for by Wang Hui – but always with an elegant flair; according to one friend: "I visited Yun Shouping and entered the house. The entrance hall was empty and quiet and clumps of chrysanthemums filled the stairs. Its style would truly not shame a famous scholar-official."

Another of Yun's friends described his method of work-

ing: "He got up each day at early dawn. He himself boiled water for tea, washed his face and hands, and prepared the lead-white and cinnabar-red pigments. Spreading out paper he would then paint. By the time the others had all gathered, the lead-white and cinnabar-red would be gone and any unfinished pictures would be stored in a case. For the rest of the day he would not paint a single stroke and do no more than play chess, sing, and drink." The quiet hours of very early morning must have been conducive to work and also to such observations on the nature of creativity as the following: "Brush and ink can be perceived; the well-springs of the universe cannot be perceived. Squares and compasses can be acquired; overtones of the unmanifested cannot be acquired. How can those who use what can be perceived and what can be acquired to pursue what cannot be perceived and cannot be acquired do it easily by effort alone!"

Through his friendship with Wang Hui, Yun met a number of important collectors of the day, including Wang Shimin (cat.34), but only days before the latter's death in 1680. Wang Shimin had known of Yun's talent for at least ten years and had sought to meet him through invitations extended via Wang Hui. However, Yun was somehow never able to find the time or the proper occasion on which to visit this very important and potentially helpful person. Yun's reluctance was likely determined by loyalty to his father, who had been opposed to Wang's political faction during the late Ming years; when Yun did finally agree to meet Wang it was after his father's death in 1678. Yun and Wang Hui arrived at Shimin's estate on the eighth day of the sixth lunar month but left after seeing him very briefly on his sick-bed. On the seventeenth Shimin died, after which a search of his bed turned up ten gold taels. A servant explained later: "Knowing that his two guests Wang and Yun were about to arrive, he wished to leave this for their expenses." In subsequent years Yun became quite close to several of Wang Shimin's sons, one of whom, Wang Pu, had even before 1680 written a story, "Vulture Peak Record," based on Yun's early life. The third son, Wang Shan, who eventually became a grand secretary, played a dramatic role in Yun's later life. A certain judicial official in Suzhou had been frustrated in his attempts to get a painting from Yun; growing increasingly angry, he had Yun brought forcibly to Suzhou, intending to humiliate him in public the next day. Being a commoner, Yun had no legal recourse and turned to Wang Shan for assistance. The house in Taicang was already shut up for the night when Yun's messenger arrived, but Wang immediately set out for Suzhou on horseback, following a servant who carried a lamp suspended on a bamboo pole tied to his back. The city gate opened at five o'clock and Wang Shan – a member of the Hanlin Academy – stormed through to secure Yun's release.

Yun's influence on such later artists as Hua Yan (cat.60) was very great and according to Yun himself he had imitators even during his lifetime. "In recent days the drawing-from-life specialists mostly follow my line-suppressed flower pictures which completely transform the thickness of washes. At a time when there are both elegant and vulgar practices these are sufficient to please the eye and gratify the heart, but when models are transmitted for a long time, they become like the overflow of a goblet [like the source of the Yangtze, the small beginnings of a great flood]. I thus praise very highly the quiet and refined type of flower paintings of Song artists, and those wishing to employ the gay and variegated attitudes of cosmetics should return again to the natural colors." The present "Paired Purities" manifests perfectly Yun's own aesthetic ideals: "Not falling into well-worn ruts is called having a scholarly air; not entering into the trends of the times is called having an untrammelled style."

Catalogue No. 53.
**Yu Zhiding** (1647-ca.1713)
*Huangshan Caotang Tu*, "Thatched House at Huangshan"
Handscroll, ink and color on silk, 40.3 x 132.7 cm.
Inscription: "Thatched House at Huangshan" (at beginning); "Painted by Yu Zhiding on an autumn day in the year 1702." (at end)
Artist's seals: *Bifeng Jiashi Yi Xiezhen*; *Yu Zhiding*; *Shenzhai*
Title: "Thatched House at Huangshan" written by Wu Xizai (1799-1870)
Colophons: Gu Ying, Chen Shiqing, Cao Roujian, Zhan Sixian, Zhang Bingyan, Qian Guisen

The title inscribed by the artist on this work, "Thatched House at Huangshan," creates expectations which are not met by the painting; the angular rocks appear with elegant willows rather than the famed pines of the mountains in Anhui province, and the rather ornate structures here are not thatched but rather tiled in the Beijing style. The painting was certainly done while the artist was in the capital, and the title may simply reflect the origins or the dreams of the subject, who is posed elegantly if self-consciously beside the fishing pond. The composition is arranged to emphasize the figure and to suggest the seclusion of his residence, surely a luxury in Beijing even in those days. The status of the figure is also communicated by his activity – clearly not the fishing of a real fisherman – and by the servant who stands at parade rest in anticipation of his master's wishes. Some influence from Western approaches to painting are visible in the use of shadow and color to model the face of the master, who is characterized as a cultivated and sensitive person by the gracefulness of his posture and the elegance of the lines of his gown.

Yu Zhiding was born in Yangzhou, Jiangsu province, and became widely famed as the pre-eminent portraitist of his day. Yu studied painting as a youth with Lan Ying (cat.30) and it was probably through the Lan family that Yu met the high official and important collector Gao Shiqi (1645-1703); a group portrait painted by Yu in 1684 includes Gao and Lan Shen, the son of Lan Ying and a classmate of Gao. While the influence of Lan Ying can be discerned in especially the landscape elements of Yu's earlier paintings, it was the figure style of Chen Hongshou (cat.33) which had a more lasting effect on Yu. Chen's supple and graceful style of drawing, which featured continuously curving lines, was melded by Yu with the Western-influenced, color-modelling style of Zeng Qing, the most famous portraitist of the previous generation.

Among the five scholars portrayed in one of Yu

Zhiding's earliest paintings were Wang Shizhen (1634-1711) and Xu Qianxue (1631-1694), both of whom figured prominently in Yu's later career. It was likely Wang Shizhen, Yangzhou's foremost poet, scholar, and official of the day, who recommended Yu for service in Beijing. By the early 1680s Yu was working in the Court of State Ceremonial as an adviser on etiquette to guests invited to state banquets; the position was not to Yu's liking, according to one biographer, nor did it make any use of his skill in painting. However, neither did it prevent Yu from accepting the many private commissions on which his fame is based, and the state ceremonies did bring him into contact with the high officials who became his patrons. As the legend of one of Yu's seals on the present painting notes: "I must meet a superior gentleman before I paint a portrait." Despite wide appreciation of Yu's artistic abilities, however, he was still a professional painter whose social status was far lower than those of his subjects, and at times he was treated accordingly: "One day a kinsman came galloping up to summon him with great urgency. Yu Zhiding was a southerner and hence not a good rider, and in addition to the rush and hurry he was already weary and flagging. When they arrived at the palace, the ceremonial reception had hardly begun when the order was given for him to paint a small portrait. Kneeling on a woven mat he moved his brush and painted. Concluding that he had been demeaned... he thus decided to return home."

Yu did leave the capital around 1690 and on his departure received a poem from the well-known scholar Zhu Yizun (1619-1709):

"The consulting official intends to go and live at
     Dongting,
   this idea has been pondered for more than six years;
   After you leave the Western Hills first plan the house,
   a small building will hold your boat filled with books."

On arrival at Mount Dongting on Lake Tai, Yu joined his old patron Xu Qianxue, who had retired there in 1690. In one collaborative work Xu wrote the *Maoshi* poems that accompany Yu Zhiding's copies of illustrations done originally by Ma Hezhi of the Song dynasty. Yu is often said to have adopted the so-called orchid-leaf line of the Tang master Wu Daozi, but it is far more likely that his knowledge of this motif was derived from Ma Hezhi. By the late 1690s Yu had returned to Beijing where he did several collaborative works with Wang Hui (cat.49) and painted portraits of such luminaries as Wang Shizhen, Song Luo (1634-1713), and Wang Yuanqi (cat.50). Although frequently placed in generalized and idealized settings, the eminent officials, scholars, poets, and artists of Yu's portraits were each individually characterized by realistic depiction of their faces, while often subtle and oblique allusions place them effectively within larger social, economic, and cultural contexts.

Catalogue No. 54.
**Lu Wei** (paintings dated 1687-1710)
*Shanshui*, "Landscape"
Handscroll, ink and color on paper, 24.2 x 375 cm.
Signature: "Lu Wei from Huating"
Seal: *Wei*
Title: "Throughout the entire region of rivers and lakes is only a single old fisherman" written by Li Caixian
Colophon: written by Zhang Wei

The composition of this engaging river scene is arranged so as to conduct the viewer's eye on a serpentine journey as the scroll unrolls, moving from fore to far ground and from top to bottom of the painting. To the varied delights of compositional movement are added those of such narrative details as houses, pavilions, and a boat, but all are subservient to the purer delights of brush and ink, which varies from wet to dry and is applied in a pleasing range of textures, tonalities, and light effects. Lu Wei's approach to painting was described well by Zhang Geng (1685-1760): "His method used a light brush and fine dots, and in building up a passage from light to heavy he did not mind going over it a hundred times. Between mountain groves and stony cliffs mist and clouds collect and mingle, and the breath of the enshrouding and misting ink can also be enjoyed. His compositions are devoted to seeking the strange and eccentric as he considered it not worthwhile following commonplace paths..."

Lu Wei was originally from Suichang in Zhejiang but moved to Jiangsu province where he lived in Yunjian. Lu began his study of landscape painting by following the styles of Mi Fu (1051-1107) and Gao Kegong (1278-1310) but later added his own ideas to establish a personal style. This is closely related to the earlier seventeenth-century Yunjian school of Zhao Zuo, Shen Shichong (cat.25), and Chen Lian, all of whom seem to have been strongly influenced by the actual appearance of their surroundings and to have imbued their works with the atmospheric effects proper to that more visual than art-historical approach.

Although Lu was a professional painter he seems not to have been overly concerned with either fame or money. "He lived to the south of the Chaoguo Temple. Those who wanted to get a painting from him always had to ascend to the first viewing-level of the temple and there watch until they saw that there was no smoke for a noon cooking-fire. They then took silver or rice and went to exchange it for a painting, for otherwise they could never get one. People thus called him 'Lu the Fool.'" However, Lu Wei did accept commissions from those he respected. According to Gao Bing, the son of Gao Qipei (cat.62), the latter employed both Lu Wei and Yuan Jiang (cat.58) to add the finishing brushwork to his own roughly done finger-paintings. Lu must have undertaken these commissions between the years 1706 and 1715, when Gao Qipei was stationed in Zhejiang province. Zhang Geng recorded that Lu Wei was in Hangzhou at the West Lake for a year before he died, and that while there he was a guest of Governor Tu, who returned Lu home to Yunjian for burial.

Catalogue No. 55.
**Lang Shining (Guiseppe Castiglione),** (1688-1766)
*Ping'an Chunxin Tu*, "Tranquil Spring"
Hanging scroll, ink and color on silk, 68.8 x 40.8 cm.
No signature or seal of the artist.
Colophon:
"In portraiture Shining is masterful,
  he painted me during my younger days;
  The white-headed one who enters the room today,
  does not recognize who this is.
    Inscribed by the Emperor toward
    the end of spring in the year 1782."
Collectors' seals: the Qianlong emperor (r.1736-1795), the
Ministry of Education (on mounting)

Guiseppe Castiglione was born in Milan, Italy. It was as
a fully trained artist that he applied for admission to the
Jesuit order and it is likely that he was destined from the first
to serve his church in China by means of a painter's brush
rather than as a religious proselytizer. After being admitted
to the Jesuit order in 1707 at the age of nineteen, Castiglione
was assigned to the Noviziato in Genoa belonging to St.
Ignatius. While there he painted two oil paintings in which
the rhetorical gestures and expressions and the dramatic use
of light and dark suggest derivation from a self-acknowl-
edged influence on his art, the work of Andrea Pozzo (1642-
1709). Following his two-year novitiate at Genoa, Castiglione
was sent first to Portugal, where he painted portraits of the
Queen's two small children, and in 1714 to China.

In November of 1715 Castiglione and an Italian doctor
were presented to the Kangxi emperor by Father Matteo
Ripa, who left the following account: "I was summoned into
the presence of the Emperor to act as interpreter to two
Europeans, a painter and a chemist, who had just arrived.
While we were awaiting his Majesty's pleasure, an eunuch
addressed my companions in Chinese and was angry when
they did not reply. I explained that they were Europeans and
knew no Chinese. He replied that since all Europeans looked
alike, he could not distinguish one from another." The
Chinese also held that European names were unpronounce-
able; at least by the time of his presentation to the emperor,
Castiglione had adopted Lang as his surname and Shining,
"World of Peace," as his given name.

Lang's initial appointment was to the enamelling work-
shop; there is no other record of his artistic activities during
the eight years he served the Kangxi emperor. Lang arrived
in China just as Jesuit influence was beginning to wane. In
1720 the emperor declared that Europeans would not be
allowed to preach their religion in China. The situation wors-
ened when the Yongzheng emperor ascended the throne in
1723, for he ratified a memorial calling for the expulsion of
all missionaries not in immediate service to the court. During
this period of restricted missionary activity, Lang continued
to exercise his artistic talents on behalf of his church. He
painted religious works for the new Dongtang or Eastern
Church, completed in 1729; for the Nantang or Southern
Church he painted a pair of works illustrating "The Triumph
of Constantine the Great" as well as two illusionistic frescos
depicting architecture drawn in scientific perspective. These
last were viewed by a number of Chinese writers, one of

whom commented: "The ancients lacked perspective
method, and when it is used so skillfully as here, one regrets
that the ancients had not seen it." The subject of "The
Triumph of Constantine" was undoubtedly intended to
inspire the Yongzheng emperor with thoughts of what victo-
ries he too could win should he emulate the Roman emperor
Constantine and convert to Christianity.

When Lang's duties to the throne permitted, he was
allowed to accept private commissions. Lang thus developed
close and important relations with two members of the impe-
rial family: Prince Yi, brother to the Yongzheng emperor, and
Prince Bao, the emperor's fourth son. Before his death in
1730 Prince Yi was in charge of the Zaobanchu, the workshop
of the imperial household, and in his official capacity he
directed Lang to paint enamel decoration on the metalware
produced in Beijing by the workshops. The prince was also a
collector and commissioned Lang to do a number of paint-
ings for him.

Prince Bao, the Manchu Hongli, was even more impor-
tant to Lang, for in late 1735 he succeeded his father on the
throne, ruling for the following sixty years as the Qianlong
emperor. Lang's early contact with the future emperor, who
was far more accessible as a prince than later, is of great
importance in understanding Lang's subsequent status at
court. The present painting, a portrait of Hongli while yet a
prince, is important visual evidence for the early association.
The painting also displays Lang's unique synthesis of
Western and Chinese approaches to painting. Facial planes
are demarcated by extremely subtle gradations of wash, with
an even, frontal lighting creating only a hint of shadow along
the contours of the face. Shading in a Western sense was
eschewed, for the Chinese demanded to be depicted as they
were in fact, not as the eye might happen to see them
momentarily from one or another angle. Lang's Western
training is most evident here in subsidiary elements, in the
bamboo, for example, and also in his acute perception of
human character and personality. The young prince, who
appears sensitive and a shade apprehensive, stands with an
older attendant, perhaps a tutor, in a garden where the blos-
soming plum heralds the coming of spring. The conventional
title, "Tranquil Spring," is intended to evoke not only the sea-
son but also the springtime of Hongli's life.

The present painting is somewhat unusual within Lang's
*oeuvre* in that it bears neither his signature nor his seal. Also
unusual are the marks which appear in the lower right cor-
ner of the painting. These sketched lines appear to be under-
drawing for an idea not pursued to completion. In later years
Hongli required all court painters to submit preliminary
sketches for his approval before the final version was begun.
He often watched Lang as he painted, suggesting changes,
even to the point of personally drawing in what he felt was
required. This suggests that the present painting is a detailed
study for a final composition that may, since Hongli must
have ascended the throne soon after this was done, never
have been executed.

Amongst the scores of court painters who served Hongli,
Lang clearly occupied a very special place. Nonetheless, the
emperor was neither wholly accepting nor totally uncritical
of Lang's style of painting. Perhaps his ultimate judgment of
Lang's art is contained in the imperial comments written

about a series of pictures of horses that Lang painted in 1763: "Occidental paintings and drawings transmit by other methods... But while resembling they only resemble, and so yield to ancient models." Illusionism, according to the emperor, was not the sole standard by which a painting could be judged; a painting could also signify or evoke some content beyond the immediate forms of which it was composed. But if we then conclude that Lang's style even at the end of his career was not purely Chinese, we must also admit that his works are just as clearly non-Western. In their media, their even lighting and lack of cast shadows, and their attention to local details, Lang's works are Chinese. His style is thus unique, an aesthetically satisfying fusion of Western and Chinese approaches to painting.

In light of that achievement it is easy to forget that Lang Shining was not motivated by purely aesthetic goals and artistic concerns. His sole purpose in serving the emperor so assiduously was to further the goals of the Jesuit mission in China. Having lost their earlier privileged position at court, the Jesuit leaders had no direct access to Hongli other than through Lang, who was only a lay brother in the order engaged in secular affairs. On three separate occasions Lang braved the real possibility of execution by speaking directly to the emperor on behalf of his church. Although none of his petitions was granted, a letter sent to him in 1755 by the Father General in Rome suggests that Lang remained firm in his belief in the validity of such service: "I have not forgotten... the painter whom you have asked for so that you may instruct him during your life and leave him as your successor in the art which so aids the progress of the mission and the Society." The sentiments recorded by Father Attiret, Lang's close friend, were those of Lang as well: "Just imagine that I am considered well rewarded by seeing the emperor every day. This is about all the payment I receive for my work, if you except a few small gifts of silk or something else of little value and which in any case come rarely. But this was not what brought me to China nor is it what keeps me here. To be on a chain from one sun to the next; barely to have Sundays and feast days on which to pray to God; to paint almost nothing in keeping with one's own taste and genius; to have to put up with a thousand other harassments which it would take too long to describe to you; all this would quickly make me return to Europe if I did not believe my brush useful for the good of religion and a means of making the emperor favorable towards the missionaries who preach it. This is the sole attraction that keeps me here as well as all the other Europeans in the emperor's service."

When Lang died on July 16, 1766, in Beijing, the emperor honored him with the following memorial: "The Westerner Lang Shining entered service to the Inner Court during the Kangxi era. He was very diligent and willing, and was once awarded the third official degree. Now that he has fallen ill and passed away, we think on his long years of duty and the fact that his years were close to eighty. Following the precedent established in the case of Dai Jinxian [the Jesuit Father Kogler], we bestow on him the official rank of Board Vice-President as well as three hundred taels of silver from the Imperial Treasury and will arrange the burial so as to manifest our abundant distress." Lang Shining was then buried outside Beijing on land donated by the emperor and with a stone tablet recording the emperor's words.

Catalogue No. 56.
**Fang Shishu** (1692-1751)
*Qiulin Tu*, "Autumn Grove"
Hanging scroll, ink on paper, 109.3 x 45 cm.
Inscription: "In mid-autumn of the year 1734, painted by the retired scholar Huanshan in the Pavilion of Honoring Subtlety."
Artist's seal" *Fang Shishu Yin*
Colophon: a two-stanza poem signed Shen Jingyun

The clear separation of foreground from background by an expanse of river – a compositional device which avoids complicated overlappings and throws emphasis on the brushwork of the trees placed against the river like a screen – is strongly reminiscent of Yuan-dynasty paintings by such masters as Cao Zhibo (1272-1355) and, especially, Ni Zan (1301-1374). The careful placement of trees and rocks, the rational spatial relationships, and the dry ink applied with sensitive brushwork are also hallmarks of the earlier style while functioning visually to create a rich and compelling image through extremely limited means.

Fang Shishu was born in Shexian, Anhui, in 1692. Within a month of his birth Fang was adopted into the family of an uncle and there received his early education under the tutelage of another uncle, the well-known scholar Fang Zhenguan (1679-1747). Upon reading one of the boy's unusual essays, Fang Zhenguan exclaimed: "Teaching this boy is as difficult as fighting with swords!" Although Fang Shishu became famed as a poet, he repeatedly failed to pass the second-degree examination; his real vocation was for painting, and self-study began in 1701. "When I was nine, knowing nothing, I began to fiddle with the brush; the pillars and the plastered wall surfaces were all covered with ink!" In 1709 Fang married and undertook various projects, including a trip to Sichuan with his uncle, in order to meet his family responsibilities. In 1725 his father and elder brother died leaving Fang Shishu the head of the family and heir to the family estate. Fang used the inheritance to enter the salt business but within a year or so had lost everything due to bad luck (his own explanation) and to his addiction to gambling. His wife was forced to pawn and sell her jewelry and clothes to pay off his debts.

During most of the following nine years, from around 1729 until 1738, Fang lived and worked in Yangzhou as a professional painter. His uncle had moved earlier to Yangzhou and was living with the merchant-collector Wang Tingzhang, and it was with Wang that Shishu also stayed. "Wang used 1000 in gold to engage Huang Ding to come to his home; by such means Fang Shishu's landscapes greatly improved." Huang Ding (1650-1730), who was a student of Wang Hui (cat.49) and Wang Yuanqi (cat.50), taught Fang the styles of the earlier masters who constituted the orthodox lineage as set forth by Dong Qichang (cat.28). Through Huang Ding and Fang Zhenguan, Fang Shishu was introduced to the poetry and collecting circles of Yangzhou and soon became an intimate member of the circle around the important merchant-collector Ma Yueguan (1688-1755). An especially important aspect in the training of an orthodox artist was the study of paintings by earlier masters so as to learn specific traits of style, brushwork, and composition, as

well as connoisseurship in the process. Fang's association with such collectors as Wang Tingzhang and Ma Yueguan thus gained him access to the source materials of his own art. In 1734, for example, the year in which the present "Autumn Grove" was painted, Fang visited Ma Yueguan, painted his portrait, and made a copy of Dong Qichang's copy of Zhao Mengfu's famous "Autumn Colors on the Qiao and Hua Mountains." The original model for the present painting was thus likely to have been seen during one of Fang's visits to the Yangzhou collectors. Fang also had a number of students who later attained some renown in painting; a few of these students travelled with Fang, who paid expenses by doing and selling paintings en route. Although it is likely that most of Fang's paintings were either done for friends or privately commissioned, a number were sold through commercial shops where forgeries abounded already during his lifetime.

In 1739 Fang Shishu's mother died; his second son died in 1740, as did the eldest daughter of his second wife and the baby girl of his son's wife. Fang's grief at these losses was deep and protracted; a mourning period of several years was observed and he painted very rarely, if at all. By 1742 he had recovered and was back in Yangzhou, active professionally and socially during that year and the next. In 1743 he was a major participant in a famous gathering of literati held on the estate of Ma Yueguan. During the summers of 1743 and 1744 successive epidemics of cholera in Anhui took the lives of a granddaughter and two daughters. His wife, already exhausted and extremely depressed by the death of her mother-in-law in 1739, was finally overwhelmed in 1744 by her most recent losses. Fang Shishu himself was survived by three sons. The eldest, Qilin, was very close to Fang and may have managed the family's affairs during the last eight years of his father's life.

Returning to Yangzhou around 1745, Fang devoted himself even more completely to painting until his death in 1751. Relieved of pressures and obligations, Fang seems to have relaxed the serious stance taken in many of his earlier works and to have adopted a more intuitive approach that utilized fortuitous developments during the actual execution of a painting. It was during this latest period that a special seal appears most frequently, applied to paintings that particularly pleased Fang: *Ouran Shide*, "Ordered by Chance." Fang's life was summed up by a friend, Min Hua, as follows: "Previously his family was rather wealthy but he was bad at managing the family estate; though he had his gains, they too followed his hand and were scattered and lost. Afterwards he met repeatedly with reverses but took his pleasures as before. Each breezy day, clear and perfect, he would sing at feasts, recite at banquets; tossing then his beard awry, he would joke and laugh – a wind god whistling and scattering like a divine immortal among men. When eating he would eat up all the fatty meat on the table and only then be happy. Although food and drink can be enjoyed, assigning them chief importance can lead to sickness. Fang was sick for five days and then passed away... When Fang was young he was a dandy fluttering about with furs, horses, and black clothes. The creator shorted him in allowing poverty but made glorious his talent in art."

Fang Shishu was a true eccentric; his life-style deviated considerably from any standard mode of behavior current in eighteenth-century China. An impulsive, disorganized, and passionate man, he valued the antitheses of those characteristics and sought them, as a balance to his life, in his own paintings. Fang Shishu was unique, and some of his Yangzhou patrons may have valued him precisely because of that. Ma Yueguan, however, wrote often of Fang after his death and remembered him with true sorrow and affection. Ma would himself die three years later and the Yangzhou literary and artistic society of which Fang and Ma were such important parts would all but end.

Catalogue No. 57.
**Leng Mei** (ca.1677-1742 or later)
*Wutong Shuangtu Tu*,
"Two Rabbits Beneath a Wutong Tree"
Hanging scroll, ink and color on silk, 176.3 x 95 cm.
Signature: "Respectfully painted
by your servitor Leng Mei."
Artist's seals: *Chen Leng Mei; Suye Feixie*
Collectors' seals: one of the Qianlong
emperor (r. 1736-1795) and one other

Two acutely observed and meticulously rendered white rabbits crouch on an embankment defined by highly stylized rocks and trees and enclosed by a bamboo railing. Present here are a host of stylistic allusions and references which even in the absence of the artist's signature would date the work to the early eighteenth century and place it within the academic context of Qing court painting. The stylized tree is derived from the style of Chen Hongshou (cat.33), the formalized rocks relate to those appearing in works by Tang Yin (cat.16) and Zhou Chen (cat.14), while the realistic approach, measured space, and perspectively correct recession of bamboo fence suggest contact with Western art. The subject here has always been popular in Chinese painting, for the rabbit is one of the zodiacal animals, and paintings of rabbits would have been in demand for display at least during the Year of the Rabbit of each twelve-year cycle.

Leng Mei was born in Jiaozhou, Shandong province. He was likely recommended for court service by Jiao Bingzhen, also from Shandong and known as the teacher of Leng Mei and Cui Hui, the latter a friend of and influence on the artist Shen Quan (cat.59). Leng Mei was at court from around the turn of the eighteenth century onward; he and Jiao Bingzhen were probably those who introduced Lang Shining (cat.55) to Chinese ideas on painting. Jiao and Leng also played primary roles in introducing Western stylistic elements into Kangxi-era academy painting. Jiao's earliest stylistic orientation is suggested by a recorded landscape painting done in 1689 in the style of Dong Qichang (cat.28). During his early service as an assistant in the Astronomical Institute, however, Jiao's close association with his Jesuit colleagues resulted in his acquiring the knowledge of perspective drawing apparent in his best-known work, the woodcut illustrations to the *Gengzhi Tu*, "Illustrations of Agriculture and Weaving," printed in 1696. Leng Mei painted a similar set of forty-six illustrations to the *Gengzhi Tu* and in 1713 completed illustrations to the thirty-six poems written by the Kangxi emperor

in commemoration of the views around the newly built summer palace in Jehol. Although both Leng Mei and Jiao Bingzhen executed individual paintings that copied or restated the styles of such artists as Li Gonglin and Qiu Ying (cat.17), the majority of their paintings seem designed to exhort and edify the viewer, to fill his eye with imperial rather than aesthetic grandeur.

This aim is nowhere more apparent than in the artistic projects that made their appearance at this time. The relatively simple *Gengzhi Tu* and *Bishu Shanzhuang* series already involved collaboration between project director, designer, engraver, and printer; in later, more ambitious works, such as the *Wanshou Tu* of 1713 which commemorated the sixtieth birthday of the Kangxi emperor, the additional personnel and logistics required creation of a special bureau. The original designs for the *Wanshou Tu* were to have been done by Song Junye (host and student of Wang Hui, cat.49, in Beijing); upon Song's death in 1713, Wang Yuanqi (cat.50) assumed responsibility for the draft copy on paper, completed in 1714, and a final version on silk, finished in 1716. The latter painting, done in two long handscrolls, well illustrates the nature of Kangxi-era academic painting. Although Wang Yuanqi had ultimate executive responsibility for the project and may have sketched the original design on paper, his name was not included among the fourteen artists whose names appear at the end of the scroll. Leng Mei, perhaps the sole full-time, professional artist then working in the Academy, signed first and was probably in charge of the actual painting; Xu Mei, She Xizhang, and Jin Yongxi, all Academy pupils of Wang Yuanqi, also took part, as did a certain Jin Kun, perhaps the same individual as the early Qianlong-era artist of that name. The remaining nine names are those of men known from no other source and with no other paintings to their credit; it is evident that they were not regular members of either Academy or court bureaucracy but were called in to contribute to that one specific project.

Leng Mei remained active at court during the succeeding Yongzheng (1723-1735) and early Qianlong (1736-1795) reign-eras. He did several paintings for Prince Bao, the title held by Hongli before he ascended the throne; in his first year of reigning as the Qianlong emperor, Hongli graciously granted special permission for Leng's son, Leng Jian, to assist his father in his court duties. A further mark of imperial appreciation came in 1742, when Leng was granted fifty taels of silver above his regular salary in honor of his long period of service at court. These dates would suggest that Leng was born around 1677 – assuming that he was around sixty Chinese years old in 1736 – and that he served at court from around 1702 until 1742 or later. "Two Rabbits Beneath a Wutong Tree" appears on the basis of style to be a late work and, according to the signature, was done specifically for presentation to the emperor. The painting was originally kept in the Summer Palace, where it likely graced one of the imperial apartments at appropriate times. The meticulous execution of the painting is clearly the result of "unremitting [effort] from dawn to dusk" – the legend of one of Leng's seals used on the painting – and the painting thus manifests both the style most appreciated by the Qianlong emperor and also the attitude expected by the ruler from such artistic servitors as Leng Mei.

Catalogue No. 58.
**Yuan Jiang** (ca.1670-ca.1755)
*Penglai Xiantao Tu*, "Penglai, Isle of Immortals"
Hanging scroll, ink and color on silk, 160.4 x 96.8 cm.
Inscription: "'Penglai, Isle of Immortals.' During the twelfth month of the year 1708, painted by Yuan Jiang of Hanjiang."
Artist's seals: *Yuan Jiang zhi Yin*; *Wentao*

In the eastern sea off the coast of China are several islands where dwell Daoist immortals in great ease and pleasure. The earliest literary record of the islands occurs in the *Shiji* record for the year 219 B.C., the twenty-eighth year of the reign of the First Emperor of the Qin: "Xu Shi, from the state of Qi, submitted a memorial in which he stated that within the sea there were three spirit-mountains, called Penglai, Fangzhang, and Yingzhou, on which live immortals. He requested leave to fast and purify himself and then to seek them in company with male and female virgins. The emperor thereupon sent out Xu Shi together with several thousand male and female virgins to search the seas for immortals." Some scholars find correlations between this mission of the First Emperor and the beginnings of the Yayoi, rice-growing and metal-using culture of Japan, and Xu's land of immortals may in fact have been located on volcanic mountains protruding from the sea. The *Hanshu* record contains a brief description of what was to be found on the islands: "These three spirit-mountains are said to be within the Bo Sea and not too far distant. Sages, various immortals, and elixirs of everlasting life are to be found there. The birds and animals are all white, and the palaces and towers are made from yellow gold and white silver. The mountains appear cloud-like when viewed from a distance but as one gets closer they suddenly recede from the ship and, in the end, one is never able to reach them. The lords of the world all would like to be there."

To reside in golden palaces, to associate with transcendent beings and, most of all, to live forever are indeed the dreams of powerful rulers, and these dreams were given appropriate visual form in the present painting, which focuses on Penglai, the best known of the three island-peaks. Wildly contorted rocks and pinnacles erupt from the sea and support such human constructions as a bridge, a lofty viewing-pavilion, and in the center a magnificent palace complex. The composition is dominated by the massive, serpentine movement of the rock forms as they expand back and upward in rhythmic surges from the foreground. Graded washes to model the forms, overlappings to establish spatial relationships, and atmospheric recession into depth are all naturalistic devices applied here to basically non-naturalistic ends. The plausibility of the scene is again asserted by the various figures, who calmly converse or walk about in seeming disregard for their metamorphosing environment. The very normality of these figures and their activities encourages the viewer to join them; to do so is immediately to be impressed by the organic power inhering in the monumental masses as well as by the secular power suggested by the human constructions. The *jiehua* or "ruled-line drawing" of the architecture here marks the artist as a follower of a tradition associated especially with the medieval period and with

courtly painting. The style of the painting thus carries connotations of wealth, power, and privilege which support the denotative subject, and the whole would glorify any owner by associating him with the greatest patrons of the past.

The artist, Yuan Jiang, was born in the garden city of Yangzhou in Jiangsu province. Little is known of his life, but extant paintings dated to the year 1691 and a recorded painting dated to 1756 suggest a working life of more than sixty-five years. Stylistically Yuan Jiang was associated quite closely with the Yangzhou painter Li Yin and may have been Li's pupil. Yuan's talent and technical proficiency brought him around the year 1706 to the attention of the Chinese bannerman and official Gao Qipei (cat.62), who hired Yuan, Lu Wei (cat.54), and others to provide the finishing brushwork for his own large, finger-painted works. Gao lived in the Liang-Zhe region between 1706 and 1715, and Yuan probably worked for him during the earlier years of that period.

During the late 1710s and early 1720s Yuan Jiang painted far more often, also for a widening clientele who called him to Nanjing, to Hangzhou, and by 1724 to Beijing. According to the *Guochao Huazheng Xu Lu*, Yuan Jiang was summoned by the Yongzheng emperor (r.1726-1735) to serve the court as a painter-in-waiting. The *Guochao Yuanhua Lu* also lists Yuan as a court painter active during the Yongzheng era. Yuan's court service has been denied on the grounds that none of his paintings are signed "your servitor," standard practice in the case of paintings done for presentation to the throne. However, the *Huaren Buyi* states that Yuan was selected to enter the *wai* or "outer" painting academy. This branch organization was established by the Yongzheng emperor in his favorite palace, the Yuan Ming Yuan, built for him by his father in 1709 but extended and elaborated by him after his accession to the throne in 1723. Yuan could well have worked mainly on the decoration of the palace and to have been recommended for service by Gao Qipei, who in 1723 had been transferred to the capital. The director of the government organ which controlled court painters was Prince Yi (1683-1730), a brother of the emperor, and at least one of Yuan Jiang's extant paintings bears Prince Yi's collection seal.

For the thirty years between 1726 and 1756 there are records of eleven paintings by Yuan Jiang; this stands in strong contrast to the nearly one hundred paintings known for the thirty years preceding 1726. Yuan Jiang is said to have spent many years in Shanxi province working for a salt-merchant family, and it is possible that following a three-year tour of court duty Yuan worked in Shanxi before returning home to Yangzhou, where most commissions were then handled by his son, Yuan Yao. The fantastic nature of many of Yuan Jiang's paintings can be related to the demands of Yangzhou's *nouveau riche* merchants for the exotic and the startling. However, other artists situated similarly did not pursue those same goals, and patronage can be considered only a partial explanation for the nature of his paintings. Another factor would certainly be the influence of Yuanji (cat.45), especially his stimulating theories. Yuanji severely criticized Yangzhou and other contemporaneous painters for "imitating the footsteps" rather than the "heart" of their models and for remaining confined by earlier styles rather than transforming them on the basis of their own feelings and experiences. Yuan Jiang may thus be considered a professional artist who continued the late Ming revival of certain aspects of Tang styles but also as one who informed those derived schemata with his own very distinctive personal vision.

Catalogue No. 59.
**Shen Quan** (1682-ca.1760)
*Laoshu Dunying Tu*, "Eagle Perched on an Old Tree"
Hanging scroll, ink and color on paper, 140 x 71.5 cm.
Inscription: "During the fourth lunar month of the year 1735, painted after the brush-conception of a Yuan master by Shen Quan called Nanpin."
Artist's seals: *Shen Quan zhi Yin; Nanpin Shi; Jiazhu Tiaonan Yubuqi*
Colophon: one-stanza poem written by Shen Bing

In 1722 Yoshimune, the Japanese shōgun in Edo, modern Tokyo, issued a request to the Nagasaki authorities to obtain both Western oil and Chinese ink paintings. Being less familiar with the former, the shōgun requested them not by artist, period, or style but by size and subject: nine-by-four feet paintings of elephants, tigers, horses, peacocks, hunting, and castle-siege scenes. For the Chinese paintings Yoshimune specified certain Ming and earlier artists who painted landscapes, figures, birds-and-flowers, and insects. By 1726 five of the Western oil paintings had been delivered but none of the Chinese paintings. The Chinese ship captain charged with the task explained that such early paintings were owned either by Chinese officials or by members of the upper class and were inaccessible even for copying, let alone purchase. The Japanese authorities, determined to get at least the style if not the age of the paintings they desired, then invited an artist from Zhejiang province to Japan. This man, named Hu Mei, had died some years earlier, so the invitation was extended instead to a direct disciple of the master named Shen Quan, better known as Shen Nanpin. Born in Wuxing, Zhejiang, Shen studied with Hu Mei and became a specialist in bird-and-flower and animal compositions. According to Japanese records, "During the Kyōhō era [in the year 1731] Shen responded to a summons and arrived in Nagasaki..." Shen's friend, the poet Yuan Mei (1716-1798) also took note of the event: "During the Yongzheng era [1723-1735] the King of Japan, bearing a dwarf [i.e. Japanese] tablet, invited him to go to Japan..." This is amplified by Sheng Pan (1701-1769): "During the Yongzheng era the King of Japan heard of Shen's fame and ordered the General to issue a dwarf tablet and to invite him with presents..." Whether the order originated with the Japanese emperor himself or even with the shōgun, and whether "summoned" or more politely "invited," Shen was likely acting in response to an offer made through Japanese bureaucratic and at least semi-official channels.

When Shen Quan arrived in Nagasaki he was accompanied by three students: Zheng Pei, Gao Jun, and Gao Qian. Shen thus came with the clear expectation of executing commissions on a very large scale. First, however, he was examined via interpreters on his opinion of paintings done by Kanō Motonobu and Kanō Tanyu, the founder and the trans-

mitter respectively of the largest Japanese school of the day. Shen's initial response to Motonobu's painting displeased his hosts, but when he quickly modified his judgment enough to satisfy them his success was assured. "Shen was welcomed to Nagasaki Island, where he was called 'The Confucian from Tang [China]' and was treated with the etiquette appropriate to a guest of high position. That country had long before established a Painting Academy in which birds-and-flowers drawn from life were especially emphasized, and it was this that Nanpin had been engaged to manage. He discussed the principles of painting with Keizan and Master Takagi. Those from the seventy-two islands who came to study bearing gifts left him not a free day..." Although Japan then had no true painting academy in a Chinese sense, this term was the best available to describe the officially sponsored and appreciated Kanō school of painters. Keizan was one of the earliest *kara-e mekiki*, "Inspector of Chinese Paintings;" Keizan was also present at Shen Quan's employment interview and indeed was one of those who had objected to Shen's characterization of Motonobu's work as "immature." In discussing the principles of painting with Keizan, Shen Quan must surely have been careful to avoid direct criticism of the firmly entrenched Kanō approach to painting.

"He submitted several paintings and his rewards were very many. In Shen's paintings the outlines and washes are skilled and orderly and the application of color is seductively beautiful. At that time the days had long been tranquil and peaceful. People had gradually become bored with the two schools of Sesshū and Kanō so at that time everyone praised Shen and closely pressed together in hastening after him. Shen transmitted his methods to Yuhi of Nagasaki and Yuhi transmitted them to Sō Shiseki of Edo. Seki's son, Shizan, succeeded to this patrimony." The style taught in Nagasaki by Shen and transmitted to Edo was, according to Shen's own inscriptions, based on such Ming masters as Lü Ji (cat.5) and Lin Liang (cat.4) and on bird-and-flower artists of the Northern Song period. This meant that his paintings were based in large part on the same Chinese lineage followed originally by Motonobu and that Shen's works would have been appreciated for the freshness of their imagery and technique in contrast to the more stereotyped renditions of the same lineage produced by eighteenth-century members of the Kanō school.

According to Yuan Mei, Shen's foreign venture earned him considerable wealth. First had come the presents that originally enticed him to Japan: "The shōgun general used much wealth to invite the lofty sage." Then there were the official rewards for paintings executed while in Japan, together with presents from those who sought to study with the master:

"Purple-striped cowries a thousand pair
    was the ruler's favor,
 Shark-eye pearls ten bushels full
    were his pupils' offerings."

Finally there were the gifts presented to him on leaving: "When old and ill he bid farewell before returning home. The King further bestowed on him many tens of thousands." In 1733, after living around twenty-two months in Nagasaki, Shen Quan sailed for home with his hard-won rewards. He did not, however, reach home with his treasure intact: "Someone on the same ship was implicated because of his account-records. Nanpin poured out everything he had in repayment, so in the end he returned home without a cent." In assisting the friend who had run afoul of customs regulations – perhaps one of the pupils who had accompanied him to Japan and for whom he would have been responsible – Shen was forced to pay the duty, and "the ten thousand in gold he first received with a wave of the hand was gone."

At least two-thirds of Shen's extant paintings from all periods are to be found yet today in Japanese collections. It is thus clear that Shen continued to produce for the Japanese market after his return home, and it is likely that he was assisted in this endeavor not only by his students but also by such relatives as his nephew, Shen Tianxiang. There is some difference, however, between Shen Quan's earlier style and that found in paintings done after his return home. The early style was continued fairly directly by Yuhi, his major Japanese follower, and by Zheng Pei, his Chinese pupil who remained and was active in Nagasaki until at least 1750. In Shen's later paintings the bird, flower, and animal subjects were rendered with even more naturalistic detail and with a solidity that often threatens to separate them visually from their settings, the rocks and trees of which are themselves more thoroughly and convincingly shaded for illusionistic ends. Shen is likely to have seen Western oil paintings during his sojourn in Nagasaki and, after returning home, would have learned much more about those methods from his friend Cui Hui (active 1722-1741), a pupil of Jiao Bingzhen (active 1679-1726) who had worked with and learned from Jesuits when holding office in the Astronomical Bureau in Beijing. Although Cui was principally a figure painter, the "untransmittable secrets" learned from Cui by Shen were equally applicable to Shen's chosen subjects: phoenixes, eagles and hawks, peacocks, cranes, roosters, geese, mynah-birds, peonies, cats and butterflies, deer, lions, horses, monkeys, rabbits and unicorns. The present work, painted around two years after Shen had returned home, illustrates well the artistic approach which transcended national boundaries: an interesting subject presented in a lively, naturalistic manner. The poem by Shen Bing is a direct reaction to the image itself:

"Looking askance it seems to worry about something,
    stilling its nerves it fixes its gaze and stares;
 Raising its body it considers something,
    its goal is not just a cunning hare."

Catalogue No. 60.
**Hua Yan** (1682-1756)
*Songshu Zhuosu Tu*, "Squirrels Pecking at Chestnuts"
Hanging scroll, ink and color on paper, 144.7 x 57 cm.
Inscription:
"The tree is hidden by an unbroken bank of mist,
    bees at times sink to honeyed bramble-bed;
 Lichee walled by grass are intertwined with junipers,
    in rainy bamboo grove shade obscures the light.
 Pines sigh with the passing wind
    and let fall wisteria blossoms,

look up and see the hungry flying squirrels
   pecking at mountain chestnuts.
On a winter day of the year 1721,
   painted by Hua Yan called Qiuyue."
Artist's seals: *Hua Yan zhi Yin*; *Qiuyue*; *Qiukong Yihao*
Collector's seals: Pang Yuanji (1864-1949)

Six squirrels, their postures arranged in an animated fig-ure-eight configuration, frolic in an old chestnut tree growing on the bank of a secluded stream. There are extant paintings of squirrels dating to the Song period and even more are known from the Yuan, when the squirrel was used in politi-cal satire as an analogy for "a small man who nonetheless occupies a high position; he is avaricious yet fears real men." Although a few paintings of squirrels are known from the Ming period, their appearance here is actually a revival of a classic theme. The artist, Hua Yan, is credited with at least eleven known or recorded paintings in which squirrels pro-vide the major focus; this painting is the earliest among them.

Hua Yan was born in Shanghang, Fujian province. While belonging to a branch of the Hua clan collateral to the famous Huas of Wuxi, the family into which Hua Yan was born were paper-making artisans; Hua Yan became an apprentice in that trade while studying in a local children's school. The youthful activities mentioned by Hua himself emphasize swordsmanship, archery, and riding: "As a youth I loved to ride and shoot. My spirit rose and soared of itself." These martial skills were pursued not solely for pleasure but in anticipation of a life of valorous activity: "Formerly, when in my prime, blood and nature were martial, mounting up and looking all about, my exhilaration could not be matched; I studied books and studied swords, saying these can be relied upon..." The earliest extant portrait of Hua Yan depicts the twenty-three-year-old in the guise of a sword-bearing *xia*, or "knight-errant," and Hua's inscription suggests an analo-gy between himself and Ruan Ji (210-263), who combined military and scholarly skills to rise to high official position. In 1698, when Hua was seventeen, his father died of dysen-tery, and "with books and sword" Hua left his widowed mother and two brothers at home "while he travelled to the markets of Suzhou." Hua Yan had determined on a career in painting and his technical training had already begun; his paintings on the walls of the Hua family shrine, done before leaving home, were admired into the present century. During the several years he spent in Suzhou, Hua applied himself to painting, being particularly attracted to the landscape paint-ing of Tang Yin (cat.16) and the bird-and-flower works of Yun Shouping (cat.52). However, "those with vermilion doors ridiculed his tapping of the sword-hilt and those with decorated gates hurried to bar the door." The scholar-official and gentry class, permitted by Qing dynasty sumptuary laws to have red and decorated gates to their houses, ignored Hua's efforts to advance his career, and "social standing was complex and distressing to the youth." The expression "tap-ping the sword-hilt" was used for a poor person waiting his chance for advancement in life; in the case of Hua Yan the swordsman, the metaphor merged with reality, for the sword and employment as a *baobiao* – the early Qing equivalent of modern security guards – offered Hua an alternative to the

brush as the foundation for a career. After several years of frustration in Suzhou, Hua travelled for a year or so in the interior provinces, from Jiangxi to Henan. However, he still made periodic trips home and the lure of distant places was always balanced by the strong pull of home ties.

In 1703, probably following the death of his mother, Hua Yan moved permanently to Hangzhou, which since the twelfth century had supported a continuous tradition of technically superior and visually, rather than theoretically, oriented painting. In Hangzhou Hua became a member of the important literary group that included such poets, schol-ars, and bibliophiles as Xu Fengji (1654-1740), Wu Yunjia (1657-1729), and Wu Chuo (1676-1733). Hua married around 1705 a wife who died eight years later after giving birth to two sons, and married a second time during the 1720s; his brothers also moved with their families to live in Hangzhou.

In 1717 Hua travelled to Beijing, where he came to the attention of an official who arranged for him to be presented to the emperor. Granted the opportunity to take an examina-tion, Hua passed easily, but was then offered a post of very low standing. Dai Xi (cat.72) suggests that Hua was also unsuccessful in securing patronage for his paintings in the capital: "Hua Yan had a high opinion of his own paintings, but when he travelled to the capital no one inquired about them. One day someone selling fake paintings came by and the paper in which they were wrapped had been painted by Hua. On seeing this, Hua sighed deeply and left the capital." After further travel, including at least one trip to Fujian, Hua Yan established a painting studio in Hangzhou whose name, the *Jiangsheng Shushe*, or "Sounds-of-Teaching Studio," appears on paintings dated between 1724 and the mid-1730s and accords well with his literary interests during this peri-od. A first collection of his poetry, completed in 1730 and prefaced in 1731 by Xu Fengji and Li E, marks the end of this phase of Hua's career.

Although Hua Yan must have passed through Yangzhou several times during his earlier career, his significant contacts in Yangzhou began only around 1730, when he met the Shanxi merchant Yuan Guotang (d.1742). Hua's friendship with Yuan was very close; when he returned to Hangzhou in the winter of 1732 Hua Yan became gravely ill and consid-ered entrusting his family to Yuan. Important to Hua's artis-tic development was the interesting circle gathered around Yuan: Yuan Dun, Chen Zhuan, Ding Jing, and Zhou Erxue, all of whom were particularly interested in the paintings and writings of Yuanji (cat.45). Hua Yan first mentioned Yuanji in his poetry collection in 1730, and his paintings done in suc-ceeding years testify to Yuanji's influence. During his first sojourn in Yangzhou Hua Yan must also have been impressed by the orthodox style of landscape painting then being practiced by such masters as Fang Shishu (cat.56).

After recovering from his illness of 1733, Hua Yan's paintings manifest a strong will to aesthetic self-expression, one which found and explored the potentials of many styles and subjects. Such experiments added to the pleasures of his Hangzhou home life, but the necessity of earning a living soon forced him again to leave for Yangzhou: "To play the lute, to read books, and to look after the family garden with its sweet mallow flowers and beans for all the remaining days of my life is my desire. But what can I do about hunger

and cold? Still with no fixed support, I must again devise some scheme for clothes and food and as usual will lodge with Yuan Guotang." From around 1737 until 1745 Hua Yan was almost continuously in Yangzhou, staying mainly with Yuan and members of Yuan's family. Hua Yan painted comparatively little during those years, perhaps because Yuan's direct support obviated any need for regular production. Through Yuan Guotang, Hua Yan's circle of friends and acquaintances expanded to include Ma Yueguan and Gao Xiang; Hua had probably met Jin Nong (cat.64) much earlier in Hangzhou, but their subsequent activities did not place them together often until the early 1740s in Yangzhou.

When Yuan Guotang died late in 1742 the psychological impact on Hua Yan was profound and his paintings exhibit a new, more introspective mood. A new studio name, *Jietao Guan*, "Dwelling of Release and Retirement," appears in Hua's collection of poems of 1744 – *Ligou Ji*, "Leaving the Dust [of the World]" – a name he continued to use until the end of his life. He returned to Hangzhou in 1746, the year his son took the prefectural examination, and began the most prolific period of his life as an artist. The majority of his extant works were painted between 1746 and 1756, the greater part being the bird-and-flower and animal pictures for which he became best known; figure paintings, of children and of scholars in landscape settings, constitute the next largest category, and they too exerted a significant influence on succeeding generations of artists. His later following in Hangzhou was such that the official, poet, and artist Chen Wenshu (1775-1845) noted: "Nowadays most Hangzhou artists follow his school of painting."

During the final decade of his life Hua Yan made several trips to Yangzhou and visited the son and daughter of Yuan Guotang. He left Yangzhou for the last time early in 1752 after visiting and living there for around twenty years. Zhang Geng noted that Hua Yan "visited Yangzhou for a very long time, and in his late years returned to the West Lake where he died at an age approaching eighty." Hua Yan's death at the age of seventy-four brought an end to the career of one of the most talented and versatile Qing artists.

Catalogue No. 61.
**Gao Fenghan** (1683-1748)
*Huahui*, "Flowers"
Album of 8 leaves, ink and color on paper, 31 x 45.5 cm. Each leaf signed, most inscribed, and one dated to the year 1725.
Artist's seals: *Gao; Fenghan; Feng; Han; Xiyuan; Xi; Yuan; Nancun*

Gao Fenghan was born in Jiaoxian, Shandong province. His early education, especially in literature and poetry, was received from his father, who served as a provincial education officer. Together with Zhang Yuan and another friend, Gao formed the Willow Dwelling Poetry Society, the members of which were strongly influenced by the poetry and theories of Wang Shizhen (1634-1711). Gao eventually met that eminent poet and scholar and in later years would visit his grave and pay his respects to him through posthumous

portraits and poems. A prolific writer of poems himself, Gao estimated that he composed 2,366 verses between 1708 and 1744, and he lived four years beyond that. Gao was also famed for his calligraphy. The basic forms of Gao's *xingcao* calligraphy were derived from such late seventeenth-century masters as Zheng Fu, but he transformed these models by writing with his left hand. While this became a necessity after 1737, when his right arm was disabled, Gao wrote with his left hand before that date to achieve the spontaneous and intuitive effects of that technique.

In 1701, the year of his marriage, Gao passed the district examination, but failed the provincial examination the following year. It was not until 1728, in Beijing, that he passed a special examination and was appointed to office in Shexian, Anhui. During the intervening years he travelled frequently in Shandong, staying with friends and meeting many scholars and officials. By 1710 both Gao and his younger brother, Fengqi, were fairly accomplished painters. During a trip Gao made to Nanchang in 1709 he met the artist Shen Zongjing and must have seen paintings by Zhu Da (cat.44). However, Gao did not develop a serious interest in painting until the 1720s, by which time he was already well established as a poet and calligrapher. During his examination visit to Beijing in 1728, Gao met Gao Qipei (cat.62), who painted fairly conventional landscapes with a brush but was better known for his paintings done with the balls of his fingers or the split end of a fingernail. The present album includes one leaf, that of a branch of blossoming peach extending from a rocky bank over a river, which is labelled as being a finger painting. The inscriptions on these leaves mention such earlier masters as Chen Daofu (cat.23) and Lu Zhi (cat.18) as models, but it is also clear that Gao was very interested in experimental techniques and approaches at this time; it was shortly after this album was done that he began to write with his left hand. Here the spontaneous and unusual effects made possible by the use of fingers and fingernails are joined with striking uses of color. Some of the leaves are still rather careful and descriptive in approach, but others anticipate his later paintings, in which natural images begin to dissolve into abstract patterns of distinct brush strokes lying on the plane surface.

During the nine years that Gao Fenghan served as an official in Anhui, from 1729 until the summer of 1737, he travelled frequently to Suzhou, Nanjing and Yangzhou, meeting many artists, poets, and scholars. Anhui had long been famed for the production of ink and ink-stones and Gao Fenghan formed a collection of more than one thousand ink-stones during his sojourn there. He also collected seals; his collection of Qin and Han dynasty seals numbered over five thousand, and his examples from the Ming and Qing periods numbered about the same. Gao used a large number of seals on his own paintings and most were personally carved in his interpretation of the *miuzhuan* script of the Qin and Han periods. He also presented seals to such friends as Zheng Xie (cat.66). Gao's interest in seal-carving and in the script styles of the early dynasties ally him closely with the artists of Yangzhou.

The official career of Gao Fenghan was not markedly successful, his rank in 1735 was no higher than that with which he began, and it seems clear that his main interests lay

in areas outside the official domain. When his superior wanted to recommend him for participation in the extraordinary examination of 1736, Gao refused, a rejection of special opportunity for advancement which may be related to his close friendship with the important official Lu Jianzeng (1690-1768). Lu was also from Shandong and, with the help of Gao's fellow poet Zhang Yuan, would later compile an anthology of poetry written by Shandong poets, including Gao Fenghan. Gao's official appointment, to Shexian, was made on the recommendation of Lu Jianzeng. Thus, when Gao was accused of accepting a 5,000 tael bribe in a murder case, Lu was also called to account. Lu told the provincial governor that "this is certainly calumny, for Gao is not that sort of man," and the accusation was later judged false. In 1736 Lu was appointed chief commissioner of the salt gabelle of the Liang-Huai region with headquarters in Yangzhou. As a powerful and influential official, one whose position related directly to the extremely lucrative salt business, Lu was welcomed wholeheartedly by such merchants as Ma Yueguan and Wang Tingzhang. Gao Fenghan, a close friend of Lu, was introduced to these merchants and also to such artists and scholars as Zheng Xie, Li Shan (cat.63), Jin Nong (cat.64), and Fang Zhenguan, the uncle of Fang Shishu (cat.56). The elegance and seeming security of a life of low official but high social status in Yangzhou must have contrasted greatly with the unknown and uncontrollable world of officialdom, and Gao elected to remain in the south rather than pursue success via more examinations. However, when Gao's term of office ended in 1736 and Lu recommended him for a vacant position, a charge of power brokering (specifically used against officials who gathered cliques about themselves for their personal end) was brought against Lu, with Gao also implicated. Lu was banished to the border regions for two years, while Gao was able to refute the charges against him. However, a paralysis of Gao's right arm prevented him from returning to office and he then moved to live in a Buddhist temple in Yangzhou. Thus reads the account left by Lu Jianzeng himself.

In later years, after his reinstatement as the chief salt-commissioner of Liang-Huai, Lu Jianzeng would be a very important patron who supported artists, employed scholars to work on a variety of literary projects, and established or improved educational academies. In contrast to such direct support, Lu in his earlier years apparently recommended many of his friends for examinations, for offices, and for promotion; such enthusiastic support of his friends could well have been misconstrued as an attempt to establish a clique of officials owing primary allegiance to Lu himself rather than to Beijing. Another interpretation of the events of 1736 is suggested by the famous satirical novel, *Rulin Waishi*, in which Lu appears in barely fictionalized guise as the major character Xun Mei. In the novel Xun Mei was suddenly arrested for accepting bribes and, in the words of the novel, "went from good fortune to disaster between dawn and dusk." In the year 1768 Lu Jianzeng and two subordinate officials were accused of having received gifts valued at 900,000 taels from salt merchants who had illegally retained nine million taels of profit belonging to the government. Wu Jingzi, author of the *Rulin Waishi*, died in 1754 and could not have been referring to the later case (in which Lu was convicted of receiving

only 16,000 taels). Moreover, Wu Jingzi was a close friend of Lu Jianzeng and portrays him in the novel as a generous, open-handed patron of talented men; Wu is thus not likely to have defamed Lu Jianzeng as a corrupt official if there were not some basis in fact. Since Gao Fenghan was a protégé of Lu Jianzeng and was involved in the same case, some of the same ambiguity beclouds the end of Gao's official career in 1737.

About the paralysis of Gao's right arm, however, there is little doubt. In support of Gao's own statements are those of such friends as Zheng Xie: "After being crippled, Gao used his left arm and his calligraphy and painting became even stranger." Gao's works became not only more eccentric but also more numerous; the years 1737 and 1738 were among the most prolific of his entire career. This suggests that his earlier practice in writing with his left hand had already given him sufficient training and control to paint with that hand at will; it also suggests that deprivation of his official position and of the support of Lu Jianzeng left him more dependent on his painting than at any other point in his career. Gao also joined Li Shan and Zheng Xie as the only calligraphers who are known to have engaged in writing name-plaques for Yangzhou's famous pleasure-boats decorated with paintings, and Ma Yueguan wrote that Gao even sold rare books that he had collected in more prosperous days. In 1741, after four restless years of shuttling between the Yangzhou and Suzhou areas, Gao wrote poems of farewell to his friends and supporters: the salt merchants Ma Yueguan, Ma Yuelu, and Wang Tingzhang, and the artists Zheng Xie and Jin Nong.

With his return to Shandong Gao Fenghan was reunited with his family, but his health did not improve and he was sick in bed for most of the following two years. In 1743 he prepared his coffin and wrote his own epitaph:

"Knowing this life, what need have we
   to learn about death;
  having seen the beginning, what need have we
  to see the end.
  Oh! Would that life could be arranged like this!"
Five years later, Gao Fenghan died at the age of sixty-five.

The paintings produced by Gao during the last twelve years of his life were all apparently done with his left hand. Several of his statements suggest that around 1739 he regained partial use of his right arm but decided to continue painting mainly with his left. As Gao explained in a letter to a friend: "When my right arm was paralyzed I suffered indescribable hardship. Recently I have tried using my left hand instead and there is an extremely different flavor, an irregularity, roughness, and awkwardness, that can never be attained with the right hand." Many of Gao's earliest paintings could indeed be characterized as regular, smooth, and skillful, and the present album represents one early attempt to mitigate the limitations of firm and rational control. The use of his left hand produced even more spontaneous images that utilized as well fortuitous developments occurring during the act of painting. That such paintings by Gao were valued by his peers is attested to by Zheng Xie: "Gao Fenghan's left-handed works and Jin Nong's calligraphy are requested from me by friends throughout the empire; short notes and long letters have all departed, and even of the fakes I have done there are no more to spare."

Catalogue No. 62.

**Gao Qipei** (1660-1734)

*Gaogang Duli*, "Standing Alone on a Lofty Ridge"

Hanging scroll, ink on paper, 70.5 x 38.4 cm.

Inscription:

"A myriad questions pile up within,
how can the visitor hurry?

Nine dots placed within mist, how is this skill good?

In broken shoes he came on foot to the mountain
which constricts the brain,

Within the empty sky how startling
to see one elderly man."

Artist's seals: *Shanhaiguan Wairen; Qieyuan Qipei;*
*Zhitou Hua*

A pensive scholar, rendered in quick and decisive strokes, stands atop a rocky pinnacle whose surface texture is suggested by slashing lines and modulated washes. The sketch-like character of this work is explained by the legend appearing on one of the artist's seals: *Zhitou Hua*, "Painted with the Fingers." The technique of finger-painting was held to have begun with Zhang Zao of the Tang dynasty who "used only a worn brush or sometimes his hand to rub ink on to the silk." The technique appears to have been used sporadically during succeeding dynasties, but it was not until the early Qing that it became a clearly defined and established technique, primarily through the talent and the paintings of the present artist, Gao Qipei. His grandson recorded the circumstances under which Gao began to paint with his fingers: "When Gao was seven years old he studied painting. Coming on a painter's manual he at once clasped it to his bosom. More than ten years later he had filled two boxes [with his copies]. When a young man of around twenty, he was vexed at not having been able to form his own style. Becoming weary one day he lay down on a bed and slept. In a dream an old man led him into a chamber with earthen walls. The four walls were covered with paintings and all the right models were present, but within the chamber there were no writing implements, so he could not copy them. Fortunately there was a basin of water, so he dipped in his finger and practiced. On awakening he was at first very happy, but what the mind had imagined proved impossible for the hand to do. Weary and depressed once again, he suddenly remembered the way he had used water while in the chamber; he thus dipped his fingers in ink and, following the general outlines of the remembered images, captured all of their spirit. Trusting his hand and moving his fingers was the very best path for him to take; having decided that, he dispensed with the brush."

The same awareness of the creative function of the unconscious mind is revealed in the legend of another of Gao's seals: "Paintings are given by dreams, dreams are formed in the mind." The above quotation suggests that Gao's use of the finger painting technique was determined in part by his desire to develop a distinctive style of painting for which he could become famous. A second reason was likely an aesthetic preference for the special qualities of finger painting, which was spontaneous, lively, and decidedly unconventional in effect. As the legend of another of his seals has it: "Because a brush leaves traces, I thus set it aside."

Another of Gao's seals on the present painting reads:

"Man from beyond Shanhaiguan," the name of a town located near where the Great Wall reaches the coast. Gao thus presented himself as coming from Manchuria beyond the Great Wall and he is sometimes referred to erroneously as a Manchu himself. Gao's birthplace is often given as Tieling in Liaoning but, although registered there, Gao was actually born in Jianchang, Jiangxi, where his father, Gao Tianjue, was serving as magistrate. The Gao family had lived for generations in the area of Manchuria within which the Manchus rose to power during the early seventeenth century; the future and fate of the family had been joined to that of the Manchus by their enrollment in one of the Chinese banner organizations by which the Manchu conquerors controlled their new subjects. Gao Qipei's birthdate is often given as 1672; however, his own inscriptions – for example one dated to 1728 at the age of sixty-eight – indicate a birthdate of 1660, which is in accord with his earliest extant works from the year 1684. Originally attached to the bordered white banner, Gao Qipei was later promoted to the bordered yellow banner on the basis of military merit earned by his elder brother Gao Qiwei. In later years Gao Qipei would recall an occasion in 1666 when he accompanied his father to the Yanqing Temple in Jianchang; eight years later his father was caught up in the uprising of Geng Jingzhong in 1674 and died in captivity two years later, still loyal to the Manchu government. Only sixteen at the time of his father's death, Gao Qipei then relied on the support and guidance of an uncle who served as governor of two different provinces. Two of Gao's four brothers eventually rose to high official rank, and it is obvious that his family circumstances favored his own eventual success in officialdom.

It was not until around 1701, however, that Gao first held office, and by that time he had already been painting seriously for several decades. During that time he must also have studied for the examinations, but his appointment as magistrate of Suzhou in Anhui came not as the result of examination success but in honor of his father's loyalty to the throne. In 1703 Gao became an assistant department director within the Board of Works but three years later was transferred back to the provinces again as intendant of the Zhejiang Circuit. Somewhat later Gao was transferred to the Salt Commissioner's office, which brought him to the city of Yangzhou. After being implicated in a shortage in the tax revenues, Gao was deprived of office and entered his period of florescence as an artist.

Already while serving as an official Gao had hired assistants to help him with certain aspects of painting: "During the time Gao travelled as an official in the Liang-Zhe region he extended invitations to Lu Wei (cat.54)... Yuan Jiang (cat.58), and Shen Ao... All were men capable of raising their own pennons [as independent artists]. To Gao's finger-inked draft inventions, the three gentlemen added their elegant brushwork and marvelous washes. Those were the thriving and prosperous years. Each painting seemed as though from a god or immortal up in heaven..." Gao's subjects and compositions were borrowed from a wide range of earlier and near-contemporaneous painters, such as Chen Daofu (cat.23), Wu Wei (cat.7), Lan Ying (cat.30), and Zhu Da (cat.44), models then transformed by his unconventional techniques of finger and fingernail painting. In 1715 Gao was reinstated in

office as circuit intendant in Sichuan. This position, which took him to districts so distant as to amount to banishment, was changed in 1720 for that of judicial commissioner of Sichuan, which at least placed him in the provincial capital of Chengdu. In 1723, on the ascension of the Yongzheng emperor (r.1723-1735), Gao was once again called to the capital, where by 1724 he was junior vice-president of the Board of Punishments and concurrently lieutenant-general of one of the Chinese banner organizations. Despite the official responsibilities of the highest offices he was ever to hold, Gao continued to paint, "relying on assistants for both the initial wetting of the paper and also for final touches with a brush. Later Gao invited Lu Qing... and Wu Li... Although he could not always speak with these gentlemen on the same day [as he had laid out the composition], they were still able to understand the general idea of his sketch. When Gao later served as an official on the Board of Punishments, the two gentlemen returned south and Gao did not find any others. Works from his late years thus yield in comparison with those from his youth and middle years..." We should note, however, that Gao's assistants were said to have worked only on the large hanging scrolls; the albums, fans, and handscrolls by implication all came from his hand alone.

Only a very few dated works are recorded or extant from the last decade of Gao's life. He may have recommended Yuan Jiang, his former assistant, for court service at this time, and he also met the young Yangzhou painter Li Shan (cat.63) during the early 1720s, but Li was soon dismissed and sent home, and in 1726 Gao too fell from grace after committing some judicial error and was again deprived of office. From 1730 through 1732 Gao served in the Ruyiguan in the Yuan Ming Yuan palace – probably in the "outer" painting academy in which Yuan Jiang served – and seems to have produced at that time a number of rather more detailed and brush-executed paintings for court use. In 1732, at the age of seventy-two, Gao was placed in charge of the new military recruits for his banner. It was at this time that Gao was often visited by Gao Fenghan (cat.61), who may have been influenced by the freedom and spontaneity of Gao Qipei's work. During the final year of his life, 1734, Gao had frequent contact with the young Prince Bao who would later reign as the Qianlong emperor. On one of the six paintings by Gao known to have been owned by the prince the latter wrote: "The one-time comrade to Huainan has ascended like an immortal, leaving behind on unsized silk his visionary figures."

Catalogue No. 63.
**Li Shan** (1686-ca.1756)
*Jiaozhu Tu*, "Banana Palm and Bamboo"
Hanging scroll, ink and color on paper, 195.8 x 104.7 cm.
Inscription: "During the tenth month, winter, of the year 1734, [painted by] Li Shan called Futang."
Artist's seals: *Shan Yin; Zongyang*
Colophon: two-stanza poem by Zheng Xie (1693-1765)

The fine detail and delicate drawing of the bamboo stalks contrast with the stronger and looser effects of the banana palm and garden rock, whose bases are lightened by the gracefully curving lines of the bleeding-heart leaves. Composed of few elements, the painting focuses attention on the formal properties of shape and on the expressive effects of ink and color. While the compositional pattern is essentially flat, overlappings of lines and variations of ink-tonality suggest both spatial continuities and dislocations. The artist would later write with pride of his ability to control the amount and thus the effects of water in his ink and color washes. Suffusion of the water-saturated wash softens the contours of forms as they merge with the paper ground. Interior washes are modulated so as to suggest curving forms, and are overlaid with darker and drier strokes that articulate those implied structures. Color tones are allowed to mix freely in rather wet and unregulated washes and are juxtaposed in nonrecurring patterns to create local effects of substantiality independent of those associated with the normative subject.

The artist, Li Shan, whose style provided an important precedent for such nineteenth-century artists as Zhao Zhiqian (cat.75) and Ren Xun (cat.74), was born in Xinghua, Jiangsu province, to a prominent family of scholars and officials. The wealth and status of Li's family assured him every educational and cultural advantage during his early years, and his program of study included painting as well as poetry and calligraphy. Li Shan's grandfather, Li Lin (1634-ca.1707), was a close personal friend of Yuanji (cat.45), who figures prominently in Li Lin's literary works and must have been known to Li Shan from a very early age. Zheng Xie (cat.66), a younger friend from Xinghua, wrote that Li began his study of landscape painting with a local teacher named Wei Lingcang; Li himself credited Wang Yuan, a local woman artist, with introducing him to bird-and-flower painting. In 1711, at the relatively early age of twenty-five, Li passed the second-level examination; two years later, on the occasion of the Kangxi emperor's sixtieth birthday, Li submitted a poem which earned him imperial favor and an appointment to the Imperial Study. Ordinarily only the most talented members of the Hanlin Academy were so honored and then used in a secretarial capacity by the emperor to compose poems and edicts and to write ceremonial scrolls to be presented to officials as gifts. Since such secretaries and confidants were in intimate contact with the emperor, they could hold great expectations of continued imperial favor and promotion. The important official Jiang Tingxi (1669-1732), then also serving in the Imperial Study, was delegated to serve as Li's tutor in painting. Many of Li's paintings done during the 1720s reflect the precise technique and ordered compositions of Jiang and seem like details of Jiang's larger, more complex works.

Following a leave of absence Li returned to Beijing where he studied with Gao Qipei (cat.62) and may have served as a court painter. Li had been extraordinarily favored by the Kangxi emperor and had even been allowed to paint in the imperial presence. With the Kangxi emperor's death in 1722 and the accession of the Yongzheng emperor, Li's situation changed radically; he was soon dismissed and returned to find solace in Yangzhou. Zheng Xie suggested that the favor accorded Li by the Kangxi emperor had aroused the envy of his peers, who then secretly slandered him, but

Zheng also noted that, after twenty years of extravagant and dissolute living, Li Shan's inherited fortune was gone, his family was in distress, and the rent collector was beating at his door. Li's fall from grace may have been due to something more than jealous slander.

By 1726 Li was living in Yangzhou at the Zhuxi guesthouse of the Tianning Temple. He probably met Zheng Xie during the 1720s and toward the end of that period became acquainted with Huang Shen: a meeting of the three artists in the temple is recorded for the year 1728. Li probably remained in Yangzhou until 1738, struggling to earn his living as a professional artist. There are some indications that Li Shan's initial success came from his skill in calligraphy; his name-plaque inscription written for one of Yangzhou's decorated pleasure-boats is said to have established his reputation throughout the city. The only other artists associated with Yangzhou's floating world were Li's closest friends, Zheng Xie, Gao Fenghan (cat.61), and Li Yuan, and all were known also for their close association with the chief salt commissioner in Yangzhou, Lu Jianzeng (1690-1768), as well as for their unconventional personal lives.

Li Yuan and Lu Jianzeng appear as somewhat fictionalized characters in the famous eighteenth-century satirical novel *Rulin Waishi*, translated as "The Scholars." An incident in the novel, attested to by other sources, reveals Li Yuan's romantic proclivities and his disregard of Confucian propriety in marrying again while his first wife was still living. When criticized, Li's fictional counterpart replied: "With romantics such as myself, so long as it is a talented man and a beautiful woman who are getting together, it is not worth wondering whether it is the first or a second wife!" In addition to acting as Li Yuan's patron through recommendations, a role he filled also for Gao Fenghan, Lu Jianzeng helped Li Yuan with direct gifts of cash. "As soon as I arrived in Yangzhou," said Li's fictionalized self, "Lu sent me 120 taels." That casual gift (which was not the only one Lu made to Li Yuan) equalled what Zheng Xie could have earned, according to his price list, only by selling twenty of his large paintings or sixty smaller ones. These amounts are placed in perspective by noting that in later years Lu was accused of accepting 900,000 taels in bribes from salt merchants, and that in turn represented only ten percent of the net profit the merchants had earned but, with the connivance of Lu, had not reported to the government. Because of Li Shan's close association with Li Yuan, the two artists became known as the *er Li* or "Two Li" and would be used in the nineteenth century by Wang Yun as his exemplars of the group known as the *Yangzhou baguai*, "The Eight Eccentrics of Yangzhou." While as many as thirteen different painters have been proposed at various times as being among the eight, the original group seems to have included seal-carvers and calligraphers as well as painters and to have been based on friendship rather than on common features of painting style. The *Feihongtang Yinren Zhuan* (1789) includes in a biography of the seal-carver Pan Xifeng a list of the seven friends "with whom Pan ran around;" among them were Li Shan, Li Yuan, and Zheng Xie, who can be considered the heart of the group of Yangzhou eccentrics.

After the accession of the Qianlong emperor in 1736, Li Shan may have felt the time propitious to attempt again an official career and thereby escape the uncertainties of life in Yangzhou. Li had failed to pass the higher examination and it was still as a second-degree holder that he left Yangzhou in 1738 for a four-year period of service as magistrate of Tengxian in Shandong. While he seems to have maintained close contact with Zheng Xie and Gao Fenghan, who were also in Shandong after 1740, Li was dissatisfied with his lowly rank and appointment and dwelt quite often in poems of those years on the frustration of his earlier expectations. This disaffection with official life apparently encouraged greater concentration on painting; the four years in Shandong, and especially the year 1740, resulted in some of his finest and most innovative paintings. Although Li's administration was said to be honest, he was dismissed after disobeying a high official and returned to Yangzhou where he built the Fuou ("Drifting Froth") Study in the south section of the city. By around 1744 Zheng Xie was also dissatisfied with his career and wrote of leaving his position and returning to join Li as a professional artist in Yangzhou.

During the 1740s Li Shan was present along with Li Yuan and Jin Nong (cat.64) at several gatherings in the garden of the salt merchant He Junzhao. Li was known as a good poet and had achieved his earlier reputation as a calligrapher, but although it is for these talents that Li is usually mentioned at such gatherings, his reputation as a painter now began to surpass that for poetry and calligraphy. Unlike Jin Nong, who had pupils in poetry as well as in painting, Li Shan taught only painting. His latest works tend to emphasize structural clarity and rational use of color and ink, which may have been due to the exigencies of reducing his art to a transmittable mode of painting. His signature on many of the late paintings is followed by *zhi*, "made by," rather than the almost invariable *xie*, "written by," used earlier. One implication of the change is that such late paintings were done in response to commissions rather than to his own aesthetic impulses, and the several sets of twelve hanging scrolls done during these years well exemplify this aspect of his career.

Only a single recorded inscription suggests that Li Shan returned to Tengxian in 1752; he was in Yangzhou the following year and wrote what might be considered his own summation of his later career:

"A single branch with red leaves,
    a thousand times painted,
  these are my paintings done
    for a golden sash in Yangzhou."

Li's date of death is unknown but was probably early in 1756, the year of his last attributed paintings. In 1762, Zheng Xie wrote: "Li Shan, called Futang, was an old master-painter... Now that I am seventy my orchids and bamboo are increasingly advanced. What a pity that Futang will not return and that I will never again have someone with whom to discuss painting."

Catalogue No. 64.
**Jin Nong** (1687-1763)
*Yuehua Tu*, "The Radiant Moon"
Hanging scroll, ink and color on paper, 116 x 54 cm.
Inscription: "'The Radiant Moon.' Painted and sent to
Master Shutong for his refined appreciation by the seventy-four-year-old man [i.e., in 1761], Jin Nong."
Artist's seals: *Jin Jijin Yin; Shengyu Dingmao*
Collector's seals: Liu Quanfu and others

A circular orb, the moon, appears on an irregularly washed ground. Rays of color radiate from the circumference; within it floats an amorphous pattern. The title given by the artist suggests that on the surface of the moon is the traditional symbol of that planetary body, a rabbit pounding mortar with pestle, but the pattern also suggests the visual phenomenon of dark clouds drifting across the face of the moon. The title was probably derived by the artist from a line in the poem "Moon Above Mount Emei" by the Tang poet Li Bo: "Before the Yellow Crane Tower the moon is radiant and white." The present image is unprecedented in Chinese painting history and points to the great originality of its creator.

Jin Nong was born in Hangzhou, Zhejiang province. His early education was obtained at home and with a neighborhood teacher and then, from 1707 until 1712, with various scholars in Suzhou, especially the well-known bibliophile, He Chuo (1661-1723). Jin spent much of his time between 1714 and 1723 travelling to study old inscriptions and, whenever possible, to make rubbings of them; thirty years later Jin would have collected about a thousand rubbings of archaic inscriptions found on stone stele and bronze vessels. In 1719 he made his first visit to Yangzhou and met two artists who would remain his close friends in later days: Wang Shishen (1686-1759) and Gao Xiang (1688-1753), who were two of the so-called Eight Eccentrics of Yangzhou, as was Jin himself. In 1724 Jin left Hangzhou on a trip that took him northward through Yangzhou to Shandong, Beijing, and ultimately Shanxi, where he worked for some years as a private tutor. Many of his journeys and visits were made primarily to study calligraphy scrolls and rubbings held in various collections; while such diversions of time and effort away from studies more directly relevant to the examinations may have limited his accomplishments in scholarship, they contributed directly to his development as a calligrapher of great importance and originality. During his travels Jin was accompanied by a dog named "Little Magpie," about whom poems were written by Jin's friends, who helped spread his reputation as an eccentric as far as Beijing.

In 1735, Jin worked as a tutor in the household of a local official who was so impressed by Jin's learning that he recommended him for participation in the extraordinary *Boxue Hongci* examination to be held the following year. In Beijing he was met by many influential officials and introduced to the important collectors of the city, but he was not among the fifteen successful candidates (out of 180 scholars recommended from throughout the empire) and his pursuit of an official career was thereby ended. On his return to Hangzhou Jin turned his talents and those of his servants to a variety of interesting enterprises having mainly to do with calligraphy.

One servant excelled in making ink-stones of elegant and refined shape and texture, and whenever Jin obtained stone of suitable quality he would order the servant to make an ink-stone. However, the servant was unwilling to work before drinking several gallons of wine, without which he invariably produced ink-stones of poor quality; although Jin himself was not fond of wine he thus often bought wine for his servant. When the ink-stone was finished, Jin would inscribe the reverse in his distinctive calligraphy so as to give it an antique flavor and would then show it to his servant, who would continue drinking happily. Another of Jin's servants excelled in tie-dyeing silk into a pattern of black lines. At the lantern fair he would select the finest quality lanterns and border them with the patterned silk of his own manufacture. When Jin Nong had added an inscription to the lamp, even the famous lamps of Suzhou were held unworthy of comparison. Jin's friend, the scholar Quan Zuwang (1705-1755), recorded that although Jin was very poor he frequently received visitors, some wanting ink-stones and some lanterns. Jin's assistant in the lamp venture may well have been Bian Shoumin (cat.67), and Jin was also very close to Zheng Xie (cat.66) and Gao Fenghan (cat.61) at this time, as well as to Hua Yan (cat.60), Wang Shishen, and Gao Xiang. Quan Zuwang provided some justification for his friend's unorthodox behavior but even he had to conclude: "However, in truth, we cannot refrain from calling him eccentric to an extreme degree." Jin's personal style of calligraphy matured in the 1740s and he was asked to write many plaques, scrolls, and texts that circulated as far as Japan and Okinawa.

Around the year 1747, after having failed to obtain an official position through his scholarship or sufficient private patronage for his calligraphy, the fifty-nine-year-old Jin Nong determined to become a professional painter, and began by specializing in bamboo. Moving from his old family home to a studio, Jin had the land in front of it cleared and planted with several hundred bamboo so that he could watch it grow and study it. He wrote that the price for each bamboo plant was around thirty copper coins, "While those who love and seek paintings of it will reward me with several hundred times the cost of buying the bamboo." Jin assumed that a painting of bamboo would always be valued more highly than the bamboo itself, but he was to find that not all customers appreciated the skill and training required to produce a painting or even to understand the cost of the basic materials. Jin would later quote Zheng Xie's summation of the problem with full approval: "The price of a bamboo painting is greater than that for the bamboo; an eight-foot sheet of paper alone costs 3000 coins." Following the death of his wife in 1750, Jin moved to Yangzhou where he lived for the rest of his life in various Buddhist temples; his only child, a daughter, lived in Tianjin.

From the later 1750s onward Jin, still unsuccessful as an artist and dependent on gifts from friends, had as many as five students in poetry and two, Luo Ping (cat.68) and Xiang Jun, in painting. Both Luo and Xiang began their painting studies with plum blossoms, the subject Jin himself was most concerned with at the time, and Luo Ping followed Jin's changing emphasis into figures, horses, and Buddhist subjects. Xiang Jun became especially skillful in Jin's style of

painting blossoming plums and sometimes ghost-painted for him with such accuracy that, according to Jin himself, even connoisseurs could not distinguish Xiang's painting from Jin's own work. A majority of Jin's extant paintings are dated to 1759 or later and some elusive percentage of those paintings were certainly executed by one or another of his pupils.

In terms of production the year 1759 marks a peak in Jin's career as a painter. Soon after the death of his friend Wang Shishen, and concerned about his own declining health, Jin Nong executed a series of self-portraits that were given to his closest friends, including Zheng Xie, to his students Luo and Xiang, and to monks in the temples in which he had stayed. On the painting given to Luo Ping he expressed the wish that when Luo travelled he would show the portrait to any extraordinary person who had heard of Jin Nong and wished to see him. In his last years Jin painted Buddhist images in order to obtain merit that would compensate for his earlier life. Li Gonglin (ca.1049-1106), Jin wrote, had painted horses during his middle years and thus entered the lower realms of existence that would influence his *karma* and level of future reincarnation; Li Gonglin therefore turned from painting horses and began to paint Buddhist figures in order to expiate the evils of his past life. Jin had also painted horses but ceased to do so after 1760, devoting the remaining years of his life to writing sutras and painting Buddhist images.

Jin Nong's career as an artist was never a commercial success. Denied after 1736 any possibility of an official career, Jin sought through his calligraphy and painting the patronage enjoyed by many of his friends. His failure in even that is suggested by Quan Zuwang's description of Jin's poverty and by Jin's own writings. Inscriptions from his last years, written after 1760 and his final commitment to Buddhism, suggest a spirit of equanimity and acceptance in which the standards of the past and even those personal criteria followed throughout his life ceased to matter. In 1762, at the age of seventy-five, Jin began to describe himself as an 'eighty-year-old decrepit old man,' and gave complete charge of the publication of his last book to Luo Ping, who printed the text and stored the blocks at his own home. There is no evidence to suggest that Jin continued to work beyond the year 1762. A postface written by Luo Ping in 1773 says that Jin died in a Yangzhou temple in the fall of the year 1763.

Catalogue No. 65.
**Min Zhen** (1730-ca.1788)
*Yingxi Tu*, "Playing Children"
Hanging scroll, ink on paper, 88 x 112.5 cm.
Inscription: "Two days after the winter solstice of the year 1771, Min Zhen, called Zhengzhai, painted this after the ideas of Tianchi Shanren [Xu Wei]."
Artist's Seals: *Min Zhen*; *Zhengzhai*

Five boys huddle together, their overlapped and crowded bodies suggesting the closeness of their relationship as well as the intensity of their play. Uneven wash and daubs of ink model the forms to some extent, but their vivid sense of bulk and animation is created mainly by skillful yet sponta-

neous modulation of rhythmic lines. The artist, Min Zhen, was a fine calligrapher and seal-carver as well as painter, and a consistent artistic personality is manifested here in all those areas.

Min Zhen was born in Hankou, Hubei province, to which area his grandfather moved from the ancestral home in Nanchang, Jiangxi. His father, Min Kun'gang, known for his skill in geomancy, and his mother both died when Min Zhen was eleven years old, leaving him desolate and in despair over the lack of any likeness of them which could be used in memorial services dedicated to their memories. All biographers of Min agree that it was initially in order to paint such an image himself that he first studied painting, a decision that eventually earned him renown as a truly filial son.

Given the stories of miraculous visitations that circulated about the young artist, one can understand the motivations of the wealthy in wanting their portraits painted by him, but given also the unconscious arrogance of that idle class, Min's disdain for his patrons is also understandable. In Min Zhen's way of thinking his lack of respect for his subjects demanded compensation of its own. "At that time the governor-general of Hubei heard of Min and asked him to come. Min first submitted a small version on a sheet of paper. Form and spirit were both there and personality was captured as well. The governor-general was very pleased and ordered him to hurry up and finish the painting work. Min then demanded a fee of 40,000 gold taels for the work in question. When criticized for this absurdity, Min said, 'The governor-general's position is within the military clique which controls Jingzhou. Should I have complied with his demand without receiving a high payment, it would have insulted the governor-general as well as my painting...' The governor-general was furious and wished to restrain him by law, so Min tucked the portraits of his father and mother under his arm and fled."

On his journey from Hankou to Beijing, Min Zhen would almost certainly have passed through both Nanjing and Yangzhou and would thus have become familiar with the art styles practiced in those cities. Although Min is sometimes associated by modern writers with the Yangzhou eccentrics, there is nothing to suggest that he lived in Yangzhou or associated with any of the so-called eccentrics save Luo Ping (cat.68), whom Min probably met in Beijing. According to Min's friend, Wang Qishu (1728-ca.1799), the well-known salt merchant, bibliophile, and collector of seals, Min arrived in Beijing in 1778. Wang, who was himself living in Beijing at the time, recorded Min's exceptional filial piety, comparing him to Ding Lan of the Han dynasty who had carved an image of his mother in wood after her death, but Wang was primarily interested in the seals carved by Min in the antique Qin-Han style. It is worth noting that the subject of one of Min's extant portraits is Ba Weizu (1744-1793), who, along with Cheng Sui (cat.38), is considered the founder of the Anhui school of seal-carving. In Beijing Min also met and became friends with Weng Fanggang (1733-1818) and Zhu Yun (1729-1781), who worked with Wang Qishu on the *Siku Quanshu* library project; both were also friends of Luo Ping.

Another of Luo's friends, Yu Jiao, was the author of the biography quoted from above. Yu continued: "His expressionistic figure paintings were his best work and at times he

worked in the *baimiao* monochrome and linear style... The fees sent by those who wanted his paintings were squandered as soon as they were in his hand. The white silk piled up until his table and bed were covered but in the end he did not repay [his patrons with a painting]. Because of this everyone found fault with him, some to the extent of hating him as an enemy, but Min ignored them. After living [in the capital] for three years he was very poor, so with his clothes on his back and riding a slow quiet horse he departed from the capital..."

Following his departure from Beijing in 1780 or 1781 (an extant painting by Min bears a colophon written by Weng Fanggang in 1781) Min seems to have dropped out of sight of his known biographers. Having been absent from Hankou for a number of years it might then have been possible for him to return home. Frederic Hirth, one of the earliest Western collectors of Min's paintings, wrote of him as being active around the year 1800. Min's biography in the *Molin Jinhua* perhaps describes this later portion of his career. "He did not easily work for people. If a friend or a poor and simple person sought a painting he would certainly get one, or get one even without asking, but if Min met someone who was rich and honored, then he would remain unwilling to paint a single stroke for years on end if he were not recompensed with a high fee. The fees he received for painting were quickly thrown away in music halls and taverns, so those who wanted a painting from him could frequently buy one there."

Catalogue No. 66.
**Zheng Xie** (1693-1765)
*Lanhua Tu*, "Orchids"
Hanging scroll, ink on paper, 96.3 x 48.2 cm.
Inscription: "On the twenty-fifth day of the twelfth lunar month of the *guiyou* year of the Qianlong reign-era [January 17, 1754], the retired scholar Banqiao painted these orchids for his friend in Daoism, Zhang Cuixi. Zheng Xie."
"White-hearted orchids as well as red-hearted orchids, all present a fragrant heart for visitors to see;
Can it be that the spring breeze will be able to arouse it, having experienced frost and snow it is 100% cold.
Inscribed again by Banqiao."
Artist's seals: *Zheng Xie zhi Yin*; *Yangzhou Xinghua ren*;
*Zhegu* ("Partridge")

Three clumps of orchids, which lack any defining context but create their own space through overlapping and placement, are held in tension-filled balance by the artist's inscriptions across the top and in the lower left of the format. This close integration of calligraphy and painting was not new, Yuan dynasty masters such as Zhao Mengfu and Wu Zhen are notable forerunners of the practice, but few Qing dynasty painters were so successful as the present artist in following and even improving on such earlier models. The Chinese orchid differs from the type commonly favored in the West in that its flowers are smaller and less conspicuous and its leaves long and grasslike, a characteristic which endears it to artists who are calligraphers as well as painters. A primary value of the Chinese orchid lies in its delicate fragrance, a scent of such desirability that Confucius remarked: "Orchids should be regarded as the perfume of kings." Perhaps because of the beneficent aura created by this unassuming plant it has long been likened to a perfect gentleman who, like the orchid itself, can be found amongst the common variety of the species as often as in hot-house environments. Zheng Xie specialized in painting orchids and bamboo, and in many ways he himself typifies the virtues of these symbolic plants.

Zheng Xie, like his close friend Li Shan (cat.63), was born in Xinghua, Jiangsu, near the city of Yangzhou. His mother died when he was two and he was subsequently raised by his grandmother's maid. "That was a year of famine, and Mistress Fei got a living outside while also managing everything at her home. Early each morning she got up, put me on her back, and went to market where she would exchange a coin for a biscuit which she put in my hands. Only then did she attend to the other business. When there were fish or melons she always fed me first and only later were her husband and children able to eat... One morning I entered her silent room and saw a broken bed and ruined table ranged along the walls. I saw that the stove was still warm and within the storage area were a cup of rice and a cup of vegetables – what she usually fed to me. I wept bitterly and was not able to eat..." Thus wrote Zheng more than thirty years later. We are remarkably well informed about many aspects of Zheng's life precisely because he recorded what he wanted others to know about himself. He thus displayed a will to overt self-expression that seems very modern and makes his writings very pleasurable to read yet today.

Zheng's father subsequently remarried and Zheng was also cared for by a loving uncle. Although the family lived in genteel poverty Zheng studied hard with a local scholar named Lu Zhen and passed the first-level examination in 1714, the second in 1732, and the third and highest in 1736. Those years of study were not easy, for his father had died in 1722, his uncle in 1726, and his wife in 1731. His emotional reactions to these events were embodied in several series of autobiographical poems which are models of direct and forceful expression and convey messages that at times transcend the immediate circumstances of their creation; some were later set to music and were sung throughout the country into modern times.

During the late 1720s until 1742 Zheng was often in Yangzhou, where he associated especially with Li Shan and the salt commissioner Lu Jianzeng but knew and wrote about artists as diverse as Huang Shen, Fang Shishu (cat.56) and Bian Shoumin (cat.67). Zheng named his seal collection the "Tower of the Four Fengs" in reference to Gao Fenghan (cat.61), Gao Xiang, Pan Xifeng, and Shen Feng. A poem by Zheng probably dating to this period manifests ideas on creative expression that were common to all of his contemporaries in Yangzhou:
"What need have heroes to read the classics of history,
  when they can directly express their own
    warm-blooded natures in writing;
I am not a Daoist immortal nor a Buddha
    nor a worthy sage,
and even apart from brush and ink
    I have things to advocate."
After receiving his third-level degree, Zheng lived in

Yangzhou and probably supported himself by painting while waiting for an official appointment.

In 1742, at the age of forty-nine, Zheng was finally given an opportunity to put into practice some of what he advocated while serving as magistrate of Fanxian in Shandong. Zheng's duties seem to have been fairly light at his new post; he wrote many poems and edited his first literary collection, which has a preface by the Manchu prince Yunxi (d.1758), whom Zheng had met ten years earlier in Beijing. Zheng summed up his life to that point as follows: "I studied poetry but accomplished nothing and so dismissed it and studied writing; I studied writing but accomplished nothing and so dismissed it and studied painting. Each day I sold a hundred cash worth in lieu of plowing and sowing. But in reality what saved me from distress and poverty was reliance on a name for elegant style which allowed me to avoid the road of official visits when begging for an official position. Here [in Fanxian] there is a pure breeze where I sit and no horses and carriages are at the gate..." In 1746 Zheng was given a more challenging role as magistrate of the far more active district of Weixian, which was then in the midst of a famine. Ju-hsi Chou has recently assessed this stage of Zheng's career: "To cope with the pressing crises, Zheng Xie's response was swift. He opened the governmental grain storages for the hungry, set up large-scale construction projects and repaired the city walls to accommodate the unemployed, forced the wealthy to share some of their wealth, and placed price controls on food commodities to reduce cost. In this way, he brought relief to the population and reduced the dying by the thousands. While such forceful measures earned for him the respect and admiration of many, they also offended the local gentry, some of the powerful merchants, and even upset his superiors..." By all accounts Zheng was a good official, efficient in his administration and caring for those under his jurisdiction. However, his well-known letters written home to his younger cousin suggest that eventually he became disillusioned with officialdom and even with art, which had continued to bolster Zheng's official income during these years: "Writing calligraphy and doing paintings are elegant activities but they are also vulgar activities. When a great man cannot do some meritorious act between heaven and earth to nourish and support the life of the people but rather trifles with brush and ink to provide amusement for others – what is that if not a vulgar activity? ... Your stupid elder brother [i.e. Zheng himself] had no calling when young, no accomplishments when grown, and now, in old age, is poor and in distress, with nothing for it but to continue relying on brush and ink for my living. This is truly shameful and a disgrace, and I hope you will work zealously toward higher goals and will not follow in your elder brother's ruts... In recent days the calligraphers and painters who fill the streets are all called 'famous scholars'."

Zheng resigned from office in 1753 and returned home to Xinghua, where he painted the present work very early in 1754. If Zheng's poem on this painting can be held to have autobiographical implications, he was asking himself how he would fare in retirement and whether he too would revive back in the heart of orchid-growing country after his years of service in the sterner climate of the north. These questions were answered by the subsequent stream of calligraphies and paintings that flowed from his brush during the final twelve years of his life and also by the many occasions on which he met such friends as Li Shan, Jin Nong, and Lu Jianzeng. One of Zheng's most interesting pieces of writing from his later years was a short handscroll "done in the year 1759 for the monk Zhuogong who asked me to write something [that could be used] in declining to receive guests." The text itself read: "Large scrolls, 6 taels; medium-sized scrolls, 4 taels; small scrolls, 2 taels; pairs of calligraphy couplets, 1 tael; fans or square album leaves, 5 copper cash. Sending presents or gifts of food is always less appreciated than silver, for what you send is not necessarily what I like. With ready cash my heart rejoices and my writing and painting are both excellent, while presents are problematic and giving credit involves bad debts. I am old and my spirit weary, so I cannot keep you gentlemen company engaging in unprofitable conversation. The price of a bamboo painting is greater than that for the bamboo, a six-foot sheet of paper alone costs 3000 copper cash; Let someone speak of old times or mention social relationships, and I will simply regard it as the autumn wind blowing past my ear." The assumption generally made by those who take note of this text is that, when writing for his friend, Zheng used his own prices as examples; some writers have even speculated that Zheng actually posted the list in a public manner. We may note that the explicit purpose of the text was to discourage uninvited visitors, which suggests that visitors would not have had the temerity to treat with the monk, or Zheng by implication, on a purely commercial basis, their actual social status being in reality much higher than that of a professional artist. While the pithy and humorous language of the text and certainly the sentiments expressed therein are those of Zheng, it should be noted that the prices are far too low ever to have applied to the works of the famous Zheng Xie of Xinghua.

Catalogue No. 67.
**Bian Shoumin** (1684-1752)
*Luyan Tu*, "Wild Geese and Reeds"
Album of 12 leaves, ink and color on paper,
26.9 x 29.5 cm.
Leaf no. 12 inscribed:
"Early winter of the year 1730, Shoumin."
Artist's seals: *Shuiyun Xiang; Qi Yin; Bian Weiqi; Laoyi; Weiqi; Yigong; Shoumin; Chen Weiqi*

Bian Shoumin, whose original given name was Weiqi, was born in Huaian, Jiangsu. In later years Bian would display a distinctive style of calligraphy and a flair for poetry, and his training in those fields must have begun early. He is known to have passed the first-level examination but seems then to have travelled extensively, living for some time near Lake Zhu in Jiangxi, an area on the migration route of the wild geese which became his specialty in painting.

Geese had from very early times played their part in Chinese cuisine, hence their popularity in art requires no special explanation. Earlier artists from Ma Fen and Muqi of the Song to Wang Zhao of the Ming had also frequently chosen wild geese as subjects for painting. It was popular belief

that geese flew in pairs and were monogamous in mating, hence paintings of them would have been especially appropriate for betrothal and wedding ceremonial gifts. Bian's early paintings of wild geese, which tend in any case to be comparatively naturalistic, may thus manifest a personal appreciation of the subject, while his later works, which are far more formulaic, may be regarded as functional works produced for specific occasions.

Bian was often in Yangzhou from the late 1720s onward. He assisted Jin Nong (cat.64) during the 1730s and was also mentioned in poems by Gao Fenghan (cat.61) and Zheng Xie (cat.66); Bian is occasionally grouped with those friends as among the Eight Eccentrics of Yangzhou. A poem by Zheng Xie describes Bian's 'Library Within the Reeds':

"Bian erected a house which is akin to the shell of a snail,
  suddenly open a window and look at empty vastness;
Several branches, rushes and reeds
  ward off the mist and frost,
all the water illumines the clouds
  and the peaceful pavilion.
In the cold night twinkling stars
  send down small rays of light,
the western wind enters the bamboo door
  and disturbs the candle beams;
From the opposite shore one dimly
  hears the cold dog howl,
I am ready to hum as I twist my mustache,
  for the night watch is long."

In later years Bian visited Nanjing, where he met Li Fangying and the poet Yuan Mei, and then returned to Huaian, where he was recorded as saying: "I rely on painting for my livelihood, but today I am sixty and old age is coming on. I have set up a bamboo receptacle with round exterior and square interior. After hollowing out the interior I sealed it up save for an aperture. During the times when my hand is able to work and I achieve something superior, I push it through the aperture into the interior where it will remain for when I am old. I call it my wastebasket."

Catalogue No. 68.
**Luo Ping** (1733-1799)
*Meihua Tu*, "Blossoming Plums"
Hanging scroll, ink on paper, 131.8 x 34 cm.
Inscription: "Painted at the direction of
Master Yungu by Luo Ping."
Artist's seals: *Luo Ping*; *Shengyu Guichou* ("Born in the year 1733")
Colophons: on mounting by Weng Fanggang (1733-1818), Song Paoshun (1748-1818 or later), Wu Xiqi (1746-1818), and others

Thick branches, their heaviness mitigated by the shimmering screen of white blossoms, insinuate their way across the surface of the paper to create a very strong formal design

which maintains the integrity of the flat surface. The contrast between rough-textured bark and delicate blossoms is matched in subtlety by the pulsating rhythms of the pictorial elements and by the arrangement of those elements with full awareness of the negative space thus created. Such formal concerns are also those of the calligrapher and seal-carver; the artist here, Luo Ping, was both as well as painter.

Luo was born in the city of Yangzhou, the fourth of Luo Yuqi's five sons. Since the father died young, Luo Ping's inheritance was limited mainly to a taste for poetry and the beginnings of a literary education. His uncle, a local official, was a friend of the important scholar Hang Shizhun (1696-1773), who in turn was a close friend of both Ma Yueguan (1688-1755), the Yangzhou salt merchant and patron, and Jin Nong (cat.64). It was likely through Hang that Luo's poetry came to be known to and appreciated by Ma and that Luo himself was accepted as a disciple of Jin Nong. Beginning in the year 1757 Luo studied both poetry and painting with Jin, met his master's friends, and probably came to appreciate the ways in which artfully displayed talent could offset a lack of money and position. One of Luo's poems suggests the quality of his life at this time:

"Coins from selling paintings are coins for buying wine,
  the joy and laughter of last year
    will return this year again;
By chance I lay drunk on the top of the northern peak,
  there thus were those who spread
    the rumor it was an immortal."

Luo, who today is commonly regarded as one of the Eight Eccentrics of Yangzhou, called himself "The Monk of the Flowery Temple," explaining that "when first born I ate neither meat nor blood and often dreamed of entering a flowery temple." During the early 1760s he established a studio he called "The Fragrant Leaves Grass Hut" and published his master's "Record of Inscriptions on Paintings of the Buddha." Luo also married at this time. His wife, Fang Wanyi (1732-1779), from the Shexian district of Anhui where Luo's clan too had originated, was also very talented in poetry and painting.

When Jin Nong died in 1763 Luo Ping was already thirty years of age but had not yet established himself as an artist – an increasingly difficult task as the older generation of patrons was gradually replaced by those more interested in theatre and opera than in calligraphy and painting. During the next eight years Luo was mainly in Yangzhou but also travelled within Jiangsu and to Jiangxi and Anhui. Part of Luo's reputation in later years was based on a scroll he painted during the 1760s. This famous work, which illustrates ghosts, demons, and strange humans, was entitled *Guiqu Tu*, "The Destiny of Yakas, Raksasas, and Hungry Ghosts." In its Buddhist usage the term *gui* refers to various types of ghosts who prowl through the human world causing fear, sickness and death. Luo Ping said that his eyes were preternaturally discerning, hence he could actually see these ghosts and simply painted them as they were. Luo's images accord fairly well with literary descriptions of these creatures given in Buddhist literature – needle-haired, needle-throated, mouths like burning torches, vile, disgusting beings living on refuse and ordure – but his actual presentation of them is more immediately reminiscent of the ghosts appearing in the sto-

ries of the *Liaozhai Zhiyi* by Pu Songling (1640-1715). Pu's book of short stories, which has a colophon by Wang Shizhen (1634-1711), was first printed in 1766, the date of the earliest colophon on Luo's *Guiqu Tu*. However, the stories could have been known to Luo even earlier since the manuscript version of the book bears a colophon written by Gao Fenghan (cat.61) in 1723. In any case, Luo carried his scroll with him during his trips to Beijing and requested inscriptions from many famous scholars, officials, and collectors, his main purpose most likely being to make a name for himself among prospective patrons in the capital.

Luo Ping made three trips in all to Beijing. During the first visit between 1771 and 1773 he met high officials and scholars who became his close friends and would serve as his patrons in future years; many, such as Ji Yun (1724-1805) and Weng Fanggang (1733-1818), were active on the *Siku Quanshu*, "Complete Library in Four Branches of Literature," project to which such Yangzhou libraries as that built up by Ma Yueguan contributed handsomely. On returning to Yangzhou, Luo Ping was reunited with his wife and growing family: two sons, the first of whom was given to Luo's uncle for adoption so as to continue the uncle's line, and one daughter, who in later years would be Luo's companion in painting. A verse written by a friend describes the family at this time:

"Two Peaks [Luo Ping] is the husband,
    White Lotus [Fang Wanyi] the wife;
  their sons are able to display
    their poetry and calligraphy,
  the deportment of their daughter
    Fragrant Virtue [Luo Fangshu] is correct."

One year before he returned to the north, Luo's friend Dong Xun presented him with a seal whose legend *Shengyu Guichou* gives the year of Luo's birth. Some of his earlier seals had been carved by Ding Jing, friend of Jin Nong, and by Huang Yi, one of the best of the later seal-carvers along with Deng Shiru, known by Luo at least from 1788 onward. Luo's interest in seals represents yet another legacy from his master.

Luo had been gone from Yangzhou for only thirteen days in 1779 when his wife died; word did not reach him until around three months later, after which he returned to Yangzhou before quickly leaving for Beijing again. It was in Beijing, late in the year 1779, that the present "Blossoming Plums" was painted; the work bears the *Shengyu Guichou* seal and was painted and inscribed in a style very close to that of Jin Nong himself. The recipient of the painting was Kong Jikan, a distant descendant of Confucius, known for his own skill in painting blossoming plums. Late in the year of 1779 Kong was leaving Beijing to take up his new post as magistrate of Taixing, Jiangsu, and this painting and another were done for him by Luo and then inscribed by their mutual friends. Kong was also one of those who inscribed Luo's *Guiqu Tu* although, in an echo of his illustrious forebear, he criticised Luo for painting what was dead rather than what was of this world of the living.

Luo Ping remained in Beijing until 1798. During that time he was especially close to Weng Fanggang, the poet-painter Zhang Wentao (1764-1814), and the important Mongol official Fashishan (1753-1813). Despite their friend-

ship and support, however, Luo was never to become even moderately wealthy and returned home in his old age only with the financial assistance of Ceng Huan, the Liang-Huai salt commissioner in Yangzhou. Luo died at home in the seventh month of 1799. His obituary concluded with the verse:

"Neither recluse nor official, he was both
    Chan Buddhist and Daoist immortal,
  wine broke poetic fetters,
    feelings gave birth to paintings' causes;
  A thousand years and after we will
    want to know of this worthy,
  he was a blossoming plum, his wife a white lotus flower."

Catalogue No. 69.
**Zhang Yin** (1761-1829)
*Jingkou Sanshan Tu*, "The Three Mountains of Jingkou"
Handscroll, ink and color on paper, 29.5 x 194.2 cm.
Inscription: "'The Three Mountains of Jingkou.' Presented to his excellency Yunting during the first month of the year 1827 by Zhang Yin from Dantu."
Artist's seal: *Zhang Yin zhi Yin*
Title: "The Three Mountains of Jingkou" written by Tu Zhuo (1781-1828)
Colophons: written by Lei Kai (b.1878) and Lei Ke (b.1881)

From the vast expanse of the river rise several rounded peaks, on the summit of which are temples and pagodas among trees. Fishing boats, ferries, and cargo vessels ply the river whose distant shore is partially obscured by low-lying clouds and mist. Small villages and towns appear along the shore and in the distance the upper portion of a city wall can be glimpsed. Jingkou, the name of the region given in the title, is the modern Zhenjiang, located south of Yangzhou on the Yangtze River where begins the canal leading northward to Beijing. Yunting, the byname of the person for whom the work was painted, could be any one of several contemporaries of the artist, all of whom used that name on occasion but, judging from the respectful language of the dedication, the recipient was most likely Tao Shu (1778-1839), a provincial governor.

The artist, Zhang Yin, was from Dantu in Jiangsu province. His father, Zhang Zikun, was well-known as a collector and connoisseur as well as for his bird-and-flower paintings in the style of Wang Guxiang (1501-1568). Although Zhang Yin never held office, he did pass the first-level examination and become a senior licentiate. However, it was as an artist that he became famed in the Jingjiang or "capital river" district of Zhenjiang, the area portrayed so evocatively in the present painting. Precocious as a painter, Zhang soon mastered the techniques of painting flowers, bamboo and rocks, and Buddhist subjects, but he was especially drawn to landscape painting. While still a boy Zhang met the reclusive Pan Gongshou (1741-1794), then the fore-

most landscapist of the region, and watched the elder master paint a landscape in the manner of Wen Zhengming (cat.15). Zhang liked Pan's work and imitated it, but then, "thinking always very highly of himself and being unwilling to occupy second place" according to one biographer, Zhang began to model himself on Shen Zhou (cat.12), the teacher of Wen Zhengming, and eventually studied the Song and Yuan masters who had been Shen Zhou's models. Zhang states his purpose in studying not the earlier Qing codifiers but rather the original patriarchs of the orthodox tradition in an inscription on one of his landscape paintings: "In our Qing dynasty, ever since Wang Yuanqi [cat.50] became famed throughout the empire for his painting, there has not been one painter among the scholar-officials who did not follow him closely; they are called the Loudong school. Then there are those who strive after peace and tranquility who say they are following Yun Shouping [cat.52], and those who love elegance and refinement who say they are following Wang Hui [cat.49]. But the great Yuan and Ming masters are simply ignored. In my district Pan Gongshou arose and pursued the tracks of Master Wen Zhengming while I... followed Shen Zhou with all my strength and traced his source to Wu Zhen, connecting directly with the orthodox lineage. But my contemporaries did not approve..." Unwilling to paint as a second-class follower of the Loudong school, Zhang persisted in creating his own style, stating with a proud defiance: "I am a painter of Jingjiang, and I have my own style; never once have I followed the Loudong [style]."

Zhang's statement is akin to several similar proclamations made by the great individualist master of the early Qing, Yuanji (cat.45), whose work was known to Zhang Yin; two colophons by Zhang appear on a famous album done by Yuanji in 1691. Zhang's highly original style of painting seems to have been understood and appreciated immediately by his fellow painters: Wang Xuehao (1754-1832), Gai Qi (cat.71), and Qian Du (cat.70) all praised his work very highly. Zhang Yin was eventually accorded the highest accolade of Chinese art history: recognition as founder and, along with Gu Haoqing, patriarch of his own stylistic lineage, named the Jingjiang or Zhenjiang school of painting.

Zhang's early biographers distinguished two distinct styles of paintings done by him: "One is heavy and dense, thick and substantial, with a theme derived from the great Song masters; this was his specialty. The other is understated and serene, quiet and reserved, with an air of absolute purity; this was very close to the work of Wen Zhengming and Wen Boren [cat.20] blended with the styles of Wang Hui and Yun Shouping. All of his small works were in this mode." The present "Three Mountains of Jingkou" is of the latter type. Sensitive, dry-brush drawing and pastel colors are combined with his characteristic impressionistic style of dotting and texturing to create an image of great lyric beauty, one which fully confirms his faith in his own talents.

Catalogue No. 70.
**Qian Du** (1763-1844)
*Bu Xiangshan Zuokan Yunqi Xiang,*
"Landscape Added to a Portrait of Xiangshan Seated While Watching Rising Clouds"
Hanging scroll, ink and color on paper, 172.5 x 53.8 cm.
Inscription: poem by the artist, inscribed and signed "The venerable Xiangshan brought a small portrait and asked me to add a picture of him seated while viewing the rising clouds. I did it following the ideas of Jiang Guandao [Jiang Shen] and added a poem. Inscribed by Qian Du during the fourth lunar month of the year 1838 of the Daoguang reign-era."
Artist's seals: *Songhu Shihua; Qian Shumei; Qian Du yin xin*

The portrait figure was apparently painted by an unknown artist for the recipient of the painting. The latter then brought it to his friend, the painter Qian Du, and asked him to add a landscape setting. The figure may appear a bit too large and the face too strongly modelled for its context, but the landscape elements are appropriately subservient to the figure and are arranged so as to ensure the primacy of the subject. "The venerable Xiangshan" was probably the Suzhou artist Bian Xiongwen for whom Qian Du had in 1813 painted one of his masterworks, "Walking in Moonlight at the Yushan Thatched Cottage." The monumental, serpentine masses of the distant mountains must represent the artist's image of the style of the Northern Song master Jiang Shen, although the coloring and the precisely rendered details are closer in style and spirit to Wen Zhengming (cat.15).

Qian Du, originally named Yu, was born in Hangzhou, Zhejiang, just in time for him to meet one of the major eighteenth-century Hangzhou masters, Jin Nong (cat.64), who was a good friend of Qian's father. Qian Du's family was large, he was the seventh of eight sons, and very well off. Qian remembered that "When I was young we lived south of the lakes. To our gate came no ordinary visitors and what was collected and stored in the study was very rich. When at leisure I could read what I pleased and so each day came face to face with the ancients..." Qian's father, Qian Qi, was appointed governor-general of Yunnan province in the far southwest of China "and his household accompanied him. When passing over a high and dangerous mountain range the sedan chair in which Qian Du was riding fell into a deep ravine and everyone thought he could not be saved. But at the bottom were some old vines in which he became entangled and these were used to pull him up. Not until he was at his nurse's breast again did he awaken." This was recorded along with other major events of his life by Qian's student, Cheng Tinglu. "When Qian was in his teens he became ill with a consumptive disease; he lost all of his teeth and hair and could not regain his strength. It happened that one of his father's colleagues had made them a gift of a polygonum root. This was split open with a bamboo knife and more than a cup of thick white liquid taken out. Qian drank half of it and then slept deliriously for two days and nights. On awakening he asked for the remainder of the liquid but it had been thrown out by his nurse. But, in any case, from then on his spirit flamed, he began to recover immediately from his

old illness, and his teeth and hair grew in again. To the end of his life he was never sick again."

"When he was young, Qian loved music and women. But after his sickness he became as tranquil and placid as an old priest. He said that he had heard that a woman's hair charm could ease a splitting headache so he married a woman from Suzhou. They had a daughter and named her Chuzhang..." By around 1790 Qian was living in Beijing where he held an appointment as a second-class secretary to one of the ministries. While this suggests that he had had some success in the civil service examinations, the position could also have been granted on the basis of merit earned by his father or brothers. Qian wrote that he had travelled throughout the empire by the time he was thirty, and some of Cheng Tinglu's statements suggest that his travelling may have been induced by sudden loss of the family's position: "The master was the son of an upper class family whose circumstances became reduced to poverty. He fled to far distant places in the southwest where all the barbarians ride on elephants. He travelled to Fujian in the south and in the west advanced as far as Mount Emei in Sichuan." The circumstances of at least one return trip to Yunnan were also recorded by Cheng: "He once followed a debtor for more than a myriad miles but when he caught up with him the man had already died. Qian then took the documents worth several thousand in gold and burned them before the coffin. Empty-handed, he was unable to return home. He happened to meet Gui Fu [1736-1805], so the two stayed together in the huts of Buddhist priests, each selling what he had written or painted. When they got some money they would buy wine and fresh food and boast and laugh happily. After several days, when the money was gone, they would do it again, leaving barely enough for food and travel."

Following the death of Gui Fu in 1805, Qian remained in the southwest and did not return home until around 1808. His first book, "Songhu's Further References to Paintings," was published in 1812 but, since it has a colophon by Gui Fu, it must contain earlier material as well. The final three decades of Qian's life seem to have been spent mainly in the Jiangnan region of Nanjing, Suzhou, Yangzhou, and Hangzhou. Cheng Tinglu said that Qian gave up writing poetry at the age of sixty and stopped painting at the age of seventy, and Qian himself confessed that after the age of sixty he became lazy and did not paint much; in fact his production of paintings seems to have increased somewhat after 1832, although each work continued to be as precisely composed and executed as before. Qian's aesthetic goals had been firmly established by this late period. "Since antiquity poets have regarded those skilled in transformation as skilled and it is just the same in painting. Where would the stylistic interest be if a thousand stanzas all had the same structure, which would bore the reader with its lack of flavor. In my view of Yuan and Ming painting there has been no one better in transformation than Wang Meng and no one less skilled in transformation than Dong Qichang [cat.28]." And: "I do not like Dong's paintings because they have only brush and ink and no 'hills and valleys' and because they only rarely embody anything of interest." Qian clearly preferred to respond emotionally rather than intellectually to the paintings of others and he catered to this taste with his own works, which were often modelled after Wen Zhengming (cat.15) and others of the Suzhou school. In comparing himself to Wen, Qian wrote: "I am not Wen's equal in fine and delicate work throughout the whole, but in antique elegance and mature refinement I am one counter ahead."

This consciousness of and concern with style is evidenced in every aspect of Qian's life. "He liked to build houses. In Nanyang [Henan], beside the vine huts, he planted pines from which to construct houses, and in Nanjing he got the unused land in Tao Valley near the foot of Mount Qingliang where Tao Hongjing [451-536] used to live. Qian built his Green Peak Thatched Cottage, the courtyard of which had old blossoming plum trees from the Six Dynasties period. On Jiaoshan [an island in the middle of the Yangtze] he erected a thatched hut and by West Lake [in Hangzhou] at the foot of Mount Baoshi he built the present Wild Seagull Cottage... the rooms of which were quiet as those of a monk's hut with only one or two young boys to serve him..." Since Qian Du had no sons, one of his brothers "invited him to adopt a nephew as his heir. Qian laughed and said: 'Perpetuation does not simply mean having descendants.' He constructed his own tomb and buried his daughter, Chuzhang, who had died after marriage, beside it."

Catalogue No. 71.
**Gai Qi** (1774-1829)
*Cailian Tu*, "Plucking Lotus Blossoms"
Handscroll, ink and color on silk, 27.4 x 201.2 cm.
Inscription:
"Kingfisher-blue water in coolness
    begets red fragrant dew,
enveloped in dawn breeze they lack
    the strength to resist the flow;
Mist gleams on drapery folds and
    cleanses them of Xiang river green,
with flower sack they row to what
    he dreamed about in the past.
Mandarin ducks are their guests
    while both think in detail,
hands that pluck new blossoms for
    the pearl room are light;
Opening an arbor which seems like jade,
    he smiles broadly,
captivating and graceful of carriage,
    who would spare her?
Of glass make the curtains so the
    shadows of the moon will penetrate,
on the flowery wall the invitation will
    arise and at that he will advance;
Her hair half let down and dancing and robe in disarray;
he listens to the oars sing of whence
    the whistle will sound recall.
In a small stream the autumn whistle
    should take heed of the red dress.
At the request of Zimu, elder brother Ren, written by
the Mountain Woodgatherer of Dragon-isle Peak, Gai
Qi, according to an earlier rhyme."
Artist's seals: *Qixiang; Gai Qi zhi Yin; Yuhu Shanren*

Colophons: Wu Yun; Qian Du (1763-1844); Feng Chenghui (1786-1840); Jiang Baoling (1781-1840)

Within luscious lotus leaves and blossoms glides a small skiff whose occupants, a proudly smiling gentleman and pensive young maid, seem equally oblivious of their surroundings, which include a pair of mandarin ducks, those time-honored symbols of conjugal bliss. Closer inspection reveals that the girl's coiffure is in disarray, a suggestive detail supported by the visibility of her crimson undergarment and given further point by the pride with which the male faces his audience. The poem suggests in evocative language that the young girl is a new virgin concubine – the "pearl room" – taken by the elder man, who is probably Li Renzai, an artist friend of the present painter.

Gai Qi's antecedants were from the "western regions," or Central Asia. His grandfather, a military man who served in the eastern portion of the empire, was granted the surname Gai by the emperor and registered in Songjiang, near modern Shanghai. Gai Qi's father was also a military man of some standing but the son excelled in poetry and painting from his early youth. Gai Qi became a specialist in figure painting and worked in the styles of such earlier masters as Li Gonglin of the Song, Zhao Mengfu of the Yuan, Tang Yin (cat.16) and Chen Hongshou (cat.33) of the Ming, and Hua Yan (cat.60) of more recent times. Gai's figure style became very well-known through his block-printed illustrations to the famous eighteenth-century novel *Honglou Meng*, "Dream of the Red Chamber;" his pale and languorous ladies inspired even the decorators of late Qing porcelains. The present work is a particularly fine and vivid example of his style, perhaps because the people were known well to him and the occasion one that obviously stimulated his own creative imagination.

Catalogue No. 72.
**Dai Xi** (1801-1860)
*Yisong Tu*, "Recalling the Pines"
Handscroll, ink on paper, 38.2 x 123 cm.
Inscription: "The honorable Qi Junzao of the former generation is officially registered at Shouyang and calls himself the Headman of Manjiu. That region is near Mount Fang, which has such scenic spots as Dragon Pond and Cloud Cave. Numerous pines spread throughout the gorges and fill up the valleys, and there are distant prospects without end. Once while walking amidst the myriad pines on a moonlit night he encountered an important person. As elder and younger brothers they bound themselves together in a study association, composed poems in response to the other, and eventually decided to become neighbors. Later, in the capital, whenever there was a direct wind and an unclouded moon he recalled those days and asked me to paint a 'Recalling the Pines' picture, but for five years I have been disorganized and had not yet responded to him. In early spring of the year 1847 I was staying at the capital

and remembered the pines and tracks of the old mountain. I thus borrowed a wineglass and poured out all my unpolished words even though late. Painted and inscribed by Dai Xi."
Artist's seals: *Luchuang*;
*Yu Jiangnan Xu Heyang Guo tongming*
Colophons: Qi Junzao (1793-1866) in 1857, Xu Zonghao (1880-1957) in 1950

The person for whom this painting was done, Qi Junzao (1793-1866), was one of six sons born to the well-known historian Qi Yunshi (1751-1815) of Shouyang, Shanxi. The father was working in Beijing as director of the Coinage Office when a deficit in his accounts led to his banishment in 1805 to Xinjiang. Qi Junzao and his mother then returned to their Shanxi home which, according to the present painting, was in a mountainous region of few inhabitants and many pines. Junzao did make a friend, however, and they are depicted here studying in neighboring houses placed within a protective valley. Junzao passed the third-level examination in 1814 and eventually rose to be a grand secretary. In 1842, the year in which he requested this painting from the artist, Qi had just returned to the capital from supervising coastal defenses against the British and from enforcing the prohibition against opium, the major point of contention of the war.

The artist, Dai Xi, was born in Hangzhou. Following an appointment to the Hanlin Academy, Dai served in the Supervisorate of Imperial Instruction; in 1838 he was appointed education commissioner to Guangdong, one of the major entries for opium into China. Dai worked tirelessly to suppress the use of the drug by the students for whom he was responsible. He was in Beijing in 1842 and likely sympathized with his friend's request for a painting that would commemorate a period of youthful hope and aspiration. Unfortunately, Dai's father died that same year and the artist left the city before doing the painting for Qi. Returning to the capital in 1847, Dai recalled the earlier commission and made amends by embodying Qi's memories in a painting of monumental scale and substantial grandeur.

Although Dai's inscriptions often mention paintings by artists of the orthodox tradition active between the tenth and fourteenth centuries, such paintings could not generally be seen, for most had become part of the virtually inaccessible Qing imperial collection. What Dai and others like him could see, and what he frequently wrote about, were paintings by such as Dong Qichang (cat.28) and Wang Hui (cat.49). Dai's consciousness of the past is reflected as well in his collection of antique coins; his awareness of a personal relationship to the past tradition is further revealed in his seal-legends: one on the present work refers to famous artists of the tenth and eleventh centuries as though they were his contemporaries: "I have the same given name as Xu [Xi] of Jiangsu and Guo [Xi] of Henan." In 1860, when the Taiping forces temporarily captured Hangzhou, Dai and several members of his family committed suicide rather than submit.

Catalogue No. 73.

**Ren Xiong** (1820-1857)

*Zihua Xiang*, "Self-Portrait"

Hanging scroll, ink and color on paper, 177.5 x 78.8 cm.

Inscription:

"What thing from within the vast cosmos is this
   before my eyes, with fleeting smile and body awry?
I have long been aware of and anxious about
   important affairs but am confused about what
   to grasp hold of and rely upon.
But this is so easy to talk about! Let us examine
   the gallant and splendid Jin, Zhang, Xu and Shi.
But how many of them could
   reach those heights today?
To return to the past would be a pity, for then the
   mirror would change to a dark moth-browed
   beauty and dirt-covered old man, both alike in
   running about without a plan.
But what deludes people still further
   are the pitiable histories, for when have they
   ever recorded a single word
   about such inconsequential people!
Lord Ping Xu was someone hoped for by the Master,
   but in the end it is difficult to know even oneself.
So lift up your voice in song
   and rise up to dance, for the path of
   officialdom is that of contempt and decadence.
When I sum up my youthful years and my original
   thoughts on right and wrong, which to a certain
   extent I wrote out in sequence from
   antiquity onward, who was the stupid
   fool and who the worthy sage?
I too have no idea at all, but, there it is – a single glance
   at what is undefined, vague, and boundless.
Composed by Ren Xiong, called Weichang,
to the tune of 'The Twelve Daily Periods'."

Artist's seals: *Ren Xiong zhi Yin; Xiangpu Shihua*

Ren Xiong, one of the most inventive of all nineteenth-century Chinese artists, was born in a farming village in Xiaoshan, Zhejiang. Although Ren studied as a youth with a local portraitist, he very soon developed his own ideas, for which he was expelled from the master's studio. By around 1850 he was selling paintings in Ningbo, where he met the famous literatus Yao Xie. While working on a series of 120 illustrations to poems by Yao, Ren Xiong had the opportunity to see paintings in Yao's collection and to meet Yao's friends. Within two years of leaving Yao's household, Ren's reputation had grown sufficiently for him to be able, in 1853, to marry. The couple then lived in Xiaoshan on Ren's earnings as an artist, an activity which took him frequently to Suzhou, home of his in-laws, and to Shanghai.

During Ren's youth the defeat of China by the British had exposed both government corruption and military weakness. During the later 1840s these same factors prevented effective government response to the great famines and attendant banditry which occurred in southern China; these led to the great revolt directed from 1851 onward under the banners of the *Taiping Tianguo*, "Heavenly Kingdom of Peace." The capital of this new "kingdom" was established in Nanjing after Nanjing and Yangzhou fell to the Taiping forces in 1853. Imperial troops under the command of Xiang Rong were sent to contain the rebels, which they did from temporary headquarters established on the outskirts of Nanjing. For some time between late 1854 and early 1856 Ren Xiong, recommended by a military friend known from his days with Yao Xie, was pressed into service in Xiang Rong's headquarters. In August, 1856, Xiang's forces were defeated and Xiang died a suicide, or possibly from illness; Ren Xiong returned home, but died the following year of tuberculosis.

The present work is undated but was likely painted during the final year or so of his life; a portrait of another military friend, Ding Wenwei, was painted by Ren in 1856. In Ren's compelling self-portrait a clear visual distinction is drawn between the person and his enveloping garments, which camouflage the figure rather than characterize it. Another aspect of the distinction is that of presentation: realistic depiction of taut forms on the one hand and strongly stylized and loose forms on the other. The figure neither faces us directly, in full stasis, nor is it clearly turning to move away. The ambiguity of the posture supports that in the relationship of figure to drapery – do we see the unveiling of the real Ren Xiong or the means by which he ordinarily disguised himself, the trousers of a farmer, the gown of a scholar or official?

The full intent and meaning of Ren's inscription is obscure, at least to the present writer; the punctuation given above is of course not present in the Chinese but rather that suggested by imagining a dialogue between the artist and the reflection he saw in a mirror as he prepared to execute this portrait of himself. This structure is suggested by Ren's mention in his inscription of the dialogue recorded in a Han dynasty poem between Ping Xu and Master Anchu on the rise and decline of the capital; Ping and Anchu took opposing viewpoints, the combination of which makes up a complete whole. In Ren's inscription his extroverted self opens the conversation by inquiring after the identity of this hesitant image. The inner voice responds that he is confused, for he has of course been party to attempts to suppress a movement with which he probably had considerable sympathy. The external self suggests that such worthies as Jin Ridi, Zhang Anshi, Xu Bo, and Shi Huan – all Han dynasty officials who rose to great power and influence – can function as guides to proper action. The internal self responds that in the modern, nineteenth-century world they would not get far at all; Zhang Anshi, for instance, rose to be chief minister of the Ministry of War on the strength of having memorized the full contents of three boxes of books. To turn back the clock would do no good either, for then Ren's image would be replaced by that of his moth-browed mother and farmer father, who were from a class fundamental to society but yet totally ignored by the official histories written by members of the leisured class. Everyone hopes to find a soulmate, the friend who understands one perfectly and intuitively, but the examples of the Han poet Zhang Heng, who was forced to speak through the character Master Anchu and converse with the invented Ping Xu, and of Ren Xiong himself suggest that understanding one's inner self is most difficult of all. The literary effort to which Ren refers may be the *Gaoshi Zhuan*, "Biographies of Noble Scholars," a woodblock-illus-

trated book completed in the year of his death.

When Ren Xiong died in 1857 the Taiping forces had not yet been defeated nor even dislodged from Nanjing. On the surface Ren was loyal to his government; he worked with one of the Qing generals, and even his close-cropped military haircut set him apart from the followers of the Heavenly Kingdom of Peace, who were forbidden to cut their hair, yet the reforms promulgated by the Taiping government were clearly beneficial to a majority of the populace. It is to Ren Xiong's credit that he acted when called upon, and even more so that he continued to question the morality of his own actions.

Catalogue No. 74.
**Ren Xun** (1835-1893)
*Huaniao*, "Flowers and Birds"
Set of four hanging scrolls, ink and color on paper, each 146.6 x 39.2 cm.
Inscription: "During the second month of spring in the year 1874 of the Tongzhi reign-era, painted by Ren Xun of Xiaoshan while lodging in Suzhou."
Artist's seal: *Fuzhang*

Ren Xun, the younger brother of Ren Xiong (cat.73), was born in Xiaoshan, Zhejiang. Xun and Xiong together with Ren Yu (1853-1901), the son of Xiong, and Ren Yi (cat.76) are the so-called "Four Rens," among whom Ren Xun is usually considered the least innovative. While it is true that in figure painting he followed the style of Chen Hongshou (cat.33), as had his brother, his bird-and-flower works employ sensitive brushwork and pastel coloring to good evocative effect. In the present paintings the forms fill much of the available space and are not generally overlapped, an approach which yields strong and decorative designs related to those of *kesi* textiles.

Catalogue No. 75.
**Zhao Zhiqian** (1829-1884)
*Huahui*, "Flowers of the Four Seasons"
Set of four hanging scrolls, ink and color on paper, each 168 x 43 cm.
Inscriptions:
(1) Peony:
"Lofty yet not perilous, fulfilling but not overflowing;
In painting the flower-of-wealth-and-honor,
lightly, lightly stroke with the brush.
Weishu."
(2) Peach: "Painted by Weishu."
(3) Chrysanthemum: "Weishu playfully copied a work by Futang [Li Shan]."
(4) Blossoming Plum: "Done during the tenth month, winter, of the year 1867 in the Tongzhi reign-era for my honorable second elder brother Chunxiang by Zhao Zhiqian called Weishu."
Artist's seals: *Zhao Ruxiang*; *Zhao Zhiqian Yin*

Born in Shaoxing, Zhejiang, Zhao Zhiqian passed the second-level examination in 1859 and during the 1870s and early '80s served as acting magistrate in various districts in Jiangxi. As a scholar Zhao had very wide-ranging interests. His study of and monograph on snuff and its containers earned him the name "The Snuff-bottle Master" in Beijing, and in art too he made important contributions in several areas. His flower paintings continued the tradition of Chen Daofu (cat.23) and Li Shan (cat.63) and, as here, move even further in the direction of abstraction and expressionism. The visual richness of the natural blossoms is here enhanced by formal variations in their presentation, a concentration on the potential for indirect expression through manipulation of line, shape, and form that was natural to an artist who was also a creative calligrapher and, especially, seal-carver. Zhao is reported to have said: "In both life and art natural endowment is more honored than human effort; only in seal-carving are they equal." Even a cursory examination of the seals applied to the present works will reveal a conscious concern for graceful rhythms and subtle balances that are achieved less obviously and more spontaneously in the paintings themselves.

Catalogue No. 76.
**Ren Yi** (1840-1896)
*Su Wu Muyang Tu*, "Su Wu Herding Sheep"
Hanging scroll, ink and color on paper, 183.2 x 47 cm.
Inscription: "Done at the instruction of my old friend Jinghua during the twelfth lunar month of the year 1889 by Ren Yi of Shanyin at the Antique Fragrance Studio in the West Building before a trimmed candle."
Artist's seals: *Ren Yi Siyin*; *Ren Bonian*; *Ren Yi*

Su Wu was sent as an envoy to the court of the Turkic Xiongnu, who sought to sway his allegiance to Emperor Wudi of the Han dynasty by both blandishments and torture. When all failed he was sent as a shepherd to the distant north, where we find him here an old man but with his back yet firmly turned against continuing enticements to disloyalty. In 81 B.C., having been held captive for nineteen years, he returned home, where his name continued ever after as an emblem of unswerving loyalty.

Ren Yi, born in Shaoxing in Zhejiang, learned to paint as an apprentice in a Shanghai fan shop. From his earliest years he excelled as a figure painter, often approaching the style of Chen Hongshou (cat.33). So great was Ren Yi's talent that when Ren Xiong (cat.73) caught him forging his own work, he accepted Ren Yi as a pupil. Somewhat later Ren Yi is said to have obtained an album of paintings by Zhu Da (cat.44) and, through study of it, to have become aware of calligraphic brushwork – of the necessity to "write" his images with a centered brushtip rather than to draw them with a slanted brush and with his arm resting on the table. Ren's lively style and easily accessible subjects captured a very large audience and earned him great renown in Shanghai, whose art-circles he dominated toward the end of the century and of the Qing dynasty.

# Suggested Reading

Barnhart, Richard. *Marriage of the Lord of the River, A Lost Landscape by Tung Yuan*. Ascona, Artibus Asiae Supplementum XXVII, 1970.

——. *Asia*, volume 8 in *The Metropolitan Museum of Art Series* (12 volumes), published by the Metropolitan Museum of Art and the Fukutake Information Service (New York and Kyoto). Japanese language edition, 1987, English ed., 1988.

——. *Peach Blossom Spring – Gardens and Flowers in Chinese Painting*. New York: The Metropolitan Museum, 1983.

——. *Along the Border of Heaven: Sung and Yuan Paintings from the Collection of Wang Chi-ch'ien*. New York: The Metropolitan Museum, 1983.

——. *To Gen Kyonen* (Tung Yuan and Chü-jan), (with Iriya Yoshitaka and Nakata Yujiro), *Bunjinga Suihen*, v. 2. Tokyo, 1977.

——. *Wintry Forests, Old Trees – Some Landscape Themes in Chinese Painting*. Exhibition catalogue, New York, 1972.

Bush, Susan. *The Chinese Literati on Painting: Su Shih (1037-1101) to Tung Ch'i-ch'ang (1555-1636)*, Harvard Yenching Studies, no. 27. Cambridge, Mass., 1971.

Bush, Susan and Christian Murck, *Theories of the Arts in China*. Princeton, 1983.

Cahill, James, 'Ch'ien Hsüan and His Figure Paintings', *Archives of the Chinese Art Society of America*, vol. 12 (1958), pp. 11-29.

——. *Chinese Painting*. Skira, Lausanne, 1960.

——. *Fantastics and Eccentrics in Chinese Painting*. New York, 1967.

——. *Hills Beyond a River: Chinese Painting of the Yüan Dynasty, 1279-1368*. Weatherhill, New York and Tokyo, 1976.

——. *Parting at the Shore: Chinese Painting of the Early and Middle Ming Dynasty. 1368-1500*. Weatherhill, New York and Tokyo, 1978.

——. editor. *The Restless Landscape: Chinese Painting of the Late Ming Period*. Exhibition at the University Art Museum, Berkeley, 1971.

——. *The Distant Mountains: Chinese Painting of the Late Ming Dynasty, 1570-1644*. Weatherhill, New York & Tokyo, 1982.

Chuang Shen and James C. Y. Watt. *Exhibition of Paintings of the Ming and Ch'ing Periods*. City Museum and Art Gallery, Hong Kong, 12 June-12 July 1970.

Clapp, Anne De Coursey. *Wen Cheng-ming: The Ming Artist and Antiquity*. Ascona, 1975.

Contag, Victoria. *Chinese Masters of the Seventeenth Century*, translated by M. Bullock. Rutland, Vermont and Tokyo, 1967.

Edwards, Richard. *The Field of Stones: A Study of the Art of Shen Chou*. Washington, D.C., 1962.

Fong, Wen, *The Lohans and a Bridge to Heaven*. Washington, D.C.: Smithsonian Institution, 1958.

——. *The Problem of Forgeries in Chinese Painting*. Ascona: Artibus Asiae, 1963.

——. *Sung and Yuan Paintings*. New York: The Metropolitan Museum of Art, 1973.

——. *Summer Mountains: The Timeless Landscape*. New York: The Metropolitan Museum of Art, 1975.

——. (with Murck, Shih, Ch'en and Stuart) *Images of the Mind: Selections from the Edward L. Elliott Family and John B. Elliott Collections of Chinese Calligraphy and Painting*. Princeton: The Art Museum, Princeton University, 1984.

Fu, Marilyn and Shen, *Studies in Connoisseurship: Chinese Paintings from the Arthur M. Sackler Collection in New York and Princeton*. Princeton, New Jersey, 1973.

Lawton, Thomas. *Chinese Figure Painting*. Washington, D.C., 1973.

Lee, Sherman E. *Chinese Landscape Painting*. New York, 1962.

——. *A History of Far Eastern Art*. New York, 1964. 2nd ed., rev. 1973.

——. *The Colors of Ink: Chinese Paintings and Related Ceramics from the Cleveland Museum of Art*. Exh. cat.: Asia House Gallery. New York, 1974.

Li, Chu-Tsing. *A Thousand Peaks and Myriad Ravines: Chinese Paintings in the Charles A. Drenowatz Collection*. Ascona, 1974.

Loehr, Max. *Chinese Painting After Sung*. New Haven, 1967.

——. *The Great Painters of China*. Phaidon Press, 1980.

Sickman, Laurence, editor. *Chinese Calligraphy and Painting in the Collection of John M. Crawford, Jr.*. New York, 1962.

Sirén, Osvald. *The Chinese on the Art of Painting*. Peking, 1936 (reprinted by Schocken Books, 1963).

——. *Chinese Painting: Leading Masters and Principles* (abbreviated CP), 7 vols. London and New York, 1956-8.

Sullivan, Michael. *The Arts of China*. University of California Press, Berkeley, 1977. 3rd ed., rev. 1984.

——. *The Birth of Landscape Painting in China*. Berkeley and Los Angeles, 1962.

Tregear, Mary, *Chinese Art*. London, New York, and Toronto, 1980.

Whitfield, Roderick. *In Pursuit of Antiquity*. Princeton, 1969.

Willetts, William. *Chinese Art*, vol. 2. George Braziller, Inc., New York, 1958, pp. 501-581.

Wu, Nelson I. 'Tung Ch'i-ch'ang: Apathy in Government and Fervor in Art', in *Confucian Personalities*, eds. Arthur Wright and Denis Twitchett. Stanford, 1962, pp. 260-93.

# Index of Artists

by Catalogue Number

*Masterworks of Ming and Qing Painting from the Forbidden City*